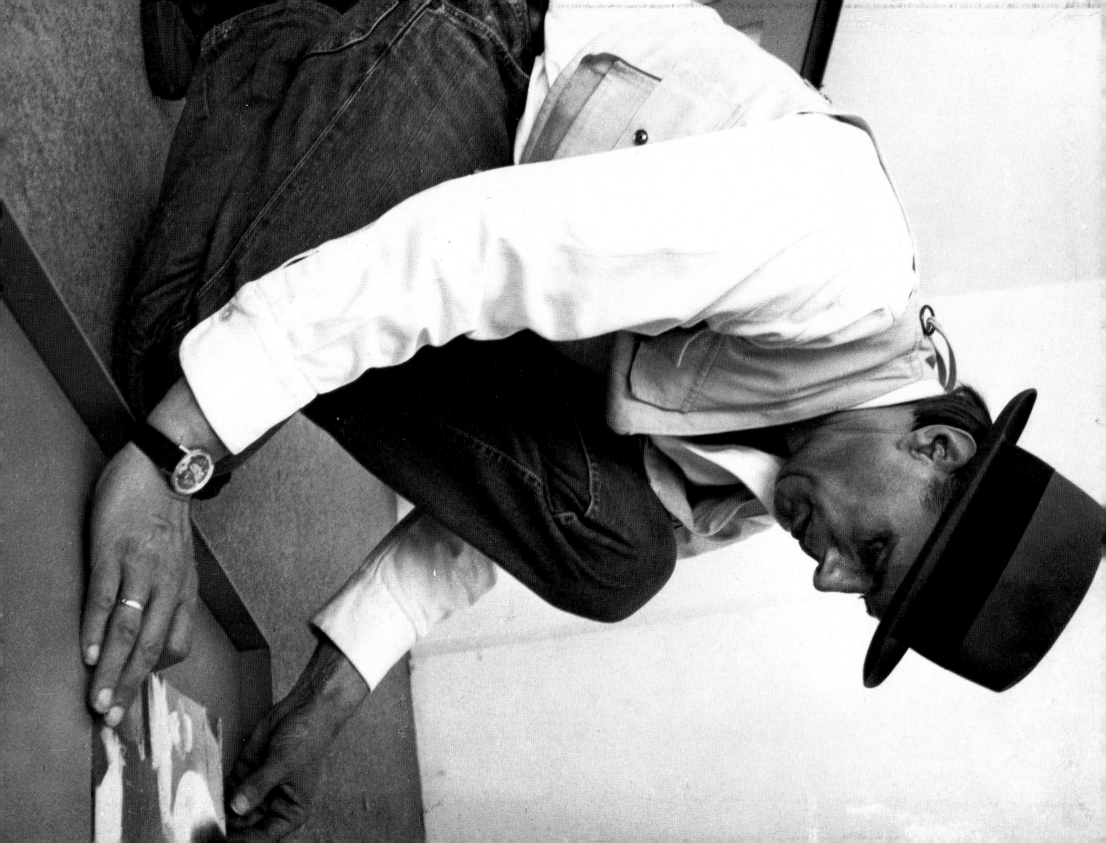

Joseph Beuys
Arena—

where would I have got if I had been intelligent!

Edited by Lynne Cooke and Karen Kelly

Dia Center for the Arts, New York
Distributed Art Publishers, New York

Library of Congress Catalogue Number 93-73428

ISBN 0-944521-29-0 (English edition)

Distributed Art Publishers
636 Broadway
New York, New York 10012

A German version of this book
is published by Cantz Verlag, Germany.
ISBN 3-89322-620-6 (German Edition)

Printed in Germany by Cantz

Table of Contents

Preface

The publication of this book inaugurates an effort to document major works in the permanent collection of Dia Center for the Arts. In Dia's extensive collection of work by Joseph Beuys, *Arena—where would I have got if I had been intelligent!* is the most ambitious and, because of its physical scale (100 panels, each approximately 55 inches by 32 inches), has rarely been seen in public in its entirety.

Dia's Curator, Lynne Cooke, acted as an editor for this project and conceived of the combination of essays from Pamela Kort and Christopher Phillips. We are deeply indebted to these writers for their critical insights and for their scholarly contributions to the book. Pamela Kort worked very closely with Eva Beuys in the effort to identify the almost three hundred images in *Arena*. The result of their collaboration is a milestone in Beuys scholarship. Lucio Amelio, longtime friend of Beuys, was the first to exhibit *Arena* in his Modern Art Agency in 1972, and gave generously of his time and deep understanding of Beuys's methods for the discussions with Pamela Kort transcribed here.

Many people contributed to the compilation of research for this book. In particular, we would like to thank Dr. Uwe Schneede and Dr. Theodora Vischer for their generous support. In addition, we'd like to acknowledge the guidance of Henning Christiansen, Richard Demarco, Walther König, and Cordelia Oliver.

The production of this book has been overseen from inception by Dia's Director of Publications, Karen Kelly, who is also co-editor of this book. Under her painstaking supervision, Franklin Sirmans dedicated himself to detailed research for many phases of this production. Also, Eleanora Louis graciously took on the arduous task of identifying and cataloguing the photographers whose work is found within the panels of *Arena*. Anastasia Aukeman and Brigitte Kölle were invaluable in their work on the biography and bibliography. Our appreciation is also extended to our copy editor, Diana Stoll, for her careful reading of the texts. Karen Kelly worked closely with Katy Homans and her associate Phil Kovacevich on the superb design of the book and with Cathy Carver on the meticulously consistent photography of *Arena*.

We are grateful for the support of Ted Fader, Artists Rights Society, VG Bild-Kunst, and the Estate of Joseph Beuys, Eva, Wenzel, and Jessyka Beuys.

Major funding for this project, and for Dia's 1992–93 exhibition of *Arena*, has been received from the National Endowment for the Arts, a federal agency, Washington, D.C., with additional funding from the Andy Warhol Foundation for the Visual Arts, Inc., the Dia Art Council, the major annual support group of the Dia Center for the Arts, and the Dia Art Circle.

Charles B. Wright
Executive Director

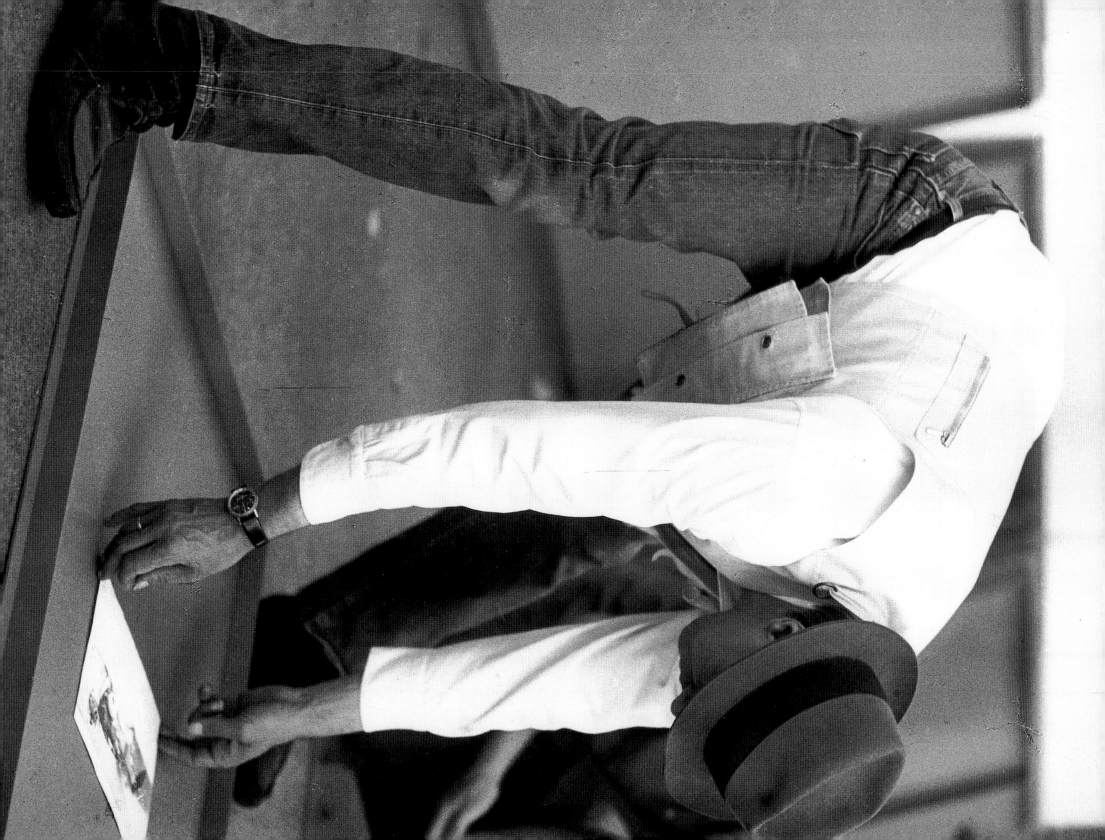

Installing *Arena*:
An Introduction
Lynne Cooke

In 1964 Joseph Beuys compiled an annotated biography called *Lebenslauf/Werklauf* (*Life Course/Work Course*), in which, fusing myth with fact, he tabulated the main episodes of his artistic life as a series of events/exhibitions. His birth in 1921, for example, is registered as "Kleve exhibition of a wound drawn together with an adhesive bandage"; 1950 was in part marked by the event "Beuys reads Finnegans Wake in 'Haus Wylermeer.'" Over the remainder of the 1960s, he continued to update this curriculum vitae, often for inclusion in exhibition catalogues and related publications. In its preliminary guise, the abbreviated, untitled version of *Arena* shown in Edinburgh in the summer of 1970 may be regarded as a kind of visual analogue to the *Life Course/Work Course*, which, after 1970, Beuys left to others to append. At its debut this photographic work took the form of an autobiographical summa, a visual diary of the public persona Beuys had chronicled in the *Life Course/Work Course*. But, as with many of Beuys's works, over time *Arena* was to undergo a process of elaboration and modification.

In the two years that lapsed prior to its next exhibition in Naples in 1972 as *Arena—Dove sarei arrivato se fossi stato intelligente!* (*Arena—where would I have got if I had been intelligent!*), Beuys completely reworked this piece. In its "final" form, the images no longer stand alone in simple, conventional mats, but are sequestered, portentously entombed, in specially designed, heavy aluminum frames.[2] They have become silent accomplices of a free-standing material component: the sculptural stacks. These two piles of wax and fat blocks interspersed with sheets of copper and iron were employed, as was the oil can, in the action, *Vitex agnus castus*, which Beuys performed on the occasion of the opening of the exhibition of *Arena* at Lucio Amelio's Modern Art Agency in Naples, on June 15, 1972. They were thus integral to the work from its inception as *Arena*. However, exceptionally for Beuys, photography is the principal medium and material of this work. Together, these brief traces of his seminal actions and of fragments from his vast sculptural repertoire form a comprehensive, if elusive, corpus of imagery that ranges from the late 1940s to the beginning of the 1970s. First, by sparingly overpainting many of these photographs with such materials as wax, fat, and *Braunkreuz*, and second, by reference via his action *Vitex agnus castus* to alchemical processes and symbolism, Beuys bound *Arena*'s pictorial and plastic components in an intricate network of association and allusion.

The preliminary version exhibited in Scotland comprised some 160 photographs mounted on white mats and placed behind glass. It was presented alongside a new action, *Celtic (Kinloch Rannoch) Schottische Symphonie* (*Celtic [Kinloch Rannoch] Scottish Symphony*), and a major sculpture, *The Pack (das Rudel)*, 1969, at what Beuys must have considered an important milestone, his artistic debut in the English-speaking world. Added late, after the catalogue was in production, Beuys's untitled photographic piece excited little attention in the press in contrast to his other two contributions, which won him considerable critical appreciation. By the time of its much-elaborated incarnation in Naples, Beuys had thoroughly reconceived it, perhaps in response to what may have come to seem a provisional, tentative first formulation, and certainly in relation to the fact that this time it was to be shown in southern Europe.[3] What Beuys finally brought gallerist Lucio Amelio in 1972 was a fully resolved, monumental sculptural installation. The considerably enlarged photographic cycle was now accompanied by three monochrome glass panels, two deep blue and one golden yellow, all encased in massive, purpose-built frames. Beuys's ideal configuration for the presentation of *Arena* had become a circular space. Like its Latin title, this evolved from consideration of the forthcoming context and action, and was reinforced by the incorporation of a single found photograph: the picture of the Roman arena in Verona is the sole image among the 264 that originates outside the Beuysian matrix. If its significance for Beuys was multiple (as it doubtless was), he would have been indifferent neither to Goethe's well-known admiration for this monument, nor to the writer's notions of its effect on a group of spectators. "…[T]he amphitheater at Verona, which is known locally by the name 'Arena'…is the first significant monument of ancient times that I have seen," Goethe wrote in his journal of September 1786. "On entering it, but still more while walking around its rim, I felt strange because I was seeing something great and yet actually seeing nothing. Of course it should not be seen empty, but brimful of people…. [Under such circumstances] a milling crowd . . sees itself united into a noble body, induced into oneness, bound and consolidated into a mass, as if it were one form, enlivened by one spirit."[4] In 1971, when traveling south for his first exhibition in Italy, Beuys seems to have deliberately adopted Goethe's route, journeying via the Brenner Pass to Verona

then down to Naples. Throughout the entire trip, he wore an elegant fur coat, as if to invest the event with due ceremony.

Notwithstanding his wish for a grand space wherein all one hundred frames could be clearly displayed, and the stacks located at its fulcrum in the center, Beuys did not hesitate to adapt *Arena* to the contingencies of the actual situation confronting him.[5] Unable to hang all the panels in Amelio's Modern Art Agency, he refrained from hanging any, stacking them instead in piles, which leaned against the walls. Several were separated, interspersed seemingly casually at irregular intervals between the larger groups, and the stacks were placed at the midpoint of the small rectangular room. The action *Vitex agnus castus* opened the exhibition. A sprig of the plant from which the action takes its name, along with a cobalt blue ribbon bearing on it that name written in sulphur, were bound into the band on Beuys's hat. For almost an hour, the artist lay on the floor rubbing the edges of the copper plates with his fingers, which he had coated with oil from the can. Eventually his whole body began to vibrate.

Several months later, *Arena* was sent to Rome to be exhibited at Galleria L'Attico. Once again Beuys was presented with a room of confined dimensions: the work was consequently installed in a similar fashion to that employed in Naples. On this occasion Lucio Amelio did the installation, which Beuys oversaw. The artist then performed an unscheduled action, titled after one of his longtime heroes, Anacharsis Cloots, reading extracts from a life of this eighteenth-century anarchist revolutionary, who, like him, was a native of Kleve.[6] Clad for the occasion in a military greatcoat, Beuys ended his action by bowing three times, once facing straight ahead, and then to the left and right, as had Cloots when mounting the steps of the guillotine on which he was to be executed. No material relics from this action were incorporated into *Arena*. Five months later, in March 1973, *Arena* was exhibited once more in a commercial gallery, this time the Studio Marconi in Milan. Once again, the piece could not be shown in its entirety, and the method of presentation followed that adopted previously. As before, Lucio Amelio laid out the panels. There was no accompanying action.

Prototypes for this seemingly casual mode of display can be traced back at least as far as one of Beuys's earliest comprehensive exhibitions, held at the farm of his first important patrons, the van der Grinten brothers, in Kranenburg in 1963. For this exhibition, entitled "Stallausstellung" (Stable Show), Beuys amassed nearly three

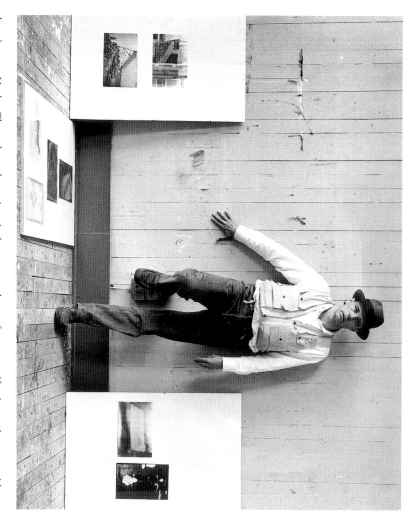

Joseph Beuys at the exhibition "Strategy: Get Arts," Edinburgh (1970).

Drawings relating to *Arena* (not dated).

hundred works, which he installed in a somewhat idiosyncratic fashion throughout a disused stable.[7] Many were grouped and hung salon-style; others were set in vitrines built in front of the stalls and troughs, others were suspended on nails found on posts and walls, and still others were simply placed on the floor, propped against the walls. This Fluxus-inspired effect of improvisation and spontaneity unified the context as an entity, encouraging an informal, unstructured mode of viewing. Despite the great diversity of sites Beuys worked in subsequently, he seems to have constantly striven for an equally vigorous style of presentation and a similar suggestion of immediacy—one that would leave the works unfixed, as if informally brought together for the occasion—not enshrined, removed and distant, as is so often the case with conventional types of installation and presentation.

In 1973 Beuys had the opportunity to show *Arena* for the first time in toto when he was invited to participate in a large international exhibition, "Contemporanea," to be held in an underground parking lot located beneath the Villa Borghese in Rome. He made it a condition of his inclusion that he be accorded a substantial area, one comparable to those promised to leading American artists, like Robert Rauschenberg, who were also asked to contribute.[8] In such a cavernous space, *Arena* could be hung in full. Although "Contemporanea" was a multimedia exhibition, Beuys proposed no action. The panels were displayed on temporary walls constructed between the concrete pillars of the garage, while the stacks were enclosed, for their protection, within a transparent cube. Low lights hung so closely over the photographs that they permitted only intimate viewing, image by image. Each component was visible, yet the general effect was far from that grand encompassing vista generated in an antique amphitheater to which Beuys had alluded in his initial sketch. Laid out again by Amelio, no preferred order or special sequence was devised for the placement of the individual panels. Although each frame had been given a number from 1 to 100 during its fabrication, Beuys never had recourse to the integers stamped into the metal for guidance when positioning the panels. Nevertheless, it seems not by chance that all three monochrome panels were hung together, and that the image of Verona was placed adjacent to them.

The significance Beuys accorded these particular panels is attested to in the prominence they gain when grouped together. In Milan, as in Rome, they had attained a noteworthy position among the apparently randomly grouped elements. Placed foremost in the stacks, the colored glasses took on the role of filters, screening while still partially revealing the layer of images beneath. They were again deployed in this manner when Beuys installed *Arena*, for the fifth and last time, at the extensive retrospective of his work staged at the Solomon R. Guggenheim Museum in New York in 1979. For this exhibition, Beuys designed an elaborate configuration of twenty-four stations that wound down the spiral of the Frank Lloyd Wright building, beginning with *Badewanne* (*Bathtub*), a work made in 1960 using his childhood bath, and ending with the monumental sculpture *Honigpumpe* (*Honeypump*), which had been a focal point of Documenta 6 in 1977.

In the center of Wright's rotunda, at what was the visual climax of the show, he installed three major works, *Arena*, *Tramstop* (1976), and the twenty-ton fat sculpture, *Tallow* (1977). In the accompanying catalogue, the huge five-block *Tallow* was hailed as "his most extreme sculpture to date."[9] Conceived—exceptionally in Beuys's oeuvre—as a site-related work cast from a corner of an underground walkway in Münster, its presence here confirmed that, for Beuys, the artwork did not have a fixed state, and that, instead of existing statically, it should be seen as something existing in time: "sculpture as an evolutionary process" was

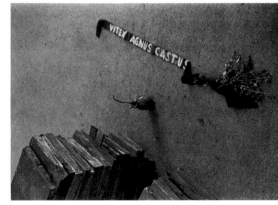

Vitex agnus castus (1973), color offset edition of 1000, signed and numbered. Edition Staeck, Heidelberg, and Modern Art Agency, Naples.

Lucio Amelio and Beuys at Studio Marconi, Milan (1973).

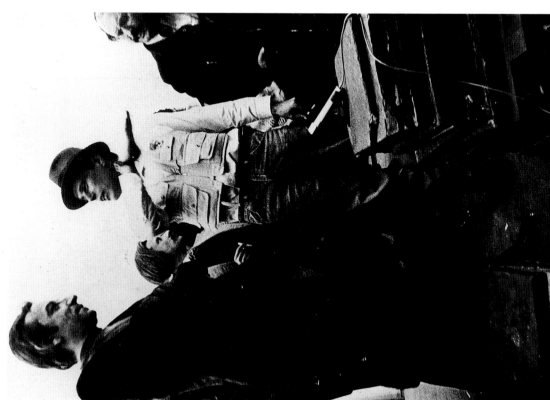

a cardinal concept in his theory of Social Sculpture. Described as "a monument to the future," *Tramstop* had formed the centerpiece of the landmark exhibition Beuys made when he represented his country in the German Pavilion at the Thirty-seventh Venice Biennale in 1976.[10] Comprised of various elements cast in iron, one of which ended in the head of Cloots, Beuys determined that once it left Venice, *Tramstop* should always be shown in a dismantled state, with the elements simply laid out horizontally on the ground." He adhered to this decision at the Guggenheim. Though disassembled, *Tramstop* in its present state does not appear fixed or frozen: rather, it seems to leave open the possibility of a renewed reconstruction or resurrection on some future occasion. *Arena* was displayed in singularly succinct fashion. All one hundred panels were grouped into three piles, then propped against the low wall of the ramp, a monochrome glass uppermost in each. The stacks and oil can were positioned nearby. In this, the most condensed presentation possible, the elements were massed into a block, or *fond* (the collective term Beuys coined for batteries that send, store, and receive energy). Its dense, compact structure was one the artist constantly utilized throughout his career—in his installations, actions, and objects—on account of its suggestive form. By adapting it to *Arena*, he turned *Arena* into a work *in potentia*: dormant in the rotunda, it too awaited other occasions for its unfolding, its enactment.

In conceiving the retrospective on the model of the stations of the cross, Beuys directly invoked that sequence of events in the life of Christ that enfolds a number of seemingly minor incidents among crucial episodes; all, however, acquire great metaphorical or metaphysical significance within the devotions of the Passion cycle as a whole.[12] In addition, he established a structural analogy with the schema of the stations; for, although usually arranged around the walls of a chapel or church, they may also be erected on mountainsides or in the landscape, as sites to be visited on a journey or pilgrimage. Capitalizing on the fact that the Guggenheim consists of a spiral with numerous small lateral bays, Beuys encouraged a very different way of apprehending his works from that which he normally fostered in his actions or environmental installations. Formerly, by giving priority to process, he had sought to generate a dynamic fluid relationship with the observer. By invoking the stations of the cross in the context of this retrospective, he reinforced the importance of a contemplative response to works now manifest mostly in the guise of batteries, residua, and/or relics.

The contrast could hardly be greater between Beuys's ideal form of presentation for *Arena*, sketched on the 1972 invitation card for the Modern Art Agency, and this, its last installation during his lifetime, shaped as it was by his larger program for the retrospective itself.[13] Nonetheless, not only the configuration but also the particular placement of *Arena* within the unfolding topology of this show indicates its role for him as both a paradigmatic and a singular work. Beuys had conceived this grand and encompassing sculptural installation at what must have seemed a turning point in his life and work. Following the pioneering example provided by the van der Grinten brothers, his first and foremost patrons from the 1950s, he had begun working with other devoted collectors to amass similarly special and substantial bodies of his work. In 1970 he had installed the extensive collection that the industrialist Karl Ströher had acquired under his aegis on long-term loan to the Hessisches Landesmuseum in Darmstadt. Spread over some six rooms, this collection formed an unusually extensive repository of his work. Moreover, its setting—in a museum that combined fine art with

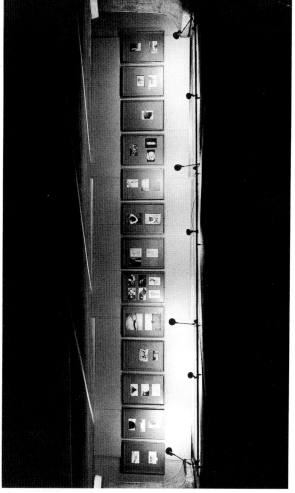

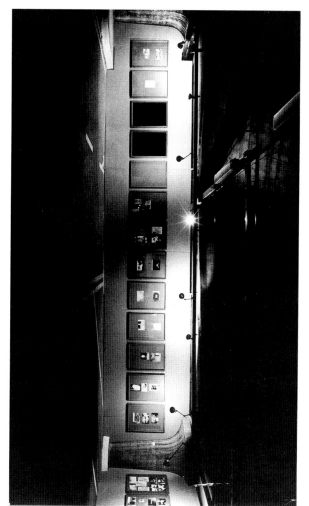

Above and below: *Arena* at "Contemporanea," Rome (1973).

natural history collections—was particularly appealing, almost ideal, to the artist, who continued to contribute to it over the following years. Then, in 1974, Beuys brought together his single most extensive compendium of drawings, *The secret block for a secret person in Ireland*, to which *Arena* has telling relations, not least because it, too, can be seen as a "block" of material, a battery of energy, of a uniquely comprehensive kind. Thus, the early seventies witnessed a singular and unprecedented moment in Beuys's career as he consolidated his work into major holdings for posterity: these "blocks" established significant presentations of his art in perpetuity. Thereafter his work and his life (never separate or separable) turned increasingly to the public sphere, as he orientated himself to the political process through his activities with the Free International University and the Organisation für direkte Demokratie durch Volksabstimmung (Organization for Direct Democracy through Referendum). At the same time he focused more intently than before on the manufacture of multiples, in order to extend his art and vision to a wider audience.[14] At Documenta 5, which opened only two weeks after the launching of *Arena* in Naples, Beuys set up an Office for Direct Democracy in which over the one-hundred-day duration of the exhibition he

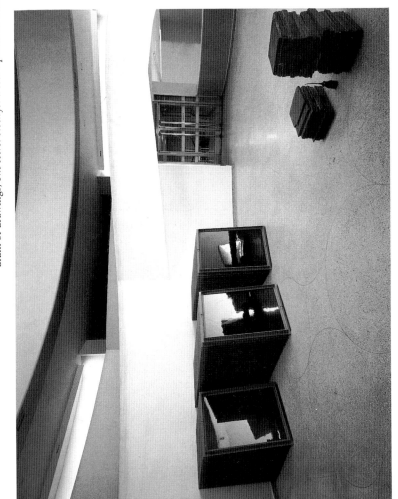

Arena at "Joseph Beuys," The Solomon R. Guggenheim Museum, New York (1979).

debated with whomever wished to engage with him or his ideas. With the notable exception of the signal work that launched his arrival in the United States, *I Like America and America Likes Me* (in which he lived in the same space as a coyote for a week), actions of the kind that had dominated his work of the 1960s rarely occurred after 1972. They were supplanted by public lectures, demonstrations, and teaching.

Seen in retrospect, the actions associated with *Arena* differ significantly from most of his previous ones. The key actions of the sixties consisted of complex, intricate bodily and gestural activity, often involving a multifarious array of props, materials, objects, and media, all interwoven through elaborate and arcane webs of association. *Vitex agnus castus* is, by contrast, noteworthy for the simplicity and spareness of its form, structure, and even content. At its most basic level, it was a kind of consecration; for, metaphorically and literally, Beuys galvanized the work by the transmission of kinetic energy.[15] Since the stacks were the physical receptacles for this transfusion, they became not only integral to but *inseparable* from the work—the contrary had usually been the case in former actions: objects were subsequently separated and dispersed, moved into

vitrines, or sold as individual pieces. Once *Arena* was anointed in this way, the energy was then stored, to be released by the intervention of an observer, whose entry into the circular enclosure liberates it from its inert state, reactivating it. For in crossing the threshold of a site with this charged typology, the viewer automatically becomes transformed from a beholder into a participant. *Anacharsis Cloots* is imbued, conversely, with a valedictory aura. Performed within the parameters of *Arena*, it added nothing physical to it. Metaphorically, however, it left an indelible trace, for it may be read as a gesture of departure, as Beuys relinquished (temporally as it later proved) the fine-art arena in favor of a new course of activity, one not unrelated in its political idealism and activism to that undertaken by Cloots himself.[16] Appropriating Cloots's farewell gesture, Beuys exited from the site of his

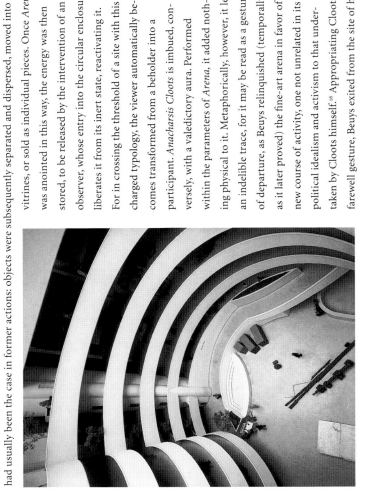

View of *Arena* from above at "Joseph Beuys," The Solomon R. Guggenheim Museum, New York (1979).

former activities—activities cryptically evoked in the compendium of blurry, fragmentary images that constitute the principal focus of *Arena*, in order to move onto a new stage. Tellingly, Cloots appeared for the last time in Beuys's oeuvre when the artist staged his own final exit. In December 1986, just one month before he died, Beuys installed his ceremonial memorial *Palazzo Regale* in Naples. In one of its two vitrines he placed the fur coat he had donned in November 1971 to begin his cycle of Italian exhibitions. Located in place of Beuys's head on this catafalque is a cast of the iron head (also used in *Tramstop*) of his revolutionary predecessor from Kleve.

Beuys thus left *Arena* neither inert nor empty. With its cloistered litany of images limning the course of the artist's life/work, the circular site is haunted by his presence. The entry of a spectator, however, transforms this memorial chamber into an arena. Under such circumstances, it is obviously not crucial whether he or she identifies all or even most of the events recorded in these pictures. Indeed, Beuys discouraged such an approach: he eliminated from his selection images with a documentary quality in favor of those that are elusive, suggestive, ephemeral, and hence open to multiple reinterpretation.[17] Chronological readings and analytical reconstructions are preempted, even precluded. Given these conditions, no definitive ordering of the panels would be appropriate. Endlessly open to reconfiguration, the work consistently offers something new to each individual who enters it. Beuys once described *Arena* as "practically my totally typical work, with its entire theory, the action fragments...."[18] Given this testimony and given Beuys's fervent belief that "everyone is an artist," the special place and role that *Arena* played in his oeuvre begins to emerge.

"*Arena—where would I have got if I had been intelligent!*" at Dia Center for the Arts, New York (1992–93).

Notes

1. For a fuller discussion of the history of this text, see Pamela Kort's essay in this book, "Joseph Beuys's *Arena*: The Way in," note 17. I am greatly indebted to Kort for the following discussion.
2. According to unpublished records at the Dia Center for the Arts, New York, Beuys may once have planned to continue updating *Arena* by adding further photographs in new panels. In fact, he never did. This proposal reaffirms, nonetheless, the open character this work retained for him.
3. Joseph Beuys, conversation with Martin Kunz, March 10, 1979, in *Spuren in Italien* exhibition catalogue (Kunstmuseum Luzern, April 22–June 17, 1979), n.p.
4. Johann Wolfgang von Goethe, *Italian Journey* (New York: Suhrkamp Publishers, 1989), 31, 37.
5. I am indebted to Lucio Amelio for this and many of the details that follow. See, in this book, "The Neapolitan Tetralogy: An Interview with Lucio Amelio" by Pamela Kort.
6. Although actually born in Krefeld, Beuys considered himself a native of Kleve, where he grew up. The *Life Course/Work Course*, for example, insinuates this with its entry for 1921, the year of Beuys's birth, "Kleve exhibition of a wound drawn together with an adhesive bandage."
7. For a fuller discussion, see Hans van der Grinten and Joseph Beuys "Stallausstellung: Fluxus 1963 in Kranenburg," in *Die Kunst der Ausstellung*, ed. Bernd Klüser and Katharina Hegewisch (Frankfurt/Leipzig: Insel Verlag, 1991), 172–177.
8. Unpublished interview, Pamela Kort, Lynne Cooke, and Lucio Amelio, Naples, 1992.
9. Caroline Tisdall, *Joseph Beuys* (New York: The Solomon R. Guggenheim Museum, 1979), 248.
10. Quoted in Tisdall, 242.
11. See discussion by Camiel van Winkel, "'Jetzt brechen wir hier den Scheiss ab' Installations of Joseph Beuys in Dutch Museum Collections," *Kunst & Museumjournaal* 5, no. 2 (1993), 34–47.
12. Numerous parallels and references to Christ appear in Beuys's works and actions. For comments on his martyrological role, see, in this book, "The Neapolitan Tetralogy."
13. *Arena* has subsequently been exhibited at "Joseph Beuys: Skulpturen und Objekte" (Martin-Gropius Bau, Berlin, February 20–May 5, 1988); "Joseph Beuys: Works from the Dia Art Foundation" (The Menil Collection, Houston, June 28, 1990–January 6, 1991); "Joseph Beuys: *Arena—where would I have got if I had been intelligent!*, 1970–72" (Dia Center for the Arts, New York, January 23, 1992–April 4, 1993); "ARENA von Joseph Beuys" (Museum für Gegenwartskunst, Basel, February 13–June 26, 1994; travels to Hamburger Kunsthalle, Hamburg, Summer 1994).
14. "Although these products may not seem suitable for bringing about political change, I think more emanates from them than if the ideas behind them were revealed directly," Beuys contended. Joseph Beuys, in conversation with Jörg Schellmann and Bernd Klüser, December 1970; reprinted in Schellmann and Klüser, *Joseph Beuys: Multiples*, Fifth ed., rev. (Munich: Schellman & Klüser, 1980), n.p.
15. Something similar though more informal seems to have occurred with the large installation *Voglio vedere i miei montagne* (I want to see my mountains), realized in Eindhoven in 1971, and so some months prior to *Arena*. Although no action was officially recorded as having taken place, photographs reveal Beuys lying on the ground engaged in some kind of activity in relation to the piece. Through a contagious transmission of energy, an anointing seems to have taken place. See, van Winkel, 40.
16. From the late seventies, as the time he allotted to political activism waned, Beuys worked increasingly within museum and gallery contexts.
17. Describing the photographs as "maddeningly opaque," Christopher Phillips persuasively argues in this book in "*Arena*: The Chaos of the Unnamed," that they are "as means not so much to document as to enter into the spirit of the events . . . ," 58.
18. Quoted in Kunz, n.p.

Joseph Beuys's *Arena*: The Way In
Pamela Kort

More than twenty years have passed since Beuys first exhibited *Arena*. And yet surprisingly little has been written about this mysterious, alluring, and brazen work.[1] Such an object demands attention. It also proffers an almost unparalleled opportunity to demonstrate the practicality of a methodology anchored in the details of *Arena*'s purpose, appearance, medium, title, configuration, and chronological placement, and its attendant relation to the events in Beuys's life and to the other works in his oeuvre.[2]

Arena consists of 264 photographs treated with sulfur, acid, wax, and paint; and three panels of handmade colored glass, locked within 100 carefully bolted, cryptlike enclosures. It also contains an oil can and two stacks comprised of twenty-one slabs of wax mixed with fat and four plates of copper and iron.

The work encompasses at least four chronologies: 1947–1973, the dates Beuys assigned it on the occasion of its final showing at "Contemporanea" in Rome, marking the beginning of his formal study of art and the year the exhibition took place; 1949–1971, the years of the sculpture, actions, and drawings that it documents; circa 1962–1972, the decade during which the photographs were taken; and 1970–1972, the term that Beuys worked on its construction. The arrangement of the photographs dismantles all of these time brackets. Theirs is an order outside chronological explication. They advance a vocabulary of shapes that refuses to be fixed, alternating between blurred and sharp representations, arrested and melting forms, and detailed and abstract compositions.

Arena bears witness to Beuys's twenty-five year struggle to present himself as an artist to the public. It embodies two operative objectives characteristic of Beuys's activity between 1947 and 1972: his desire to break free from the category of the "outsider" German artist, intensified by the escalation of his career relatively late in life; and to position himself internationally as an aesthetic leader capable of effecting a new modernism. Both intentions belong to the history of the "cult of the artist," a tradition that Beuys self-consciously referenced and reworked in *Arena*.[3]

Practical Purposes

Arena has always been about presentation.[4] It was made for a 1970 exhibition, "Strategy: Get Arts," at the Edinburgh College of Arts, touted in the catalogue as the first major exhibition of contemporary German art "to be shown in Britain since 1938."[5] Beuys introduced himself to an English-speaking public with three works: an action, *Celtic (Kinloch Rannoch) Scottish Symphony*; a sculpture, *The Pack (das Rudel)*; and approximately one hundred sixty of the photographs that today comprise *Arena*. Though the organizers of the exhibition had counted on an action and arranged for the loan of *The Pack (das Rudel)*, the inclusion of the photographs probably came as a surprise.[6] Beuys brought the photographs and one hundred frames with him from Düsseldorf, where he had already treated the images and placed them in a box.[7] After arriving in Edinburgh, he arranged them on mat boards, inserted these into the simple glass frames, hung a few around the room, and left the majority nonchalantly leaning up against the walls. This work provided what the exhibition's catalogue did not: an extensive visual compendium of Beuys's activity, which removed him from the company of the other exhibitors and suggested the unfolding of his career as beyond schematic delineation.

The timing of the exhibition collided with a series of ongoing disruptions in Beuys's professional life. The first of these had surfaced in November 1968 when nine full-time professors at the Düsseldorf Art Academy (out of a faculty of twenty-one full-time teachers) filed a so-called "mistrust manifesto" against Beuys, who was teaching without a fixed contract. This open letter accused Beuys of being a dangerous influence upon his students and announced the instructors' loss of confidence in him. Later that year, one of his accusers published an article in *Die Zeit* that described Beuys as playing "Messiah" and producing "Jesus kitsch."[8] By May 1969 the Art Academy was closed, at the order of the Ministry of Science and Research, on the occasion of "Die Arbeitswoche der Lidlakademie," ("The work week of the Lidl Academy), organized by Jörg Immendorff, a student supported by Beuys. A few months later an article published in the *Frankfurter Allgemeine Zeitung* described the events at the Art Academy as a "witch hunt" with Beuys as its target.[9]

Beuys probably saw "Strategy: Get Arts" not only as an important opportunity for international exposure,[10] but also as a means of polemically fighting the parochialism of his accusers at the Art Academy. None of them had been invited to exhibit in the show, which was an official part of the Edinburgh Festival, and which focused solely upon the Düsseldorf art scene as representative of the best of West German contemporary art.[11] The exhibition was met with widespread critical acclaim.

The August 30, 1970, issue of the London *Sunday Times* contained a review under the headline "A Great Subversive." The critic commented: "It makes most English artists look provincial. It even makes the New York avant-garde look tame . . . it reestablishes the dialogue between American and European art."[12] It was Beuys's work upon which reviewers focused.[13] And yet, although the photographs were installed in a room immediately adjacent to the one in which Beuys and Henning Christiansen performed *Celtic* for three and one half hours, twelve times over eight days, almost no one commented on them. Even those close to Beuys at the time varied in their appraisal of this early version of *Arena* as a "work of art." Ute Klophaus, whose photographs partly constituted the piece, did not document it at all.[14] Richard Demarco, the organizer of the exhibition, recently assessed it as a "didactic component."[15] Still others, despite their connection to the exhibition and friendship with Beuys, now do not recall having seen it. And yet, though its form would later change, Beuys clearly considered it sufficiently substantial to be saleable, as this comment from 1979 makes clear:

> I had already exhibited this work [*Arena*] in 1970 in Edinburgh, although not in the form, which it assumed only later, but still in a sparse direction. If someone then, from England or Ireland, had come along and said that they wanted to buy this work, then it would probably have been titled differently.[16]

Chronological Conjunctions

1970 also marks the date that Beuys ceased expanding a central element of his repertoire that had preoccupied him since 1964, *Lebenslauf/Werklauf (Life Course/Work Course)*.[17] This curriculum vitae is actually a quasi-fictional narrative that, like the photos in *Arena*, blurs the borders between reality and its abstraction. The *Life Course* is Beuys's manifesto of style. It is a point-by-point demonstration of his aestheticization of the self, accomplished by turning his life into an allegory for his production of art.

Beuys formulated his *Life Course* exactly at the time that he first began to garner global recognition. The relatively minor publication for which it was written—the pamphlet for the Festival der neuen Kunst in Aachen on July 20, 1964—appeared less than a month after the opening of Documenta 3, the first important international exhibition in which Beuys had been invited to participate. From its outset, the *Life Course* was the written counterpart of that portion of his oeuvre with which he presented himself to the public. It portrays Beuys as an *Ausstellung* (exhibition), a word found no less than twenty-six times in this otherwise terse text. Like all manifestos, the document presents a program, but instead of describing what he will do, Beuys *does* it before the readers' eyes. The first entry is an allegory of his birth, "1921 Kleve Ausstellung einer mit Heftpflaster zusammengezogenen Wunde" (Kleve exhibition of a wound drawn together with an adhesive bandage), and a fictionalization of a near truth: he was not born in Kleve (where he grew up), but in Krefeld. The *Life Course* also betrays Beuys's rapt interest in semantics: for example, in the twelfth entry: "1928 Kleve Ausstellung um den Unterschied zwischen lehmigem Sand und sandigem Lehm klarzumachen" (Kleve exhibition to explain the difference between loamy sand

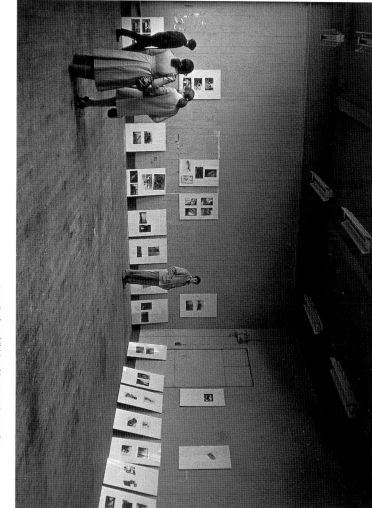

Arena in the exhibition "Strategy: Get Arts" in Edinburgh (1970).

JOSEPH BEUYS:

Joseph Beuys Lebenslauf Werklauf

1921 Kleve Ausstellung einer mit Heftpflaster zusammengezogenen Wunde
1922 Ausstellung Molkerei Rindern b. Kleve
1923 Ausstellung einer Schnurrbarttasse (Inhalt Kaffee mit Ei)
1924 Kleve Öffentliche Ausstellung von Heidenkindern
1925 Kleve Documentation : "Beuys als Aussteller"
1926 Kleve Ausstellung eines Hirschführers
1927 Kleve Ausstellung von Ausstrahlung
1928 Kleve Erste Ausstellung von Ausheben eines Schützengrabens
 Kleve Ausstellung um den Unterricht zwischen lehmigem Sand und sandigem Lehm klarzumachen
1929 Ausstellung an Dschingis Khans Grab
1930 Donsbrüggen Ausstellung von Heidekräutern nebst Heilkräutern
1931 Kleve Zusammengezogene Ausstellung
1933 Kleve Ausstellung von Zusammenziehung
1933 Kleve Ausstellung unter der Erde (flach untergraben)
1940 Posen Ausstellung eines Arsenals (zusammen mit Heinz Sielmann, Hermann Ulrich Asemissen und Eduard Spranger)
 Ausstellung Flugplatz Erfurt-Bindersleben
 Ausstellung Flugplatz Erfurt-Nord
1942 Sewastopol Ausstellung meines Freundes
 Sewastopol Ausstellung während des Abfangens einer JU 87
1943 Oranienburg Interimsausstellung (zusammen mit Fritz Rolf Rothenburg + und Heinz Sielmann)
1945 Kleve warme Ausstellung
1946 Kleve Ausstellung von Kälte
 Kleve Künstlerbund "Profil Nachfolger"
 Happening Hauptbahnhof Heilbronn
1947 Kleve Künstlerbund "Profil Nachfolger"
 Kleve Ausstellung für Schwerhörige
1948 Kleve Künstlerbund "Profil Nachfolger"
 Düsseldorf Ausstellung im Bettenhaus Pillen
 Krefeld Ausstellung "Kulhaus" (zusammen mit A.R.Lynen)

4

1949 Heerdt Totalausstellung 3 mal hintereinander
 Kleve Künstlerbund "Profil Nachfolger"
1950 Beuys liest in "Haus Wylermeer" Finnegans Wake
 Kranenburg Haus van der Grinten "Giocondologie"
 Kleve Künstlerbund "Profil Nachfolger"
1951 Kranenburg Sammlung van der Grinten Beuys: Plastik und Zeichnung
1952 Düsseldorf 19.Preis bei "Stahl und Eisen"(als Nachschlag Lichtballett von Piene)
 Wuppertal Kunstmuseum Beuys: Kruzifixe
 Amsterdam Ausstellung zu Ehren des Amsterdam—Rhein-Kanal
 Nijmegen Kunstmuseum Beuys: Plastik
1953 Kranenburg Sammlung van der Grinten Beuys: Malerei
1955 Ende von Künstlerbund "Profil Nachfolger"
1956-57 Beuys arbeitet auf dem Felde
1957-60 Erholung von der Feldarbeit
1961 Beuys wird als Professor für Bildhauerei an die Staatliche Kunstakademie Düsseldorf berufen
 Beuys verlängert im Auftrag von James Joyce den "Ulysses" um 2 weitere Kapitel
1962 Beuys : das Erdklavier
1963 FLUXUS Staatliche Kunstakademie Düsseldorf
 An einem warmen Juliabend stellt Beuys anlässlich eines Vortrages von Allan Kaprow in der Galerie Zwirner Köln Kolumbakirchhof sein warmes Fett aus.
 Joseph Beuys Fluxus Stallausstellung im Hause van der Grinten Kranenburg Niederrhein
1964 Documenta III Plastik Zeichnung
1964 Beuys empfiehlt Erhöhung der Berliner Mauer um 5 cm (bessere Proportion!)

Life Course/Work Course (1964).

and sandy loam). It was more than a matter of syntactic order: at stake was the ordering of Beuys's life, and the fixing of his self. This is the hidden agenda of Beuys's *Life Course*; it is implicit in its construction and suggested by his continuous adjustments to it between 1964 and 1970. That Beuys considered it a manifesto is indicated by the fact that he authored no other document to which he accorded such importance: it was included in almost every book and catalogue published about him over which he had some form of control. In 1973 it became the "orientational basis" of a book by Götz Adriani, Winfried Konnertz, and Karin Thomas, *Joseph Beuys: Leben und Werk*

(*Joseph Beuys: Life and Work*), the first monograph produced in close cooperation with the artist.[18]

It is within this succession of events that we may locate Beuys's work on *Arena*, begun in the same year he stopped working on his *Life Course* and completed exactly during the period when the latter document's possibilities had been most fully realized. *Arena* continues the aesthetic Beuys established in the *Life Course* but inverts the manner of its operation: instead of writing pictures, he pictures writing. The single panels look like entries in what resembles a loose-leaf visual chronology of his work. While the *Life Course*'s authenticity is sanctioned by its similarity to a curriculum vitae, the classical austerity of the black-and-white photographs certifies *Arena* as a sober documentary.[19] Just as the *Life Course* had become the axis of Beuys's presentation of himself to a readership by 1973, so did certain changes he made to *Arena* in 1972 enable it to become the quintessential vehicle for the exhibition of his artistic persona to a viewing public. These adjustments may have resulted partially from what Beuys must have considered the work's ineffectiveness in Edinburgh.[20]

Aesthetic Histories

The most striking change in *Arena*'s format was the one hundred aluminum frames with plate-glass panes, in which Beuys enclosed the work's images early in the summer of 1972.[21] These ponderous casings are out of proportion with the delicate, illusive photographs they confine—pinned in place forever by the long, rusted bolts that fasten the frames shut. The ceremoniousness of the presentation is heightened by the solemn gray of the metal frames and back plates onto which the black-and-white photos have been directly mounted. These encasements are like memorial caskets enshrining and perpetuating the delicate larvae of Beuys's achievement.

Both the *Life Course* and *Arena* refute the possibility of exactly illustrating things, and instead assert the viability of resembling them. The conjunction of Beuys's interest in recovering his personal history, his decision to fictionalize it, and his production of art that looks like (rather than represents) something, resulted from the historical circumstances in which he found himself at the outset of his career. Beuys entered the Düsseldorf Art Academy in 1947, just a year after it was reopened, having been heavily shelled and set on fire in March 1945. Together with the Munich Art Academy, it was the only functioning art school in Germany.[22] Beuys's determination to become a sculptor was allegedly prompted by the formal possibilities he detected in Wilhelm Lehmbruck's work, preserved in a photograph he had come across sometime between 1937 and 1940.[23] To become a sculptor in postwar Germany was to overcome three almost insurmountable obstacles: the emphasis the National Socialists had placed upon the production of monumental sculpture that supposedly exemplified the resolute vigor and beauty of the prototypical German race; their virtual obliteration of the accomplishments of Germany's previous cultural heroes; and the war's devastation of the landmarks of one's personal past.

Beuys's achievement is his development of an aesthetic that allowed him unrestrainedly to deal with the effects of the war by reopening the very wounds, that others found paralyzing. He returned to the Expressionist tradition (which Lehmbruck embodied for him), and systematically began to produce work that repostulated the utopian vitality of the singular artist as the shaper of a future age of man.[24] In so doing, he deliberately played with concepts that formed the ideological core of the National Socialists' politicization of aesthetics, as well as their aestheticization of politics. At the same time, Beuys made a virtue of the very sculptural qualities that they had worked so hard to eliminate: his sculptural oeuvre champions the fragmented, contorted, grimy, unfixed work of art.[25] He was also able to reconnoiter the brutal realities of Germany's immediate past—evident everywhere in the decimated landscape—by looking further backward, to the unencumbered site of his childhood. There, he found a promising, wide-open space in which he could grub about unperturbed, freed from the constraints brought about by the unalterable processes of history.[26]

It was just as important for Beuys to align himself with certain traditional aesthetic formats as to remove himself from the immediate vestiges of the historical proceedings that jeopardized his ability to make art. In the same manner that the *Life Course's* entries approximate the serial progression of a "typical" artistic career, so do the mounted photographs of *Arena* look like the sequence of a catalogue raisonné. To be sure, *Arena's* new frames suggest the work as a kind of memorial. This impression was heightened by another new component, the two piles of copper, iron, fat, and wax, meant to be placed in the center of *Arena*. The decomposing photographs, together with the rusting metal and gummy fat and wax elements of this sculpture, suggest the stench of a national history, decontextualized and melted down to the site of a singular biography.

Beuys's concentration on individuality betrays the infusion of his expressionistic proclivities with an existentialist strain. Though he affiliated himself with the Fluxus movement, his struggle for identity has more in common with the aspirations of the American action painters.[27] Both Beuys and Jackson Pollock heroized their personae by making a monument of their personal intervention in the production of a work of art. The photographic traces of the actions enshrined in *Arena* are similar to the painted trails of Pollock's physical invasion into the "arena" of the canvas. Both artists engaged "art in the life of the times *as the life of the artist.*"[28] Pollock was also acutely aware of the power of the photographic documentation of his dramatic painted maneuvers, evident in his close collaboration with Hans Namuth. *Arena's* title, form, medium, and the highlighting of Beuys's image challenge the preeminence of Pollock's achievement and the primacy he accorded to the canvas.

Arena is and is not a traditional portrait gallery: it is a storehouse of select recollected fragments, newly assembled into biographical legends and self-depictions. As soon as the viewer becomes mesmerized by the sanctified aura surrounding these photographic icons, his cognitive faculties are snapped to attention by the jumbled order of the images. Where just seconds before he had been inclined to dwell upon a photo, he now finds his eye jumping around in a futile attempt to make sense of the unevenness of these groupings. Even the surfaces of the images refuse to hold still; the caustic substances with which they have been treated have transformed them into active cultures. In one fell swoop, the static quality of the display is revealed as a fiction, the seemingly frozen moments captured by the fluttering of the camera's lens as an illusion. These features reveal two central aspects of Beuys's aesthetic: he poises himself between the transitory and the eternal.

Building Blocks

Arena is structurally connected to another cluster of work, a group of drawings spanning the years 1936 to 1972, titled *The secret block for a secret person in Ireland.* This work was also assembled for an English-speaking audience, this time at Oxford's Museum of Modern Art. It appeared four years after

Krummstab (Crooked Staff), 1974. Handwritten catalogue of *The secret block for a secret person in Ireland* (1936–1972).

The register for *The secret block for a secret person in Ireland*, exhibiton catalogue, Oxford Museum of Modern Art (1974).

Arena was shown in Edinburgh and two years after Beuys had tentatively completed it. Unlike *Arena*, the drawings of *The secret block* were organized in a hand-written register in a sequence that originally stretched from 1 to 266. These numbers introduce a fictional order: there were neither 266 drawings nor 266 frames in the Oxford exhibition.[29] Despite the care Beuys took in assembling the register, he ignored it when arranging the images; sometimes he framed several drawings from different years together, which he designated with a single number. At other times he united in a frame images from the same year, to which he had assigned separate integers.

The tiny numbers ranging from 1 to 100 stamped on the frames of *Arena* fabricate an equally imaginary order.[30] They do not correspond to the number of photographs, nor do they order the sequence of the frames to which they are appended, since Beuys did not make use of them during his various installations of the work. The series they build can only be that of a catalogue, an unfinished future project that would help organize these untitled and undated photographs.

Neither *Arena* nor *The secret block* has a fixed installation order. Though the frames that comprise *Arena* are uniform in dimension, those that make up *The secret block* are several different sizes.[31] Nevertheless, whether stacked in groups or splayed out on a wall, each body of work is similar to a series of closed volumes whose pages are heaped one upon another, or folios whose leaves can be opened out.[32] The impression of an illustrated book gone out of focus and come undone was particularly strong in Edinburgh, where the photographs were silhouetted against white mat board backings, in frames without borders, and scattered along or hung on the blank walls of an otherwise empty room.

The secret block's register, reprinted in English in the Oxford catalogue, vacillates between empty lines with question marks (used to designate untitled drawings) and lines filled in with titles that often bear an allegorical relationship to the drawn form. This oscillation between unformulated and constituted words is reminiscent of the fuzzy and focused images that make up *Arena*. The huge, lined spaces that dominate *The secret block*'s index suggest it as more of a private journal with drawn words—centered one above the other—than a register. The same dichotomy (but reversed) is evident in the *Life Course*; its repeated and isolated word-images build a display case rather than a résumé.

The interrelatedness of the *Life Course*, *Arena*, and *The secret block* can also be posited on the basis of the elements from each work that appear in the other. The drawing *toter Mann (Dead Man)*, 1953, from *The secret block* is one of ten works on paper photographed in *Arena*.[33] The sixth entry of the

Life Course reads, "1926 Kleve Ausstellung eines Hirschführers" (Kleve exhibition of a stag leader). Not only is *Stag Leader* the title of the thirteenth entry in *The secret block* catalogue, but *stag* is the most often repeated word in the five-page typed list. Finally, and most importantly, only one photograph of *Arena* consists of a name, Joyce. This isolated and centrally framed image is a reproduction of a small placard the artist produced in 1961.[34] In the same year, he made this entry in his *Life Course:* "1961 Beuys verlängert im Auftrag von James Joyce den »Ulysses« um 2 weitere Kapitel" (Beuys extends *Ulysses* by 2 chapters at the request of James Joyce). As it happens, at least two of the drawings produced for these "chapters" were later integrated into *The secret block.*

The semantic dimensions of the word *verlängert* (extends) are essential to Beuys's procedure, embedded in the processes of addition, alignment, perpetuation, survival, endurance, and preservation. These same predilections inform the structure and style of Joyce's *Ulysses,* a book that threads together Homer's epic *Odyssey* with the prolonged meanderings of a contemporary man during a single day.[35]

1961 was a momentous year in Beuys's career, about which his *Life Course* makes no secret: "1961 Beuys wird als Professor für Bildhauerei an die Staatliche Kunstakademie Düsseldorf berufen" (Beuys is appointed Professor of Sculpture at the Düsseldorf Art Academy). The appointment represented a triumph for Beuys; for the previous ten years he had tried with relatively little success to establish himself as a free-lance sculptor, and though he had applied for a professorship at the Art Academy in 1958, his former teacher, Ewald Mataré, had impaired his appointment.[36]

1961 was also the year in which Beuys's first and only son, Boien Wenzel Beuys, was born. This consequential personal event is disclosed metaphorically in Beuys's 1961 *Life Course* entry about his extension of Joyce's *Ulysses.* The act describes a biological engenderment in terms of a creative feat. From this perspective, the seeming disparity between Beuys's description of the sketchbooks as "2 additional chapters" and their enclosure in six folios may be resolved. The two additional chapters are really two new chapters of Beuys's life—one in the form of his own offspring as an extension of himself, and the other in the shape of a professional post that became the springboard for the vital continuation of his aesthetic work.[37]

Writing Biography

Like *Arena* and the *Life Course,* the works on paper that make up *The secret block* are a genre of biographical history.[38] The three groups of work merge the processes of picturing, writing, and drawing; for Beuys, they were all forms of sculpting.[39] Beuys's oeuvre is characterized by a series of blocks that ranges from the chunk of words made from the events in his life; the drawn compendia encased in sketchbooks; the relics enshrined in his vitrines; to the entire museum rooms. Ultimately, as his *Life Course* reveals, Beuys sought to extend his block building beyond the confines of his own production of art to merge his achievement with the titanic quests of a few others.[40]

Beuys's interest in biography also initially surfaced in 1961 when in mid-September he formulated the precursor of the *Life Course: Notizzettel Josef Beuys* (*Notes Josef Beuys*). This narrative begins with the telling sentence, "Die biographische Dinge hätte ich nicht so gerne in der konventionellen Form behandelt, wie man sie überall in Katalogen und Zeitungen liest (siehe *Rheinische Post*)" (I couldn't have dealt with the biographical things very happily in the conventional manner one reads everywhere in catalogues and newspapers, [see *Rheinische Post*]).[41] The phrase refers to a profile on Beuys, "Ehrenvolle Berufung für Klever Künstler" (Honorable Appointment for Klever Artist), which appeared in the *Rheinische Post* on September 12, 1961, shortly after Beuys's assumption of his teaching position. *Notes Josef Beuys* was Beuys's programmatic response to the focus and details of this public portrait with which he disagreed.[42] Its appearance marks the beginning of Beuys's active intervention in his critical reception. It was immediately put to a pragmatic use when, less than a month later, it was printed in the front of

A view in Beuys's home, Drakeplatz 4, Düsseldorf, ca. 1963.

the catalogue of Beuys's October 7, 1961, exhibition at the Haus Koekkoek in Kleve, where it served as Beuys's own introduction to his life and work.

Biography was also a special genre for Beuys, because (as with Joyce) his struggle to become an artist was resolved, to a certain degree, by his discovery of its possibilities. Through the medium, Beuys found a means to come to terms with his past by reshaping the very experiences that had at times crucially shaped him. For both men, autobiography meant focusing upon the thoughts of their lives rather than its fortuities of act or occasion. By turning fact into fiction and fiction into fact, they reordered their lives and universes to fit the purposes of their production of art.[43]

Beuys was not only interested in recounting his own biography but read those of others, and acquired Richard Ellmann's book on James Joyce in 1971.[44] Whereas Beuys's copies of *Ulysses* and *Finnegans Wake* are clean, he marked thirteen passages in Ellmann's book with penciled triangles. It is tempting to conclude that he read the book soon after buying it, given his long-standing interest in the author and considering the presence of the Joyce photograph in *Arena*, exhibited just a year later.[45]

The concepts of the expansion and contraction of time, of things being in a continuous dialogue with one another, and of linguistic elasticity are all central to *Arena*'s aesthetic. They are also comments that Beuys has made over the years about the very features of Joyce's work that he admired.[46] Like Joyce, Beuys was interested in the production of works of art that both preserved certain eternal ideals and made use of a formal language appropriate to the late twentieth century. A penciled triangle marks this passage of his copy of Ellmann's biography:

> Don't you think there is a certain resemblance between the mystery of the Mass and what I am trying to do? I mean that I am trying … to give people some kind of intellectual pleasure or spiritual enjoyment by converting the bread of everyday life into something that has a permanent artistic life of its own.…[47]

These words could just as well have been written about Beuys as Joyce. Both men begin with the known—the essentials of man's existence and the way he communicates needs and perceptions—and then make it strange. In *Arena*, these acts of displacement are taken a step further by the process of photography itself. The images approximate actions, poses, drawings, and sculpture already embedded in allegorical narratives.[48] It is this trick, if one may call it that, which enables Beuys to make the everyday extraordinary, thereby eternalizing it: to imbue rather "ugly" images of pieces of gelatin, fermenting substances in beakers, gauzy filters, soles of felt, and chunks of fat, with a classical "beauty."

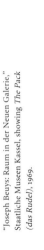

Detail from *Arena*, panel #55.

"Joseph Beuys: Raum in der Neuen Galerie," Staatliche Museen Kassel, showing *The Pack (das Rudel)*, 1969.

Survivalist Strategies

As may be recalled, *Arena* was originally presented with *Celtic* and *The Pack (das Rudel)*. The central theme of these latter two works is endurance: *Celtic* concludes with an image of Beuys standing directly behind a blackboard, triumphantly grasping a spear/staff, and *The Pack (das Rudel)* consists of a rusting Volkswagen bus out of whose back window spill twenty-four sleds. These vehicles are equipped with materials essential to human vitality—flashlights, felt, and fat—symbols of illumination, insulation, and nutrition.[49] With them Beuys evokes the journey of man from infancy to old age, and, by extension, the development and durability of the human species. As it happens, the number of sleds bears a relationship both to the span of a single day—a microcosm of human life—and to the lapse of time in *Celtic*: the

performance time amounted to a total of forty-two hours.[50] This playing with numbers is a metaphor for Beuys's toying with time. A central component of *Celtic* was his display of a sequence of seven blackboards. Two of these are reproduced on panels #5 and #69 in *Arena*. Inscribed on the blackboard's surface are a cipher ʃ, an abbreviation (*Syb* for "Sibyl") and three digits, 1, 2, 3. These numbers refer to the action's structure: it was divided into three sections meant to evoke the passage of time from antiquity to the Middle Ages to the modern era of man.[51]

Though in 1969, when he first exhibited *The Pack* (*das Rudel*), Beuys may not have had Joyce on his mind, by 1985 he had produced a multiple, *Joyce mit Schlitten* (*Joyce with Sled*), which unified the image of the sled with a statement that makes clear his work's relationship to Joyce's.[52] Joyce's connection to *Celtic* was far less tangential. As Henning Christiansen recently wrote:

> The scripted tablets that he [Beuys] carefully pushed around the floor, certainly had to do with Joyce. The manner of speaking, the tongue, palate, teeth, how one speaks purely technically, how one articulates, these are thoughts that Beuys understood through Joyce.[53]

Despite Beuys's success in Edinburgh, his duels in the art world did not end in 1970 but escalated as his reputation grew and his defiance of administrative policy continued at the Art Academy. Beginning in June 1971, he also began to make practical use of his exhibitions to further the aims of his newly established Organisation für direkte Demokratie durch Volksabstimmung (Organization for Direct Democracy through Referendum). The collusion of Beuys's aesthetic, pedagogical, and political interests culminated at the 1972 Documenta 5, where he set up an office and talked for one hundred days to anyone who came by.[54] It was at this point that he effected his transition from the process of self-determination accomplished in the *Life Course* (and further advanced in *Arena*'s early form in Edinburgh) to that of a demagogic candidate given form in *Arena*, exhibited just fifteen days before the opening of Documenta. In it art and life are joined in a new manner, one that may have been confirmed for Beuys in Ellmann's book. For seven years after writing his *Life Course*, and in the midst of reformulating *Arena*, he would have been particularly intrigued by the only two marked passages, whose page number he jotted down on the book's inside cover together with one word *Volksabstimmung*.

But Stephen's esthetic notions are not renunciant; he becomes an artist because art opens to him "the fair courts of Life" which priest and king were trying to keep locked.

In later life Joyce, in trying to explain to his friend Louis Gillet the special difficulties of the autobiographical novelist, said, "When your work and life make one, when they are interwoven in the same fabric . . ." and then hesitated as if overcome by the hardship of his "sedentary trade."[55]

Formative Structures

Arena is Beuys's exclusive courtyard, a theater he built for the display and enactment of the increasingly heroic dimensions that came to characterize his new vision of his artistic role. The invitation card to its second showing on June 15, 1972, at Lucio Amelio's Modern Art Agency, aligns the heightened political direction of Beuys's art with the site of the ancient Roman amphitheater, in which the public assembled for elections and gladiator battles. On the card's surface are the image of a circle, the word *Arena*, and the subtitle—*dove sarei arrivato se fossi stato intelligente!* (*where would I have got if I had been intelligent!*), itself framed within a rectangle. The announcement's shape emulates the format of *Arena*'s panels. Printed on the back of Beuys's letterhead for his Organization for Direct Democracy and impressed with his *Hauptstrom* (head stream) stamp, it is the first evidence of *Arena*'s title and conformations. These conjunctions indicate a connection between the circular shape of *Arena* (the configuration preferred by Beuys),[56] the ring form of the stamp, and the semicircular nimbus delineated by the word *Hauptstrom* around the inner circumference of the imprint. Neither its configuration nor its titles were inconsequential:

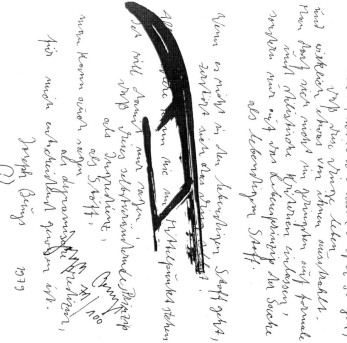

Joyce with Sled (1985). Edition of 100, signed and numbered. Edition Staeck, Heidelberg.

First of all this "Arena" has this Latin name, it would perhaps not have existed, if the thing had been further developed in the North, as once had been intended... So through this name and the action "Vitex agnus castus," I made reference to the Mediterranean situation and what was then packed into it, is practically my totally typical work, with its entire theory, the action fragments...[57]

Beuys was not content merely to name the work *Arena*: he added a new image to it that was distinctly different from the other 263 photographs. This isolated, centrally placed creased image, stands out from the others: it is an older, sepia-hued souvenir photograph whose type identifies it as "VERONA, Arena."[58] Its form makes explicit the significance of the circular shape drawn on the invitation card. An arena-like structure was also imprinted on the tote bag for Direct Democracy, first distributed by Beuys in Cologne in June 1971, and later from his office at the 1972 Documenta.[59]

Both the title *Arena* and the word *Volksabstimmung* reference the Roman age. The largest and most important arena in antiquity was the Flavium Amphitheater (the Colosseum) built in Rome between 70 and 80 AD. The festival celebrating its completion lasted for one hundred days, an epochal event whose proceedings have been preserved in the annals of history.[60] The idea of an occasion that lasted for one hundred days also became the slogan of Documenta 5: the "100-Tage-Ereignis" (100-day-event). The motto was Harald Szeemann's polemical rejoinder to Arnold Bode's conceptualization of the previous two Documentas as the "Museum der 100 Tage" (Museum of 100 days). Szeemann announced his motto in May of 1970, three months prior to Beuys's decision to take the one hundred frames with him to Edinburgh.[61] Though Beuys revised almost every other aspect of *Arena* for its showing in Naples, he did not increase the

number of frames. Whether or not a connection exists among the duration of Documenta, the number of frames in *Arena*, and the length of the celebration that commemorated the completion of the Colosseum in Rome is of secondary importance; what is consequential is Beuys's increasing association with the structure of Documenta, both as a forum for presenting himself and as an institution that he could supplant by creating alternative spaces.[62]

Arena was such a site; it became Beuys's own museum and stage. It was within its circular shape that his aesthetic persona found its locus and completion; born, displayed, and eternalized in a work that was itself hatched from survivalist strategies.[63] Just as the stream of sleds pouring out of *The Pack* (*das Rudel*) evokes the act of delivery, the ideal circular shape of *Arena* suggests it as a womb.[64] One

rather odd photograph links this panoramic display of Beuys's output with the source of his own life: a portrait of his mother sitting next to the stove in his atelier/kitchen. This image identifies the place of the production of art with the site of a hearth, and posits virile creative energy as a counterpart to female reproductive vitality. The round configuration of *Arena* is in itself an ancient symbol of the universal source of fire and warmth.

Arena is a primal hearth,[65] from whose epicenter Beuys literally attempted to throw off sparks. Concurrent with the exhibition's opening in Naples he performed a three-hour action, *Vitex agnus castus*, in which he unremittingly rubbed the copper and iron elements of the

Detail from *Arena*, panel #13.

Carrier bags made of polyethylene and plastic, first edition: 10,000 (1971).

sculpture and uttered the words "Ich strahle aus" (I radiate). The procedure culminated in his generating sufficient energy to cause his entire body to vibrate. The merging of sexual energy with creative energy is inherent in the symbolism of fire.[66]

The forming of man and his cerebral activation was accomplished by Prometheus, an ancient proto-type of the artist who receives the sacred spark of creative imagination. Beuys is not a Prometheus, but, rather, his extension. Both saw their vocation as preserving and transferring the gift of fire. Just a few days before his death, Beuys gave a talk upon his receipt of the Wilhelm Lehmbruck Prize, which concluded with this statement and quotation from Pietro Antonio Metastasio:

I should also like to stand on the side where Wilhelm Lehmbruck lived and died, and where he entrusted every single person with this inner message: "Protect the flame, since if you fail to do that, before you've noticed the wind will easily extinguish the light it provides. . . ."[67]

Beuys's notion of artistic mission was deeply informed by his desire to position himself within certain aesthetic traditions stretching from antiquity to the present day. In so doing, he inserted himself into one of the greatest aesthetic battles of history, the *Querelle des anciens et des modernes* (quarrel of the ancients and the moderns). In the final analysis, it is Beuys's very consciousness of time that provides the clue to the nature of his modernism, which negates the need to make a radical break with history.[68] Instead of emulating works of art, he aligned himself with certain artistic postures. He became a participant in the cult of genius by displacing the principle of imitation and advancing the concept of invention.[69] An early indication of this predilection is the slip of paper pinned to the wall of the room in which Beuys and Christiansen performed *Celtic*. On it was the question, "Where are the souls of Van Gogh, Duchamp, Piero della Francesca, William Nicholson, Fra Angelico, . . . and Leonardo da Vinci?"[70]

Posturing

Beuys's *Arena* appends itself to the tradition of the hagiographic self-portrait. These paintings first appeared in the Renaissance, when the work of the artist-genius began to be venerated in itself.[71] Albrecht Dürer's 1500 *Selbstbildnis* (Self-portrait) is one of the earliest examples of this emerging trend.[72] Dürer's construction of his own likeness is both a demonstration of his creative power, and the painted site of this self's identification.[73] The act of painting his own image stabilized and fixed it, for himself and for posterity. The date, 1500 AD, and the Latin words, which border his likeness, reveal this objective: *Albertus Durerus Noricus ipsum me propriis sic effingebam coloribus aetatis anno XXVIII* (I, Albrecht Dürer from Nuremberg, reproduce myself, in lasting colors at the age of 28).

Just as that portrait was the symbolic armor of Dürer's sacred individuality, so was *Arena* Beuys's fortress, from which he projected his ordered, framed, and secured image. Armed with the tradition of the lore of the artist, Beuys launched his offensive from an impenetrable locus, the private arena invented, constituted, and governed by the self.

The images of Beuys that dominate *Arena* also make reference to an aesthetic trend that began in the mid-nineteenth century: photographic portraits of artists. The very self-consciousness that such portrayals exhibit reveals them for what they are: displays of an artist's presence. It was this quality that led Arnold Bode to erect a kind of photo memorial to the artists the National Socialists had labeled "degenerate." Displayed at the entrance to Documenta 1 in 1955, these enlarged photographic portraits conveyed a sense of the extraordinary character of these men. This was an enshrinement rather than a rehabilitation, a strategy that also inserted them into the cult of the artist. The tactic was augmented by the inclusion of sixteen of these photographs in the catalogue of the exhibition.[74] It is likely that Beuys

Detail from *Arena*, panel #51.

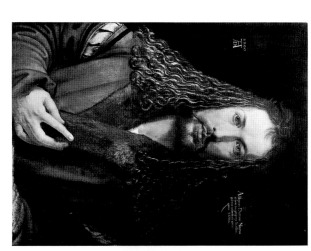

Albrecht Dürer, *Self-Portrait in Fur Coat* (1500).

saw this important exhibition or at least looked through the catalogue. By 1961 he was convinced of the value of photography to an artist's work and decided that his second application for the Art Academy professorship should be comprised solely of photographs of his sculpture, watercolors, and drawings, taken by Fritz Getlinger.[75]

Unlike the rather conservative photo portraits of the artists displayed in Documenta 1, Man Ray's 1921 photograph of Marcel Duchamp presents a likeness that dispenses with the nuances of dress and physiognomy. Instead of a face, we are confronted with the back of Duchamp's head, whose hair has been sculpted at its crown into a star. Not only does the ledge upon which Duchamp leans truncate his head from his body, but the lack of a locale suggests he exists outside of time. The photograph transfers the site of the production of art from the atelier to the mind of the artist, the place where the ordinary object is transformed into the extraordinary work of art. The sculpted star-shape that appears on Duchamp's head along with the inscription of his name and the title Man Ray gave to the image, *Tonsure*, directly beneath the portrait, identifies him as a particularly sanctified initiate, a "chosen" member of a sacred fraternity.[76] Beuys's 1964 action *Das Schweigen von Marcel Duchamp wird überbewertet* (*The silence of Marcel Duchamp is overrated*) references Duchamp's position, not his work. The fact that it was televised proposes Beuys as an active interventionist, in diametric contrast to Duchamp's stance of withdrawal. The title both challenged the increasing attention Duchamp began to garner in the 1960s and heroized the older artist's demeanor by making an issue of it.[77]

Beuys was well aware of the catalytic strength of posturing; by 1964 he had already developed his own badges of office: his jeans, vest, and felt hat. It was this last emblem above all for which he became known, one that again directs our attention to the site of the artist's head and the demiurgic power of the workings of his mind. Beuys did not leave the intensity of these interior processes to the imagination. Instead, he chose to present himself as a vibrant speaking and gesturing "exhibitor" who refused to remain silent.[78]

Beuys's lengthening of Joyce's *Ulysses* has its counterpart in his extending the possibilities of Duchamp's silent stance. Beuys's refusal to designate a work complete represents his rhetorical response to Duchamp's "finished" oeuvre, accomplished by his giving up art for chess at the age of thirty-six.

On the occasion of *Arena*'s second exhibition, Beuys added approximately 100 new photographs to it, and declared that he intended to continue expanding it each year thereafter.[79] When the

Man Ray, *Tonsure (Marcel Duchamp)*, 1921.

Dia Art Foundation purchased the work in 1976, the terms of the sale were dictated by the fact that the work was "still in progress."[80] As such, the number one hundred marked not a stopping point, but a pause after which Beuys could continue.[81] This same attitude characterized Beuys's work on *The secret block*. Like *Arena*, *The secret block* cycle was provisionally closed in 1972.[82] Yet, even for the first installation, Beuys included thirty-six drawings not in his register. Beuys's playful hand added not only entries to the *Life Course* and drawings to *The secret block* but also objects to another cycle of work that exhibits the private artifacts of an aesthetic history, one provisionally closed in 1970: the vitrines in the "Block Beuys" in the Hessisches Landesmuseum in Darmstadt.[83]

Beuys's refusal to declare a cycle closed is matched by the quality of his statements insofar as they cannot easily be assigned a finite meaning. Not only does the order of his words defy intelligible explication, but his thought patterns tend toward the poetic rather than the exegetical. Beuys's language operates outside the boundaries of "logical" discourse. What he says sounds unbelievable, because he can be neither pinned down nor discredited through the use of dialectical praxis.[84]

It is impossible to resolve the contradiction between Beuys's obvious desire to convince his audience of the seriousness of his objectives and the enigmatic language he uses to convey himself, precisely because the artist's message and his method are so deeply intertwined. Beuys's hammering

tongue reshapes language at will. In the same manner, the operation of his autonomous individuality in the *Life Course* and in *Arena* presents sculpted, fictionalized images of himself. Instead of laying out pragmatic strategies, he breaks down linguistic and methodological schemes. The very "illogicality" of this discourse and procedure is its significance.

Revolutions

The enigmatic nature of the photographic images that make up *Arena* resonates in its rather cryptic subtitle, *where would I have got if I had been intelligent!* The phrase is plainly ironic: by 1972 Beuys was not only successful but well on the way to becoming Germany's most celebrated postwar artist. The work's subtitle puts into question the procedure of progression: it suggests where Beuys would have gotten if he had advanced within the confines of rationality—into the dead end indicated by the marked-out corner of the rectangle that encloses the phrase. The circular image and the word *Arena* immediately above the statement discredit the process of an incremental journey. It suggests instead that there is nowhere for Beuys to go: he had become what he *already* was within the parameters delineated by the sacred circle of his self's completion.[85] Beuys saw his career as beginning and ending concurrently. For, just as he maintains in his *Life Course* that he was already exhibiting at birth, so do the formal proper-ties of *Arena* collapse chronology—to the degree that it appears as if he produced his entire oeuvre simultaneously.

Beuys's decision to give the work an Italian subtitle ties *Arena* to several multiples and one sculp-ture he produced during the years of its inception. The earliest of these are two postcards of Sils Baselgia and Maloja, acquired during a trip he took at the end of 1969 to Sils Maria, in close proximity to these Engadine villages in Eastern Switzerland. In Sils Maria, Beuys probably visited the Nietzsche Haus; in nearby Maloja he went to Giovanni Segantini's atelier several times.[86] Across the surface of each card are written the words, "La rivoluzzione siamo Noi" [sic] (We are the revolu-tion).[87] The capitalization of the word *Noi* suggests this "we" as a sacred brotherhood with whom Beuys personally identified.

Oddly, though Beuys stayed in Sils Maria, there is no card from this locale. And yet, Nietzsche had been important to Beuys since at least 1944, when he visited the Nietzsche Archive in Weimar and made a small watercolor and poem whose last stanza reads: "Der Mensch kann wandeln durch sein Genie und seinen faustischen Willen das dionysische ins apollinische...." (Man can change the Dionysian into the Apollonian through his genius and Faustian will).[88] Beuys's visit to Sils Maria twenty-eight years later took place at a moment of particularly intense infighting at the Düsseldorf Art Academy.

The gyrating form of Beuys's *Hauptstrom* stamp, printed immediately below the written words, again connotes circular motion. It was not political revolution, but the rotation of a succession of sons (those identified by the word *Noi*) that was on Beuys's mind.[89] A wheel of virile inventive energy that endures despite an untimely physical eclipse is indicated by the title and composition of a later work Beuys made that directly evokes Nietzsche, *Sonnenfinsternis und Corona* (*Solar Eclipse and Corona*). The upper register of this 1978 collage is dominated by Hans Olde's 1899 etching of Nietzsche's visage, which Beuys has punctured with three circular holes.[90]

Between 1970 and 1971 Beuys made a sculpture whose title, *Voglio vedere i miei montagne* (*I want to see my mountains*)—the last words Segantini uttered before his death near Maloja—makes direct reference to Beuys's 1969 trip. But, it was not the Engadine mountains that Beuys was thinking of in 1971: "I mean an inner archetype of the idea of mountain: the mountains of the self."[91]

In 1971 Beuys also opened his first exhibition at Amelio's gallery; the invitation card reproduced the 1970 Sils Baselgia multiple. The sarcastic subtitle written in Italian announcing his second exhibition at Amelio's gallery—the showing of *Arena*—was a private witticism, a programmatic statement of his new-found autonomy. If in 1970, when he conceived of *Arena*, Beuys may be said to have only condition-ally formulated his aesthetic persona, then in 1972, when he installed a more permanent version of the

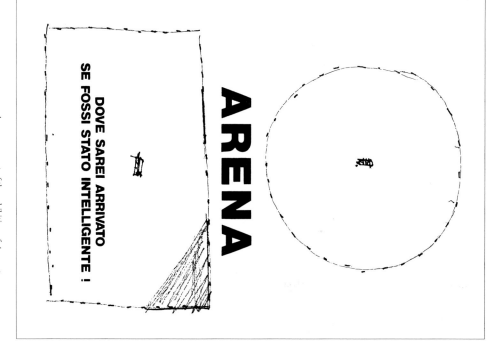

Announcement of the exhibition of *Arena* at Modern Art Agency, Naples, on June 15, 1972.

work, Beuys announced that he was ready to assume the role of a steadfast aesthetic leader. This heroic disposition was given unequivocal form in another multiple titled *La rivoluzione siamo Noi* (*We are the Revolution*) issued the year of *Arena's* tentative completion. The life-sized photograph reads like a programmatic statement of Beuys's coronation within the cult of the artist. Here Beuys presents himself as both an allegorical missionary and an invincible orator.[92]

Termini

Beuys's interest in public speaking in tandem with his antiauthoritarian stance found their counterpart in Anacharsis Cloots, the self-proclaimed "Orator of the Human Race." Cloots, born in 1755 in Kleve (Beuys's alleged birthplace), deeply opposed the constriction of personal liberty imposed by aristocratic and ecclesiastical sovereignties. Though Beuys's interest in Cloots dates to the artist's childhood, his identification with the orator did not surface until 1958, the same year that he began to work on the drawings for his extension of Joyce's *Ulysses*. It was then that he made a small drawing, *das T-Kreuz* (*The T-cross*), whose title and shape correspond to the intersection of Beuys's name with Cloots's written on the watercolor's upper register: "Anacharsisbeuyscloots, Clootsanacharsisbeuys."

The last action Beuys performed within *Arena*, titled *Anacharsis Cloots*, took place on October 30, 1972, at the Galleria L'Attico in Rome. There he read excerpts from Carl Richter's biography, *Anacharsis Cloots: Ein historisches Bild aus der französischen Revolution von 1789* (A historical image from the French Revolution of 1789).[93] Beuys's narration of Cloots's ideals, life, and fate joined them with his own disposition, less than ten days after he himself had been dismissed from his teaching position in Düsseldorf.

Nietzsche, Segantini, and Cloots were all isolated nonconformists: none of them was particularly popular during his own lifetime, committed as each was to a mission, that like Beuys's was often considered eccentric. Each of the three men's lives was cut short by tragic circumstances.[94] Caught between the political fronts of the French Revolution, Cloots's German nationality, anticlericism, and radical Jacobean leanings, contributed to his arrest and execution in 1794. In the same manner that Beuys made Segantini's last words a personal credo, he reenacted Cloots's final gesture to those who had come to witness his execution at the guillotine. By bowing three times at the finale of *Anacharsis Cloots in Arena*, Beuys transformed Cloots's last act of defiance into an allegory of his own adamant individualism.[95]

The French Revolution generated a cult of martyrs who stood for principles that came to be associated with the myth of solar revolution.[96] The entire age was characterized by an obsession with Greco-Roman models: public comportment and civic architecture were accorded prestige on the basis of their emulation of the oratorial behavior and radial structures of Republican Rome.[97] So it was that Jacques-Germaine Soufflot's church of Sainte Geneviève came to be remodeled by Quatremère de Quincy as Paris's Pantheon.[98] Like it, *Arena* is a form of ideological history-making, forged by an aesthetic that collapses historical time while situating the artist firmly within an artificially constructed continuum. In it, Beuys united the gladiatorial battles for survival enacted before a public in the Roman amphitheater of antiquity, the gestural and locutionary maneuvers of an assembly of heroes, stretching from the Renaissance to pre-World War II Paris, with his own struggle in the boxing ring of the twentieth-century art world.

We are the Revolution (1970). Top: *Sils-Baselgia;* Bottom: *Maloja.* Edition of 33, not signed and not numbered.

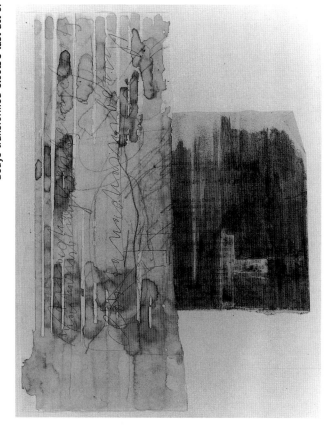

The T-Cross (1958).

Notes

The writer is grateful for the assistance of Lucio Amelio, Eva and Wenzel Beuys, and Erhard Klein.

1. For a discussion of *Arena*, see Achille Bonito Oliva, "Nel/Arena/In the Arena," in *Joseph Beuys: Il ciclo del suo lavoro*, exhibition catalogue (Studio Marconi, Milan, March 6, 1973); Lucio Amelio, "*Arena*," in Lea Vergine, *Il corpo come linguaggio* (Giampaolo Prearo Editore, 1974), n.p.; Germano Celant, ed., *Beuys: Trace in Italia* (Naples: Amelio Editore, 1978), 37–50; Caroline Tisdall, *Joseph Beuys*, exhibition catalogue (New York: The Solomon R. Guggenheim Museum, November 2, 1979–January 2, 1980), 224–225; Heiner Bastian, "*Arena—Wo wäre ich hingekommen, wenn ich intelligent gewesen wäre!*" in *Joseph Beuys: Skulpturen und Objekte*, exhibition catalogue (Martin-Gropius Bau, Berlin, February 20–May 1, 1988), 276; Armin Zweite, "Prozesse entlassen Strukturen, die keine Systeme sind," in *Joseph Beuys: Skulpturen und Objekte*.

2. This methodology is aligned with three highly useful books on Beuys: Eva, Wenzel, and Jessyka Beuys, *Joseph Beuys: Block Beuys* (Munich: Schirmer/Mosel Verlag, 1990); *Joseph Beuys: Die Multiples*, ed. Jörg Schellmann (Munich/New York: Edition Schellmann, 1992); and Mario Kramer, *Joseph Beuys: Das Kapital Raum 1970–1977* (Heidelberg: Edition Staeck, 1991).

3. On the cult of the artist, see Siegfried Gohr, *Der Kult des Künstlers und der Kunst im 19. Jahrhundert: Zum Bildtyp des Hommage, Dissertationen zur Kunstgeschichte* vol. 1 (Vienna: Böhlau, 1975).

4. The work remained untitled until its showing at Lucio Amelio's Modern Art Agency in 1972 when Beuys titled it *Arena—Dove sarei arrivato se fossi stato intelligente!*.

5. Peter Diamond, *Strategy: Get Arts*, exhibition catalogue (Edinburgh International Festival, August 23–September 12, 1970), n.p.

6. The work was not mentioned or depicted in the Edinburgh catalogue, having been installed after the publication was already in production. A letter from Ute Klophaus to Karl Ruhrberg, director of the Städtische Kunsthalle, Düsseldorf, dated September 10, 1970, mentions the presence of about 160 photographs (Stadtarchiv Düsseldorf, File #50, #28026, "Edinburgh E–Z," 1970). In the same file is an unsigned and undated memo that states: "Beuys insists on two rooms. One for a permanent concert and Happenings, one for showing his VW and photos that will be taken during the concert." According to Richard Demarco, who coordinated the exhibition, Beuys never suggested moving *The Pack (das Rudel)* from the corridor. He wanted to devote this second room entirely to the exhibition of the photographs he had brought with him from Düsseldorf (Demarco, conversation with the author, November 5, 1992).

7. In Joseph Beuys's agenda, the entry for August 13, 1970, contains the words *Rannoch Moor* (one of the films he showed during *Celtic*), *Photokisten* (box of photos), *the 100 frames* (Archive of Joseph Beuys, Düsseldorf).

8. Norbert Kricke in *Die Zeit*, December 20, 1968, cited in Heiner Stachelhaus, *Joseph Beuys*, trans. David Britt (New York: Abbeville Press, 1987), 91–95.

9. Georg Jappe, "Quo vadis, Akademie? Diter Rot verlässt Düsseldorf/Beuys gefährdet," *Frankfurter Allgemeine Zeitung*, May 9, 1969, cited in Götz Adriani, Winfried Konnertz, and Karin Thomas, *Joseph Beuys: Life and Works*, trans. by Patricia Lech (New York: Barron's, 1979), 189.

10. Georg Jappe, conversation with the author, October 1992.

11. The selection of the artists to be included in "Strategy: Get Arts" was the subject of at least one article, which expressed the hope that "the image of the exhibition would round itself out and all appearances of 'clique terror' would be eliminated." Yvonne Friedrichs, "Wer repräsentiert in Edinburgh," *Düsseldorfer Feuilleton*, 142, June 24, 1970. Karl Ruhrberg's introductory statement in the catalogue can be interpreted as his response to the controversy: "The fact that these men [Götz, Geiger, Kricke, Hoehme, et al . . . are not represented on their work. . . . In an exhibition which is intended to demonstrate the progressive vitality of modern Düsseldorf, it is necessary to place the emphasis on the latest trends and developments, hence the consensus of opinion between artists, organizers, and advisers was that Group ZERO should provide the starting-point for the exhibition." Ruhrberg, in *Strategy: Get Arts*, n.p. One of Beuys's antagonists, Gerhard Hoehme, was so incensed at his exclusion from the exhibition that he filed a "Protest" with the Chief City Director and Cultural Attachés of Düsseldorf. In a subsequent letter to Ruhrberg, dated October 11, 1970, Hoehme accused him of favoring those artists whose work is "identical with life)," thereby implicating Beuys without naming him. The issue of his omission was far from insignificant for Hoehme: "This is for me an existential proceeding; it concerns my international reputation and also the material consequences connected with it." (Stadtarchiv Düsseldorf, File #50, #28026, "Edinburgh E–Z," 1970).

12. Edward Lucie-Smith, "A Great Subversive," London *Sunday Times* August 30, 1970, n.p., cited in "Pressestimmen," in Edinburgh *Schottland Kunst-Zeitung* 5, n.p.

13. See Adrian Henri, "Get Arts," *Scottish International* November 12, 1970, 43–44; and Alastair Mackintosh, "Beuys in Edinburgh," *Art and Artists* 5, no. 8 (November 1970), 10.

14. Klophaus's letter to Ruhrberg requests payment for the use of her photographs in the exhibition and for three additional reproductions of Beuys's and H. P. Alvermann's work in the catalogue.

15. Richard Demarco, conversation with the author, July 27, 1992.

16. Joseph Beuys, conversation with Martin Kunz, March 10, 1979, in *Spuren in Italien*, exhibition catalogue (Kunstmuseum Luzern, April 22–June 17, 1979), n.p.

17. The original copy of *Life Course* is in the possession of Armin Hundertmark in Cologne. The final version is reproduced in *Joseph Beuys: Werke aus der Sammlung Karl Ströher*, exhibition catalogue (Kunstmuseum, Basel, November 16, 1969–January 4, 1970), 4–5. A bibliography of Beuys's supplementation of the *Life Course* between 1965 and 1970, and the changes themselves, ending with the words *PLASTISCHER FUß* is to be found on pages 6–7. According to Eva Beuys, Heiner Bastian decided to supplement the *Life Course* catalogue (Kunsthalle, Tübingen, September 8–October 28, 1984) as cited in Karin Thomas, "Lebenslauf/Werklauf," in *Beuys vor Beuys*, exhibition catalogue (Ministerium für Bundesangelegenheiten des Landes Nordrhein-Westfalen, Bonn, November 27–December 31, 1987), 222.

18. Götz Adriani, Winfried Konnertz, Karin Thomas, *Joseph Beuys: Leben und Werk* (Cologne: DuMont, 1973), 7. The authors formulated their manuscript using transcriptions of taped interviews they had held with Beuys, who then edited them, removing certain passages and elucidating others (Karin Thomas, conversation with the author, July 1992). It was Adriani's idea to use the *Life Course* as the basis for the book's format, with which Beuys readily agreed. In using it, Adriani hoped to expose its truths and fictions (Götz Adriani, conversation with the author, August 1992). The first monograph on Beuys was by Lothar Romain and Rolf Wedewer, *Über Beuys* (Düsseldorf: Droste, 1972).

19. Several parallels may be drawn between Beuys's autobiographical interests, his fictionalization of them, and his interest in black-and-white images (including filmed ones) and Edgar Reitz's interests and methods in his 1984 film *Heimat*. On Reitz, Germany, and memory see particularly Anton Kaes, "Germany as Memory," in *From Hitler to Heimat* (Cambridge, Mass.: Harvard University Press, 1989), 161–182.

20. No mention is made in Adriani, Konnertz, and Thomas's book of *Arena*'s exhibition in Edinburgh. Given Beuys's close supervision of the text, this omission suggests his dissatisfaction with its early form. Beuys could not have simply forgotten—the material for the book was compiled just a few months after the installed *Arena* in Naples and Rome. Both of these latter sites are referenced in the text.

21. Three of these frames encase sheets of glass, two blue and one yellow, a feature that was also particular to the 1972 installation. Their meaning may be connected with a postcard that Beuys issued in 1970, whose colors and format match those of the sheets of glass, with the exception that two of the postcards are yellow and one is blue. See, Schellmann, 411.

22. Ekkehard Mai, "Kunst lehren, mit der Kunst leben: Kunsthochschulen in NRW–Umrisse," in *Zeitzeichen: Stationen Bildender Kunst in Nordrhein-Westfalen*, ed. Karl Ruhrberg. exhibition catalogue (Ministerium für Bundesangelegenheiten des Landes Nordrhein-Westfalen, Bonn, September 13–October 19, 1989), 191–192.

23. Beuys, conversation with Kate Horsefield, in *Energy Plan for the Western Man: Joseph Beuys in America* (New York: Four Walls Eight Windows, 1990), 65.

24. On Lehmbruck and Expressionism, see Walter Grasskamp, *Die unbewältigte Moderne: Kunst und Öffentlichkeit* (Munich: C. H. Beck, 1989), 99. Ewald Mataré, with whom Beuys studied, surely also directed Beuys's attention to the Expressionist tradition.

25. Siegfried Gohr, "Über das Hässliche, das Entartete und den Schmutz," in *Bilderstreit: Widerspruch, Einheit und Fragment in der Kunst seit 1960*, exhibition catalogue (Museum Ludwig in den Rheinhallen der Kölner Messe, Cologne, April 8–June 28, 1989), 48–49.

26. Beuys's 1928, 1929, and 1933 *Life Course* entries refer to an "excavation," a "grave," and a "digging."

27. On the connection between Beuys and the Expressionists and the similarities between the Abstract Expressionists and German Expressionists, see Donald E. Gordon, *Expressionism: Art and Idea* (New Haven: Yale University Press, 1987), 204–209.

28. Harold Rosenberg, *The Anxious Object* (Chicago: University of Chicago Press, 1982), 40, 46.

29. Joseph Beuys, *The secret block for a secret person in Ireland*, exhibition catalogue (Museum of Modern Art Oxford, April 7–May 12, 1974), n.p. Though there are 266 title lines in the register created for the Oxford exhibition, there were actually 327 single-sheet drawings, plus an additional 35 designated "Ex Catalogue" on the back of the frames; see Céline and Heiner Bastian, "Katalogredaktion," in *Joseph Beuys: The secret block for a secret block person in Ireland*, ed. Heiner Bastian, exhibition catalogue (Martin-Gropius Bau Berlin, February 20 May 1, 1988), 485–486. The 327 drawings were mounted in 244 frames; see Dieter Koepplin, "Inkarnation, Ausscheidung, Potential," in *Joseph Beuys: The secret block for a secret person in Ireland*, exhibition catalogue (Kunstmuseum, Basel, April 16–June 26, 1977), 48; no. 3. All numbers refer to *The secret block's* exhibition in Oxford.

30. Beuys instructed H. Huiskens Schlossermeister, Düsseldorf, to stamp the numbers on each frame (Mr. Dümer from H. Huiskens Schlossermeister, conversation with the author, November 11, 1992).

31. *The secret block* is on long-term loan to the Wilhelm-Lehmbruck-Museum in Duisburg. According to Eva Beuys, the frames of *The secret block* were originally uniform in size (conversation with the author,

author, March 3, 1994). *The secret block* drawings were reframed by Heiner Bastian in 1979. See, Bastian, 1988, 485.

32. Beuys made a multiple in the form of a book in 1974, *Die Leute sind ganz prima in Foggia* (*The People are Just Great in Foggia*). The "text" consists of pieces of paper with various phrases from his *Life Course* and actions, one of which is pasted on each of the seventy-five pages. These isolated statements, randomly mounted in a jumbled chronological order, resemble *Arena*'s aesthetic. See Schellmann, 130, 445.

33. *Dead man* was given the number 90 in *The secret block* catalogue register, and is in frame #21a. The other works on paper are located in frame numbers 37b, 42d, 60a, 68a, 68b, 75a, 76b, 96a, and 96b.

34. There are fourteen images in *Arena* that are framed alone. The photograph of the placard bearing the name Joyce is frame #55. The others are located in frame numbers: 13a, 22a, 32a, 32a, 34a, 36a, 41a, 48a, 49a, 52a, 59a, 95a, 98a, and 99a. The placard was made for a play that Eva Beuys wrote, *Jahrhundertwende*, in 1962 (Eva Beuys, conversation with the author, July 15, 1992). The specifications of this untitled placard were furnished by Anny De Decker, in whose possession the work is now. Her Wide White Space Gallery purchased it from Beuys around 1967 (Anny De Decker, letter to the author, July 23, 1992).

35. The following statement, made by Richard Hamilton in 1972, reveals the extent of Beuys's interest in Joyce: "Being in London somehow reminded him [Beuys] that Leopold Bloom fried kidneys in *Ulysses*. My comment that Bloom had eaten pig's kidneys [whereas Beuys had cooked sheep's kidneys] provoked a torrent of Joycean erudition. Though Beuys's fluency in English, at that time, was not great, his knowledge of a masterpiece of English literature was intense and deep"; see Hamilton, in *Beuys zu Ehren*, exhibition catalogue (Städtische Galerie im Lenbachhaus, Munich, July 16–November 2, 1986, English edition, 626). Beuys's interest in Joyce has not been sufficiently explored. He had been interested in Joyce's *Ulysses* since at least 1958, when he first began to create the drawings for what eventually amounted to six sketchbooks of graphic material. *Wärme-Zeit-Maschine, Fra Joyce-vaerket* (1958) is reproduced in Hans Jörgen Nielsen, "Beuys's Joyce," in *Hvedekorn* 5 (1966), 178–179. This drawing and another (not reproduced in the article but integral to its composition and therefore also from the *Joyce-vaerket*) were framed together. They were titled *Warmth Time Machine* and given the number 174 in *The secret block* Oxford catalogue register.

36. "Zur Biographie," in *Transit: Joseph Beuys–Plastische Arbeiten 1947–1985*, exhibition catalogue (Kaiser Wilhelm Museum, Krefeld, November 17, 1991–February 16, 1992), 35; Stachelhaus, 79.

37. In 1963 Beuys wrote a second biographical statement that begins with, "Am 4.10.1963 [sic] wird Beuys als Professor für Bildhauerei an die Staatliche Kunstakademie berufen." The typographical error is unfortunate: 1961 was the actual date. A list of events followed centered on the page, the second of which is Boien Wenzel; see *Josef Beuys Fluxus Aus der Sammlung van der Grinten*, exhibition catalogue (Stallausstellung im Hause van der Grinten, Kranenburg, October 26–November 24, 1963), n.p. Beuys also prepared a curriculum vitae on the occasion of his appointment to the Düsseldorf Art Academy and in 1978, to the Hochschule für angewandte Kunst in Vienna. (Archive of Joseph Beuys, Düsseldorf); see "Selbstbiographie Joseph Beuys," in Eva, Wenzel, and Jessyka Beuys, *Block Beuys*, 17–19.

38. See Beuys, conversation with Louwrien Wijers, November 22, 1979, published in *Joseph Beuys Talks to Louwrien Wijers* (Velp: Kantoor voor Cultuur Extracten, 1980), 8.

39. Beuys had considered becoming a writer; see his conversation with Heiner Bastian and Jeannot Simmen, August 8, 1979, published as "If Nothing Says Anything, I Don't Draw," in *Joseph Beuys Zeichnungen, Tekeningen. Drawings*, exhibition catalogue (Museum Boymans-van Beuningen, Rotterdam, November 1979–January 1980), 102.

40. This desire is seen, for example, in his reference not only to Joyce, but also to Leonardo, in the 1950 *Life Course* entry "Kranenburg Haus van der Grinten 'Giocondologie.'"

41. Beuys, "Notizzettel Josef Beuys," in *Josef Beuys, Zeichnungen, Aquarelle, Olbilder, Plastische Bilder aus der Sammlung van der Grinten*, exhibition catalogue (Städtisches Museum Haus Koekkoek, Kleve, October 8–November 5, 1961), n.p.

42. See Gerhard Kaldewei, "Unsere Arbeit war nicht umsonst," in *Getlinger Photographiert Beuys 1950–1963*, exhibition catalogue (Städtisches Museum, Kalkar, October 14–November 11, 1990), 10–13; the article from the *Rheinische Post* is reproduced along with several others from the same paper.

43. In 1969 Beuys described the contents of the vitrines in Hessisches Landesmuseum in Darmstadt in the following terms: "Those are all autobiographical documents"; see Ernst Günter Engelhard, "Joseph Beuys: Ein grausames Wintermärchen," *Christ und Welt* 21, no. 1 (January 3, 1969), n.p., cited in the exhibition catalogue of the Kunstmuseum, Basel, 1969. For Joyce and autobiography, see Ellmann 1983, 3, 49.

44. Richard Ellmann, *James Joyce*, trans. Albert W. Hess, Klaus and Karl H. Reichert (Frankfurt: Suhrkamp, 1959), located in the Archive of Joseph Beuys, Düsseldorf.

45. Beuys owned a copy of *Finnegans Wake* (London: Faber and Faber, 1939) and two copies of *Ulysses*: a translation by Georg Goyert in its sixth edition (Zurich: Rhein-Verlag, 1956), and an edition of 1972 (New York: Penguin). The date of this second publication is another indication of his ongoing interest in Joyce particularly during the year he was completing *Arena* (Archive of Joseph Beuys, Düsseldorf).

46. See Beuys's conversation with Heiner Bastian and Jeannot Simmen, 1979, 101; Beuys quoted in Adriani, Konnertz, and Thomas, 1979, 29. Beuys's interest in Joyce began in 1950 (*Life Course*: "Beuys liest im

'Haus Wylermeer' *Finnegans Wake*"), and surfaced subsequently in 1956 (*Joyceregion* listed on the invitation card to Beuys's 1965 exhibition ". . . irgend ein Strang . . ." Galerie Schmela, Düsseldorf; in 1958 (first drawings of *Ulysses Sketchbooks*): 1961 (*Life Course*: "Beuys verlängert . . . 'Ulysses' . . ."); in the same year (*Joyce*): 1965 (*Division of the Cross* oil drawing with "Joyce" written on it); 1972 (photograph of Joyce placard incorporated in *Arena*): 1974 (the multiple *The People are Just Great in Foggia* includes the words "verlängerter 'Ulysses' von Joyce"); 1984 (multiples *Nicht von Joyce* [*Not by Joyce*] and *James Joyce*): and 1985 (multiple *Joyce with Sled*).

47. Ellmann 1959, 173; Ellmann 1983, 163.

48. Peter Bürger, "Der Alltag, die Allegorie und die Avantgarde: Bemerkungen mit Rücksicht auf Joseph Beuys," in *Postmoderne*, ed. Christa and Peter Bürger (Frankfurt: Suhrkamp, 1987), 206–208.

49. Wilhelm Bojescul, "Joseph Beuys," in *Kunst der sechziger Jahre in der Neuen Galerie Kassel* (Kassel: Staatliche Kunstsammlungen, 1982), 12.

50. Beuys set up 24 "stations" in his exhibition at the Guggenheim Museum in New York in 1979, a show Beuys acknowledged as inherently autobiographical: "I am finished now with my biography, you see. . . [t]he Guggenheim exhibition] was a very clear intention of a wish to have this piece as a biographical overview over my intentions" (see Beuys's conversation with Wijers, 12).

51. Beuys, conversation with Mario Kramer, December 9, 1984, in Kramer, 14.

52. The text of the multiple is an excerpt from Beuys's 1979 interview with Bastian cited in note 39. In discussing the relationship of his work to the theme of Joyce's *Ulysses*, Beuys answered: "Ja, es gibt eine Parallelität, und ich habe mich auf Joyce bezogen." (Yes, there's a parallel there and I related my works to Joyce).

53. Henning Christiansen, letter to the author, November 27, 1992. That Joyce was connected in Beuys's mind to *Celtic* is evinced by his unexpected discussion of Joyce in response to Kramer's question about composer Eric Satie's relationship to the action: "In the world of sound, Satie assumed a significance similar to Joyce's poetic or literary feats. Both attempted to construct a mythos that made reference to the ordinary man" (see Beuys's conversation with Kramer), 10.

54. See Stachelhaus, 110.

55. Ellmann 1959, 159; Ellmann 1983, 148, 149.

56. Amelio's gallery is rectangular; Beuys was well aware of the difficulty of finding the ideal circular exhibition room (see Beuys's conversation with Kramer), 19.

57. See Beuys's conversation with Kunz, n.p.

58. Beuys probably acquired this photograph when he visited Verona during his air force service in March 1943 (Eva Beuys, conversation with the author, December 1, 1992). For a copy of his letter to his parents mentioning his visit to Verona, see *Joseph Beuys: "Die Soziale Plastik"* (Naples: Academia di Belle Arti, 1987), n.p.

59. Adriani, Konnertz, and Thomas, 1979, 230, and Pia Witzmann, "Das Inventar für direkte Demokratie," in *Joseph Beuys: documenta Arbeit*, exhibition catalogue (Museum Fridericianum, Kassel, September 5–November 14, 1993), 83–84.

60. Augusta Hönle and Anton Henze, *Römische Amphitheater und Stadien: Gladiatorenkämpfe und Circusspiele* (Zurich: Atlantis, 1981), 56.

61. Documenta 3, the first Documenta to which Beuys was invited (this fact is mentioned in the *Life Course*), was also the first Documenta to run for one hundred days; see, Arnold Bode, "Vorwort zum Documenta-3-katalog," and Harald Szeemann, "Das 100-Tage-Ereignis: 1. Konzept zur Documenta 5," in *Documenta: Idee und Institution*, ed. Manfred Schneckenburger (Munich: Bruckmann, 1983), 70–71, 113.

62. One instance is Beuys's conceptualization of his "Freie Universität" as an ongoing Documenta. See Stachelhaus, 114.

63. The circle is an age-old symbol of self-containment and self-sufficiency, a space that obfuscates the distinction between clear-cut beginnings and ends; see Erich Neumann, *The Origins and History of Consciousness*, trans. R. F. C. Hull, Bollingen Series 42 (Princeton: Princeton University Press, 1973), 8–9; and Manfred Lurker, "Kreis," in *Wörterbuch der Symbolik*, ed. Manfred Lurker (Stuttgart: Alfred Kröner, 1991), 404.

64. See Bojescul, 12.

65. The title of at least one other work in Beuys's oeuvre, itself written on a blackboard that is part of the installation, makes explicit reference to the site of fire: *Feuerstätte* (*Hearth*), 1974. Öffentliche Kunstsammlung, Museum für Gegenwartskunst, Basel. See Theodora Vischer, *Joseph Beuys: Die Einheit des Werkes* (Köln: Verlag der Buchhandlung Walther König, 1991), 77–80.

66. See Gaston Bachelard, *Psychoanalyse des Feuers*, trans. Simon Werle (Frankfurt: Fischer Taschenbuch, 1990), 52–59.

67. Joseph Beuys, "Thanks to Wilhelm Lehmbruck," in *In Memoriam Joseph Beuys: Obituaries, Essays, Speeches* (Bonn: Inter Nationes, 1986), 61. For the reference to Pietro Metastasio see Beuys, "Dank an Wilhelm Lehmbruck," in *Reden zur Verleihung des Wilhelm-Lehmbruck-Preises der Stadt Duisburg 1986 an Joseph Beuys* (Duisburg: Wilhelm-Lehmbruck Museum, 1986), n.p; no. 6.

68. Jürgen Habermas, "Modernity's Consciousness of Time and Its Need for Self-Reassurance," in *The Philosophical Discourse of Modernity: Twelve Lectures*, trans. Frederick Lawrence (Cambridge, Mass.: MIT Press, 1987), 1–22.

69. See Jochen Schmidt, *Die Geschichte des Genie-Gedankens in der deutschen Literatur, Philosophie, und Politik 1750–1945* (Darmstadt: Wissenschaftliche Buchgesellschaft, 1988), Vol. 1, 17. Beuys produced a series of postcards in 1971 in which the word *Erfinder* (inventor) is joined to the image of Christ and his own name.

70. Richard Demarco, "Notes to Beuys," in *Similia Similibus: Joseph Beuys zum 60. Geburtstag*, ed. Johannes Stüttgen (Cologne: DuMont, 1981), 119.

71. The concept of genius also interested James Joyce; see James Joyce, *Ulysses* (New York: Vintage, 1990), 195.

72. Dürer is not a random example. His is the first name that Beuys typed on a 1962 list titled "Dieses Lied singen gemeinsam, moduliert nur durch ihre jeweilige Existenzform" (Singing this song together, modulated only through its specific form of existence). The text was printed in *Hvedekorn* 5 (1966), 5, and reproduced in Eva, Wenzel, and Jessyka Beuys, 190. At Documenta 5 Beuys made a work entitled *Dürer, ich führe persönlich Baader + Meinhof durch die Dokumenta V (Dürer, I personally lead Baader + Meinhof through Documenta V)*. On Beuys and Dürer see Peter-Klaus Schuster, "Man as His Own Creator: Dürer and Beuys—or the Affirmation of Creativity," in *In Memoriam Joseph Beuys: Obituaries, Essays, Speeches*, 17–25.

73. See Georges Didi-Huberman, "Das Gesicht zwischen den Laken," in *Jahresring* 39 (1992), 26–29.

74. See Grasskamp, 89–91. After passing by the photographic portrait wall, the spectator was confronted with Lehmbruck's *Kniende (Kneeling Woman)*.

75. According to Stachelhaus, "The inclusion of photographs in the [van der Grinten] brothers' collection was inspired by Beuys, who first directed their attention to the artistic significance of photography," in *Joseph Beuys*, 45. On Getlinger and Beuys see Thilo Koenig, "Fritz Getlinger photographiert Joseph Beuys," in *Getlinger photographiert Beuys 1950–1963*, 29; Fritz Getlinger, conversation with Annette Theyshen, "Biographische Gespräche mit Fritz Getlinger," in ibid., 46.

76. See Achille Bonito Oliva, "Joseph Beuys, Ein Phänomen," in *Dia International* 1 (November 1983), 7–9.

77. See Dieter Daniels, "Duchamp als Objekt der Kunstgeschichte seit 1960," in *Duchamp und die anderen* (Cologne: DuMont, 1992), 234–237.

78. This behavior manifested itself in the countless interviews and lectures Beuys gave and the marathon quality of his actions, whose protraction often tested the limits of his physical endurance. The fifth entry of Beuys's *Life Course* reads "1925 Kleve Dokumentation Beuys als Aussteller" (Kleve documentation Beuys as exhibitor).

79. See Amelio, 1974, n.p.

80. Lucio Amelio, conversation with the author, August 8, 1992.

81. Despite his intentions, Beuys did not expand the piece; his death in 1986 effectuated its completion.

82. See the register for *The secret block for a secret person in Ireland*, Museum of Modern Art Oxford, n.p.

83. Beuys also removed certain drawings from *The secret block* and rearranged the contents of the vitrines in the Hessisches Landesmuseum in Darmstadt.

84. See Laszlo Glozer, "Beuys in Stockholm," in *Süddeutsche Zeitung* (January 30–31, 1971), cited in Glozer, *Kunstkritiken* (Frankfurt: Suhrkamp, 1974), 230; and Eckhard Neumann, *Künstlermythen* (Frankfurt/New York: Campus, 1986), 112–113.

85. In this sense, the Italian phrase bears certain relationship to the subtitle, the ironic nature of certain chapter headings, and the themes of Friedrich Nietzsche's autobiography, *Ecce Homo: How One Becomes What One Is*, trans. R. J. Hollingdale (New York: Penguin, 1982).

86. According to Eva Beuys, it was one of very few vacations the family ever made to a cold climate during winter. She does not recall Beuys's going to the Nietzsche Haus; however, she remembers well his visits to Segantini's atelier (Eva Beuys, conversation with the author, December 1, 1992). The meaning of Sils Baselgia for Beuys has not yet been ascertained.

87. Schellmann, 63, 432. That these postcards were particularly important to Beuys is suggested by the fact that they were the first and only multiples that he produced privately; he sent them primarily to his friends.

88. The drawing *Belevedereblatt* (1941) and poem "Nordischer Frühling" (Northern Spring) are reproduced in Werner Schade, "Ausgehend von einer frühen Zeichnung," in *Joseph Beuys-Tagung Basel 1.–4. Mai 1991*, ed. Volker Harlan, Dieter Koepplin, Rudolf Velhagen (Basel: Wiese, 1991), 14–15. Though Beuys names Nietzsche and Goethe in his *Notes* Josef Beuys as being of significance to him, his interest in Nietzsche has been neglected in the secondary literature. For a brief commentary see Ivo Frenzel, "Prophet, Pioneer, Seducer: Friedrich Nietzsche's Influence on Art, Literature and Philosophy in Germany," in *German Art in the 20th Century: Painting and Sculpture 1908–1985*, exhibition catalogue (Royal Academy of Arts, London, 1985), 75. Beuys made another drawing in 1954, *Zarathustra*, whose title also references Nietzsche. The work is reproduced in *Beuys vor Beuys*, catalogue number 40.

89. Helmut R. Leppien, *Joseph Beuys in der Hamburger Kunsthalle* (Hamburg: Hamburger Kunsthalle, 1991), 34.

90. According to Bernd Klüser, Beuys may have acquired the Hans Olde etching of Nietzsche at the Nietzsche Haus in Sils-Maria. (Bernd Klüser, conversation with the author, October 5, 1992). The collage is reproduced in Frenzel, 75, and the multiple in Schellmann, 312.

91. Beuys, cited in Tisdall, 62.

92. Hans-Werner Schmidt has pointed out that, beginning in 1972, Beuys increasingly used photographic portraits of himself, including postcards, as a vehicle to carry his ideas; see Hans-Werner Schmidt, "Andy Warhol 'Mao—Joseph Beuys Ausfegen,'" in *Idea* 9 (1990), 224.

93. The book was given to Beuys by Oswald Wiener sometime between mid-December of 1971 and October of 1972, when he used it in the action to exchange ideas with him. It was then that Wiener became aware of Beuys's deep interest in Cloots. At some point thereafter he went to a rare-book store and purchased the book on Cloots for Beuys (Oswald Wiener, conversation with the author, November 25, 1992).

94. Segantini developed peritonitis and died in the remote mountain village of Schafberg at the age of forty-one; Nietzsche went mad and was paralyzed in his forty-fourth year; Cloots was executed shortly before he reached forty.

95. Beuys's interest in Cloots is evident throughout his oeuvre. Jean-Jacques Barthélemy's book *Voyage du jeune Anacharsis en Grèce (Travels of Anacharsis the Younger in Greece)* is located in the central vitrine of Beuys's last installation, *Palazzo Regale* (1985), first shown in the Museo Capodimonte in Naples; see Armin Zweite, "Ich kann nur Ergebnisse meines Laboratoriums nach aussen zeigen und sagen, schaut einmal her . . ." in *Beuys zu Ehren*, German edition, 62–63.

96. See Jean Starobinski, *1789: The Emblems of Reason*, trans. by Barbara Bray (Charlottesville: University Press of Virginia, 1982), 43–51; and Werner Hofmann, "Wahnsinn und Vernunft: Über die allgemeine Sonne und das Lampenlicht des Privaten," in *Europa 1789: Aufklärung, Verklärung, Verfall*, ed. Werner Hofmann, exhibition catalogue (Hamburger Kunsthalle, September 17–November 19, 1989), 13–40.

97. Simon Schama, *Citizens: A Chronicle of the French Revolution* (New York: Alfred A. Knopf, 1989), 162–169; and Starobinski, 68–87.

98. According to Tisdall, *Arena* is connected to the structure of the Pantheon; see Tisdall, 225.

The Neapolitan Tetralogy: An interview with Lucio Amelio

Pamela Kort

Pamela Kort: How did you come to meet Joseph Beuys in September of 1971?

Lucio Amelio: I didn't meet Beuys in

September 1971. I *met* Beuys in 1943.

What do you mean by that?

It's not a joke: in September 1971 I met Beuys in

Heidelberg. In 1943 we didn't say hello, but we saw each other.

Where was that?

It was in Naples. Then, in 1971, we

both participated in a meeting held in Heidelberg in opposition to the Cologne art market, because it was becoming very selective. I was there with him, with Klaus Staeck, Germano Celant, Jannis Kounellis, Mario Merz, and others. On this occasion I noticed his green eyes looking at me in a very curious way. I wondered why he was so interested in the small gallery that I had opened in Naples in 1965. I had shown Kounellis in 1969 and Cy Twombly in 1970. I was, already, if you like, on the right way, but still I didn't understand why Beuys was interested in me. After the meeting, I instinctively followed him to Düsseldorf and I said, "I would like you to come to Naples and Capri." At that time I had a villa in Capri with my friend Pasquale Trisorio and we invited artists there. Well, he started to resist. I said I would get a ticket for him and his family. "If you do that, I will come tomorrow," he said. So we all went to Capri.

How familiar were you with Beuys's work at that time?

In a sense he was made for me, because I was involved with Arte Povera. But I didn't really know much about him, except that other artists had been saying how great he was.

What did your involvement with Arte Povera have to do with your knowledge of Beuys's work?

I wanted to work with him. But during that period, Beuys didn't want to make any shows. He was becoming more involved in political situations. So I asked myself, "Why did Beuys choose me?" I didn't choose him, he chose me. I think he came to Naples to discuss the cycles of his work with me, because he had a plan. In 1943, he had come as a soldier to Naples and to Foggia, another beautiful city nearby. From Italy, he wrote to his parents about the beauty of "the land where the lemon trees are blooming," how wonderful, how exciting. Beuys decided to become an artist through being in Naples. There is a letter to his parents from Italy in which he said, "I want to be an artist," and asked them to enroll him in an art academy. "I want to be a sculptor," he said. That statement is very important.

So when he saw you in Heidelberg, returning to Naples, where he had first thought of becoming an artist, this was very much on his mind?

Absolutely. It was as if—unconsciously—he had planned this meeting. Beuys liked the south of Italy, the sunny part of Italy. That's why he wanted to make this show in Naples. He never made a show by chance: every show had a special meaning. Every object, every action was thought of at least twenty years beforehand. I represented Capri, like Cythera, the island of happiness in the golden age. It's a German way of looking at the South, but it also has a lot to do with Rimbaud's ideas of art. Rimbaud said that a poet must become "the Son of the Sun." *Les fils du soleil*—the Sons of the Sun—are the angels, the poets who are able to reach the sun and become immersed in radiations which they later transmit to people. The artist too is the Son of the Sun. Some people call such ideas religious, but, in fact, it's a kind of spirituality. Beuys was interested in Paracelsus, too, because he was obsessed above all with ideas of alchemy and spirituality.

Did Beuys mention Paracelsus?

Many, many times.

Did Beuys discuss Rimbaud with you?

No. He never discussed Rimbaud with me, but it's very, very clear that Rimbaud's theory is at least parallel to Beuys's theory about the sun. The sun is the first battery, the first source of energy. That's a very archaic notion, Egyptian, Greek. . . .

What is it about Rimbaud that you believe was of importance to Beuys?

Beuys often used the word *angel*. I didn't understand: it seemed strange for someone who speaks about the earth, about the plants . . . Beuys always used to draw when he was speaking. There was no speech without drawing.

At the end of his life, Beuys said that he wanted Naples to become a world center for the arts. Why did he say that? Two years before in Switzerland, he had written, "We are the Revolution"—"La rivoluzione siamo Noi" [sic]. In Capri in 1971, he said, "I would like to present my political ideas to change European society." We used a postcard from Sils Baselgia, in the Italian part of Switzerland, which he collected in 1969, as the announcement of his first show at my Modern Art Agency in November 1971. On the back was written: *La rivoluzione siamo Noi*. Italy and Switzerland were very important for Beuys; Italy represented energy at its source and Switzerland represented formalized energy. Mountains are the final moment of aggregation. They are crystalline forms, pyramids, triangles; energy in its most perfect form. And the mountain has a relationship with the spirit. Up a mountain you are nearer the spirit. That's why Beuys so loved the mountains, crystals, and Giovanni Segantini, who painted mountains.

Did Beuys discuss Segantini with you?

Beuys loved his work, just loved it. Segantini was an Italian-Swiss painter who carried his large canvases into the mountains. When he fell sick, and he knew he was dying, he said "Open the window, I want to see my mountains." Beuys used these words, "voglio vedere i miei montagne," as the title of his installation at the Stedelijk van Abbemuseum in Eindhoven that same year, 1971.

When Beuys came to Naples, what did he most want to do and see? Did he want to get down to work immediately or did he want to go and look at monuments?

First, he wanted to see nature, which he liked very much. He liked the garden that we had in Capri. He knew the name of every plant and every flower—he would eat them. In Capri, in the kitchen, I asked him for a show, and he said slowly, "It's difficult for me to make one show because I make various things—drawings, actions, objects, and so on." I said, "Let's make two shows." He said, "Ah, let's make four." And so we planned four shows. The drawing outlining this strategy was done in Capri in September 1971. (It was

later stolen from the Ronald Feldman Gallery when I lent it to their first Beuys show). He made a *Partitur* for me, a note of what I should show of the drawings and sculpture. The concept of a "*Partitur*" (musical score), is a musical term that evolved for him while he was in Fluxus. He spoke via a *Partitur*, a list of ideas. Later, when he was lecturing, he used blackboards. A blackboard is just a large *Partitur* meant to be seen by many people at the same time. . . . Unfortunately he's not here, otherwise you would get a beautiful *Partitur* of this interview.

What was the strategy that you worked out with Beuys while you were in Capri in September 1971?

Mario Merz, Jannis Kounellis, Lucio Amelio, Germano Celant, and Joseph Beuys in Heidelberg (1971).

35

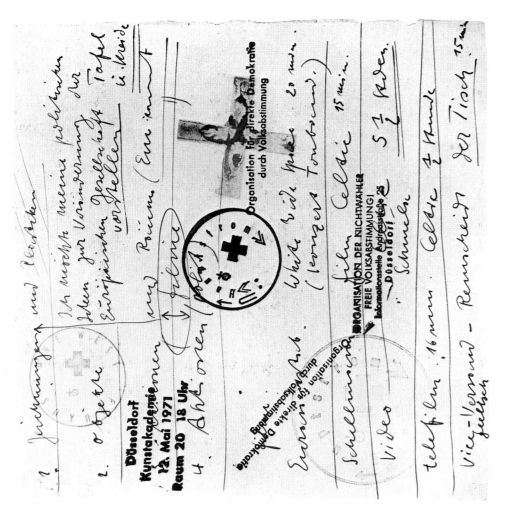

Partitur (1971) outlining the strategy for Beuys's exhibitions with Lucio Amelio in Naples.

I was just a simple guy who had started to become familiar with Beuys's work. I didn't know that for maybe twenty years he had wanted to do something in Naples. With time, his ideas about it were becoming more precise. By chance I arrived at the right moment, the point when he started to think about every human being as an artist. I call Beuys's plan his *tetralogy*, because he had four moments in a strategy all relating to Naples: *tetralogy* because of Wagner—but we could also say the four movements of a symphony.

The first step was consciousness of what needed to be done. So he made a talk at the gallery with a blackboard *Partitur*.

So, he had named the first step as the revolution. . . .

I would say that he realized that he was the catalyst for the revolution. On November 13, 1971, Beuys opened his first show in Italy at my gallery with 130 drawings from all periods of his career, lent by a smart German collector, Lutz Schirmer. Then, using me as a translator for the long discussion with the audience, Beuys made a speech of four hours during which he also wrote on a blackboard. In addition some movies, including *Eurasienstab* (*Eurasian Staff*), were shown. After the opening, the carpet was completely burned by cigarettes, and the gallery was a mess. Beuys didn't want the gallery cleaned. He wanted everything, including the cases in which the drawings had arrived from Germany, to be left as it was.

The second step was the path of the artist, his place in society. To realize the idea that every human being is an artist, that "we are the revolution," he made *Arena.*

Are you saying, then, that the second step, that of the role of the artist, has to do with *Arena?*

Arena is the battlefield, the battlefield for the hero-artist who has to fight for the freedom of every human being. In the middle of *Arena* is a sculpture infused with ancient energy from its two elements: copper and wax. Wax as the product of bees, and copper as the conductor of energy.

And the second stage was then to define how he could effect the revolution?

Exactly. The artist is the hero who spends his life in the battlefield. Like the torero, he's ready to die to make everybody free. This is another

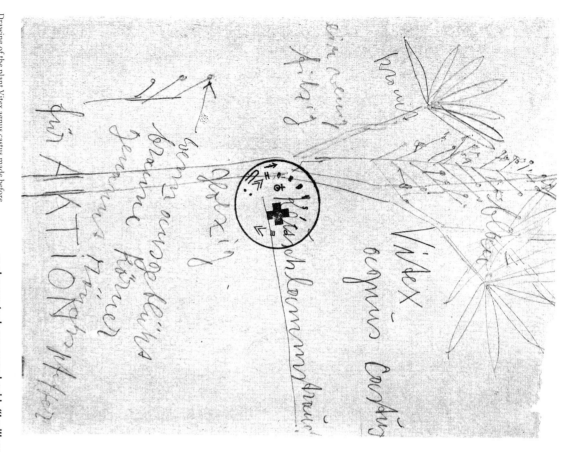

Drawing of the plant *Vitex agnus castus* made before the action *Vitex agnus castus* (1972).

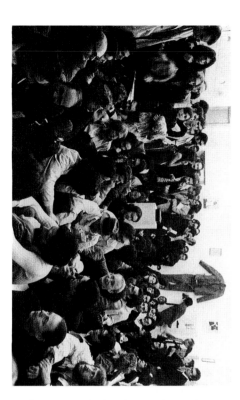

Beuys during a lecture at his first exhibition at Modern Art Agency, Naples (1971).

aspect of the work, Beuys's relationship with Christ. He also made a drawing of *Vitex agnus castus*, the plant he used in his action of that name, which occurred during the opening of *Arena*'s exhibition in Naples. It involves his identification with Jesus Christ, an identification he often made: *Vitex agnus castus* is the lamb of God, the pure lamb, which is an image of Christ.

Would you say that Beuys saw his role as that of a martyr?

In a way, yes. Once in 1971, when we were driving through a very ugly street, a beggar—an old crone—came up asking for money, offering us images of Jesus Christ. I started pushing her away, but Beuys said, "Stop. Buy me five of her little things." So I bought five images of the Sacred Heart of Jesus.

Over one, he wrote his name.

Right. Not only that, he wrote on one, "Der Erfinder der Dampfmaschine" (The inventor of the steam engine). He said to me, "Christ is the first one who saved every man. I will make you free."

The arrow points to Christ's face. The words above Christ's head read, "The inventor of the steam engine." The image combines science, Christ, and the artist. How are we to understand this mixture?

You can understand it by looking at alchemy, and at Rimbaud's poem "Voyelles" (Vowels). The colors in the poem are the colors of the alchemical process, which aims to transform everything into gold. That's where the artist starts. The artist has to transform base matter to make gold. The origins of science lie in alchemy, in the moment when the magician

or shaman took power and said, "I will cure your sickness." At that moment he charged himself with responsibility for humankind. This is the alchemical image of the savior, and every savior is always a martyr, or at least risks being a martyr because he gives of himself completely, without regard for the consequences. Beuys expressed his relationship with this via Jesus Christ. The work of Nietzsche was also very important to Beuys because of its similarity to that of Rimbaud, to his theory of the deregulation of the senses. To arrive at the truth in his poetry, Rimbaud sought madness. In Nietzsche, as in Rimbaud, you find the idea of there being no limit between being wise and mad. This idea of going to the limit, to the extreme limit of rationality was very important to Beuys: to laugh and to be free, and to become somebody who said, "I have nothing to do with art."

I see. Let's go back to the title of your first Beuys show in 1971, "We are the Revolution." Could you explain the relationship between the image on your multiple of a single forward-striding man—Beuys, the artist—and the words "We are the Revolution"?

"We are the Revolution," because Beuys wanted to be one of us. He didn't want to be a saint. He was a saint, but he was also like every human being.

How did Beuys travel to Naples for his first exhibition with you?

He came by train because this was the way he had arrived the first time in 1943. On the train he wore a fur coat, which means he had already begun the work the moment he left Düsseldorf. It was his own "Italienische Reise."

In the tradition of Goethe.

He started his "Italienische Reise" again, and arrived in Naples. And he spoke to people: "I've been reading Goethe's *Italienische Reise*." He spoke with a lot of excitement about his trip to Italy,

when he went through the Brenner Pass to Verona, and so on. He wrote his friends about his wonderful travels, about the landscape, and things like that. Now, by accident, I discovered that Beuys, as a soldier in 1943, had made the same trip. He had to come to southern Italy for weapon training, and he started to write letters, like Goethe. Like Goethe, he was dreaming of Italy even before coming. And so when he finally arrived, he started to write of his adventures, the same strategy as Goethe. And then, when he went back, his mind was filled with images, with books—with Dante and Leonardo—and with the idea of the sun, the sun as the source of energy. My opinion is that Italy was not just one of the countries where Beuys worked, it was the *main* place, chosen as the ideal where nature is strong and generous and the sun is the origin of every fantasy. And Naples is the capital of the south. . . .

The arena was the central place for art, for the idea of the fight, the intellectual fight. In reality the arena in the postcard is in Verona. It's the antique, the idea of the ancient society, that he is thinking of.

When you went to the station to pick him up, what was your impression?

Of a very happy person who had come back to the city where he had been happy a long time before.

After a journey that was how long?

Twenty-four hours.

Twenty-four hours—he didn't get off anywhere en route. Twenty-four hours on a train in a fur coat.

Yes. It's warm in November; he didn't need a fur coat, but it was his dress.

A posture almost?

Yes. It was the dress of the popes, of the king, of somebody who has authority. As was his hat. The hat is the symbol of the person with power. The magician always has a hat to distinguish himself from other people. So if you always have a hat even if you are in a restaurant or in a reception, that's because you are a magician. That's what Beuys wanted to point out, that he was a shaman.

Was this the same coat that Beuys wore in the action *Titus/Iphigenie* in 1969?

Yes. This coat was used for his trip to Naples and for *Titus/Iphigenie*.

What happened to it after that?

Beuys had already planned his end; it was kept for the end of his work. When he went to the United States and did the action with the coyote, *I Like America and America Likes Me*, he also wore the same coat, a kind of red fox.

Doesn't *Arena* also present a certain image of Beuys?

***Arena* is a battlefield, *Arena* is the sun, radiating energy, *Arena* is a tomb.**

A tomb?

A tomb. It is a tomb containing the whole life of the artist. That's why it's interesting. *Arena* can be installed in many ways. You can make a big tank (*Panzer*) from *Arena*. It has a kind of military character in its color, in the weightiness of each panel, in the strength. There's a disproportion between the photographs and the force of the material holding the photographs. It's a container; it's a tank; it's a tomb.

Were these three concepts named by Beuys, or are they the way that you understand the piece?

We never spoke directly about this connection, and I never asked direct questions. But I speculated like that and he responded: "Yes, in a way you are right. Yes, a tomb, a monument, a tank."

What about the subtitle of the work?

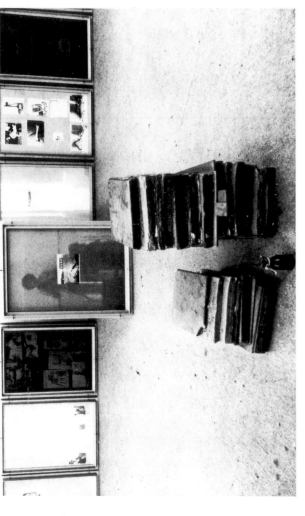

Arena at Modern Art Agency, Naples (1972).

38

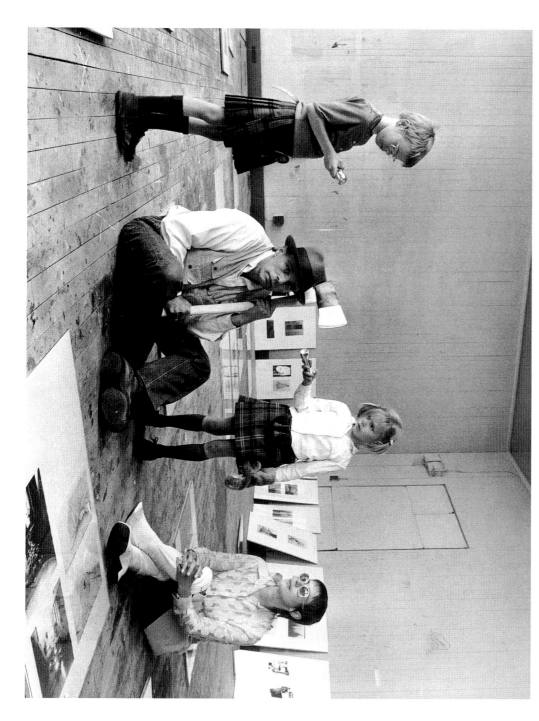

39

had been intelligent! Beuys represented this idea of art—of the human being transformed by art—by means of energy coming from the ground, going through the heart, arriving at the head, and becoming a crystal triangle. The triangle is the traditional representation of God. But Beuys was against all formalizations. He preferred to say, "And then there are the angels." He thought that intellectuals and art historians destroy innocence. In a drawing you can more or less see a representation of what I'm saying. The feet, the fat, then the emotional part, represent harmony: the thought is the crystal, God. The form is just the result of the evolution of a process of energetic movement. In fact, he wrote "Intellectual Abstraction" on it.

Meaning . . .

Intellectualism is an abstraction of reality; it interrupts the movement from the ground to the sky. It's an abstraction that removes one from the natural process of becoming a spirit. Having been a Communist, I was very surprised to hear things like that. People were very shocked at that time—it was not very fashionable to say things like that.

It seems to me that this subtitle, where would I have got if I had been intelligent!, is also ironic because, as you just told me, Beuys had very carefully worked out how he wanted to proceed with his work.

But he thought it was important to be in touch with animal instincts. The innocence of this relationship gets destroyed if one becomes too clever. He found not only human beings but also animals intelligent. Nature, too, is intelligent—that was a theme throughout his life. When Beuys went to the United States, for *I Like America and America Likes Me,* he lived for several days with a coyote and developed a relationship with it.

Didn't Arena originate in 1970, in the exhibition "Strategy: Get Arts" in Edinburgh?

No. The Edinburgh exhibition shouldn't be considered the beginning of *Arena* because *Arena* was just a vague idea there. It was shown without frames in Edinburgh.

Very simple glass frames, anyway.

It's very important: *where would I have got if I*

Do you think it was called *Arena* then?

Yes, but there was no character to them.

I don't think so, but I really don't know.

And probably the subtitle wasn't part of it.

No, the subtitle was born in Naples for the announcement card. You see how important that was.

On the back of the invitation card to your exhibition of *Arena* in Naples in 1972, it clearly says, "The Cycle of the Work of Joseph Beuys, second exhibition, June 15, 1972."

These phrases were never used again.

That was the end?

We did two other shows, *Terremoto in Palazzo* (1981) and *Palazzo Regale* (1985), but we never referred again to the word *cycle* as we had for the first two exhibitions.

Arena's images were produced between 1949 and 1971. I wonder if there is a connection between the dates of the photographs in *Arena* and the dates of the cycle announced on the occasion of your first Beuys exhibition, 1946–71.

***Arena* is a collection of most of Beuys's works.**

But you don't think it was a cycle?

It's not a cycle, it's a life. That's different.

Arena is the result of a life cycle.

Who suggested that *Arena* be the work for this second exhibition at your gallery?

Nobody suggested it.

After the first exhibition, I visited Beuys almost every week.

In Düsseldorf?

Yes. We were very, very close at the time. I kept asking him to give me more works, more works, and he always said, "No, I don't have anything, I'm sorry." But one day he said, "I could give you a work but I don't know if you can pay." I said, "Show it to me." So he brought out a little box—which he opened to show me some overpainted photographs. It was like finding a stream full of jewels. It was wonderful. I couldn't believe my eyes—he had always claimed, "I have nothing." Then he said, "I have to construct a special form for it. Are you interested?" "Yes, how much is it?" He gave me the price and I said, "My God!" because it was quite high. Then I said, "If you give me time to pay," He said, "Oh, you have time."

Did you know it had been exhibited in Edinburgh?

He did say that he had shown it in Edinburgh. But now, the photographs were lying in a wooden box and without frames. This is a clear sign that he didn't want them treated like drawings. He had already planned it. He only wanted to find the right destination; he gave me responsibility for the work.

He chose this for the second exhibition and singled it out then?

Yes, because I had said that we had to continue the cycle, and asked for the second part.

When we were talking about the invitation card with its two drawn shapes I wanted to ask you about the circle. Do you think that there's a connection between his ideal circular installation, the name *Arena*, and the image of the arena in Verona that appears in *Arena*?

Verona itself has nothing to do with it. *Arena* is an arena anywhere. It suggests strongly the idea of the fight between the human being and the animal, as in a Roman arena. Lions against gladiators, the idea of the victory of humans over bestiality.

The strange thing about this photograph of the Verona arena is that it looks like it's a postcard—it's very different from the other images. Unfortunately, it's framed so we can't look at the back of it, but it looks like a postcard.

It's either an old postcard or a printed page.

Which means that it may have been a postcard that Beuys picked up in 1969 when he was briefly in Italy and got other postcards.

40

He was collecting old images of Italy for forty years. But he didn't collect photographs, he collected souvenirs of the streets. That's different. It was not a collection of photographs, but a collection of notes on his trips. Picking up things like photographs was the same as making a drawing, as Goethe had done. Also, later on when he was back in Germany if he found a magazine with old photographs of Naples, he would cut them out.

I think what you said about antiquity needs more comment, though. Someone wrote that *Arena*'s dimensions were taken from the Pantheon in Rome. Did Beuys talk with you about this?

I think it's a charming idea but one without any foundation. I never heard Beuys say anything like that. There are no fixed dimensions for *Arena*; it's a mistake to speak about dimensions. You can show *Arena* in this room in this apartment in which we're sitting. I was surprised, too, when Beuys installed the show at the Guggenheim Museum in 1979. *Arena* was stacked on the floor against the wall in three piles. There are two sketches by Beuys explaining the form *Arena* could take. He said, "The ideal form would be the circular one, but it can also be rectangular." And, in fact, it was shown as a rectangle in Naples.

And at the "Contemporanea" show in Rome in 1973.

That was a kind of square space. In Naples it was more irregular, with different-sized spaces between the frames.

We didn't want to take part in "Contemporanea." Beuys said that he would give permission to lend the work only if the frames in *Arena* were hung with space between them larger than the frames themselves. In the end this was not respected, but he went to Rome anyway.

Was it your decision to lean the works up against the wall in Naples?

No, the space necessitated it. Every time Beuys made a show in Naples, he invented a form relating to the space. *Arena* can also be a square. The square is the world. That's why on the announcement card the word *Arena*—the idea of the spirit—is placed in between the two diagrams, the circle and the rectangle. Do you know what I mean? The spirit of *Arena* is in the title but not necessarily in the installation.

But there's another thing about *Arena*—*Arena* is the mother, *Arena* is the vagina, *Arena* is the place where everything comes from. There is one panel in which the mother is represented. Only the mother.

Returning to the installation of *Arena* in your gallery, did the stacks of panels have a relationship to Beuys's aesthetic, to his interest in the process of accumulating and storing energy?

Of course it did. If you put energy in one frame and then you put twenty frames together, you make a big battery.

What about the sculpture in the center of *Arena*?

It's the same concept.

Did you get the wax for it in Naples?

No. Everything came from Düsseldorf, including the copper plates. It's not simply masculine versus feminine, it makes more sense to consider wax as energy and copper as the transmitter of energy, as the conductor. That's why, for the action *Vitex agnus castus*, Beuys gripped the copper, not the wax. Beuys was very, very interested in the idea of woman, in the sex of woman, which he represented obsessively in many, many drawings. I don't want to go too far in speaking about feminine or masculine attributes of wax, but it is the result of a harmony amongst the bees, who are under the power of the queen. This is original beeswax. It has not been treated.

I believe you said in an article, dated 1974, that the sculpture is the fulcrum of *Arena*, it is the symbol of the primary force of vital energy.

I didn't say that. That's what Beuys told the world. Beuys used to say: "I emanate" (*Ich strahle aus*). This is, again, the idea of the Son of the Sun, of the artist who radiates, or emanates, like a battery or the sun. The idea of "ich strahle aus" means "I feed myself by wasting or dissipating energy." In Naples, he said—in two languages, Italian and German—"I feed myself by spending energy."

How did the audience react to your exhibition of *Arena* in Naples?

In the same way everyone does who goes to see something that he doesn't understand. There were only a few spectators.

Was there more interest in the action Vitex agnus castus than in Arena itself?

The action was, of course, very important because it was the last action that Beuys did in Europe using his body. Later, in Rome, he did *Anacharsis Cloots*, but in that piece he was walking and speaking, using his mind more than his body. It was *acting* more than *action*. In Naples he was the body traversed by energy. This was his last action proper, aside from the coyote piece, *I Like America and America Likes Me*, which he did in 1974.

Were the blocks of wax and metal around which the *Vitex agnus castus* action was performed present in Edinburgh?

I doubt it.

Is it true that you didn't even know that *Vitex agnus castus* was going to happen? It's been said that in fact Beuys asked you for the oil can only on the morning of . . .

No, the oil can was always part of the work.

Did he bring it with him to Naples?

Yes. But nobody knew he would do something. Just four hours before the opening he said: "If you find me plants like this" (he made the drawing), "I may make something." So we ran around, but the plant was very difficult to find since the botanical garden was closed. Finally, we got it by crawling over a wall! During *Vitex agnus castus*, he wound the plant around his head like a bacchic crown. *Vitex*, which is the wine, is Dionysus; it means being drunk and losing control. So does *agnus castus*, which is Jesus. Jesus Christ was also completely possessed. There is a very strange parallel between *terremoto*—a continual earthquake in the mind—and these ideas coming from Beuys. In the beginning of the action he moved very calmly, rubbing both pieces of the copper. Soon, this rubbing of the element did not just produce friction, it induced a frenzy. At the end, his whole body trembled, as in a Dionysian frenzy. Charged with suffering. By chance, my friend, the artist Nino Longobardi, was there with a camera. Otherwise, we wouldn't have any documentation. The movie is good because it's in real time. When you look at the film, pay attention to the kind of movement going through his whole body.

It's a vibration, especially in the leaves, but his feet too are trembling.

It's an orgiastic situation. His movements are growing more energetic.

Do you think then that the Dionysian is an element of *Vitex agnus castus*?

Absolutely, because under its influence the person is invaded by the mystery.

How long did the action continue?

For almost three hours. He was very exhausted afterwards because of the tension from putting his hand in constant motion like that. Only one hand was used. The yellow writing on the blue band is in sulphur.

So the three monochrome panels in *Arena* are connected in some way to the processes of *Vitex agnus castus*. Those are the same two colors as in the panels.

Maybe the blue—the Madonna is always shown in blue—is the blue of sanctity.

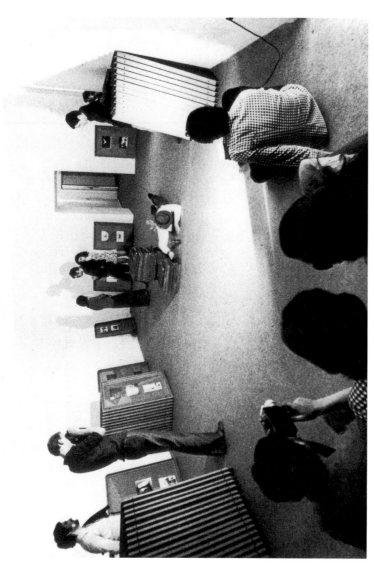

Vitex agnus castus, Modern Art Agency, Naples (June 15, 1972).

Of sanctification?

Yes. Of sanctification. The blue is the appearance of gold trans-formed in an alchemical idea.

What about the oil can, immediately in front of him on the ground?

He didn't use it.

Didn't he pour oil

over the sculpture?

Yes, but before the action began, not during the action.

Would you say that in some way he

anointed himself?

It's a ceremony in a way similar to that conducted by a priest. But the action is not part of Arena, it is something Beuys did for Arena. Arena was shown in other situations, such as in Milan, without any actions, although Beuys was there at the opening.

But there was an action at Galleria L'Attico in Rome on

October 30, 1972.

The owner of the gallery agreed to show Arena if Beuys made a performance for him, because by that time he was famous for his performances. However, this gallerist didn't say "action," he said "performance." Beuys hated the idea of performing. Performance has to do with theater; action has to do with being alive. There is a big difference. Action is not performance. Performance is something you have written for the theater and then you perform. Actions came out of Beuys's body. I responded that I could not ask Beuys to make an action. But in the meantime, unbeknownst to me, Beuys was preparing an action. For the journey from Naples to Rome, he dressed in a Swiss Red Cross coat and, of course, a hat, and once there, he sat in the office of the gallery absorbed in a book. Then, without any warning, he said, "Do you have a tape recorder?"—which he later used in the action. By chance, there was also somebody there with a movie camera. So Beuys began reading the story about Anacharsis Cloots. He looked straight ahead while walking back and forth. "Look at this charlatan," people said. "This is just a theatrical thing." Nobody understood. Not even me, because I didn't know what he was reading.

What was

he reading?

He was reading the life of Anacharsis Cloots, an eighteenth-century revolutionary who was guillo-tined in the French Revolution. This man was born in the same city as Beuys, in Kleve. That's why Beuys identified with him. When he was on the steps of the guillotine, Anacharsis Cloots said to the execu-tioner, "Watch this head, you rarely see a head like this." And then Cloots made three greetings, first bowing forward, then to one side and then to the other. That's what Beuys did too. That was the action. Afterwards Beuys explained the story of Anacharsis Cloots to me, and that he had brought the book to Rome to make this action.

Do you think Rome meant something to Beuys?

I don't think Rome was particularly interesting to him. He was not as excited by it as by Naples. He came to Rome because we wanted to show Arena there, and afterwards, in Milan. And, finally, once again in Rome, in "Contemporanea." At the Studio Marconi in Milan and in "Contemporanea," there was no action.

Wasn't the Arena installation you and Beuys made for "Contemporanea" the first time that the work was installed on the wall? And is that sequence of images the one that should be followed if one wants to reinstall Arena today?

I always did the installation. Beuys would come later.

So was

Arena a shell, which Beuys wanted to use as an action site?

Not at all. It's as if Beuys made a piano, a very large beautiful piano, and sometimes, just to give an example of how good the piano was, he played it. But everybody can play this piano: the piano is just there. Similarly, everybody can move inside Arena. Beuys twice played this sonata to underline Arena, but he never considered it a container for his actions. It was a photographic piece, with symbolic images of the mother and other signs of his own work. And, because everything is so mixed up in it, it becomes an allusion to his work, not a pedagogical way to see his work. These photographs in Arena are completely mysterious. They don't explain anything. There is nothing to explain. One only feels. Sometimes artists mislead, because every elucidation destroys the

work. *Arena* is the best way to hide Beuys's meaning—in the sense of "Forget it, put it in a tomb and make it impossible for anybody to look at it by revealing it only a little at a time."

Arena in the book *Tracce in Italia* that has the words "Plaza de Toros," or bullring, written on it. You have been speaking about the piece as being a battlefield. What do you think he meant by writing that?

There is a drawing relating to

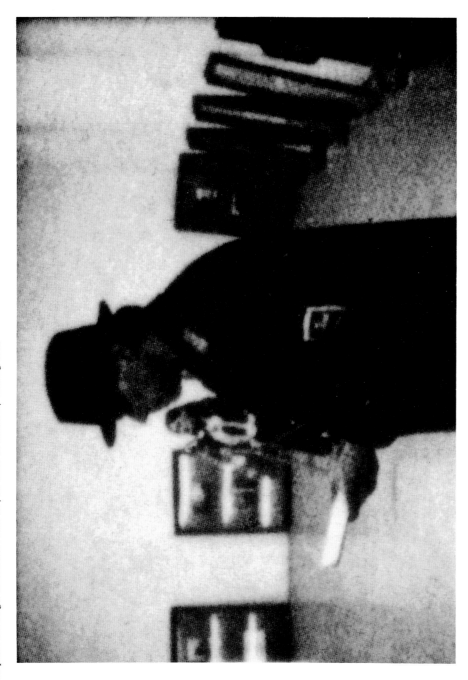

He meant the battle of the human being, of the hero or the artist, with the beast. The beast is stupidity, opposed to spirit, against the evolution of mental processes; it is mediocrity and jealousy, evil. But yet maybe Beuys also saw himself as the beast, since he wrote, "where would I have got if I had been intelligent!" Who is the beast? The roles are counterpointed—the coyote and Beuys, Beuys and the coyote.

What was the Plaza de Toros? Is it here in Naples?

We don't have corridas here, thank God. But remember, Picasso painted bulls and bullfights. It's exactly the same. The fascination with a victory that is risky, from which a human being can die, or does not always win. That's the fascination of the arena in general.

I want to return to the monochrome glass panels in *Arena*. They are the only colored elements.

I imagine that, once again, they have much to do with Rimbaud, though this is the first time I've thought about it. But also, in the alchemic process, when producing gold, the first stage is the burning—black—then comes the calcification—white. The third moment is red, which is the moment of the possibility of gold. If the process isn't successful, then it results in blue. Then you have to start again.

Do you think that alchemical processes play an important part in the theme of *Arena*?

Certainly. Consider the use of sulphur, acid, wax. The changing of states, including temperatures, is not only physical, it's also alchemical. Beuys explained it all in a contemporary way. It's not poetic, as it is with Rimbaud, it's more tough, more direct. By the way, it's handmade glass. That's important.

How do you know?

Because I know how expensive and difficult it is to replace if it is broken. But why did Beuys want handmade glass when there are already so many

beautiful colors of glass? Because he wanted to go through an alchemical process; he wanted to have sheets of glass made by hand, using an antique alchemical process. That's why he didn't want industrial glass. But, this is already the beginning of an interpretation, a process, which I'm against.

That's very interesting.

Also, they are filters.

What do you mean?

I mean, if you put these sheets of glass in front of some of the other panels—as Beuys and I did for years, you see the photographs through the colored surfaces as in a filter. Felt is a filter of energy. These colored glasses are filters of light. It makes it more difficult visually, but it introduces a moment of happiness. You can put them in any order. It's a way of playing with the forms.

They themselves become transformers.

It's "eine Pause im Schmerz"—a pause in the pain. There is a moment when you're really suffering looking at Arena because . . . do you know the Schmerzraum (Pain Room)? It's a fantastic assemblage Beuys made in Düsseldorf. The whole room was covered with lead and there was only one light down its whole length, a circular, silver light. Arena, too, is a "Pain Room."

In what sense?

In the sense that it's a place that embodies the pain of the artist.

Think of the earlier exhibition for Galerie Schellmann und Klüser "zeige deine Wunde" ("Show Your Wound"), of 1976. Do you understand the connection?

No.

In Arena, the artist allows colored panels to be pauses in this pain.

I'm overcome—it makes a lot of sense to me. It's so obvious, but everyone tries to make those panels into something else.

No, they're just beautiful. At a certain moment, when everything looks gray, it becomes suddenly blue. It's just a pause. You have looked at so much, you have absorbed so much suffering from these panels and now you rest a little, and are happy for a while, then you continue. The mourning is still in the sector waiting for you.

The lead Pain Room seems to relate to Arena's incredibly heavy aluminum frames.

One feels their weight.

Do you think Beuys deliberately intended those frames to be so heavy compared with the lightness of the photographs?

Don't tell me! For years we had to move them.

The frames can't be opened very easily,

The pain is intense, bad. . . .

And they're bolted together.

It would not be credible

otherwise they would have been too heavy to move at all.

Yes, although Beuys used aluminum, because if they were very light. They must be dramatic. They must be strong; you have to be able to hide behind Arena. They cannot be destroyed by the first wind. It's a tank, don't forget.

which makes sense if they are a sort of defense mechanism, like a tank.

Beuys numbered the frames 1 through 100. Actually, I know from a June 1972 invoice issued by the framer that when Beuys ordered these hundred frames for Arena, which at that time was called Aktion Neapel (Action Naples), he also ordered ten additional ones. Do you know if the intended to use those frames?

He also ordered more glass of the same color. Do you know if the number 100 meant anything to him? Why a hundred frames? Why not ninety? Why not eighty?

Numbers are numbers.

It gave him the possibility of adding, eventually, if he chose to. He said, "I may have something, maybe . . . perhaps I will add some more panels."

He arrived with his suitcase and then he put everything together. Arena was assembled in Naples. There's a photograph of him putting the images together on a table and then his assistant would glue

them down and bolt the frames shut.

So he actually completely recomposed Arena *after Edinburgh.*

Not recomposed, composed. I don't think there was a composition in Edinburgh.

Did he think of adding other photographs to those one hundred frames or to the additional ten?

I'm not sure. I can't answer that question.

Do you think that Beuys considered the work to be incomplete in Naples in 1972, and did it remain incomplete?

No. It has nothing to do with incompletion. It was thought of as an open work. That's different. I would say that it's complete in the form that Beuys conceived it. Certainly, it was incomplete in Edinburgh, but now it's quite complete. That Beuys said he might add something doesn't mean it was incomplete.

Is there a relationship between this process of permitting a possible extension to the piece, and, say, the way Beuys wanted to be able to add things to the collection of sculpture, drawings, and the vitrines he installed in the museum in Darmstadt, beginning in 1970?

Yes, it's the same idea. If he made a collection of objects, he would say, "I may give you more things to make it wider."

When and how did the Dia Art Foundation in New York acquire Arena?

When Heiner Friedrich, former director of Dia, first contacted me, I was against the sale. I spoke with Beuys, although the piece was already mine because I had paid for it. I asked Beuys what he thought—since I did not particularly want to sell the piece right then as I was very attached to it. He said, "Oh, come on, sell it, sell it," because he was obsessed with placing his large works in museums or places where they would never move. I always respected his will, so we decided to sell it. That was in 1974.

Was Dia the first institution in the United States to show a serious interest in Beuys's work, as far as you know?

No, because by 1974 Beuys already had done an exhibition in the form of lectures.

Where?

In New York, Minneapolis, and Chicago. Beuys spoke in front of students for hours.

Did Beuys intend to make more panels in the United States, or perhaps to rework the existing ones there after it had been sold?

I don't think so. Actually Beuys never spoke of Arena **again after it was finally sold in 1976.**

Do you know whether Beuys had a specific order in mind when he installed Arena *in Naples?*

Although there are numbers from one to one hundred engraved on the panels, we never took any notice of them. We never considered any specific order.

Do you think Beuys put those numbers on the frames?

I think Beuys wanted these numbers because in the beginning he had an idea of a more ordered Arena. **Then he changed his mind, and** Arena **became an open-ended installation, so he completely forgot the numbers. Later, nobody really cared about the numbers, because we were more interested in putting it together like a musical composition. This blue could be the trumpet that announces victory and—who knows—the yellow may be a reference to God. In alchemy, the appearance of gold is often taken as a symbol of the achievement of God's vision.**

And this one "golden" panel in Arena *could perhaps be interpreted. . . .*

It's not gold, it's an allusion to gold. Maybe it's just a filter. There are different conceptual layers. They work like parts in a musical symphony.

Is it important that we recognize and interpret the different images in the panels?

They are fragments of stages in an alchemical process. This panel looks like it contains details from an alchemist's studio. What you recognize is less important than the realization that they are photographs of someone obsessed with transforming things.

tion from life.

Did Beuys ever come up to you during the various phases in which Arena was being installed, assembled, or leaning against the gallery walls and point out a photograph and discuss it with you?

As a beautiful composi-

But when you find a group of photographs like these, dating from 1960 to 1971, juxtaposed in a single frame, how do you think they are to be understood?

Yes, he did, occasionally, laughing, as when looking at the photograph of der Unbesiegbare (The Unconquerable), 1963, for instance.

Why was that an important image to him?

It has a lot to do with batteries, I guess, but his attention was more focused on trying to invent a machine to condense this energy and save it.

In a certain sense, then, Arena is this machine that condenses energy?

Exactly.

Do you think that Arena has a connection in this regard to the postcard celebrating the invention of another energy-catching device, the steam engine? As we discussed, the caption "the inventor of the steam engine" is written on the postcard depicting Christ, signed "Joseph Beuys."

Every image in Arena is autobiographical, which means Arena is an autobiography; every image is a step or trace in a long trip, which was his life, a long trip.

Do you have an idea about who this inventor might have been?

Every inventor is a creator. Every inventor is a God, and Beuys identified himself with the Creator, with the Savior. And with Leonardo, if you want. Leonardo surpasses the idea of art to do research on humanity. He was not only interested in making paintings but in looking everywhere, in every direction, in order to understand reality.

Did Beuys ever talk about Leonardo with you?

Actually he did, because Beuys's drawings after the Leonardo Codices in Madrid were started in Capri in 1974. The first drawing in this group was of the mount where the Villa Jovis, the Villa of Tiberius, is. One day, we were supposed to make a motorboat trip, but the engine broke down. While we were sitting in the sun, Beuys started the Leonardo suite. I remember him saying, "I have to learn again how to draw," because for years he didn't draw.

I wanted to ask you about the possible connection between Arena and another block of drawings that Beuys did, namely The secret block for a secret person in Ireland (1974).

One piece from it, *Dead Man*, is reproduced in *Arena*. Do you think that *Arena* has a connection to *The secret block*?

Only in that it was done by Beuys. *Arena* has more of a tomb character. The drawings of *The secret block* involved looking inside himself. It was more the painting side of Leonardo, whereas *Arena* was the Leonardo who made weapons. In different ways, they are both incredible energy accumulators. Leonardo was a poet, he made weapons, he made airplanes, he was a complete artist, he was trying to make people free in every way; that's what interested Beuys. In a way, Leonardo had the same approach to art that Beuys had, and then there is his incredible draughtsmanship. But there are also other reasons, more mysterious ones. There were other artists, too. Lehmbruck is a very important formal reference, especially for the drawings. But also for the idea of a new spiritualism in a modern style.

So do you think *Arena*'s theme is related to Beuys's 1969 action, *Ich versuche dich freizulassen (machen)* (*I attempt to set [make] you free*)?

Yes. The idea of freedom was crucial to him, but this sentence is not by Leonardo, it's by Christ because Christ was the first one to tell people, "I will make you free." Beuys used the found object, the postcard he found in Naples in 1971, to speak about Jesus Christ, to express his interest in science and to warn of science's betrayal of people, saying you have to go back to the idea of Christ, and that everything goes through love. *Liebe* equals *Kreativität* equals *Freiheit* (love equals creativity equals freedom). *Arena* is the most comprehensive work in his oeuvre up until 1972. It was kind of a summa, as if to say, "Okay, I did this, and now, how do we start?" In fact, *Arena* came into existence in 1972, the same year he launched the Organization for Direct Democracy at Documenta.

Not only the same year, but the same month, June, just a few days before.

In that Documenta, he projected another image of himself: "I have nothing to do with art, now I'm here and I speak with you." It's a political cause, for democracy, for popular self-definition.

Could we talk about the third step in the strategy that you developed with Beuys? It was nine years after your installation of *Arena* before you did another show with Beuys. What happened in the interim?

He now wanted to work throughout Italy. He was very involved with making multiples. For instance, there are two multiples from the action *Vitex agnus castus*. One, called *Vitex agnus castus*, is just an image of the plain blue band. The other one, taken from the movie, shows Beuys lying down. But he wanted the edition done so that it seems like he was flying.

Yes, it's called *Levitazione in Italia* (*Levitation in Italy*).

In Italian, *levitazione* means that the thought has already ascended to the sky. He made that multiple in 1978—six years after the action, so the ideas presented in *Vitex agnus castus* continued to be important to him.

I think that the edition *Levitation in Italy* came out on the occasion of the show we made in Naples at the Museo Diego Aragona Pignatelli Cortes, "Tracce in Italia." At that time, the idea of the action was changed into an ascent to the sky. Before that, in 1974, Beuys had expressed his wish to see Foggia again. He always said, "The people in Foggia are just great," so the first edition we made after the 1971 poster, *We are the Revolution*, was *The People are Just Great in Foggia*, in 1974.

It's a rather strange book. As I recall, it's comprised of blank pieces of gray paper . . .

It's like *Arena*. Fragments of his writings have been put together to make *Arena* in a book form. It cost a fortune to do this wonderful, very precious edition. After *Arena*, he came to Capri every year. In 1974, we went to Foggia and to Manfredonia to look at the places he had visited when he was young. I never saw him so touched. Once, when we were at Manfredonia, Beuys said, "I want to look for the place where, as soldiers, we shot at the rocks with new guns. It must be here, it must be here." We were in the middle of a forest, a wild forest, wandering around, almost lost, for hours. He was more and more disappointed at being unable to find the site. Finally we found an old countryman, whom I asked if he remembered German soldiers shooting somewhere nearby. He looked so sad and said, "Yes, I remember. I still hear those sounds. It must be here, by these rocks." And Beuys said, "Yes, these are the rocks that we were shooting at. I see the signs still

"on the rocks." He was now ecstatic, almost crying. We all were very touched because he was *à la recherche du temps perdu*. Then he spied something on the ground, and picked up a piece of ceramic which was almost certainly ancient. That made him very happy. During that trip he was very prolific, making many pieces.

When Beuys met you in 1971 do you think he was attracted to your previous socialist stance?

Yes, of course, because we supported the same ideas of social progress. I wasn't a Communist any longer. My ideas paralleled his belief that in an anarchic world every human being tries to organize himself and his life.

We were, in a way, anticipating a situation that is more clear to-day—the political parties are over and now you have to speak about larger movements that involve people in a wider way. He antici-pated this. This was one point of connection. But the principal thing I had in common with him was a love for Naples. That was the most important thing. I was the anarchic Naples, the city where people learn to manage themselves with-out any form of representation. No rules. You invent the rules day by day. Beuys loved this idea of free-dom, plus the idea of the sun, the song, the music. Naples was the golden future for him. Naples rep-resented what he expressed at the end of his life, which was that *Palazzo Regale* is the golden fu-

Terremoto in Palazzo, Modern Art Agency, Naples (1981).

ture. Gold was a key idea, especially in this last piece. In *Palazzo Regale*, the frames, the vitrines, everything, is painted in real gold, gold that has been dissolved in solution. We still have the container and the brush. This is, as I say, a hypothesis.

Baudelaire said that genius didn't consist in the power of invention but in the capacity of receiving, and that the artist was nothing more than a translator, a decipherer. This is very interesting if you think of all the work by Beuys concerned with the receiver and the transmitter. It's not by chance that Rimbaud was inspired by Baudelaire. His ideas of deciphering, or translating, of the reception of some-thing from another situation were important. He argued that the real poets would be angels, messengers, the emissaries of God.

Do you think that Beuys regarded himself as having not only a martyr's role but also one of a prophet, a prophet who transformed an idea into a message?

Into golden messages. Saint Martin, the philoso-pher of occultism, conceived of a golden age in the future. "Golden Age of the Future" would be a perfect title for *Palazzo Regale*. So you see how all these alchemic ideas come back in different persons. *Palazzo Regale* is the conclusion of all the attempts to arrive at the gold.

And how are the elements in the accompany-ing vitrines to be understood? In one vitrine, Beuys represents himself through his selection of certain objects: a fur coat, cymbals, a conch shell, and the head of the monument of Kleve.

Whose head is that, by the way?

This head was part of the *Tramstop*, installed at the Thirty-seventh Venice Biennale in 1976. It was derived from a childhood memory of a monument in Kleve where Beuys was born. The cymbals are in one way the noise from *Titus/Iphigenie*, and in another, the sound of his speech in Naples. He bought a shell in Capri in 1972, and used it at the Art Academy to call the students to protest the *numerus clausus* in the university admission system in Germany, which restricted the num-ber of students admitted to any class. In this vitrine, Beuys is the silent king, a sovereign. In the second

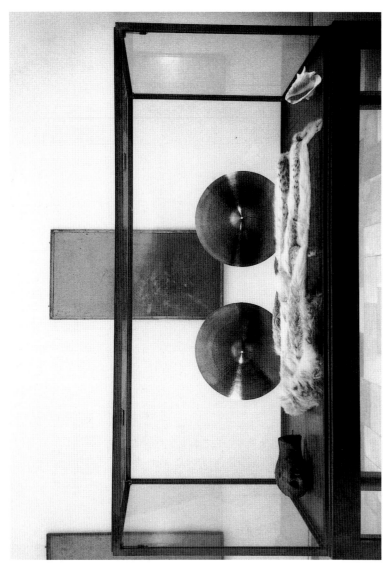

Palazzo Regale (1985).

vitrine there is a representation of himself as a poor trapper, the wanderer with a rucksack and a copper element, the staff or cane. It recalls the body of a shepherd found recently in the mountains. Did you hear about that?

The glacier man?

That guy was also a magician. Beuys would have loved these ideas because he loved the idea of glaciers. He was very much interested in glaciers, in the idea of the glacier as a thermal sculpture.

Could we recapitulate the strategy that you first formulated with Beuys in 1971, and that Beuys wrote down in the form of a *Partitur?*

On the first announcement to his exhibition in 1971, it says, "Joseph Beuys will discuss his political concepts concerning the transformation of European society." At that moment European art was suppressed by the enormous marketing power of North America, because the U.S. not only had very good artists, but also an incredible marketing structure. It was able to send artworks out like Coca-Cola. The museums in West Germany were full of Pop Art. But European artists weren't recognized in the United States. We needed to establish a balance between the two cultures. It was an artistic problem. In the kitchen at Capri in 1971, we established a strategy for changing the idea of art, for arriving at social sculpture. That strategy had long been in the mind of Beuys, although in a mysterious way. He had been waiting for the right moment, and the right moment was now, there on Capri, "the island of sleep," as he called it. The first step was to show the classical work he had done in the fearful days after the war, the drawings that would

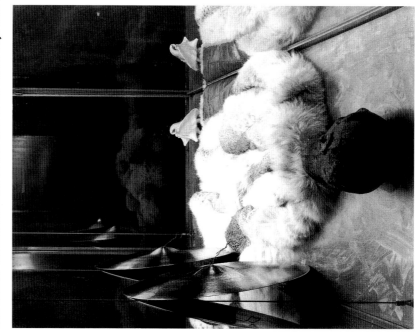

Palazzo Regale (1985).

foreshadow the later work. But because it was not to be a retrospective strategy, this exhibition also had to have a contemporary component. Drawings, objects, film, video, and speaking were all part of this presentation. That first step, then, was the preaching of creativity, of art as freedom, like creativity.

The second step was *Arena*, *Arena* as a tomb, as a mysterious container of all the artist's ideas, the battlefield, the weapon by which the artist invests dignity into every human being, the role of the artist as the catalyst of the creativity in every human being.

The third phase was a reinforcement of the previous two: *Terremoto in Palazzo*. During the intervening nine years of very intensive work we had seen each

50

other every two weeks. To make *Terremoto in Palazzo*, Beuys stayed in Naples for fifteen days. Every day we would travel around to find the objects that were used in the work. The show *Terremoto in Palazzo* was partly done by leaving the objects where the shippers had placed them. Beuys didn't move anything. They had done it perfectly. One day during the installation, I went out because I wanted to buy a little bread, I was hungry. When I came back Beuys said, "You missed the best part of it. You missed the best action of *Terremoto in Palazzo*." He had made a glass tower and it had suddenly started shaking, then it fell and broke. So it was a process. Every installation was a process by which he arrived at the form for the exhibition.

The fourth step was both the conclusion and the hope of victory—the golden future. Every man is a sovereign, an artist, and a child. Each has the power to direct his own life. This is why the artist could rest now, with all his symbols of power, the cymbals of 1969, the shell of 1972. If *Terremoto in Palazzo* was the moment of shaking people awake, *Palazzo Regale* was the conclusion, the final celebration. It's not a *missa solemnis*, it's a *te deum*, a song celebrating the victory of the human being become sovereign. *Arena*, *Terremoto in Palazzo*, and *Palazzo Regale* are columns, very important columns in the architecture of Beuys's oeuvre, which is a very large structure. Of course, there are also the drawings of *The secret block*, which is another column. . . .

Arena and *Palazzo Regale* were both born in Naples. They are two sides of the same idea. *Arena* is the consciousness of the role of the hero, the artist-hero, and in *Palazzo Regale* he can die, but like a king, like Tutankhamen. We made the strategy in 1971 but we never spoke about it. In art you don't speak about a plan, you do it. You can't preplan everything. We were in the water and we were swimming.

September 14, 1992. Naples.

51

[Beuys] didn't want to feel that his secrets could be torn

from him and brought to light. He didn't want that from the

silence belonging to him; speech should be made; and photography is speech.

—Ute Klophaus

Arena: The Chaos of the Unnamed
Christopher Phillips

Arena is at once the most and least accessible of Joseph Beuys's major installations. Carefully laid out in 100 panels framed in gray metal, its 264 photographs and photocopies seem at first to promise a summarizing, retrospective look at the artist's life and work from the early 1960s to the early 1970s. Many of the photographs are partly obscured by hand-applied overlays of fat, wax, sundry chemical compounds, or Beuys's trademark *Braunkreuz* paint; all of these substances occupy clearly defined places in Beuys's elaborate art theory, and their use underscores *Arena*'s links to his wider concerns. Even the initially puzzling presence of three monochrome panels—two in cobalt blue, one a brilliant yellow—can be quickly deciphered: here, in a play on Beuys's familiar allusions to the cultural encounter of East with West, the frozen North meets the expansive warmth of the South. Finally, the stacks of rectangular plates made of fat, wax, iron, and copper that complete the installation are easily recognized as a variant of Beuys's "battery" motif—a conglomeration of materials awaiting the kind of energy-charge that Beuys himself provided in the 1972 action *Vitex agnus castus*, in which he lay on the floor of Lucio Amelio's Naples gallery for three hours, patiently rubbing the copper plates with his oil-coated hand.

With all of these interpretive elements readily at hand, why insist on *Arena*'s difficulty? The first perplexities begin to arise when we realize that here, for virtually the only time in Beuys's career, photography provides him with the impetus and the material for a major work. It is tempting to try to understand this sprawling array of black-and-white images as part of the broad reassessment of photography by European and American artists in the 1960s and 1970s. But the more one considers *Arena*, the greater the distance that opens up between Beuys's use of photography and the practices of his contemporaries, such as Robert Rauschenberg, Andy Warhol, Michelangelo Pistoletto, Giuseppe Penone, Joseph Kosuth, or Christian Boltanski. For Beuys was not concerned with using photography as a component of some updated collage technique; or as a means to challenge the traditional hierarchy of artistic media; or as a vehicle for exploring the visual conventions of realism and abstraction; or as a way to acknowledge the growing incursion of the processes of mechanical reproduction into high art.

It proves surprisingly difficult, in fact, to say precisely what purpose Beuys's deployment of photographs in *Arena* serves. *Arena* has often been regarded as a documentary compilation or scrapbook presentation of images of the artist's activities in the 1960s and early 1970s. Yet even for those armed with an extensive knowledge of Beuys's life and oeuvre, the installation is likely to prove maddeningly opaque.

Scrutiny of the images themselves, which depict hundreds of Beuys's objects, installations, and actions, opens up a primary set of problems. One's first suspicion is that most of these prints are clumsy mishaps, mysteriously salvaged, perhaps, from the garbage pail of an amateur photography class. Many of the photographs seem to have resulted not from design but from a series of baffling accidents that have struck at every stage of the photographic process—in the camera (haphazard focus, framing, and exposure), in the darkroom (streaks, spots, and splotches produced by faulty chemical processing), and in the handling of the prints (tears, cuts, stains, and creases). Then one notices that these images have been organized in seemingly arbitrary groupings, and mounted in panels for which Beuys provided no fixed order of hanging. Devoid of identifying captions or textual gloss, *Arena* supplies scarcely a clue to the cumulative meaning of the disparate imagery that largely constitutes the installation. The puzzled viewer eventually realizes that the flood of commentary that Beuys lavished on many of his works, providing elaborate keys for their interpretation, has left *Arena* entirely untouched.

One way to begin thinking about *Arena* is as an instance of the extreme and enduring ambivalence that marked Beuys's relation to photography. On the one hand, Beuys wanted his art and his ideas to reach the widest possible audience; hence his attraction to photography as an unrivaled vehicle of visual propaganda. He obsessively commissioned and collected photographs of his works, his actions, and even his daily activities, reproducing them in multiples, posters, books, postcards, catalogues, and the pages of avant-garde magazines such as *Interfunktionen* and *Avalanche*. By the end of his life, he had amassed a photographic archive running to thousands of images.

On the other hand, given the fundamentally mystical terms in which Beuys conceived his work, one might suppose that there was a genuine wariness on his part in regard to photography. Beuys always insisted that the primary power of his art sprang not from its representational or symbolic qualities, but from his "sculptural" manipulation of physical substances that already had meaning in themselves. He described the resulting works as setting in motion a "constellation of energies" that would continue to radiate over time, as these substances aged and changed.[1] Given the absolutely central importance that Beuys ascribed to these material and temporal aspects of his work, one can imagine his hesitations vis-à-vis photography, a medium whose images not only stand at one remove from the physical world but also irrevocably fix the transformational flow of time.

Moreover, scattered throughout Beuys's interviews and pronouncements are unmistakable signs that he regarded not just photography but the human visual sense itself as part of the dangerously over-developed analytic (or "cold") side of modern life, the side to which he offered his work as a necessary "intuitive" complement. Beuys accorded to human vision an extremely problematic role in his aesthetic system. Within the complex series of oppositional qualities that form the basis of his "theory of sculpture"—variously expressed as chaos versus order, malleability versus fixity, the raw versus the formed, or warmth versus cold—Beuys situated the processes of visual perception near the cold, fixed pole. In so doing, he explicitly linked both human vision and its photographic extension to the analytic pole of human culture:

> . . . Sense perception, especially the retinal, or through the eye, is cool, distanced.
> One must add something, that means one must do something with the eye so
> that it can somehow grasp the warmth process. Because if one leaves the eye
> alone . . . it will cool and divide things, analyze them, like a photo apparatus. . . .[2]

Such notions led Beuys repeatedly to express his disdain for modernist art's emphasis on pure visuality. Yet if he repudiated the idea that, as he put it, "the visual arts are retinal, something that must be grasped by the eye,"[3] he likewise showed no enthusiasm for the kinds of conceptual art that sprang from Marcel Duchamp's earlier critique of retinality; indeed, Beuys testily dismissed Duchamp's ideas as "antediluvian."[4] His own conviction, rooted in an esoteric tradition, was that art's aim should be "sculpturally" to mold and set in motion energy forms lying beyond the thresholds of human perception. Only those whose senses have been deformed by the excesses of reason, Beuys argued, who are too narrowly "intelligent," could ignore the reality of these invisible forces animating life. (Hence the artist's oft-repeated rhetorical question, which furnishes *Arena*'s subtitle: *where would I have got if I had been intelligent!*)[5]

In rendering those esoteric forces visible, Beuys regarded drawing as his main artistic tool, an elementary and indispensable technique that provided him with a "basic source material from which I can draw again and again."[6] In his thousands of cryptic, shorthand drawings and diagrams, though, direct visual observation plays almost no role. As Beuys explained:

> . . . our eyes aren't really too attuned to picking up [these forces] anymore. What
> our eyes see are all these huge chunks of reality, not these invisible forms that are
> the only thing that tell us anything worth knowing about reality. We're trained to
> think only in terms of physical reality, surface appearances, in terms of the retinal
> image, in other words, that picks up everything like a camera. So if I can pick up
> other things with other organs of perception or cognition, then they are just as
> much a part of reality, and I feel that it's my true intention, my duty even, to
> follow this thing up. . . .[7]

Mistrusting photography as a kind of mechanical extension of the analytic eye, Beuys seems to have been haunted by profound doubts in regard to its possible use within his own work. Even if Beuys's suspicions of photography arose mainly as a corollary of the metaphysical system the artist forged for himself, they nonetheless help to account for the unusual fact that throughout his artistic career Beuys seldom used the camera himself. This mistrust also explains why photography's role in his artwork, in comparison to that of his contemporaries, remained so curiously tangential. According to Ute Klophaus, who for two decades was the photographer with whom Beuys worked most frequently, "he both used and refused photography." She observes that, while Beuys constantly commissioned and collected pictures of himself and his works, in the end "he despised photography like an opponent to which he felt superior."[8]

If *Arena* prompts us to consider this antagonistic relation, it is because here, for once, photography moves from the periphery to the center of a major Beuys installation. Rather than as a synoptic "life of the artist," or as a casual assortment of image-souvenirs, we might begin to imagine *Arena* as a product of Beuys's struggle with the paradoxes inherent in his long-standing entanglement with photography.

3

If photography played an unusually circumscribed role in the main body of Beuys's work and thought, this was not because of any lack of early involvement with the medium, or obliviousness to the expanded role it played in the visual arts of the postwar decades. Beginning in 1950, while still living in his native town of Kleve, in the lower Rhine region not far from the Dutch border, Beuys had frequent contact with a local press photographer, Fritz Getlinger, who through the early 1960s regularly photographed the artist and his works; these sessions were often commissioned by the van der Grinten brothers, Franz Joseph and Hans, Beuys's patrons and first major collectors. Through Getlinger (who was aware of the activities of Otto Steinert's "foto-form" group and the "Subjective Photography" exhibitions of the early 1950s), Beuys almost certainly became aware of the European revival of 1920s-style avant-garde photography; in fact, Getlinger and the van der Grintens exhibited their own experimental photographic works in a regional gallery in 1955.[9]

Getlinger's clean, crisp images seem rather dryly professional compared to the photographs that later appear in *Arena*. His photographs meticulously document Beuys's early sculptures, prints, and drawings, often moving in to isolate interpretative details of the sculptures. Getlinger also showed the young and extraordinarily photogenic artist posing in his studio or attending local art functions. Through his association with Getlinger, Beuys no doubt received a valuable lesson in the various ways that sculptural works can be translated into two-dimensional images. The experience seems in any case to have kindled Beuys's passion for accumulating photographs of himself and his work. That such images might serve as effective surrogates for the works themselves became clear late in 1961 when, at the time he sought a teaching post at the Düsseldorf Art Academy, Beuys asked Getlinger to prepare a portfolio of photographs of his work for presentation to the faculty committee. As Beuys himself acknowledged, this portfolio, presented in lieu of the actual works, played a crucial role in his winning the position.[10]

During his years in Kleve, Beuys seems never to have been tempted to undertake photographic work himself; this was the period when his production of drawings was at its most frenetic.[11] Yet he was sufficiently aware of the medium to encourage the van der Grinten brothers to add photographs to their varied and growing collection,

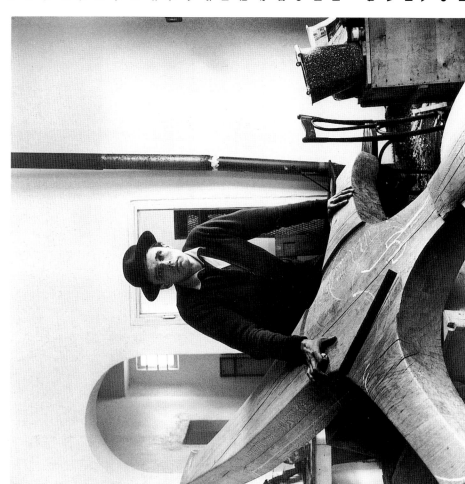

Beuys in Kleve Studio (1957).

offering them as the first example an image with an oblique autobiographical connection. According to the recollections of Franz Joseph van der Grinten,

How seriously Beuys took photography as an artistic medium can be seen in the fact that one day he told us that we must also collect photography; and he himself brought with him the first example for this branch of our collection. It was a photograph from the first World War, of the French front in 1914, on which his father had been involved.[12]

Over the years, in fact, Beuys appears to have given the van der Grintens thousands of photographs—historical and documentary images as well as a cross-section of images tracing the medium's aesthetic development from its beginnings.[13]

4

Such interests parallel the growing fascination with the photographic image evident among a whole generation of artists in Europe and America in the early 1960s. In the Rhine region, this development was doubtless spurred by the 1958 Dada retrospective at the Düsseldorf Kunsthalle, which provided many young artists with their first direct contact with the photomontages and photo-collages of George Grosz, John Heartfield, Raoul Hausmann, and Hannah Höch.[14] The rediscovery of such precedents very likely helped provide a rationale for the use of fragmentary photographic imagery in the early 1960s "décollage" or torn-poster work of Cologne artist Wolf Vostell and the Paris-based French Nouveaux Réalistes like Jacques de la Villéglé and Raymond Hains. With the advent of Pop Art and especially the photo-silkscreened canvases of Warhol and Rauschenberg, mass-media imagery and family snapshots took on a new appeal as artistic raw material: here were as yet "unaestheticized" sources of figurative imagery that could be played off the increasingly moribund abstraction of international Informel painting. Around 1962–63, Vostell and Gerhard Richter started assiduously to collect mass-media photographs, and Sigmar Polke first introduced into his paintings an enlarged dot-pattern, characteristic of halftone reproduction.

In Düsseldorf, a clear sign of the new strategic role assigned to the camera image within the visual arts was provided by the one-day exhibition that Richter mounted in December 1966 as part of an homage to the gallery owner Alfred Schmela. Richter wished ironically to indicate the distances that separate the twentieth century's three main realist media—painting, photography, and film—from one another and from the "reality" to which they all refer. To this end he "exhibited" in the Schmela gallery a local student and art-scene regular, Volker Bradke. Bradke was presented in person and was also represented in several distinct media: in an enlarged painted sketch hung bannerlike outside the gallery; in a painting based on a casual snapshot of the student; in Richter's own blurred photographs of Bradke eating, laughing, and making faces; and in a short 16mm film showing him in Richter's studio.[15]

Above and below:
Gerhard Richter's exhibition, "Volker Bradke" at
Galerie Schmela, Dusseldorf (1965).

5

This kind of nascent "critique of representation" found no equivalent in Beuys's work of the 1960s. Nevertheless Beuys was deeply involved with photography—not critically but pragmatically, as a medium with which to record the actions that he had begun to stage in the wake of his participation in Rhineregion Fluxus events in 1963. For his own contribution to the 1966 Schmela homage, Beuys presented one of his best-known actions, *MANRESA*, which explored a Christian thematic of spiritual transformation through allusions to the Spanish village, Manresa, where Ignatius Loyola changed himself from a soldier to a Catholic mystic.[16] A unique, single performance, the *MANRESA* action was documented by at least four photographers.

The increasing use of photography, film, and soon video to document intentionally ephemeral art posed a host of difficult questions. From the emergence of happenings, actions, and performances in the late 1950s and early 1960s, artists realized that the visual records of these activities would inevitably shape the subsequent historical record. Thus the participation of photographers and filmmakers was calculated from the start. A handful of photographers came to specialize in "action photography"—among them Harry Shunk in Paris, Peter Moore and Ugo Mulas in New York, Ludwig Hoffenreich in Vienna, and Reiner Ruthenbeck and Ute Klophaus in the Rhine region.

From the outset there were sharp disagreements over the visual form that photographic documentation ought to take and the ends that it should serve. Certainly the use of a "reproducible" medium like photography seemed to promise artists access to new circuits of distribution and reception, a way to reach beyond the confines of the art exhibition and its specialized audience. But "action photography" brought its own dilemmas as well. In the first place, a reliance on photographic documentation to preserve and convey evanescent works posed the threat of a kind of aesthetic regression, a reduction of purposely aleatory real-time works to a fixed, two-dimensional image. In addition, to insert such images into mass-media channels carried a second risk: that the specific artistic concerns informing performance work might be flattened out and rendered innocuous within the regime of the spectacle.[17]

Arena can be seen as part of Beuys's response to these dilemmas. Before examining the installation more closely, we might briefly consider two related examples of photography-as-documentation from the same period, those of the Viennese Actionists and the American happenings artist Allan Kaprow. Because of the extreme and sometimes bloody nature of the early Viennese actions by Hermann Nitsch, Günter Brus, Otto Muehl, and Rudolf Schwarzkogler, these events were often closed to the public. Hence much of what we know about them today is through the films and photographs made and circulated at the time, for example by Ludwig Hoffenreich, one of the chief photographers of the Vienna actions. The Vienna Actionists recognized early on that their reliance on photographic recording raised the danger of a relapse into a pictorial aesthetic they had supposedly abandoned. Schwarzkogler, in fact, did come eventually to work exclusively for the camera in privately staged actions, preparing detailed scripts and sketches, and halting his performance at predetermined points so that Hoffenreich could make photographs. Nitsch, who found this kind of mise-en-scène far too calculated, looked to an alternative visual model—that of the tabloid press photograph. "Actions," Nitsch said, "should be registered like a traffic accident, like some sensational event."[18] He explained:

Photography . . . is a means and not an end. We have attempted to instruct our photographers to document our Actions as objectively as possible. No "artistic" photography can serve our purpose; this would only falsify the content of our Actions.[19]

A similar preference for anonymous-looking, journalistic-style photographs is evident in Kaprow's massive compilation *Assemblage, Environments and Happenings* (1966), which depicted actions carried out around the world by artists including himself, Jim Dine, Rauschenberg, Vostell, and the Gutai group,

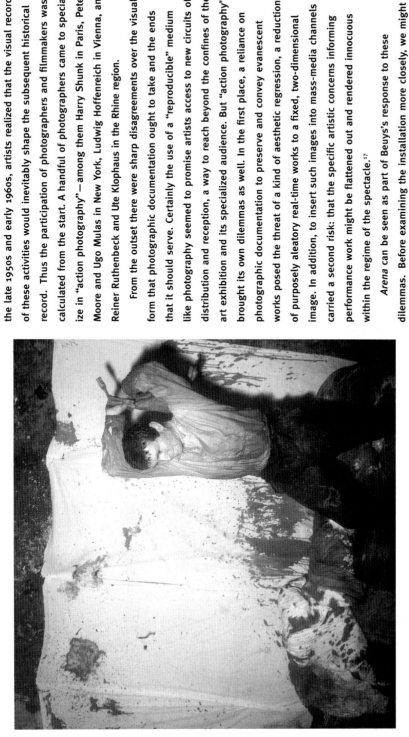

Hermann Nitsch, *Aktion*, Vienna (1963).

among others. In their clarity and objectivity, most of the photographs reflect the visual conventions of mainstream 1960s photojournalism. Sometimes there are single photographs of isolated moments, sometimes written scenarios accompany photographs of their performance, and in one instance a series of fifteen photographs follows the unfolding of Kaprow's *Push and Pull: A Furniture Comedy for Hans Hofmann*.

But if the photographs themselves are not visually out of the ordinary, Kaprow offered the reader a surprising and sophisticated proposal for turning to advantage the inherently partial and incomplete nature of them as records. He advised:

> [These photographs] refer to their models, but strangely, as would a movie taken of a dream, stopped at unexpected intervals. A movie of a dream cannot be the dream, and a frame, here and there pulled from it, must leave the viewer guessing even more. Yet guessing is dreaming too, and if we can never know another man's dream as he knows it, we can come close to the spirit of his activity by engaging in a similar process. Beyond art, sharing in a dream process is probably what we call reality.[20]

What Kaprow identified as the reverie-inducing power of the photograph was an element that Beuys also seems to have responded to. It was this elliptical quality, which Beuys came to emphasize in the 1960s, in the photographs that he commissioned not only of his actions but also of his objects and installations.

6

From the time of Beuys's first participation in Fluxus performances in Düsseldorf in 1962, his involvement with photography as a means of documentation was constant and complex. Many young German photographers were attracted to the Fluxus events and to the happenings staged by Vostell, not least because of their novelty, their chaotic atmosphere and their one-time, improvisational nature. Heinrich Riebesehl and Reiner Ruthenbeck, for example, photographed avant-garde events in the Rhine region in a way that reflected the "objective" standards of contemporary photojournalism, making series of predominantly sharp-focus images that highlighted the loose interplay between performers and audience/participants.[21]

Klophaus, the photographer whose images left the most decisive stamp on Beuys's photographic iconography, worked in a radically different manner. Klophaus, a young freelance photographer from Wuppertal who had studied in Cologne at the Staatliche Höhere Fachschule für Photographie, was led by her search for what she called "new perspectives" to attend the famous *24-Hour-Happening* at Wuppertal's Galerie Parnass in June 1965. The gallery, established in 1948 by the architect Rolf Jährling, had long been a leading regional showcase for the art of international figures such as Raoul Ubac, Alexander Calder, and Karel Appel. In 1962–63, Jährling presented work by Nam June Paik and other members of the Fluxus group, and by the Gruppe Neue Realisten (Sigmar Polke, Gerhard Richter, and Konrad Fischer-Lueg.)[22] A subsequent *24-Hour-Happening* was announced as a collection of simultaneous round-the-clock actions by Beuys, Paik, Vostell, Charlotte Moorman, Bazon Brock, and others. Although Klophaus knew virtually nothing at this point about Fluxus, happenings, or Beuys, she arrived on the scene as an observer, became caught up in the event and stayed to photograph it until its conclusion; the resulting images were prominently featured in the subsequent book that documented the event. Acknowledged by the artists as a collaborator, an "action-photographer," Klophaus decided to continue to photograph such Rhine-area Fluxus events.[23]

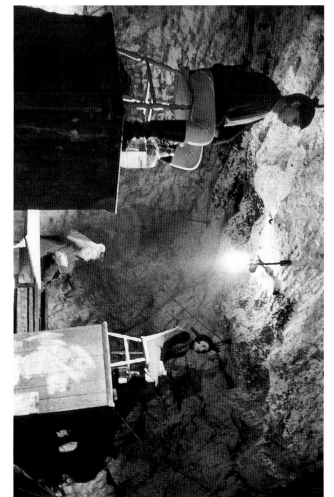

Allan Kaprow, *Eat* (1964).

She gradually became closely associated with Beuys, developing—no doubt with Beuys's encouragement—a highly idiosyncratic approach toward photographing his actions, installations, and sculptural objects. Although well-versed in the conventional techniques of photojournalism, Klophaus chose to court a wide range of photographic accidents in both her shooting and her darkroom work. Thus her photographs of Beuys's actions are characteristically marred by such "mistakes" as haphazard framing, over- and underexposure, misfocusing, streaks, spots, and scratches. The cumulative "look" of the images—technically flawed, often visually incoherent—nevertheless serves perfectly to evoke the cultlike, otherworldly atmosphere that surrounded Beuys's early actions.

Klophaus considered her procedures as means not so much to document as to enter into the spirit of the events she photographed. "One can only try to translate these experiences of the action artists," she wrote, "they can't really be reproduced. So I attempt to make sure the photograph doesn't have a 'final' air to it."[24] To this end, she often made several very different-looking prints from the same negative, some extremely dark, others very light. She went so far as "even consciously to make photos that appear in the eyes of other photographers to be almost garbage, or that really are garbage. That corresponds, though, to the aesthetic of the Fluxus people and the action-artists that I photographed."[25]

In a similar fashion she justified her habitual presentation of her photographs with hand-torn paper borders. Using language that echoes Beuys's remarks on his own frequent use of torn paper in his drawings, she explained:

> The torn borders are perhaps a kind of reference to the fact that what is being shown is only a moment that has been torn out of time. . . . Every object has two parts: what it is, and what it means. What is visible and what is invisible. The other half, the invisible, is elsewhere; and that leads one to look further in search of the other half."[26]

For all of Klophaus's attempts to fashion a photographic practice that reflected Beuys's aesthetic credo, Beuys seems never to have become

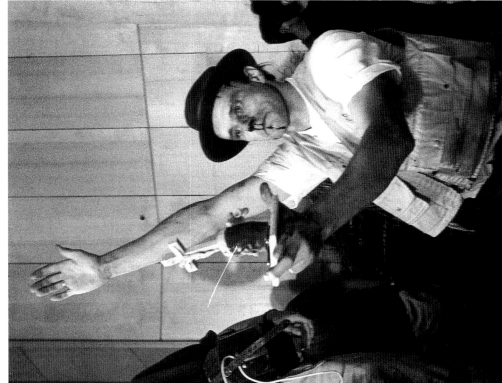

Beuys as a participant in the "Festival der neuen Kunst," Aachen (1964).

totally reconciled to her efforts, especially when they concerned the photographing of his actions. Certainly, as Ursula Peters has pointed out, Beuys wanted these ephemeral performances to have the widest possible reverberation; hence his steady solicitation of photographers, filmmakers, and videomakers for the images that filled his picture archive. But he must have felt the extent to which this recording activity ran counter to the aesthetic of transitoriness that gave meaning to the actions themselves. As one of Beuys's most perceptive early critics, Monsignore Otto Mauer, suggested in 1967, Beuys's actions are rooted in the attitudes of postwar Christian existentialism; they dramatize the search for fleeting signs of transcendence amid the terrifying succession of accidents, the flux-toward-death, that defines human life.[27] For Beuys, photography's freezing of this temporal flow can only have suggested a kind of premature closure, a deathly finality. Klophaus—again reflecting Beuys's own ideas—suggests the cycle of ambivalence in which Beuys was caught up:

> Photography fixed him, and at the same time provided him with the impulse always to change himself, to flee the fixing (pinning down).
>
> He didn't want to be pinned down, and he didn't want to let himself be pinned down. What he saw of himself in the pictures, he sought to go beyond, or he left it and he took other paths.
>
> He didn't want to let himself be caught. . . .
>
> He was alert, he tried to shake me off, took zigzag paths. At such moments I was for him the enemy. At such moments he never wanted to be photographed. . . .

By the late 1960s, Beuys came to make regular and increasingly sophisticated use of the images that he obtained from Klophaus and from many other photographers. In the multiples that he started to produce in the mid 1960s, he regularly incorporated photographs (actually offset reproductions of photographic images) of his works, his actions, and himself.[29] For example, the 1970 London exhibition catalogue *Three Towards Infinity: New Multiple Art* included two frequently reproduced Klophaus photographs of early Beuys actions—*How to Explain Pictures to a Dead Hare* (1965) and *DER CHEF/THE CHIEF* (1964)—along with a one-page artist's biography and a characteristically gnomic statement: "To be a teacher is my greatest work of art. The rest is a waste product, a demonstration."[30] Beuys designated the entire 4,000-copy edition of the catalogue a personal unsigned multiple.

Moreover, Beuys began increasingly to employ selective and surprisingly nuanced arrangements of photographs in catalogues and avant-garde magazines. As early as 1967 he gave prominent treatment to a number of single photographs by Klophaus and others in a Mönchengladbach catalogue that was itself produced as a limited-edition multiple.[31] By 1971, for the Moderna Museet catalogue *Joseph Beuys: Zeichnungen und Objekte 1937–1970 aus der Sammlung van der Grinten—Aktioner, Aktionen*, he supplied the black-and-white photographs for a lengthy opening picture section that presented, in roughly chronological order, sixty-eight images by eleven photographers depicting some twenty of his actions up to 1970. Most of the photographs are by Klophaus, carefully reproduced with the torn borders that had already become for her a kind of signature device. The images in the catalogue concentrate on the most dramatic individual moments in the Beuys iconography—the artist defiantly holding aloft a cross, as blood streams from his nose after an assault by right-wing students in Aachen (1964); sitting in the Schmela gallery in Düsseldorf, his head covered in honey and his arms cradling a dead hare, in *How to Explain Pictures to a Dead Hare*; wrapped in an enormous fur coat, standing motionless on a brightly lit stage with a mysteriously glowing horse's head in the background, in *Titus/Iphigenie* (1969); and standing rigidly at attention with a spearlike pole in hand, in *Celtic (Kinloch Rannoch) Scottish Symphony*, a 1970 action performed in Edinburgh. If these individual images convey little of the arcane webs of associations that gave meaning to Beuys's actions, they do very effectively evoke the intensity, gravity, and dreamlike air of Beuys's performances. If nothing else, these widely reproduced images confirm his genius for staging individual moments within his actions with a view to their ultimate translation by the camera.

Simultaneous with his presentation of such emblematic single images, Beuys also employed photographs of his actions in a very different manner. Between 1969 and 1971, in F. W. Heubach's Cologne avant-garde journal *Interfunktionen*, we find increasingly lengthy photographic sequences, most running more than twenty pages, that depict contemporary Beuys actions: *EURASIENSTAB (EURASIAN STAFF); Titus/Iphigenie; Celtic; Action the dead mouse/Isolation Unit;* and *Give Me a Point Where I Can Stand and I Will Move the Earth (Put the World Out of Joint).*[32] These sequences appeared in the context of other, more deadpan photographic documentation of site works and performances by artists such as Michael Heizer, Rebecca Horn, Vito Acconci, Robert Smithson, and Dennis Oppenheim.

Give Me a Point . . ., a variation on an earlier Basel performance, took place at the Düsseldorf Art Academy in 1971 before an audience largely made up of students. In *Interfunktionen #7*, this action was presented via a series of fifty-nine Klophaus photographs. In contrast to the pictures in the Moderna Museet catalogue, these images take us through the successive micro-moments of a single, exceptionally dramatic action. Klophaus's photographs concentrate especially on the Christological aspects of the action. Beuys washes the feet of seven spectators in a ceramic bowl; he is then "baptized" from a watering can while he kneels, fully clothed and with a flashlight strapped behind each leg, in a shallow tin basin containing a solution of sulfur powder, a substance with alchemical associations of burning and ascension.[33]

However the picture arose, he or his work were in the picture, and this picture threatened to freeze him, to fix him. He was fluid. He changed himself. From within him came new silence, new speech or speechlessness, new actions, new forms; and there were new photographs of his works.[28]

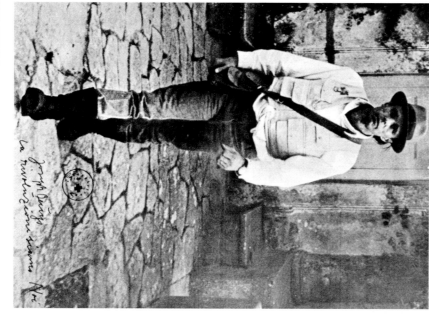

We are the Revolution, (1970), postcard, Edition Staeck, Heidelberg.

As it appears in *Interfunktionen*, the sequence unfolds almost cinematically. It opens with a blurry close-up of Beuys's hands ceremoniously bearing in a ceramic washbowl, and it closes with an image picturing Beuys from behind as he stands, hands on hips, confronting a dazed and noncommital audience. The sequence flows as smoothly as a film; even though individual images may be extremely hard to decipher, there is never any real temporal disorientation. Most of the photographs are taken from an extremely close range: we are often looking right over Beuys's shoulder or scrutinizing the tiniest inflections of his gestures and facial expressions. Yet, in all of the photographs, films and videotapes of his actions, Beuys never acknowledges the presence of the camera or the complicity of the photographer with so much as a flickering glance. His absorption in his performance is perfect and unwavering.

8

Do these scattered strands of information enable us to establish any more clearly the sense of *Arena*? We might begin by trying to clarify what the installation does *not* do with photographs. First, *Arena* clearly does not involve any kind of systematic formal experiment with photography. It cannot be regarded as an exploration of photography as a personally expressive vehicle; it is neither an attempt to isolate the visual characteristics of the photographic image that distinguish it from other artistic media, nor an inquiry into the conditions and processes of photographic representation. As we have seen, none of these concerns played a significant role in Beuys's own conception of his art.

Second, the photographs in *Arena* do not provide the raw materials for mounting the kind of "individual mythology" (to recall Harald Szeemann's phrase of the early 1970s) that Beuys elsewhere seemed so anxious to construct. In *Arena* we notice what seems to be the purposeful avoidance of the best-known and most visually powerful images of the Beuys iconography—the kinds of images that he employed so effectively in the 1971 Moderna Museet catalogue, for example. The most conventionally dramatic and evocative photographs of Beuys are conspicuously absent from *Arena*.

Third, *Arena* cannot really be understood as a species of private album or scrapbook, or as a private archaeological expedition by Beuys into the fund of his personal memories. Aside from the near total absence of scenes from Beuys's everyday world—only one photograph takes us out of doors—there are important areas of both his private and public life that remain largely outside the frame of *Arena*: his intimate family relations; his tumultuous activities as a teacher at the Düsseldorf Art Academy; his contentious involvement with the artists, curators, and art dealers of the Rhine region; his participation in the 1964 and 1968 Documentas; and his activities with the two organizations he founded, the German Students Party and the Organization for Direct Democracy. *Arena* remains intently fixed on Beuys's artworks and actions.

interfunktionen

7

Interfunktionen, magazine cover, (September 1971).

Fourth, even if *Arena* concentrates mainly on Beuys's sculptures, objects, actions, and installations, it by no means furnishes a systematic or comprehensive documentation of this work. In addition to the intentional informational poverty of many of the images, there are simply too many omissions, elisions, and intentional scramblings for *Arena* to serve as a useful didactic guide to Beuys's enormous and varied output. Photographs of a single installation or action, for example, may turn up in different panels. There is no extended treatment of any single action, as there is in the photographs reproduced in *Interfunktionen*. There is no indication of any overall sequence to the 100 panels that *Arena* comprises.

And, as if to kick the final prop from beneath the idea of "documentation," there is the stubborn withholding of the kind of caption information that might render marginally comprehensible the content of the individual images.

In the end *Arena* is best understood as an elaborate gesture on Beuys's part, aimed at shaking loose his work of the previous decade from any retrospective closure, in the hope of reinstilling it with an air of transience and mutability. Thus regarded, *Arena* recalls Beuys's famous 1963 "Stable Show" in the cow shed of the van der Grinten farm in Kranenburg. There, presenting around three hundred works from the previous decade of his work, Beuys purposely excluded those that seemed to him to have acquired a fixed or final character; his improvised, associational groupings of the exhibited works pointed less toward the past than toward his next phase of activity.[34] In the same vein, it is equally suggestive that when *Arena* was shown at Rome's Galleria L'Attico in the fall of 1972, Beuys chose to carry out a performance in which he read from a book about a chameleonlike eighteenth-century figure named Anacharsis Cloots, a native of Kleve who repeatedly shed his name and identity to take up others.[35]

In *Arena*, by means of a radical disarticulation of the images that publicly "documented" and defined his works and actions, Beuys sought to evade the consequences of his own hyperadroit use of photographic "speech." No doubt he hoped to recreate around these works a sort of originary turbulence—something of the silence and the chaos of the unnamed. For it is in such an equivocal space, Beuys believed, where old unities are dissolved and hypothetical alternatives are set in motion, that the beginning of the new always takes place.[36]

If *Arena* can be regarded as an audacious attempt to make use of photography to clear an empty horizon of artistic possibility, it should also be seen as a provisional, one-time effort, tied to a specific transitional moment in Beuys's own career. Certainly the aleatory "look" of Klophaus's photographs quickly proved to be codifiable and repeatable; their ephemeral quality hardened into a recognizable style. By 1974, in her photographs of one of Beuys's most haunting installations, *Show Your Wound*, the old photographic "errors" have become stylized and self-conscious, resulting in images of a calculated and more conventional poetic beauty.[37] Although Beuys continued until the end of his life to make extravagant practical use of photography as documentation, in no subsequent installations did he call upon photography to play the complex and paradoxical role that it did in *Arena*.

Retter den Wald (*Sweeping the Woods*), (1972), edition of 200, Heinz Moos Verlag, Munich.

Notes

1. For an exploration of Beuys's adamant rejection of the idea that his work primarily involved the manipulation of symbols, see the interview with the artist in *Mythos und Ritual in der Kunst der siebziger Jahre*, exhibition catalogue (Kunstverein Hamburg, 1981), especially page 90. One of the most succinct overviews of Beuys's characteristic themes and working methods is Paul-Albert Plouffe's "Joseph Beuys: Avers et revers," *Parachute*, no. 21 (Winter 1980), 32–41. For a rare attempt to interpret Beuys's work without taking too seriously the artist's metaphysical utterances, see Armin Zweite's essay in *Joseph Beuys: zeige deine Wunde*, (Munich: Schellmann & Klüser, 1980).

2. Beuys quoted in Volker Harlan, *Was ist Kunst? Werkstattgespräch mit Beuys* (Stuttgart: Urachhaus, 1986), 23. Unless otherwise indicated, translations from German-language sources are my own.

3. Ibid., 21.

4. See Jacqueline Burckhardt, ed., *Eine Gespräch, Joseph Beuys, Jannis Kounellis, Anselm Kiefer, Enzo Cucchi* (Zurich: Parkett Verlag, 1986), 156.

5. For more on Beuys's vehement insistence on the reality of a realm of invisible forces, see his 1979 interview with Horst Schwebel, reprinted in *Zeichen des Glaubens: Geist der Avantgarde*, ed. Wieland Schmied (Stuttgart: Klett-Cotta, 1980), 206.

6. Beuys, in conversation with Heiner Bastian and Jeannot Simmen, "If Nothing Says Anything, I Don't Draw," in *Joseph Beuys. Zeichnungen. Tekeningen. Drawings*, exhibition catalogue (Rotterdam: Museum Boymans-van Beuningen), 94.

7. Ibid., 92.

8. *Ute Klophaus: Sein und Bleiben. Photographie zu Joseph Beuys*, exhibition catalogue (Bonn: Bonner Kunstverein, 1986), 6.

9. Franz Joseph van der Grinten, "Joseph Beuys, der Niederrhein und Fritz Getlinger," in *Getlinger photographiert Beuys 1950–1963* (Cologne: DuMont, 1990). In this publication, see especially Thilo Koenig's meticulously researched essay "Franz Getlinger photographiert Joseph Beuys. Künstler und Kunstwerke vor der Kamera." On the Subjective Photography movement, see "Subjektive Fotografie." *Images of the 50's*, exhibition catalogue (Essen: Museum Folkwang, 1984).

10. Upon learning that he had been given the post, Beuys wrote to Getlinger, "Our labor (yours especially) was not for naught. It worked. Got the professorship." In van der Grinten, *Getlinger photographiert Beuys*, 13.

11. A handful of Beuys's works and projects from the 1950s and 1960s touch on photography: for example, a series of photographs made with a pinhole camera by candlelight, occasional overpainted or stamped photographs, and photographs from the First and Second World Wars included in the "Block Beuys" in Darmstadt.

12. Franz Joseph van der Grinten, "Joseph Beuys, die Niederrhein und Fritz Getlinger," in van der Grinten, *Getlinger photographiert Beuys*, 19.

13. Ibid.

14. For Wolf Vostell's remarks on the significance of the 1958 Dada retrospective in Düsseldorf, see the interview "DADA und Mentale Energie," *Sprache im technischen Zeitalter*, no. 55 (1975), especially pages 214–215. On Vostell's subsequent recognition of the possibilities of using news photographs in his own art, see the interview with the artist in *Flash Art*, no. 72–73 (1977), 34–39.

15. See Reiner Ruthenbeck's photographs of the various one-day exhibitions that constituted the "Homage to Schmela" in *Reiner Ruthenbeck: Fotografie 1956–1976* (Stuttgart: Edition Cantz, 1991). See also the brief remarks on Richter's contribution to this event by Pachutan Buzari, Matthias Roeser, and Jörg Zboralski in *Texte zur Kunst*, 2, no. 7 (October 1992), 183–185.

16. See *Beuys MANRESA: Zeichnungen, Fotos, Materialien zu einer Fluxus Demonstration*, exhibition catalogue (Cologne: Kunst-Station Sankt Peter, 1991).

17. For a discussion of the related questions raised by the photographic documentation of ephemeral sculptural and performance works during the same period, see Dennis Oppenheim's pertinent observations in the catalogue *Dennis Oppenheim: Selected Works 1967–90. And the Mind Grew Fingers* (New York: Institute for Contemporary Art/Abrams, 1991), 143–145, 164. On the more general topic of the art-historical interpretation of photographs showing artists at work, see the essays by Rosalind Krauss and Francis V. O'Connor in Hans Namuth, *L'Atelier de Jackson Pollock*. (Paris: Macula/Pierre Brochet, 1978).

18. Hermann Nitsch, cited in Hubert Klocker, "The Shattered Mirror," in *Viennese Actionism. Vienna 1960–1971. The Shattered Mirror*, ed. Klocker (Klagenfurt, Austria: Ritter Verlag, 1989), 93.

19. Hermann Nitsch, cited in Dieter Ronte, "Hermann Nitsch: Fragen zur Ästhetik der Aktionsfotografie," in *Nitsch: Das bildnerische Werk* (Salzburg and Vienna: Residenz Verlag, 1988), 26.

20. Allan Kaprow, "Note on the Photographs," *Assemblage, Environments & Happenings* (New York: Abrams, 1966), 21.

21. See, for example, the extensive selection of photographs of German Fluxus events from 1962–63 in *Stationen der Moderne*, exhibition catalogue (Berlin: Berlinische Galerie, 1988), 499–517.

22. For a comprehensive account of the gallery and its exhibitions, see *Treffpunkt Parnass*, exhibition catalogue (Wuppertal: Von der Heydt Museum, 1980).

23. See *Fluxus: Aspekte eines Phänomens*, exhibition catalogue (Wuppertal: Von der Heydt Museum, 1981), especially Klophaus's statement and Ursula Peters's essay "Aktionsphotographie: Dokumentation als Interpretation." See also *Joseph Beuys: Nueve acciones fotografíadas por Ute Klophaus*, exhibition catalogue (Madrid: Fundacíon Caja de Pensiones, 1985); and the Klophaus catalogue *Sein und Bleiben. Photographie zu Joseph Beuys* (Bonn: Bonner Kunstverein, 1986), especially Klophaus's statements and Margarethe Jochimsen's essay.

24. Ute Klophaus, statement in *Fluxus: Aspekte eines Phänomens*, 230.

25. Ibid.

26. Ibid., 229.

27. Monsignore Otto Mauer, "Einführungsrede zur Austellung Beuys," transcription of remarks presented at the opening of Beuys's 1967 exhibition at the Städtische Museum Mönchengladbach, reprinted in the catalogue *Joseph Beuys: Werke aus der Sammlung Karl Ströher* (Basel: Kunstmuseum Basel), 52–55. The founder of Vienna's avant-garde Galerie nächst St. Stephan, Mauer was a key figure in the development of postwar Austrian Informel painting. See Robert Fleck, *Avant-Garde in Wien: Die Geschichte der Galerie nächst St. Stephan 1954–1982*, exhibition catalogue (Vienna: Galerie nächst St. Stephan/ Löcker, 1982).

28. Ute Klophaus, statements in the catalogue *Ute Klophaus: Sein und Bleiben. Photographien zu Joseph Beuys*, 5–6.

29. It is significant that in Beuys's multiples of the 1960s and 1970s, photography and other "reproducible" media such as film reels and audio cassettes are never really meant to invoke the Benjaminian idea of the "loss of aura" through mechanical reproduction, which was at the time a topic of widespread discussion. The Beuys multiple produced in the largest number was *Intuition* (1968), a wooden box with the word "intuition" penciled inside it, which eventually appeared in about 12,000 copies.

30. Beuys, cited in *Three Towards Infinity: New Multiple Art*, exhibition catalogue (London: Arts Council of Great Britain, 1970), 21.

31. See *Beuys*, exhibition catalogue (Mönchengladbach: Städtisches Museum Mönchengladbach, 1967).

32. *Interfunktionen*'s first ten issues were published irregularly from 1968 by Friedrich Wolfram Heubach; the final two issues were edited and published by Benjamin H. D. Buchloh. See Heubach's retrospective note on the journal, "*Interfunktionen* 1968–74," in *Brennpunkt Düsseldorf 1962/1987. Joseph Beuys. Die Akademie. Der allgemeine Aufbruch*, exhibition catalogue (Düsseldorf: Kunstmuseum Düsseldorf), 128–130.

33. See Klophaus's remarks on the action in ibid., 240.

34. See Hans van der Grinten, "Joseph Beuys 'Stallaustellung' Fluxus 1963 in Kranenburg," in Bernd Klüser and Katharina Hegewisch, eds., *Die Kunst der Ausstellung* (Frankfurt am Main: Insel Verlag, 1991), 172–177.

35. Caroline Tisdall, *Joseph Beuys*, exhibition catalogue (New York: The Solomon R. Guggenheim Museum, 1977), 225.

36. Beuys, quoted in *Joseph Beuys*, exhibition catalogue (New York: Dia Art Foundation, 1988), 17. On the notion of the "chaos of the unnamed" as the starting point of myth, see Hans Blumenberg, *Work on Myth*, trans. Robert M. Wallace (Cambridge, Mass.: MIT Press, 1985), especially chapter two, "The Name Breaks into the Chaos of the Unnamed."

37. *Joseph Beuys: zeige deine Wunde*. In the 1987 photo-book *Beuys in Amerika*, the use of unfocused, overexposed, dust-specked photographs, taken by Klaus Staeck and Gerhard Steidel during Beuys's 1974 American tour, seems an almost nostalgic exercise in period photographic style. See *Joseph Beuys in Amerika*, edited and photographed by Staeck and Steidel (Heidelberg: Editions Staeck, 1987).

Plates and Identifications

The titles of the identified works are first indicated here with the English translation, the original-language title immediately following. All of the original-language titles have been supplied by Eva Beuys-Wurmbach from materials in the Archive of Joseph Beuys, Düsseldorf. The photographs have been ordered according to the number stamped on the frame that contains them (1–100); alphabetical letters denote the progression from upper left to lower right. Photographs that show works whose state differs from the form they now take are indicated as (in progress); those that exist only as a photographic document, as (positioned by Beuys for the camera); those that depict an aspect of a vitrine, as (detail); those that present an isolated view of an object, which is part of a larger group of work, as (close-up); those that display a work in an exhibition situation are noted as (installation view), with the site identified when possible; and those with descriptive designations that are not proper titles are enclosed in parenthesis immediately adjacent to the alphabetical letter denoting their placement. For further information regarding cited works, see Glossary, pages 266–277. Compiled by Pamela Kort.

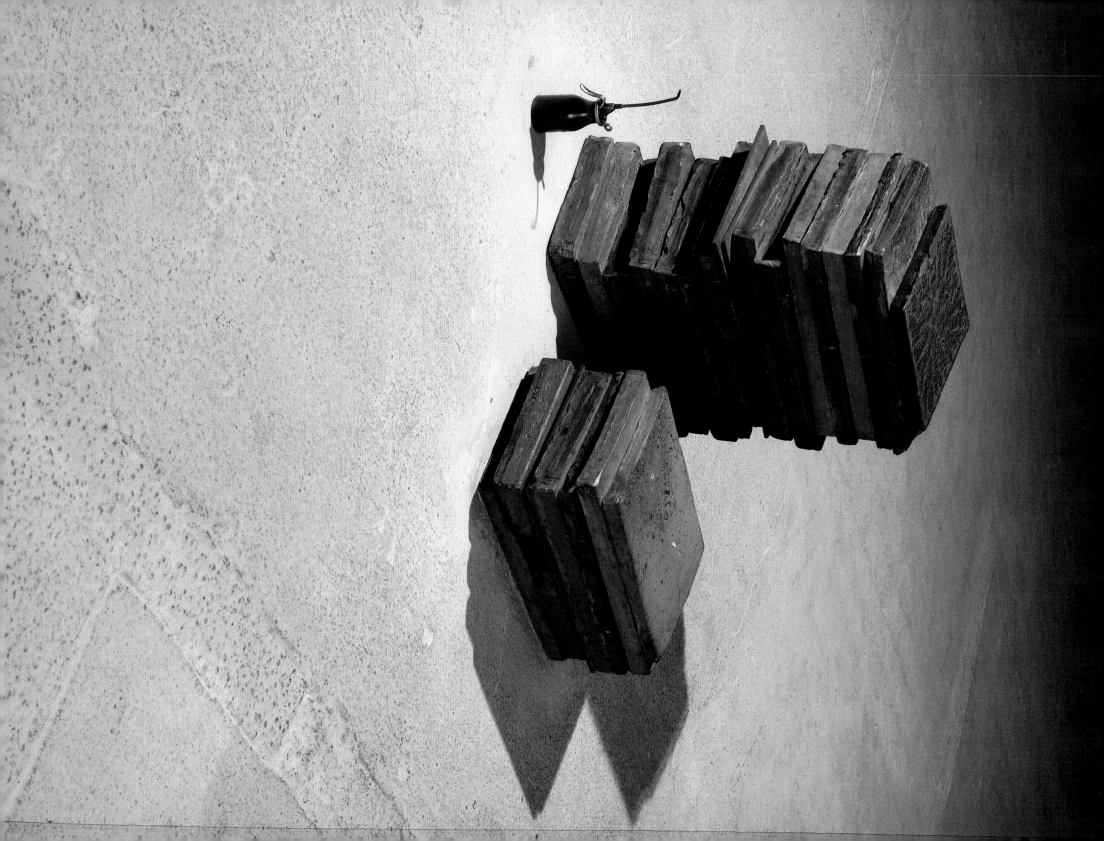

#1

a *Auschwitz Demonstration 1956–1964*
 (in progress)

b *Action the dead mouse/Isolation Unit 1970*

c ⊃→
 :»Hauptstrom»»
 FLUXUS 1967

#2

a *Warm Chair with Felt Sole, Iron Sole, and Magnet 1965*
warmer Stuhl mit Filzsohle, Eisensohle und Magnet

Felt Roll from: The Chief 1964
Filzrolle aus: Der Chef

From: »THE CHIEF« (2 Parts) Felt-Copper 1964
Aus: »DER CHEF« (2 Teile) Filz-Kupfer

b *U-Shaped Double Lamp with Hare's Fat (Rolled Picture) 1961*
U-förmige Doppel-lampe mit Hasenfett (Rollenbild)

#3 a (installation view "Block Beuys")

b *Fat Corner 1963 (1968)*
Fettecke

c *Chair with Fat 1963*
Stuhl mit Fett

Fat Corner from: The silence of Marcel Duchamp is overrated 1964
Fettecke aus: Das Schweigen von Marcel Duchamp wird überbewertet

(installation view "Block Beuys")

d (not identified)

#4 a *Lightning 1964*
Blitz

b (installation view "Block Beuys")

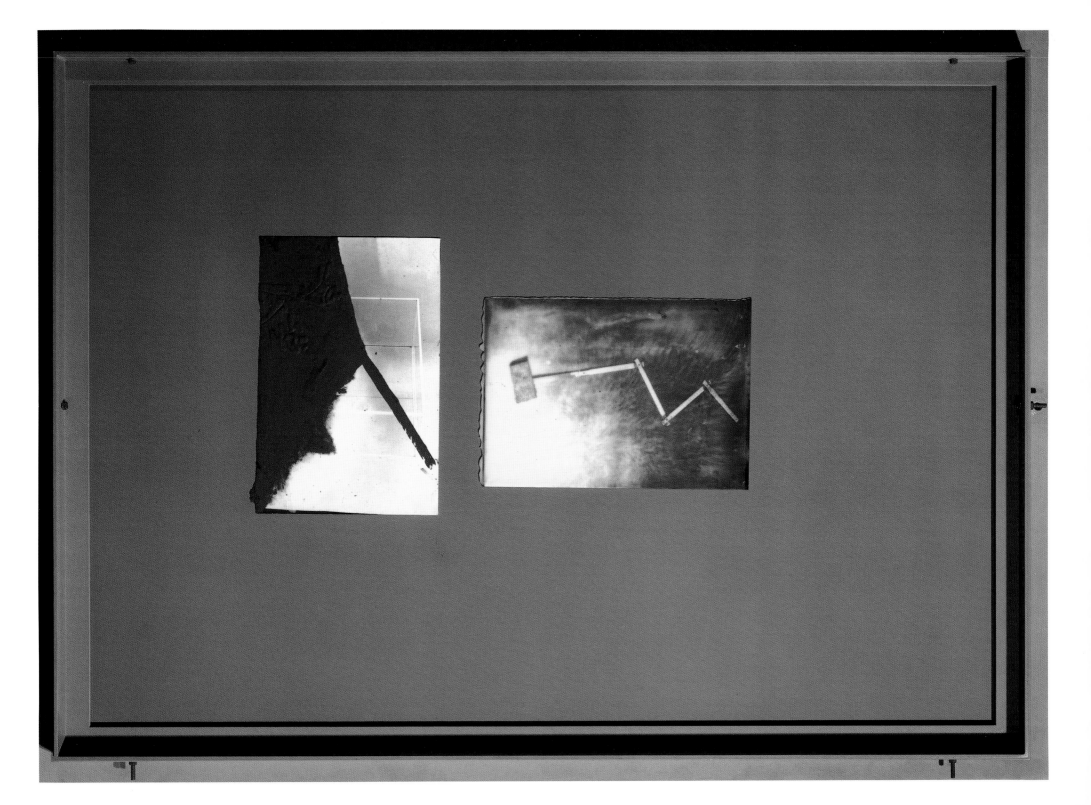

a *Titus/Iphigenie 1969*

b *Telephone ca. 1969*
Telephon

c *Bathtub 1960*
Badewanne

d *Celtic (Kinloch Rannoch) Scottish Symphony 1970*
Celtic (Kinloch Rannoch) Schottische Symphonie

e *Celtic + ∿∿∿ 1971*

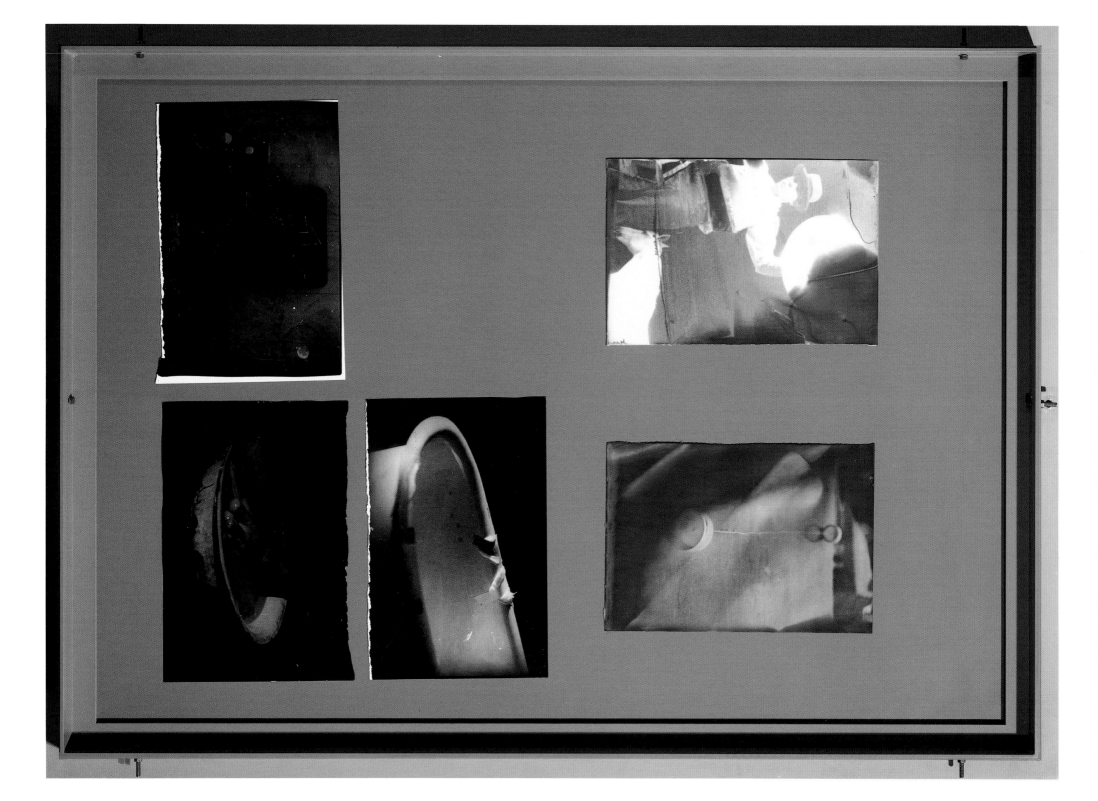

#6 a *TOTH* 1949

b **2 Mining Lamps 1953**
2 Berglampen
(positioned by Beuys for the camera, Drakeplatz 4, Düsseldorf)

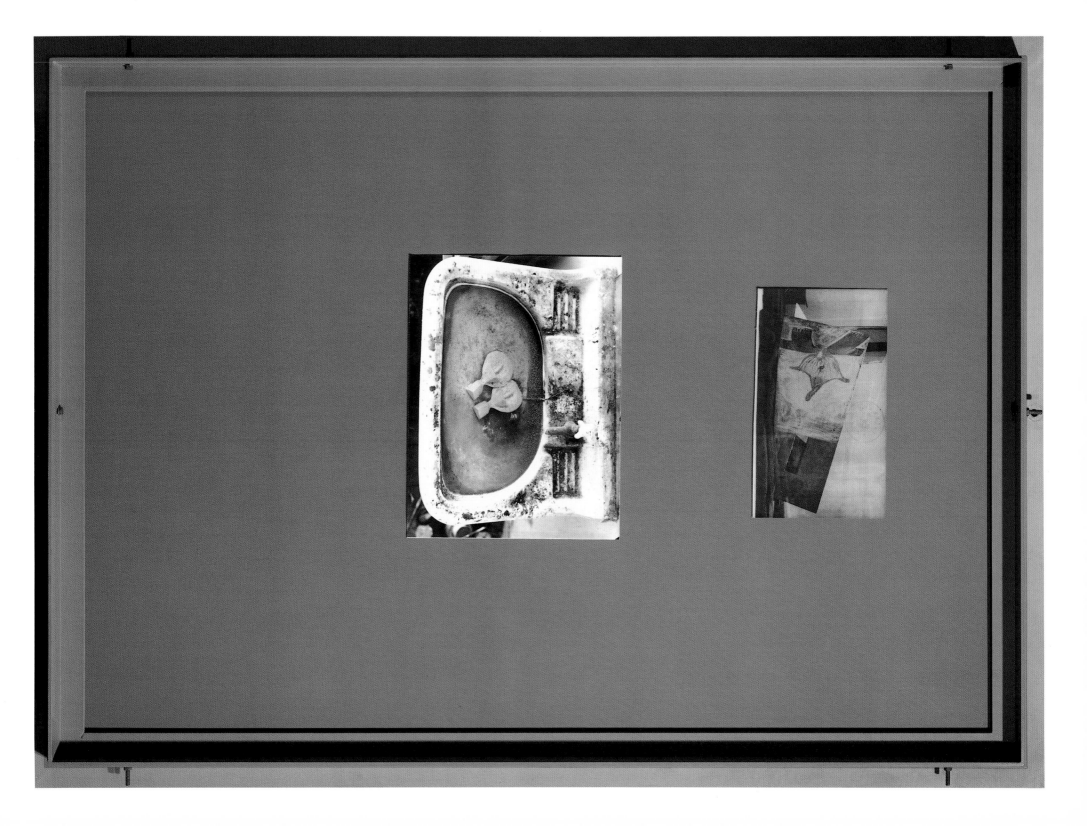

#7

a *Sheep in Snow* 1952
 Schaf im Schnee

b *Fat Corner* 1963 (1968)
 Fettecke

c *2 Mason Jars with Soda*
 2 Weck-Gläser mit Soda
 (detail from *Barraque D'Dull Odde* 1961–1967)

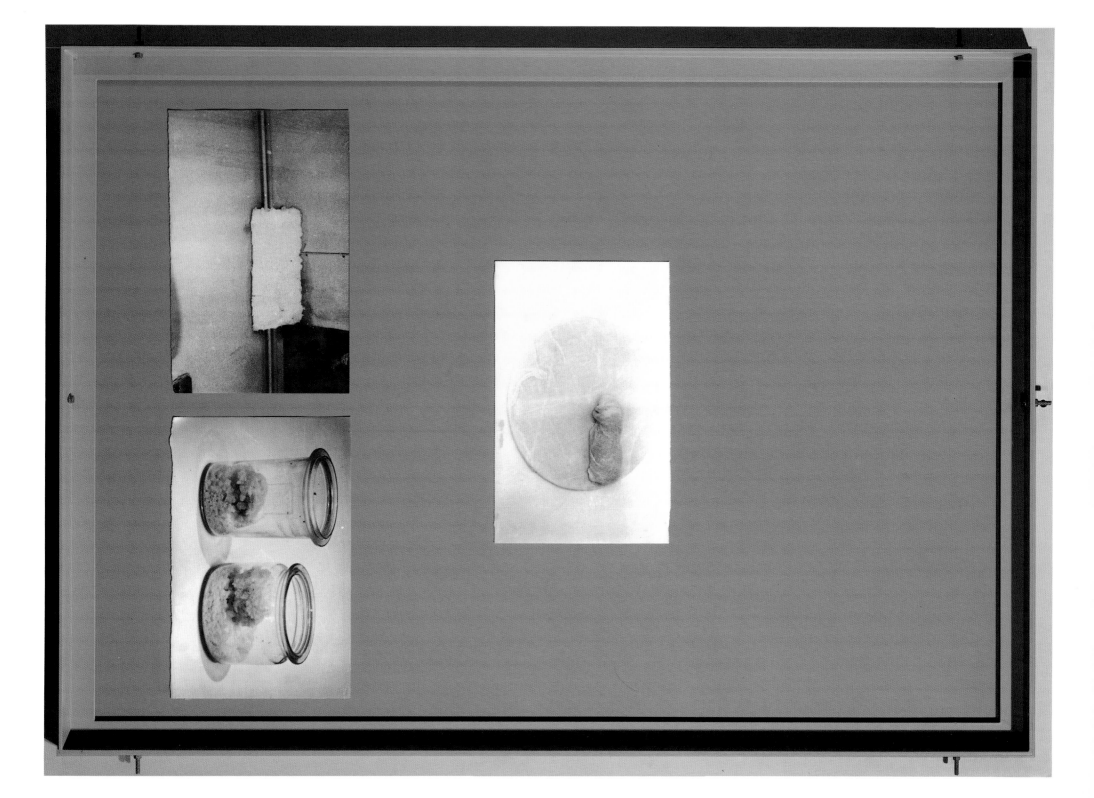

#8

a *Action Corner (Sausage) — Physiology 1963*
 Aktionswinkel (Wurst) — Physiologie

 Element 1, Element 2, Paper 1966
 Element 1, Element 2, Papier

 comprimed exhausted 1966

b *Concentration Camp=Food 1 1963*
 KZ=Essen 1

c *MANRESA 1966*

#9

a (photocopy with installation numbers to Vitrine 1954–1967, "Block Beuys")

b (photocopy with installation numbers to Vitrine 1949–1964, "Block Beuys")

c *I want to see my mountains 1971*
 Voglio vedere i miei montagne

#10 a *Cross with Kneecap and Hare's Skull 1961*
Kreuz mit Kniescheibe und Hasenschädel

b *Siberian Symphony (Finale) 1963*
Sibirische Symphonie (Finale)

c *Irish cross/Birth signs 1951*

d *EURASIAN STAFF 82 min fluxorum organum 1968*
EURASIENSTAB 82 min fluxorum organum

#11

a

90 Degree Felt Corner Notch 1965
90 Grad Filzwinkelkerbe

2 x 90 Degree Felt Corners 1964
2 x 90 Grad Filzwinkel

ELEMENT 1 and parts of ELEMENT 2 (complete with high-voltage alternating current) [six parts] 1966
ELEMENT 1 und Teile von ELEMENT 2 (vollständig mit Hochspannungswechselstrom) [sechs Teile]

Eurasian Staff with 4 x 90 Degree Felt Corners (II) 1967
Eurasienstab mit 4 x 90 Grad Filzwinkel (II)

From: Eurasian Staff (Detail) 1967
Aus: Eurasienstab (Detail)

Warm Chair with Felt Sole, Iron Sole, and Magnet 1965
warmer Stuhl mit Filzsohle, Eisensohle und Magnet

Felt Roll from: The Chief 1964
Filzrolle aus: Der Chef

From: »THE CHIEF« (2 Parts) Felt-Copper 1964
Aus: »DER CHEF« (2 Teile) Filz-Kupfer

(installation view "Block Beuys")

b

90 Degree Felt Corner Notch 1965

2 x 90 Degree Felt Corners 1964

ELEMENT 1 and parts of ELEMENT 2 (complete with high-voltage alternating current) [six parts] 1966

Eurasian Staff with 4 x 90 Degree Felt Corners (II) 1967

From: Eurasian Staff (Detail) 1967

Warm Chair with Felt Sole, Iron Sole, and Magnet 1965

Felt Roll from: The Chief 1964

From: »THE CHIEF« (2 Parts) Felt-Copper 1964

(installation view "Block Beuys")

c

Eurasian Staff with 4 x 90 Degree Felt Corners (I) 1967

Eurasian Staff with 4 x 90 Degree Felt Corners (II) 1967

Eurasian Staff with 1 x 90 Degree Felt Corner 1967

2 x 90 Degree Felt Corners 1964

ELEMENT 1 and parts of ELEMENT 2 (complete with high-voltage alternating current) [six parts] 1966

Rubberized Box 1957
gummierte Kiste

(installation view "Block Beuys")

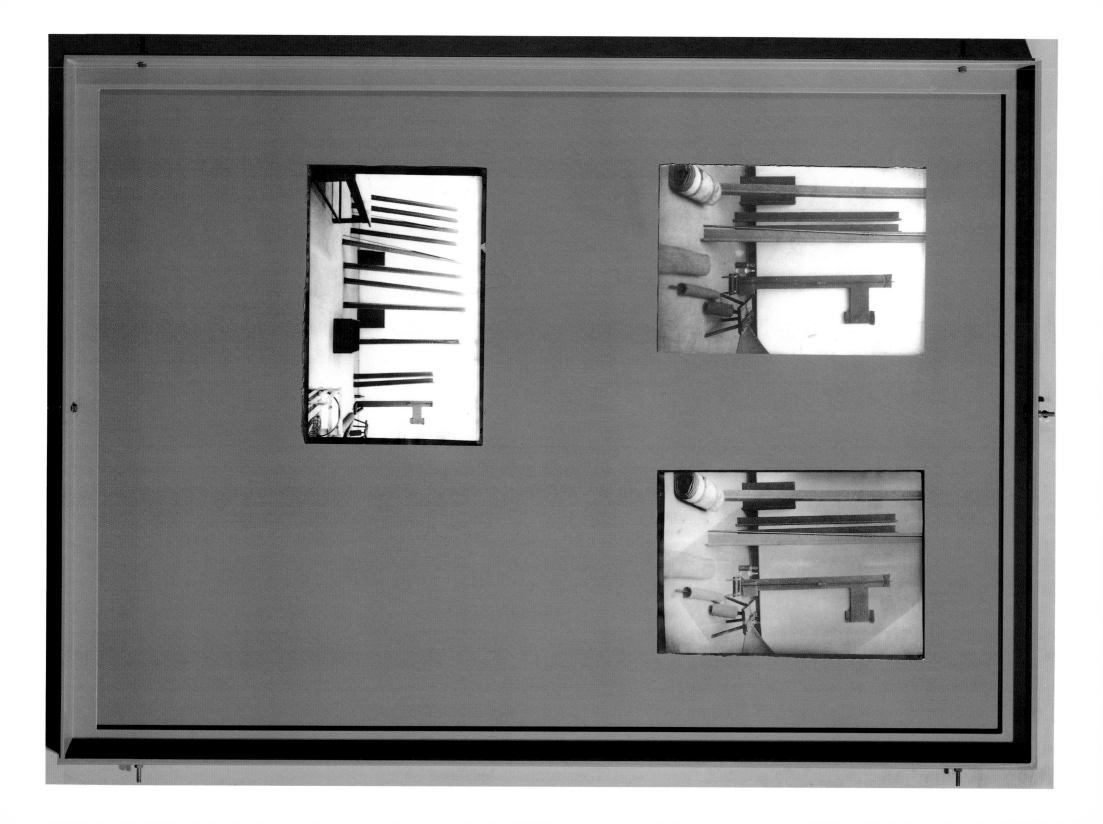

#12 a *Room: Warmth-Time Machine (One-Armed Aggregate)* 1959
Raum: Wärme-Zeitmaschine (einarmiges Aggregat)
(positioned by Beuys for the camera, Drakeplatz 4, Düsseldorf)

b *SYBILLA (Version II)* 1954–1959
SYBILLA (Fassung II)

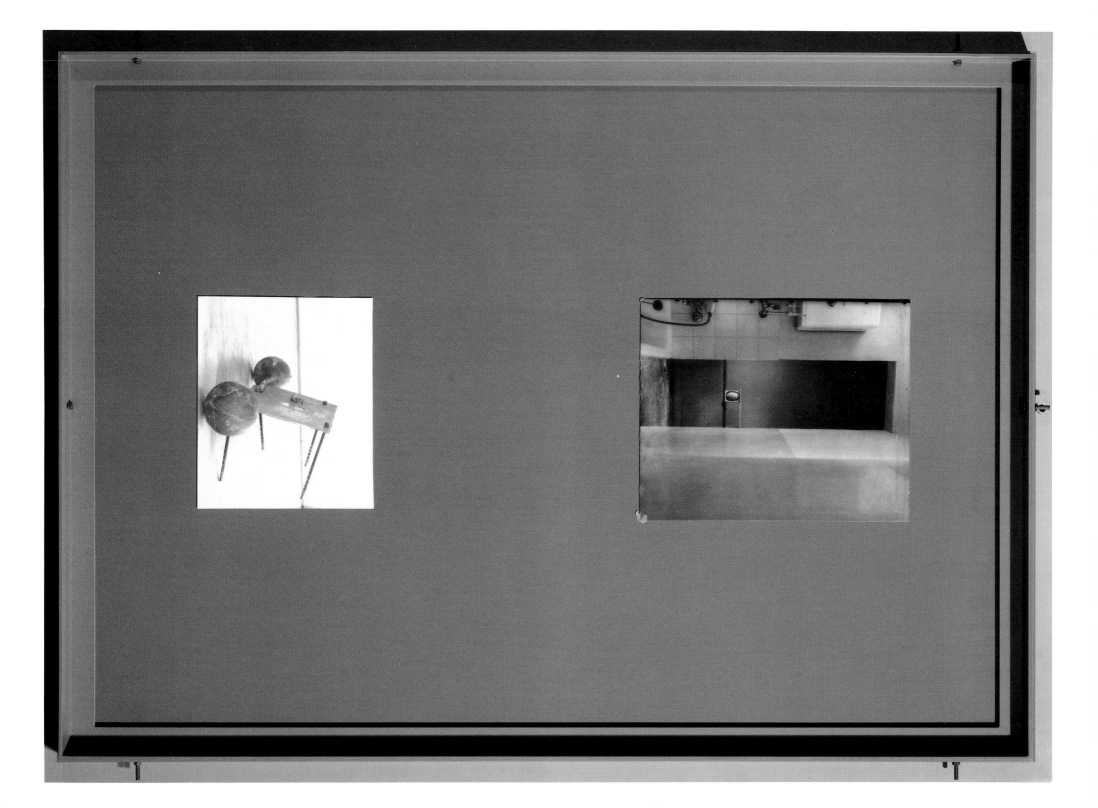

#13 a | (Verona arena)

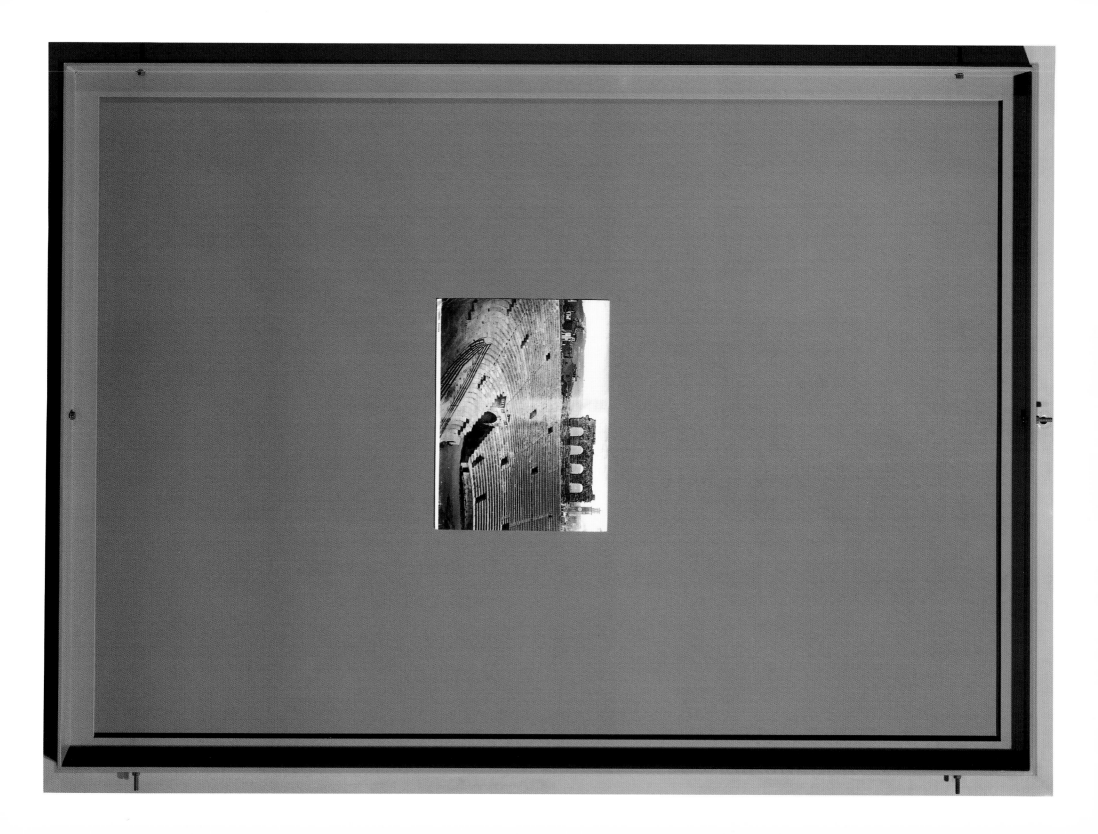

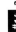

#14 a *EURASIAN STAFF 82 min fluxorum organum 1968*
EURASIENSTAB 82 min fluxorum organum

b *EURASIAN STAFF 82 min fluxorum organum 1968*

c *(Plastic Charge Lightning [detail]) 1969*
(plastische Ladung Blitz)

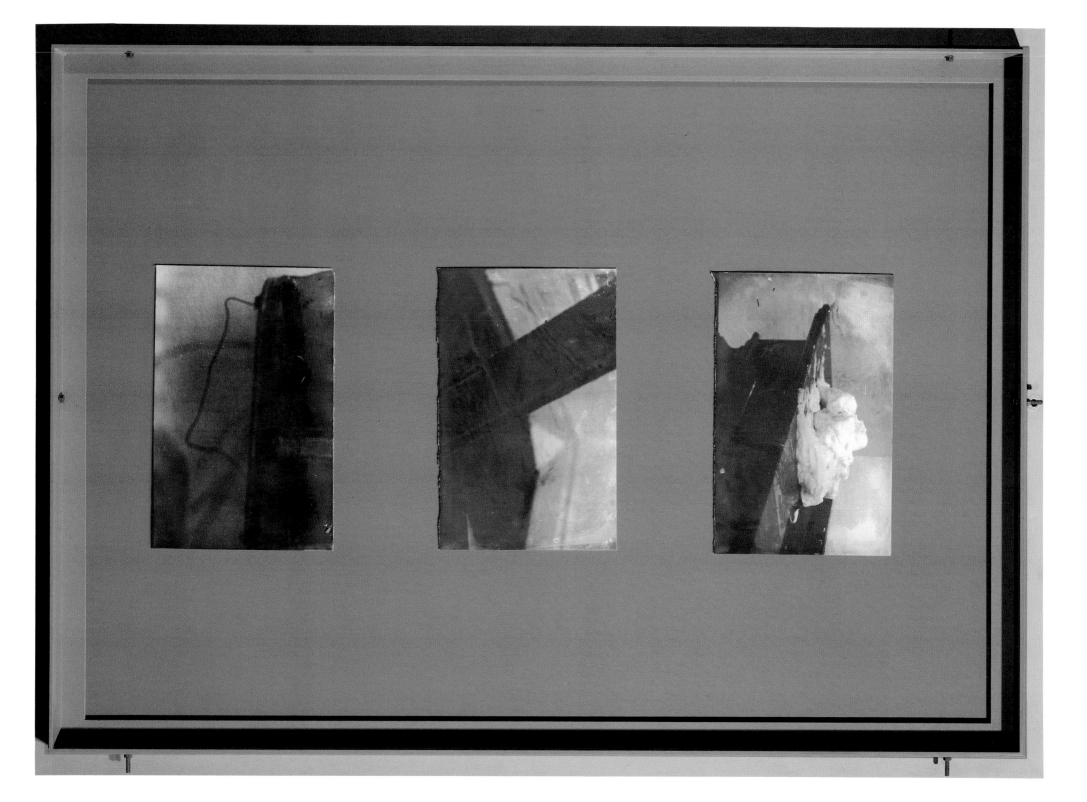

#15 a *Fat Corner* 1963
Fettecke

b *SITE (Fat Felt Sculpture) Complete with High-Voltage Alternating Current and Charged Copper Plate* 1967
STELLE (Fettfilzplastik) vollständig mit Hochspannungswechselstrom aufgeladener Kupferplatte
(installation view, "BEUYS," Stedelijk Van Abbemuseum, Eindhoven, 1968)

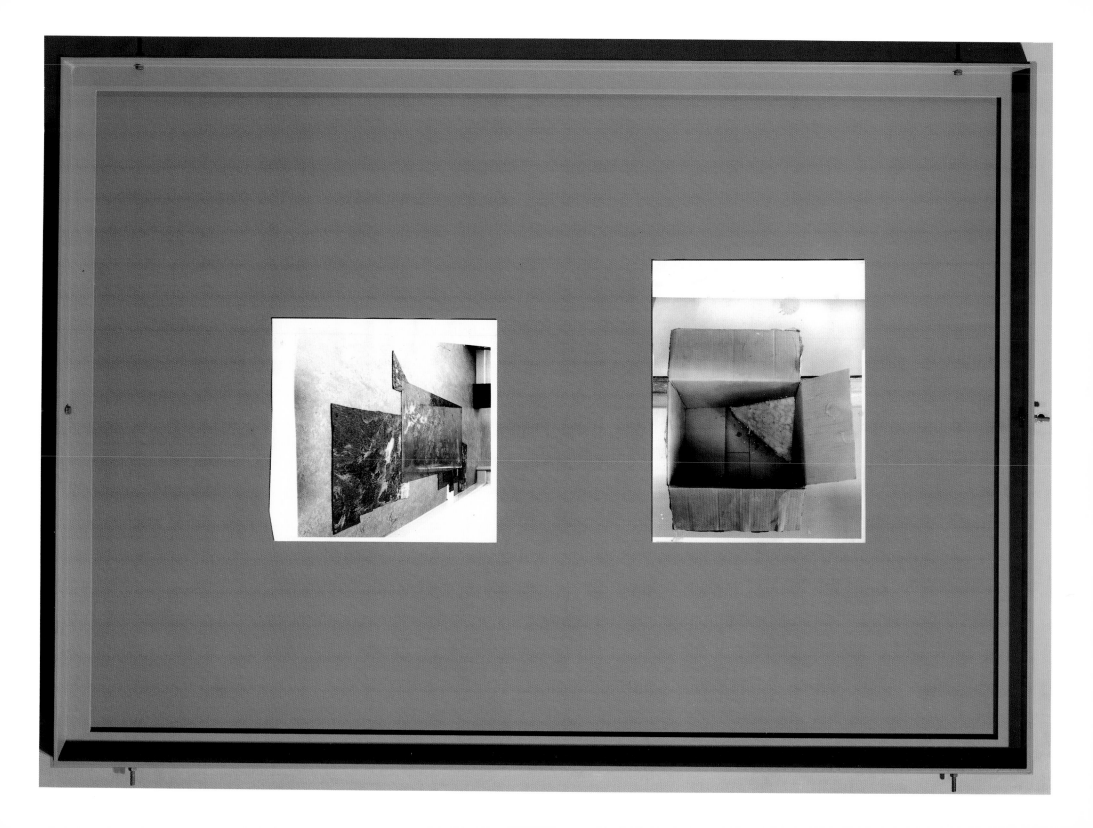

#16 a *The Pack (das Rudel)* 1969
(positioned by Beuys for the camera in the Düsseldorf Art Academy)

b *The Pack (das Rudel)* 1969
(positioned by Beuys for the camera in the Düsseldorf Art Academy)

c *Let's overcome the party dictatorship now 1971*
Überwindet endlich die Parteiendiktatur

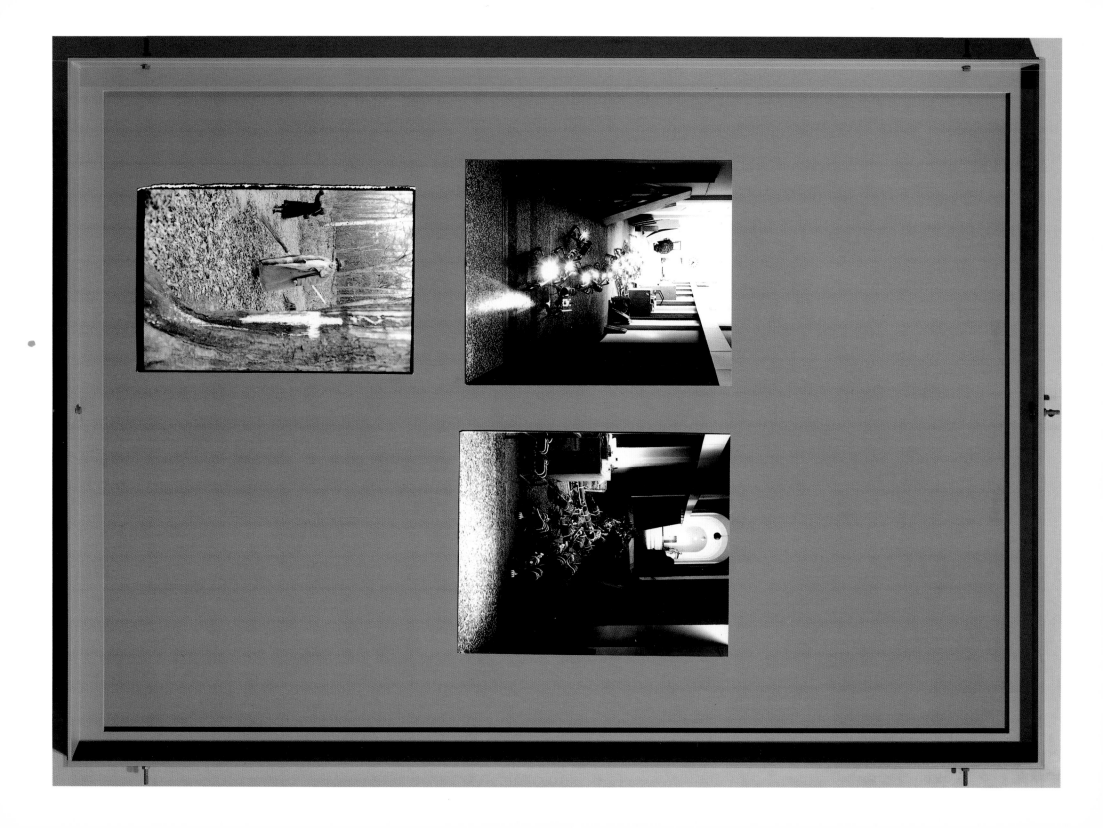

#17 a ⊃ →
: ›› Hauptstrom ››
FLUXUS 1967

b EURASIAN STAFF 82 min fluxorum organum 1968
EURASIENSTAB 82 min fluxorum organum

c FOND II 1961–1967 . . . 2 Copper Tables with High Voltage–High Frequency Generator 1968
FOND II 1961–1967 . . . 2 Kupfertische mit Hochspannungs-Hochfrequenz Generator

d Double Aggregate 1958–1968
Doppelaggregat

Scene from the Stag Hunt 1961
Szene aus der Hirschjagd

(installation view "Block Beuys")

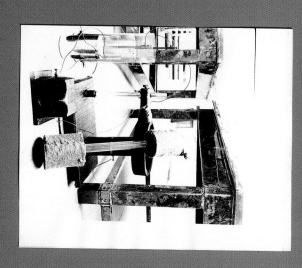

#18

a *Titus/Iphigenie 1969*

b *Action Sculpture 1963*
 Aktionsplastik

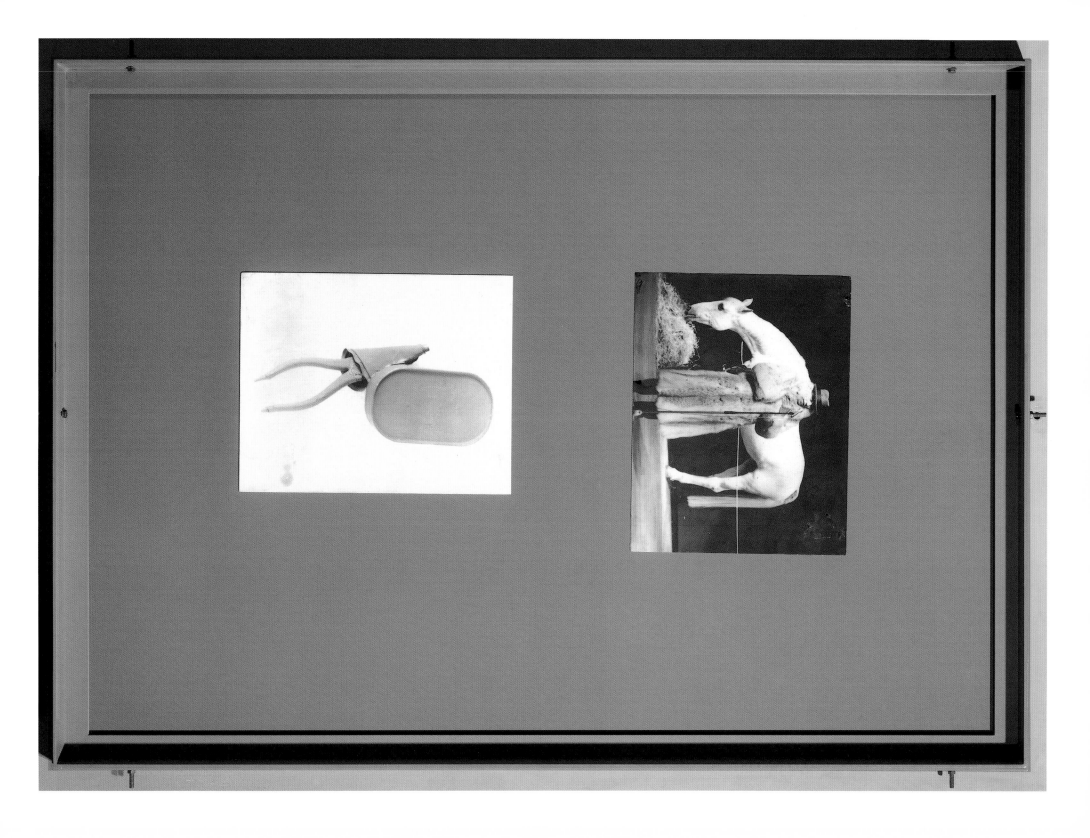

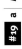**#19** **a** *EURASIA SIBERIAN SYMPHONY 1963*
32nd COMPOSITION (EURASIA) FLUXUS 1966
EURASIA SIBIRISCHE SYMPHONIE 1963
32. SATZ (EURASIA) FLUXUS

b *Warmth Sculpture 1968*
Wärmeplastik

c *Infiltration Homogeneous for Grand Piano 1966*
Infiltration homogen für Konzertflügel

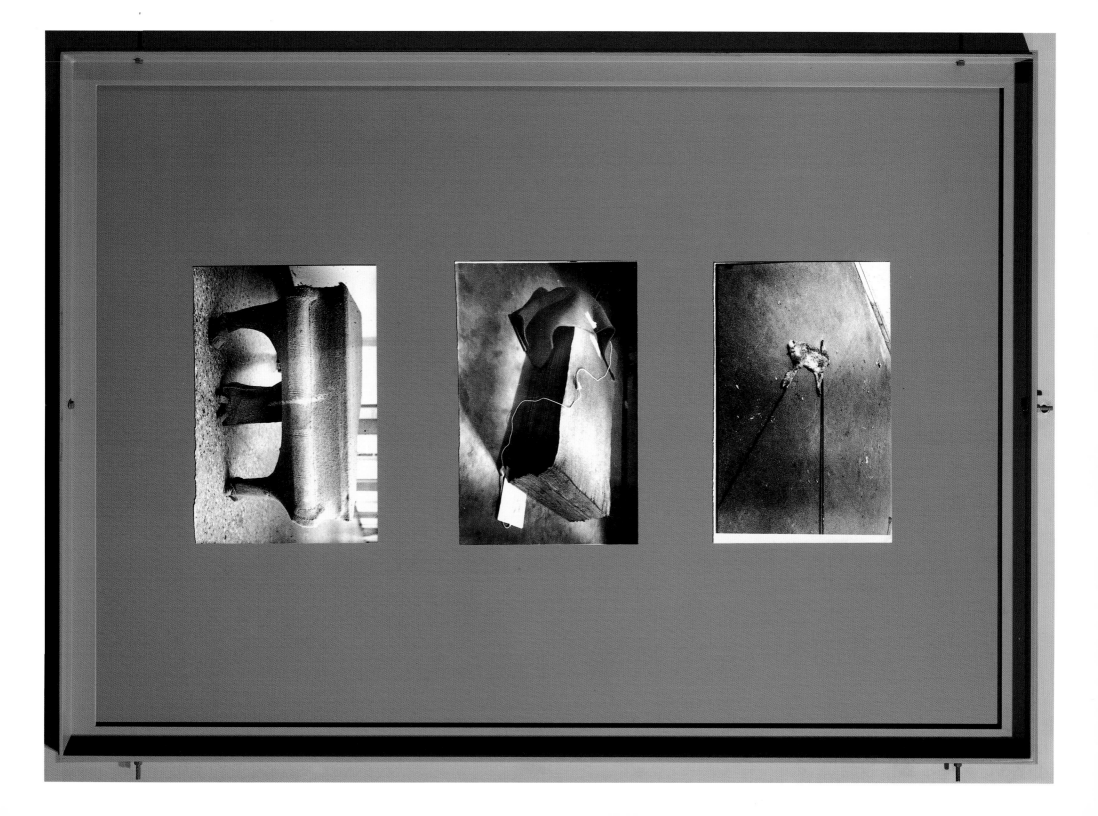

#20 a *EURASIA SIBERIAN SYMPHONY 1963*
32nd COMPOSITION (EURASIA) FLUXUS 1966
EURASIA SIBIRISCHE SYMPHONIE 1963
32. SATZ (EURASIA) FLUXUS

b $\supset \rightarrow$
:››Hauptstrom››
FLUXUS 1967

c *Titus/Iphigenie 1969*

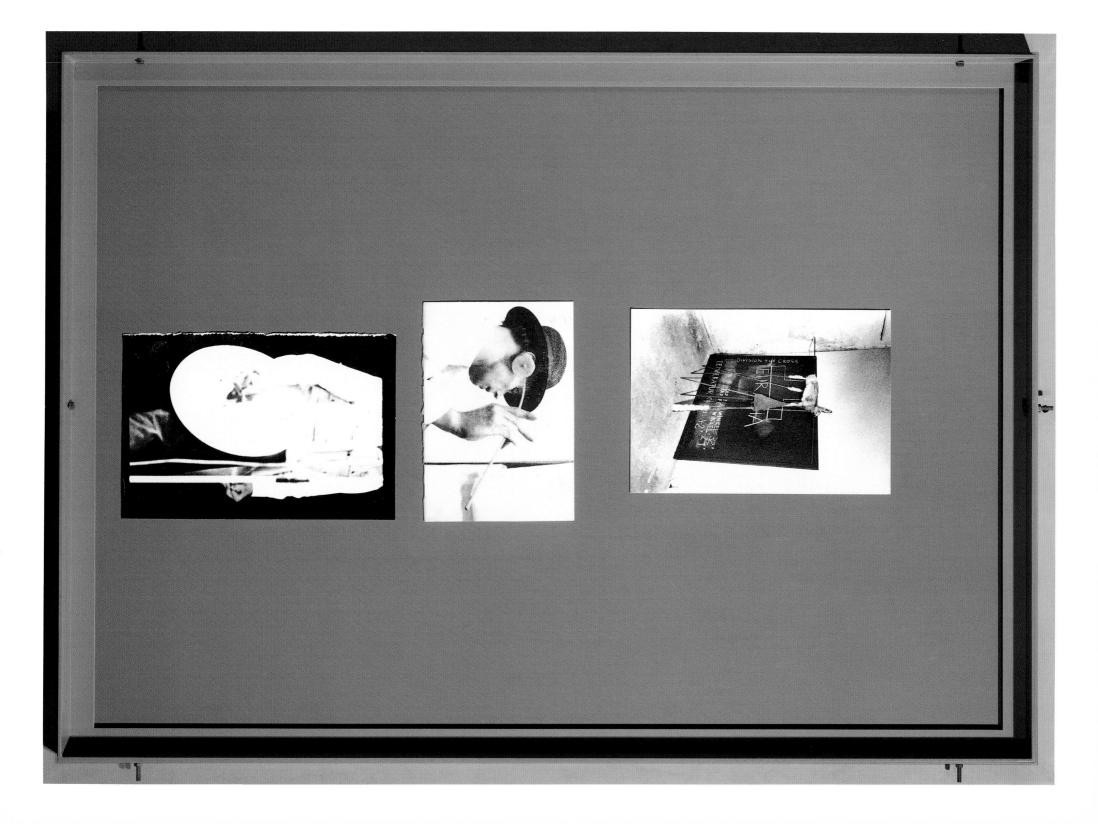

#21 a *Dead Man 1953*
toter Mann

b *Instrument for Concert 1961*
Instrument für Konzert

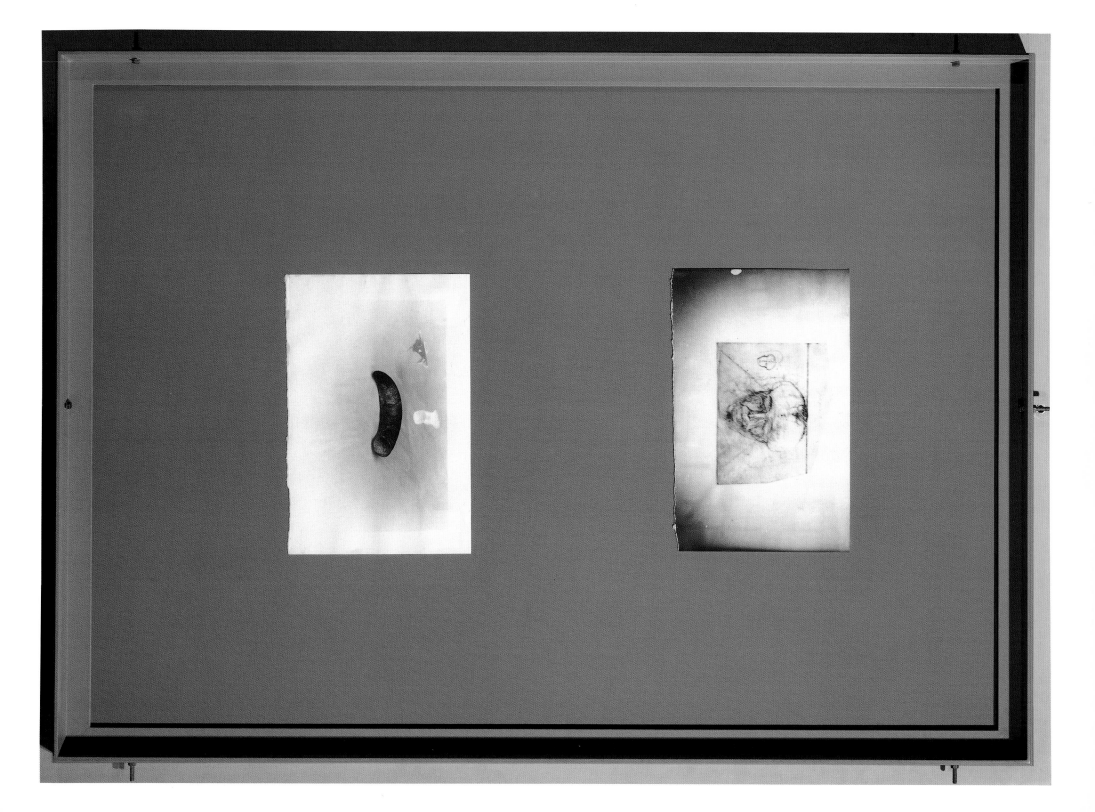

#22 a | *90 Degree Tented Felt Corner 1965*
| *90 Grad überzelteter Filzwinkel*

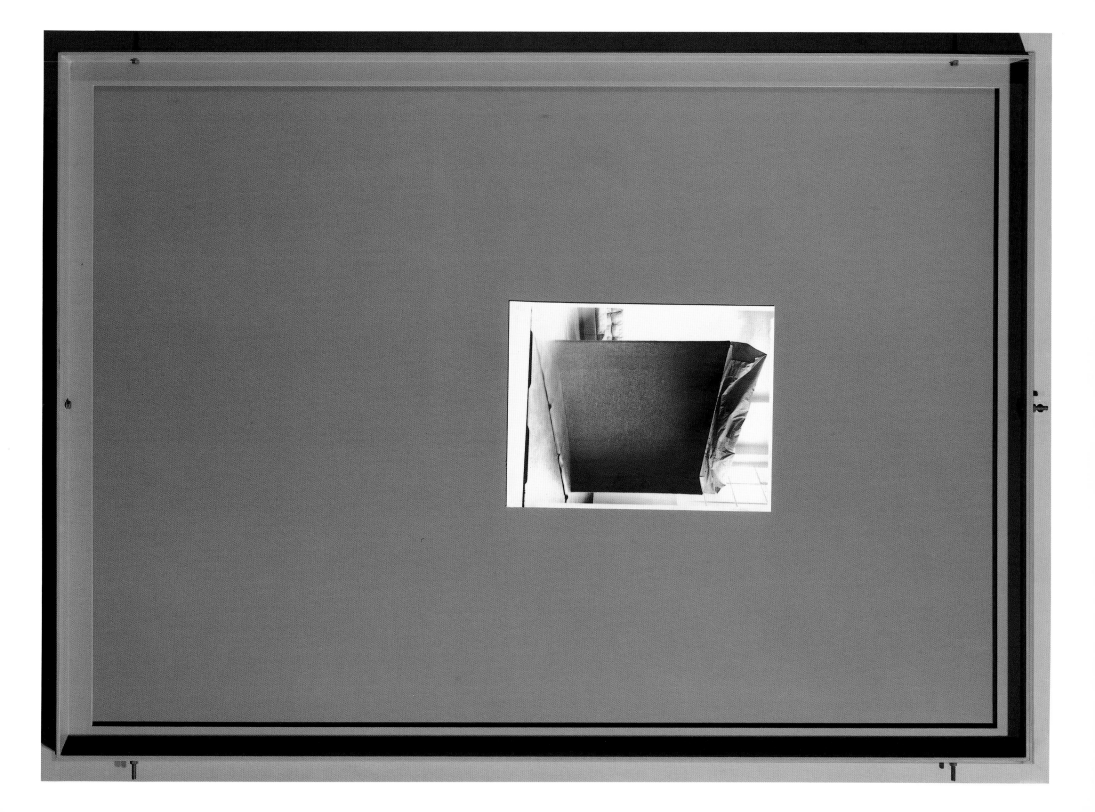

#23

a *From: Infiltration Homogeneous for Grand Piano 1966*
 Aus: Infiltration homogen für Konzertflügel

b *ROOM 563 x 491 x 563 with Fat Corners and Dismantled Air Pumps 1968*
 RAUM 563 x 491 x 563 mit Fettecken und auseinandergerissenen Luftpumpen

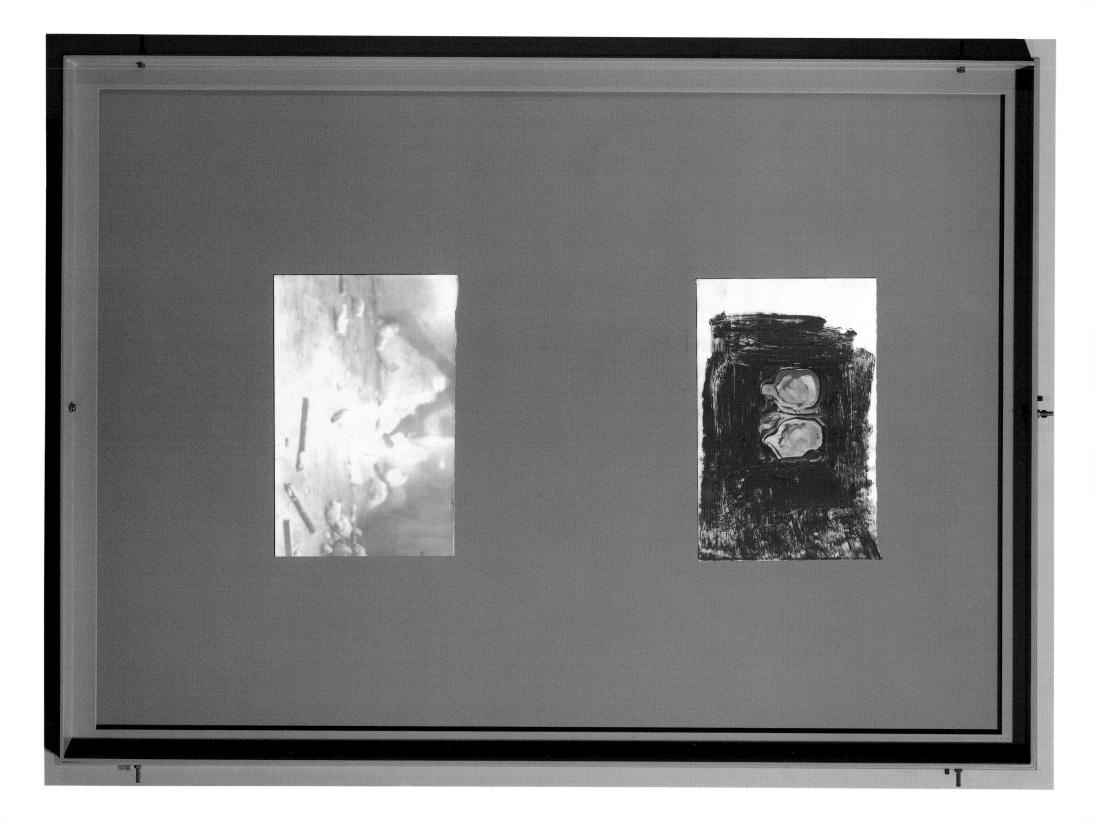

#24 a *Lateral Bordered Line*
Seitlich begrenzte Linie
(detail from *Barraque D'Dull Odde* 1961–1967)

b *Funnel* 1965
Trichter

c *Celtic + ∿∿∿∿* 1971

d (Celebration of Beuys's fiftieth birthday at the Düsseldorf Art Academy) 1971

#25

a **24 Hours: and in us . . . under us . . . landunder 1965**
24 Stunden: und in uns . . . unter uns . . . landunter

b **Silent Gramophone (I) 1961**
stummes Grammophon (I)

c **(not identified)**

114

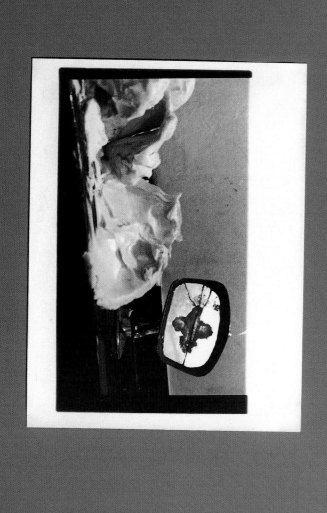

#26 a *Titus/Iphigenie 1969*

b *ROOM 563 x 491 x 563 with Fat Corners and Dismantled Air Pumps 1968*
RAUM 563 x 491 x 563 mit Fettecken und auseinandergerissenen Luftpumpen

c *Felt and Iron Elements from Actions 1963–1968*
Filz und Eisenelemente aus Aktionen
(installation view "Block Beuys")

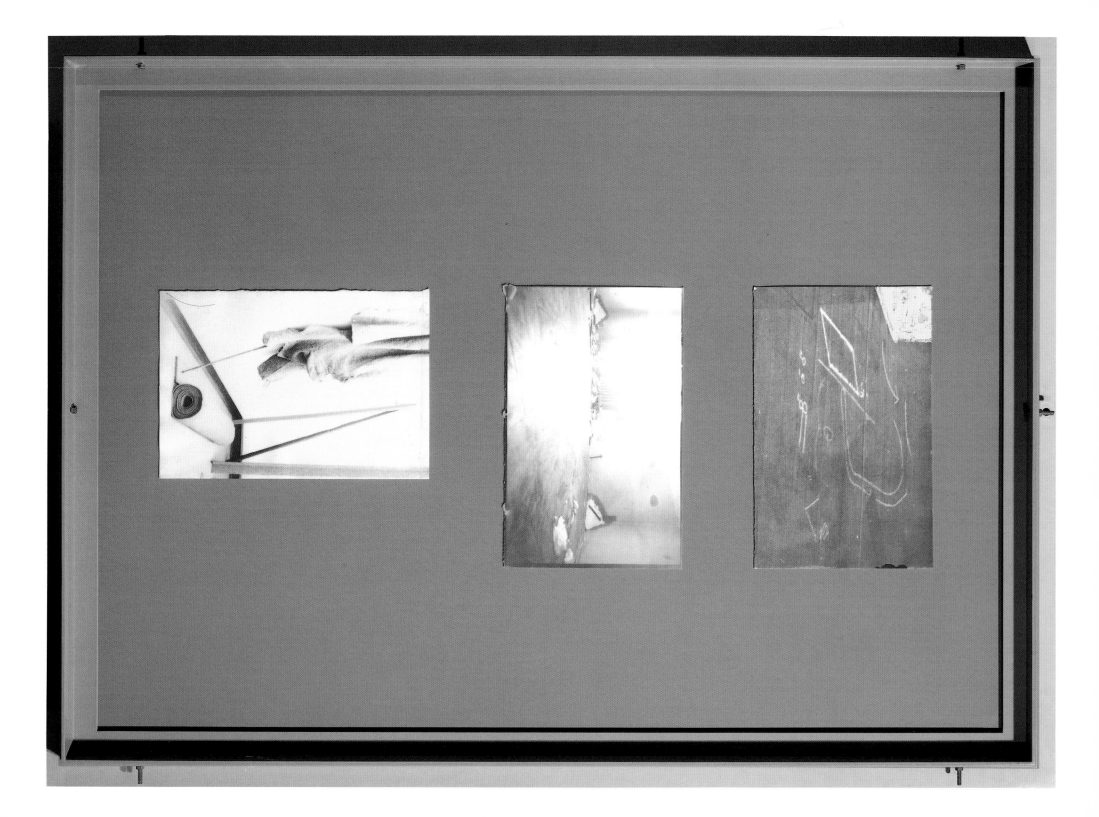

#27

a *Tin of Fat for Piercing (Acoustic) FLUXUS* 1963
 Fettdose zum Stechen (Akustik) FLUXUS

b *Neptune 1967*
 Neptun

c *Action Object from:*
 Aktionsobjekt aus: ⊃ →
 :»Hauptstrom»
 1967

d *Concentration Camp=Food 2 1960*
 KZ=Essen 2

e *. . . stayed too long on the ice 1953*
 . . . zu lange auf dem Eis geblieben

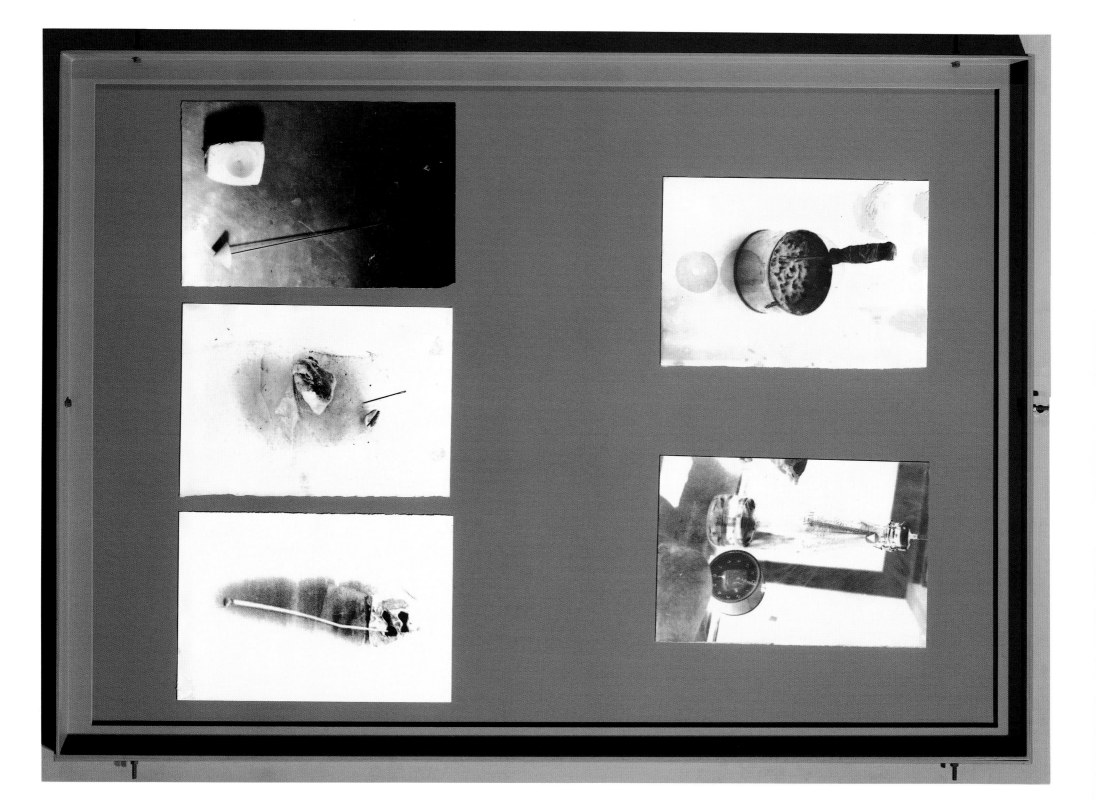

#28 a | *Fat Elements Fat-Felt 1963*
Fettelemente Fett-Filz

b | *Fat Battery 1963*
Fettbatterie

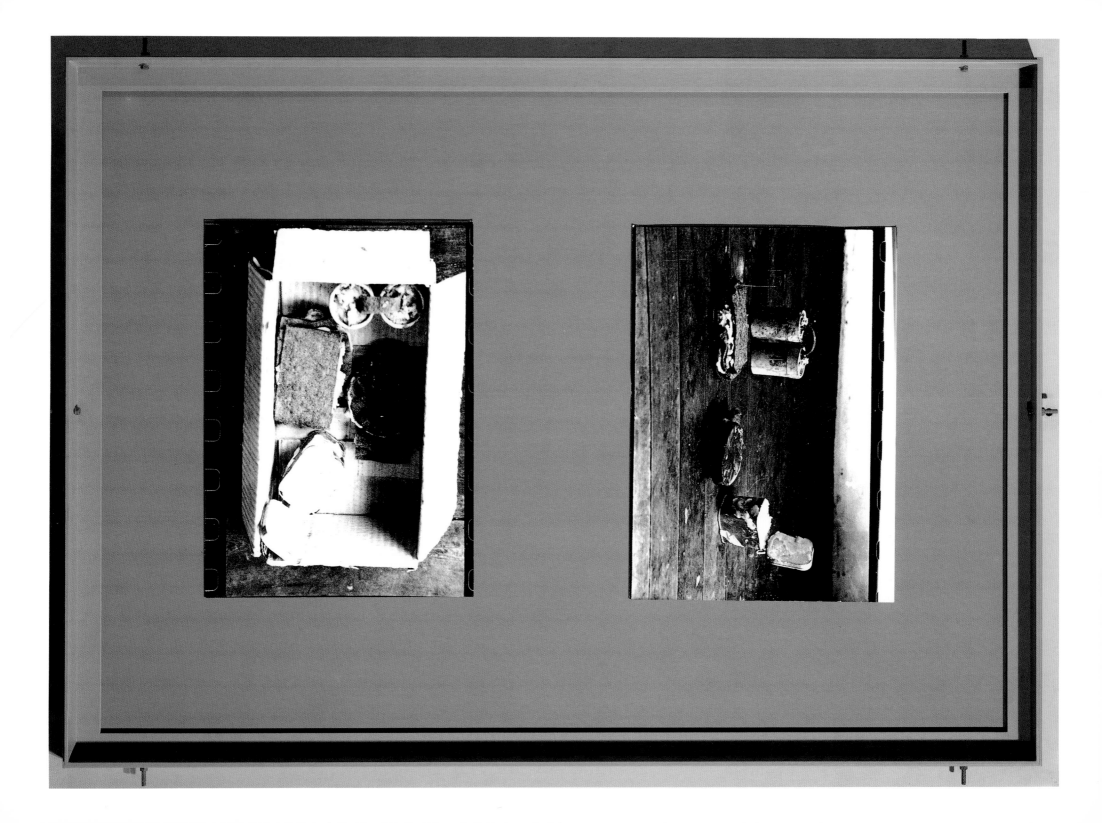

#29 a

Filter from:
Filter aus: ⊃→
:›Hauptstrom››
1967

b *(Dried Cod)* 1957
(Stockfisch)

Hammer for the Hard of Hearing 1963
Hammer für Schwerhörige

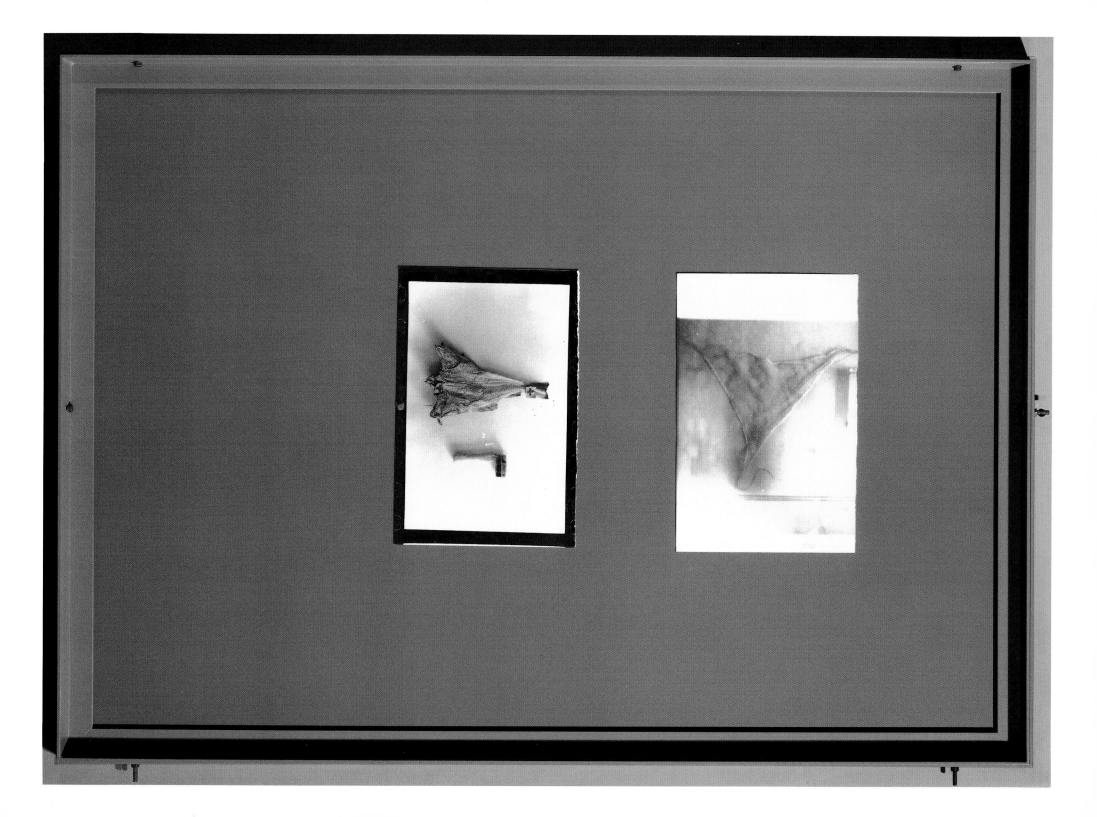

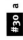

#30 a *Transmitter 1963*
Sender

b *Fat Sculpture 1952*
Fettplastik

c *The Pack (das Rudel) 1969*

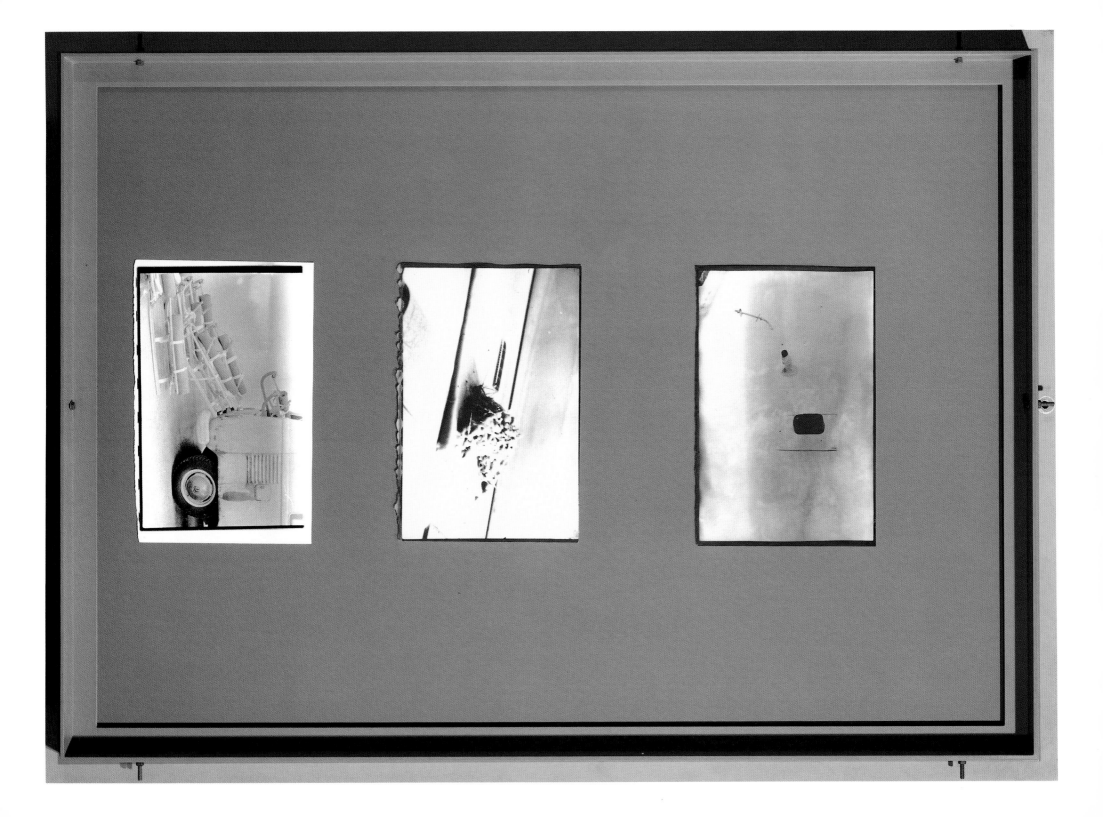

#31

a *EURASIAN STAFF 82 min fluxorum organum 1967*
 EURASIENSTAB 82 min fluxorum organum

b *Hand Action/Corner Action 1968*
 Handaktion/Eckenaktion

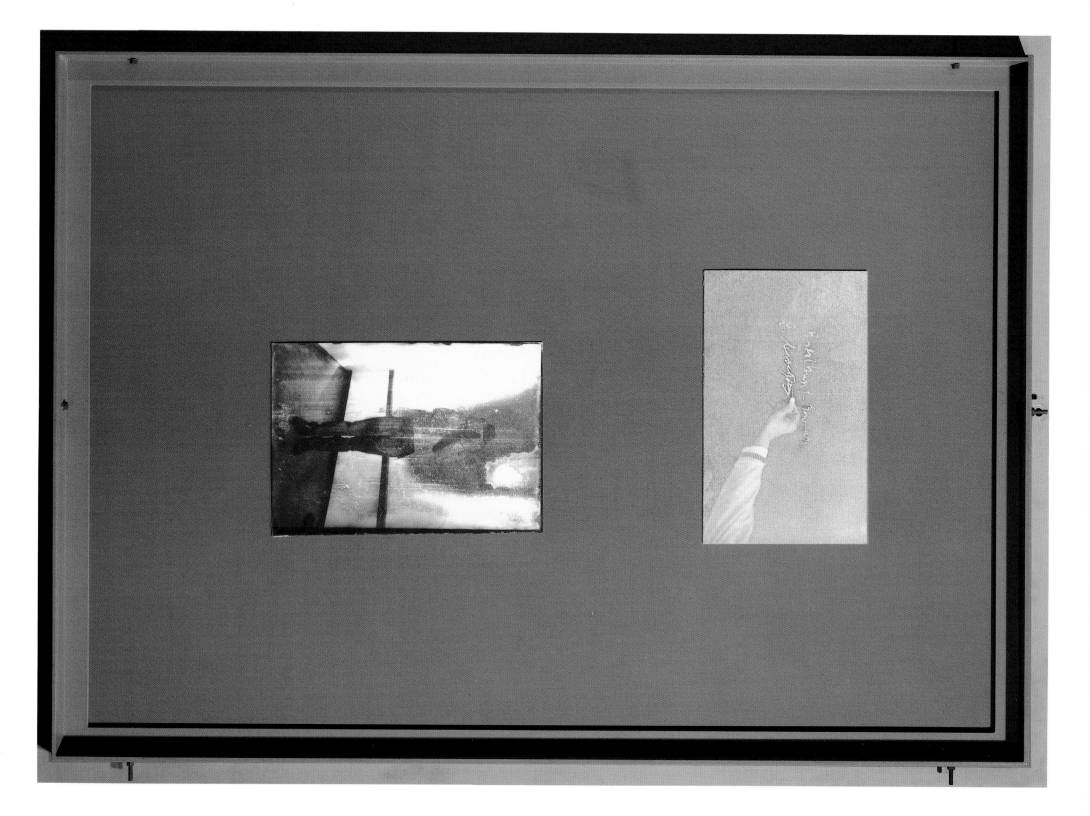

#32 a | *Hand Action/Corner Action 1968*
Handaktion/Eckenaktion

#33 a *Plastic Base Elastic Base 1969*
Plastischer Fuß Elastischer Fuß
(installation view "Prospect 69," Düsseldorf, 1969)

b *FOND III 1969*

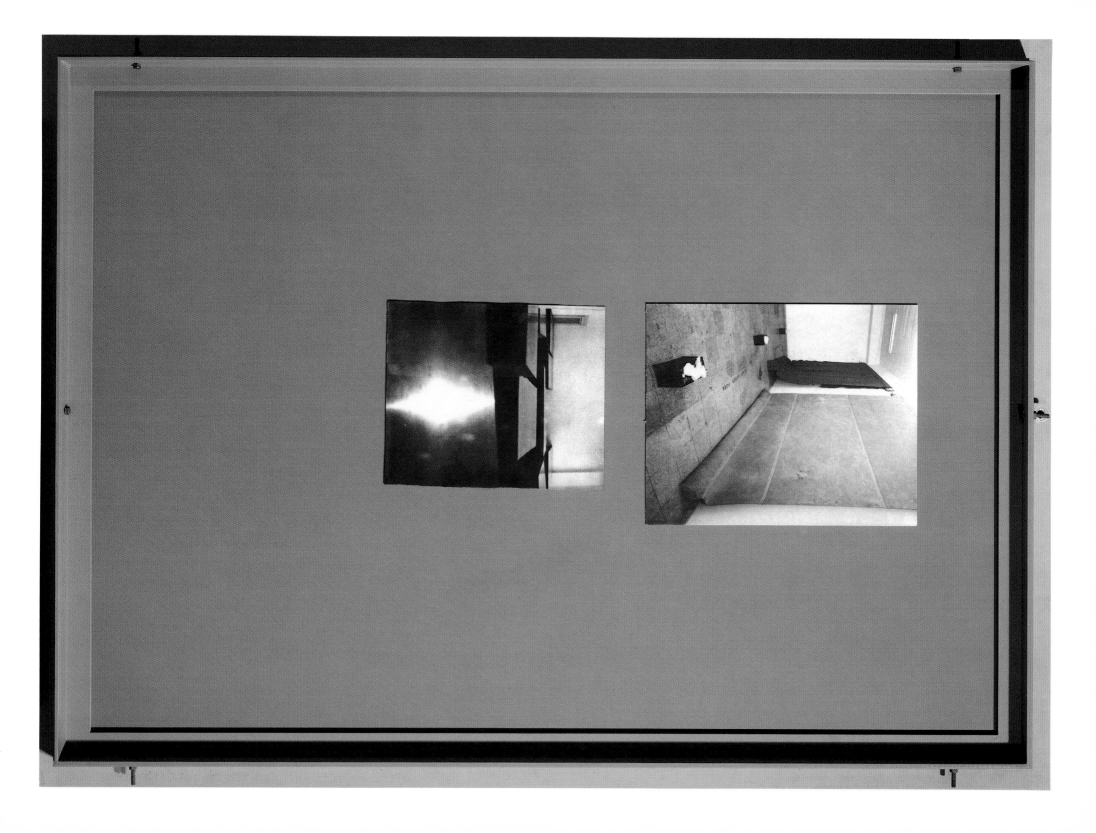

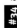 a │ (cleaning up during the course of the action *I attempt to set [make] you free, 1969* [*Ich versuche dich freizulassen (machen)*]).

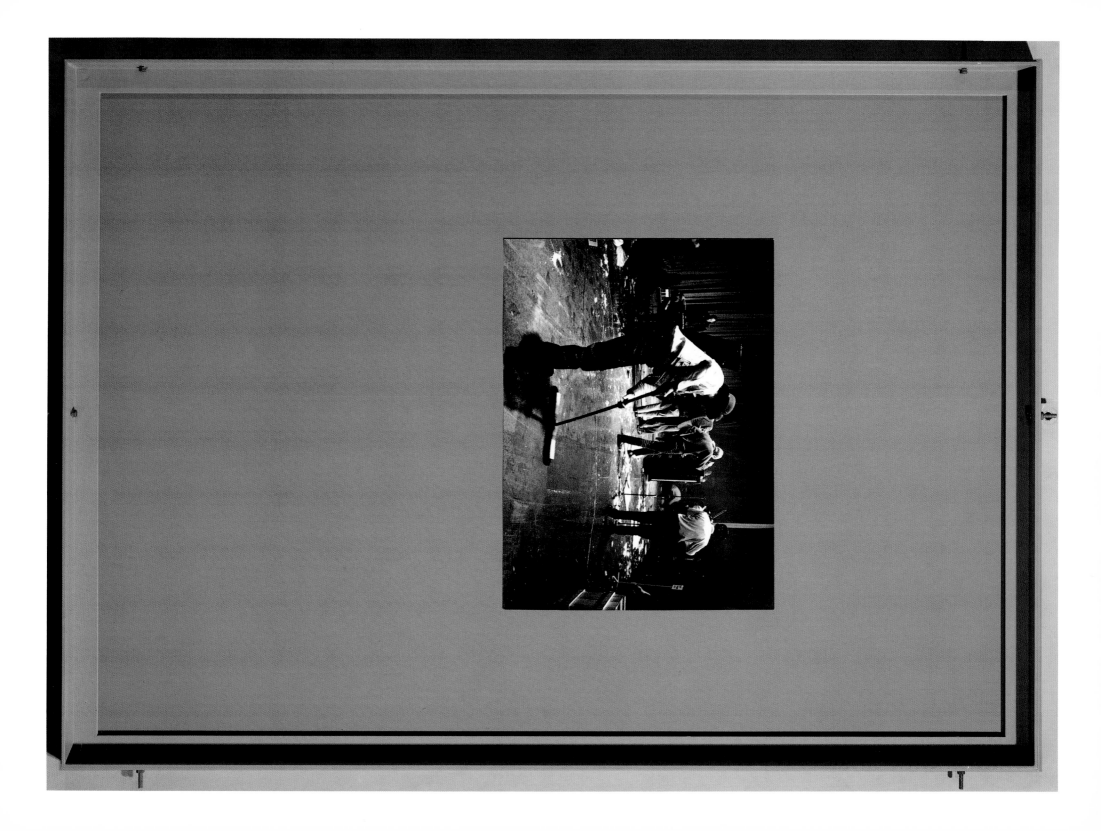

#35 a 24 Hours: and in us . . . under us . . . landunder 1965

24 Stunden: und in uns . . . unter uns . . . landunter

b *MANRESA* 1966

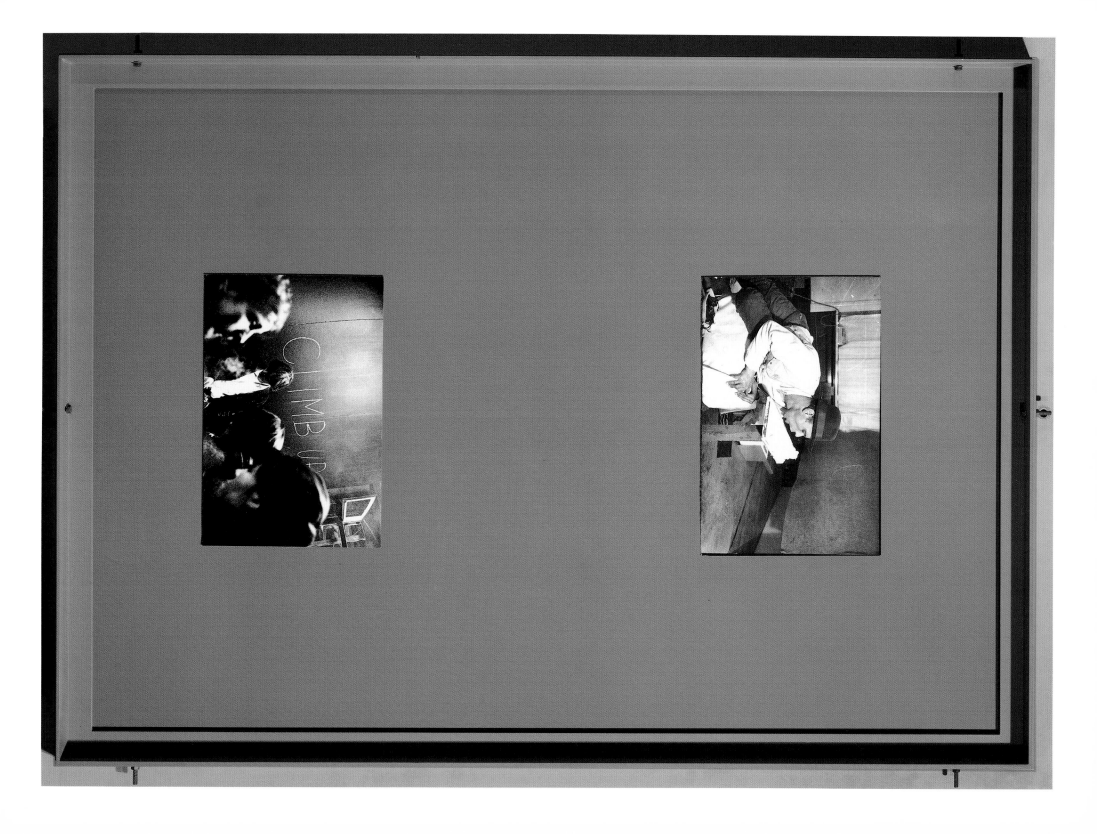

#36 a | *Samurai Sword (Sausage)* 1962
Samuraischwert (Wurst)

#37

a *From: Intelligence of Swans (scratched)* 1952
 Aus: Intelligenz der Schwäne (geritzt)

 Trap (copper) 1955
 Falle (Kupfer)

b *Gliding Sculptural Charge→before←Isolation Pedestal* 1960
 Anschwebende plastische Ladung→vor←Isolationsgestell

c *WEATHER TECHNICIAN* 1960
 WETTERWART

d *Untitled* 1963

a *24 Hours: and in us . . . under us . . . landunder 1965*
 24 Stunden: und in uns . . . unter uns . . . landunter

b *Vacuum↔Mass*
 Simultaneous=Iron box
 Halved Cross
 Contents: 20 kg fat
 100 air pumps 1968

 Vakuum↔Masse
 Simultan=Eisenkiste
 halbiertes Kreuz
 Inhalt: 20 kg Fett
 100 Luftpumpen

c *Grauballe Man 1952*
 Grauballemann

#39 a *Chair with Fat* 1963
Stuhl mit Fett

Project Westmensch 1963
Projekt Westmensch

Spade with 2 Handles (2x) 1964
Spaten mit 2 Stielen (2x)

(installation view "Block Beuys")

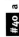

#40 a **Space Compass 1962**
Raumzirkel

b **Two Hares are Bombarding the Mysterious Village 1969**
zwei Hasen bombardieren das geheimnisvolle Dorf

c **Felt Corner 1964**
Filzecke

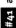

#41 a From: *Infiltration Homogeneous for Grand Piano 1966*
Aus: *Infiltration homogen für Konzertflügel*

146

#42 a *Scene from the Stag Hunt* 1961
Szene aus der Hirschjagd

b (Music room: home of Hans Ulrich and Clara Bodenmann, Basel) ca. 1969

c *3 Cast Crosses with 2 Toy Stopwatches* 1951
3 Wurfkreuze mit 2 Spielstoppuhren

d *The Flag Alan Khoa* 1956
Die Fahne Alan Khoa

e *PAN XXX ttt from: »24 Hours«* 1965
PAN XXX ttt aus: »24 Stunden«

#43 a (matriculation celebration) 1967

b Eurasian 1958
Eurasier

c Lightning 1964
Blitz

#44 a From: Eurasian Staff (Detail) 1967
Aus: Eurasienstab (Detail)

THE EARTH TELEPHONE 1967
DAS ERDTELEPHON

Infiltration Homogeneous for Grand Piano 1966
Infiltration homogen für Konzertflügel

Felt-TV II 1968
Filz-TV II

(installation view "Prospect 68," Düsseldorf, 1968)

b SITE (Fat Felt Sculpture) Complete with High-Voltage Alternating Current and Charged Copper
Plate 1967
STELLE (Fettfilzplastik) vollständig mit Hochspannungswechselstrom aufgeladener Kupferplatte

152

#45 a *I attempt to set (make) you free 1969*
Ich versuche dich freizulassen (machen)

b *24 Hours: and in us . . . under us . . . landunder 1965*
24 Stunden: und in uns . . . unter uns . . . landunter

c *24 Hours: and in us . . . under us . . . landunder 1965*

d *EURASIAN STAFF 82 min fluxorum organum 1968*
EURASIENSTAB 82 min fluxorum organum

154

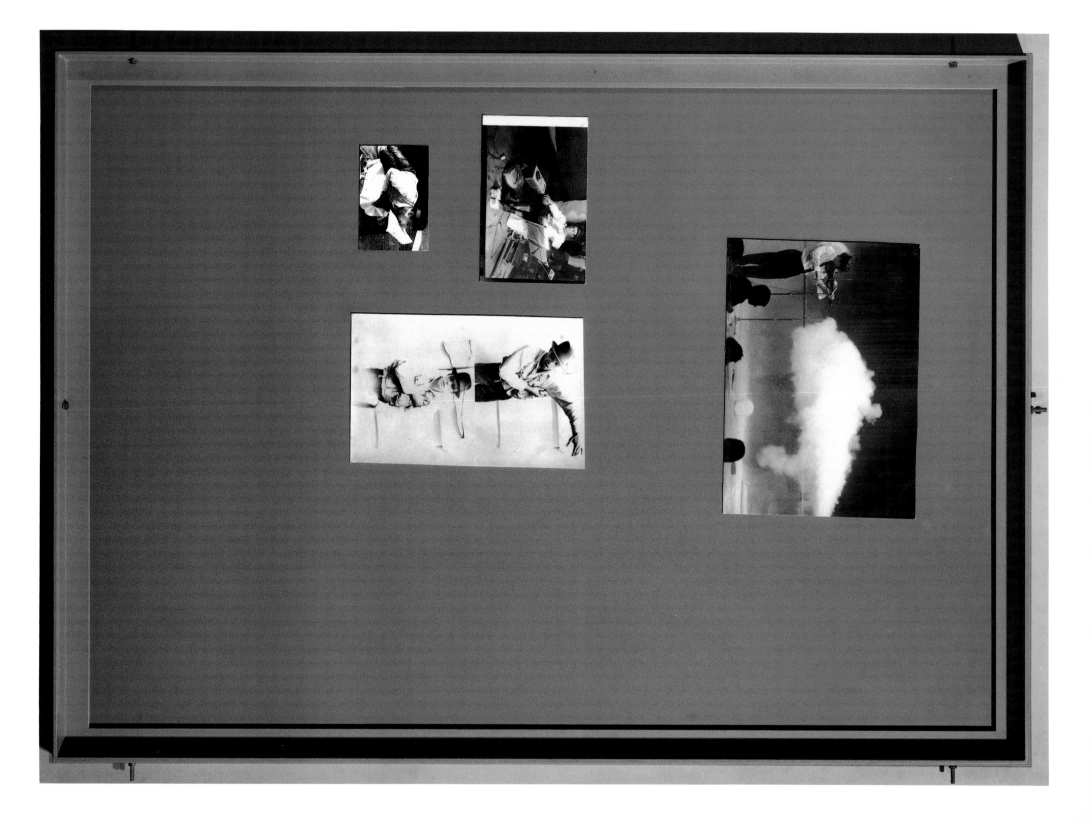

#46 a *EURASIAN STAFF 82 min fluxorum organum 1967*
EURASIENSTAB 82 min fluxorum organum

b *Action the dead mouse/Isolation Unit 1970*

c *Gliding Sculptural Charge→before←Isolation Pedestal 1960–1969*
Anschwebende plastische Ladung→vor←Isolationsgestell

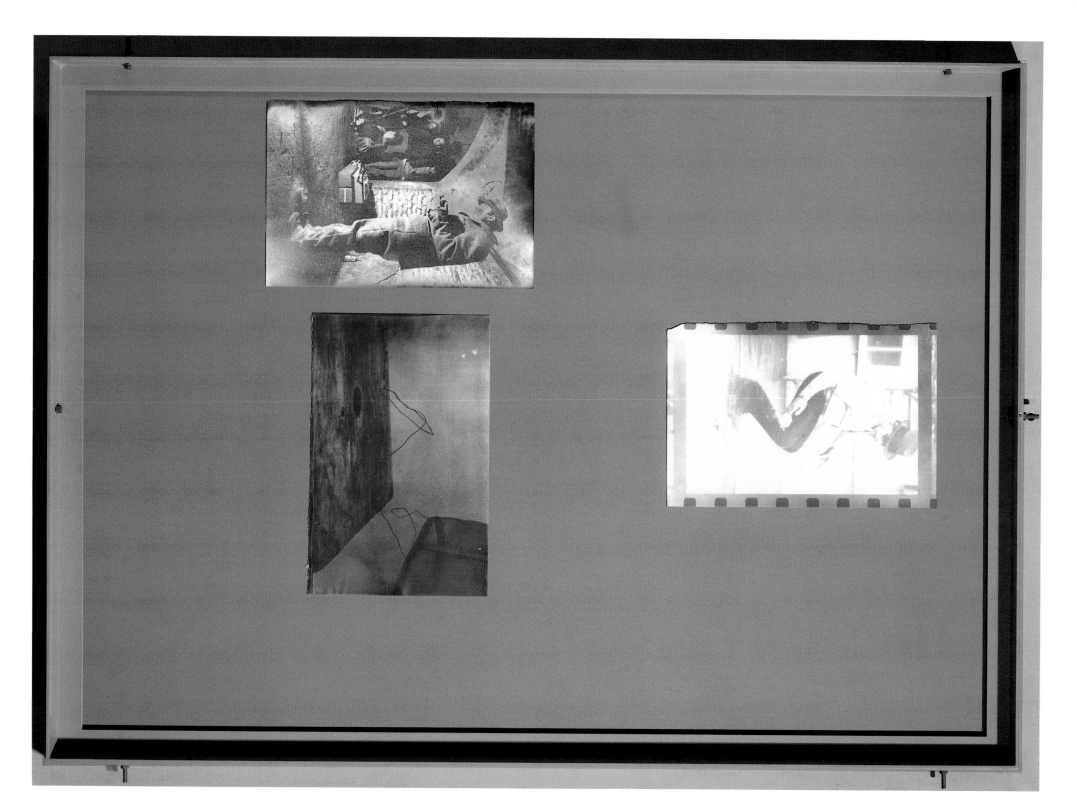

#47

a *Transsiberian Train 1961*
 Transsibirische Bahn

b *(Dried Cod) 1957*
 (Stockfisch)

c *From: The silence of Marcel Duchamp is overrated 1964*
 Aus: Das Schweigen von Marcel Duchamp wird überbewertet

d *Mountain King (Tunnel) 2 Planets 1958–1961*
 Bergkönig (Tunnel) 2 Planeten

e *Thunderstorm 1957*
 Gewitter

 BEUYS 1962

 Bees (Giocondology) 1963
 Bienen (Giocondologie)

 (close-up, Vitrine 1950–1967, "Block Beuys")

f *Bees (Giocondology) 1963*

 2 Loaves of Bread 1966
 2 Brote

 Fat Sculpture (transposed) Wax 1964
 Fettplastik (transponiert) Wachs

 Electrode (Fat-Felt) 1963
 Elektrode (Fett-Filz)

 (close-up, Vitrine 1950–1967, "Block Beuys")

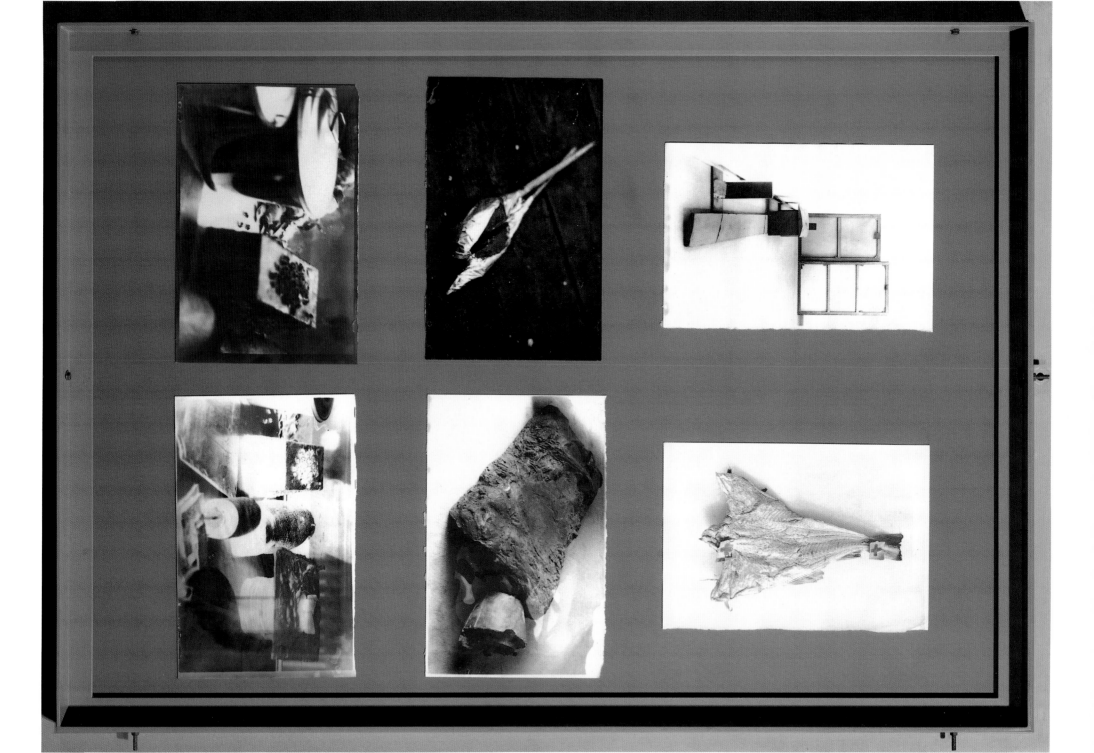

#48 a | *Fat Sculpture (transposed) Wax 1964*
| *Fettplastik (transponiert) Wachs*

#49 a | *Fat Corner 1963 (1968)*
Fettecke

#50 a *ROOM 563 x 491 x 563 with Fat Corners and Dismantled Air Pumps 1968*
RAUM 563 x 491 x 563 mit Fettecken und auseinandergerissenen Luftpumpen

b *Fat Corner 1963 (1968)*
Fettecke

164

#51 a *Two Hares are Bombarding the Mysterious Village* 1969
zwei Hasen bombardieren das geheimnisvolle Dorf

b (Johanna Beuys, the mother of Joseph Beuys) ca. 1966

#52 a | *LICHAMEN 1967*

#53 **a** *Room: Warmth-Time Machine (Aggregate)* 1958
Raum: Wärme-Zeitmaschine (Aggregat)
(positioned by Beuys for the camera, Drakeplatz 4, Düsseldorf)

b *Scene from the Stag Hunt* 1961
Szene aus der Hirschjagd
(in progress)

c *Project for Felt-Environment* 1965
Entwurf für Filz-Environment

#54 a | *From: IPHIGENIE 1969*
Aus: IPHIGENIE

b | *Snowfall 1965*
Schneefall

#55 a | (Joyce) 1961

#56 a *Celtic (Kinloch Rannoch) Scottish Symphony 1970*
 Celtic (Kinloch Rannoch) Schottische Symphonie

 b *Celtic (Kinloch Rannoch) Scottish Symphony 1970*

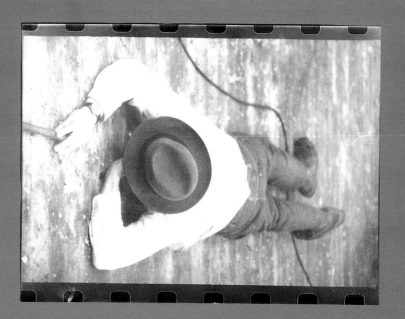

#57 a (Joseph Beuys) ca. 1966

b *ROOM 563 x 491 x 563 with Fat Corners and Dismantled Air Pumps 1968*
RAUM 563 x 491 x 563 mit Fettecken und auseinandergerissenen Luftpumpen

178

#58

a *Acoustic Filter 1962*
 akustischer Filter

b ⊃→
 :»Hauptstrom»»
 FLUXUS 1967

c *Action the dead mouse/Isolation Unit 1970*

#59 a

Acoustic Instrument from:
Akustisches Instrument aus:

∩→
:››Hauptstrom››
1967

#60 **a** *Untitled* 1956

b (title and year unknown, from "Block Beuys")

Electrode (Fat-Felt) 1963
Elektrode (Fett-Filz)

c (not identified)

∩ ↑
›››Hauptstrom››
FLUXUS 1967

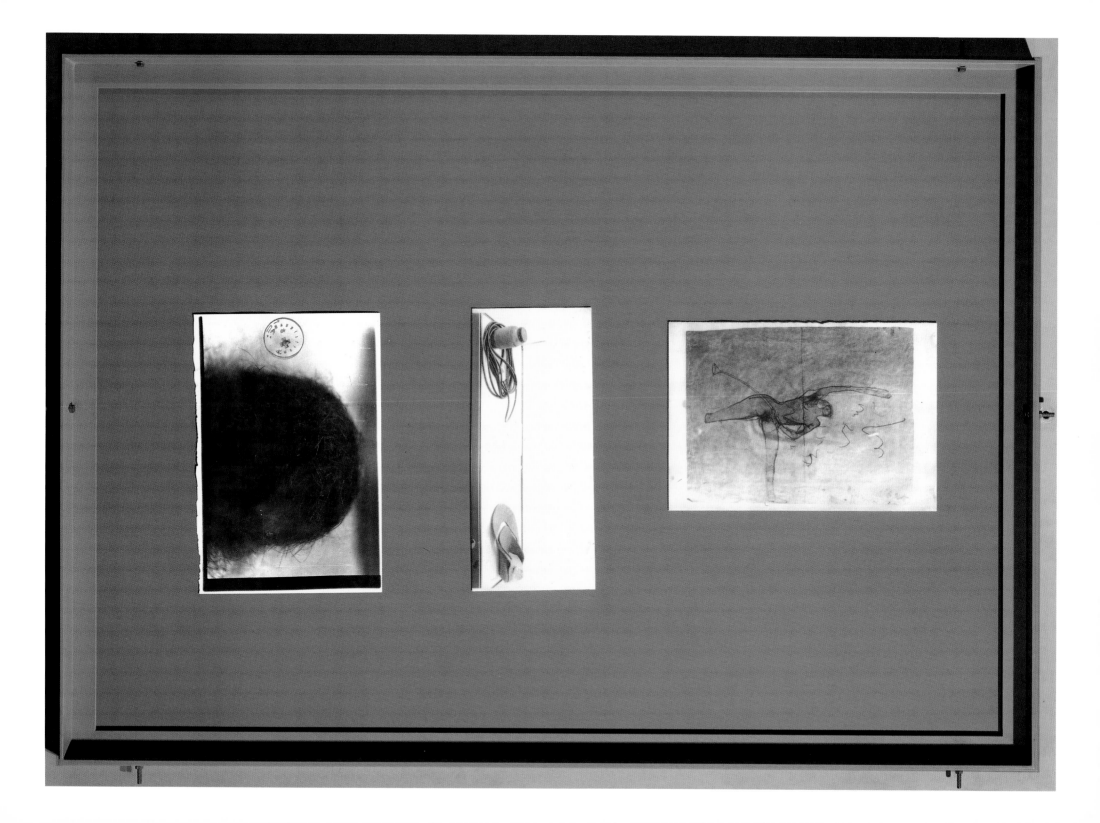

a *Variable Current Aggregate 1968*
 Wechselstromaggregat

b ⊃↑
 :›Hauptstrom›
 FLUXUS 1967

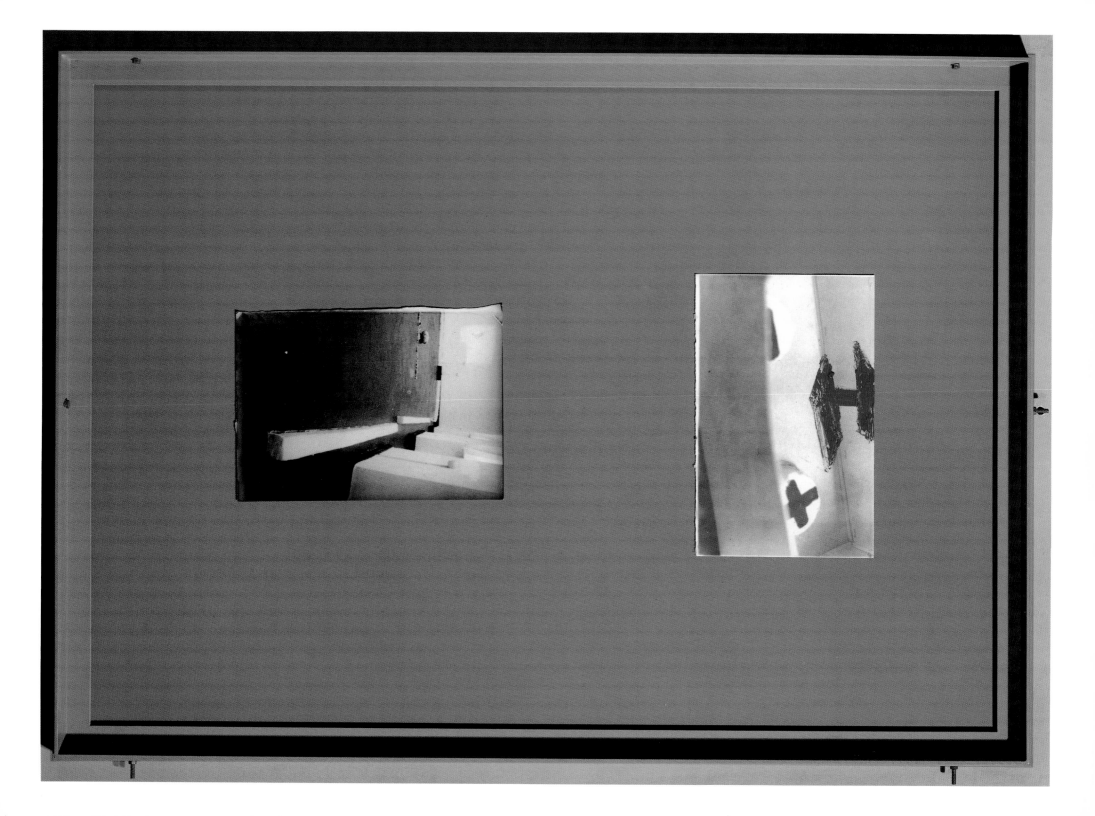

#62 a ∪→
.:»Hauptstrom»
FLUXUS 1967

b (catalogue cover design for "BEUYS," Stedelijk Van Abbemuseum, Eindhoven,
from *MANRESA* 1966)

c *Object: 2 Rubber gloves + Felt pieces + F-Stop + Yellow filter*
Objekt: 2 Gummihandschuhe + Filzstücke + Lichtblende + Gelbfilter
(detail from *Barraque D'Dull Odde 1961–1967*)

d ∪→
.:»Hauptstrom»
FLUXUS 1967

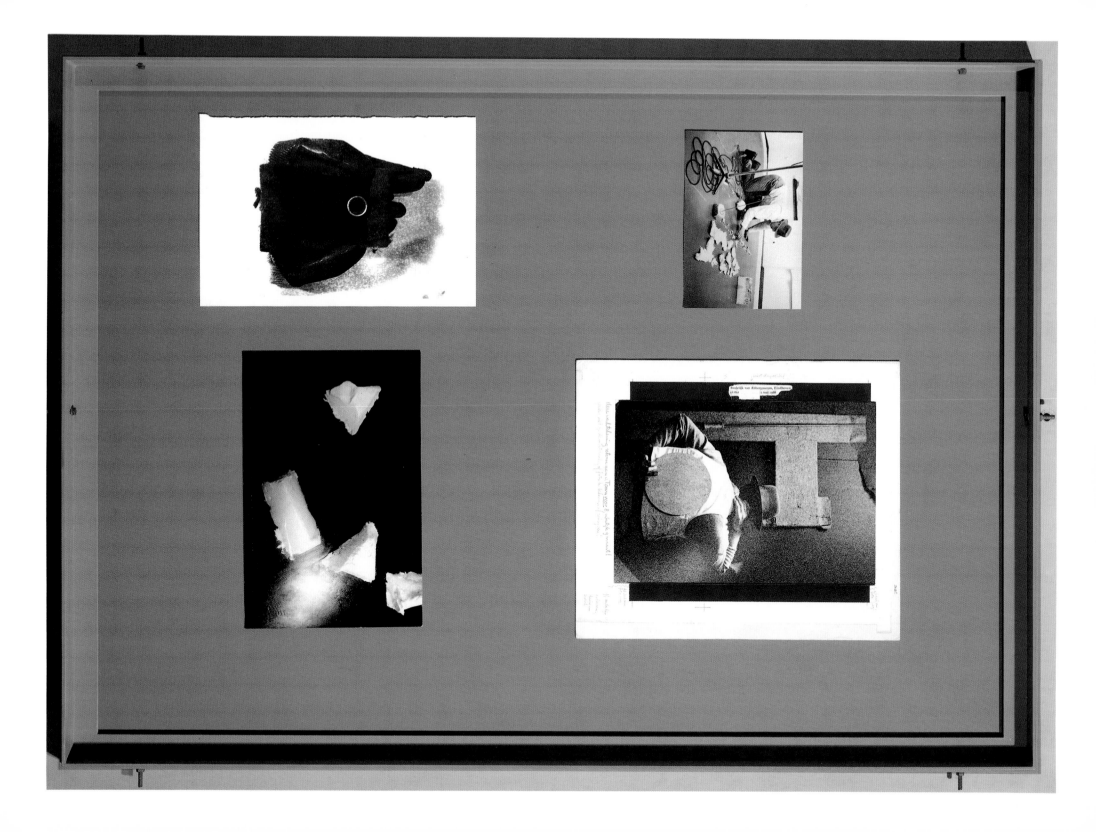

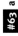**#63** a *From: Infiltration Homogeneous for Grand Piano 1966*
Aus: Infiltration homogen für Konzertflügel

b *(not identified)*

c *Felt TV 1970*
Filz TV

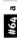**#64** a (photocopy with installation numbers to a vitrine in progress in "Block Beuys")

b *Celtic (Kinloch Rannoch) Scottish Symphony 1970*
Celtic (Kinloch Rannoch) Schottische Symphonie

c (photocopy with installation numbers to a vitrine from "Block Beuys")

d *Untitled 1963*

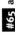

#65 a *Chair with Fat 1963*
Stuhl mit Fett

Fat Corner from: The silence of Marcel Duchamp is overrated 1964
Fettecke aus: Das Schweigen von Marcel Duchamp wird überbewertet

(installation view "Block Beuys")

b *ROOM 563 x 491 x 563 with Fat Corners and Dismantled Air Pumps 1968*
RAUM 563 x 491 x 563 mit Fettecken und auseinandergerissenen Luftpumpen

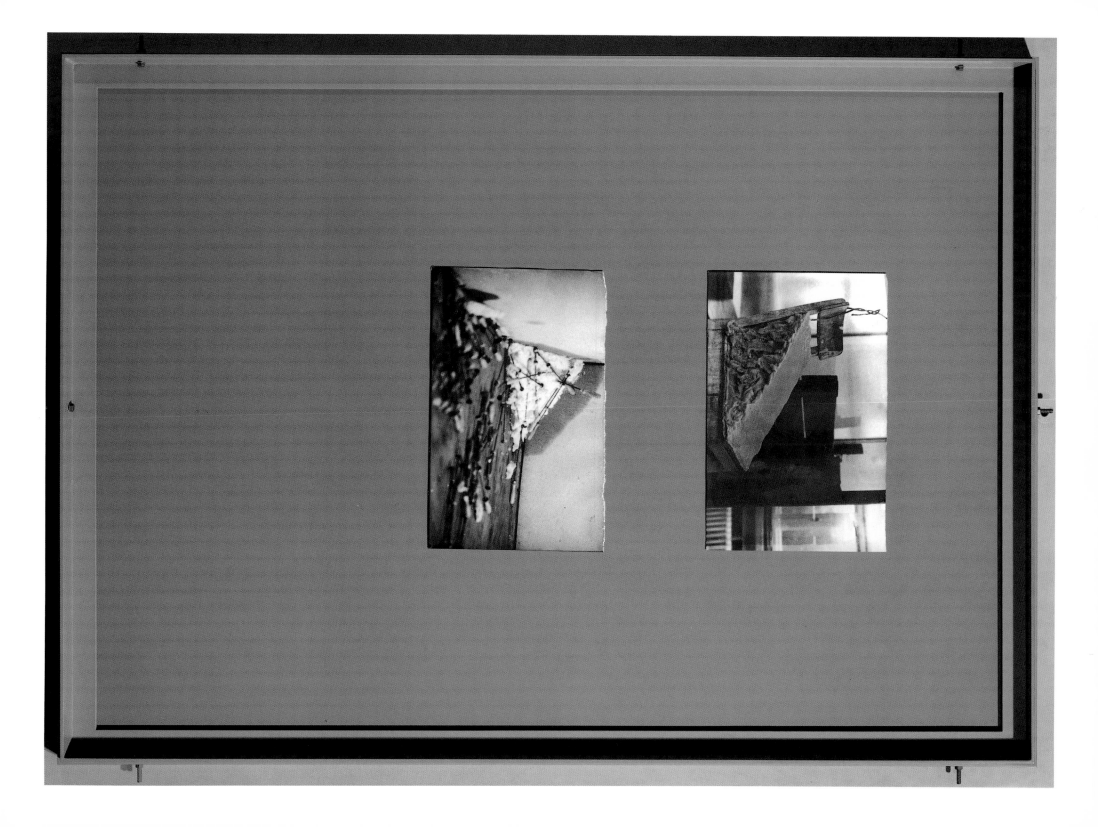

#66 a | *Titus/Iphigenie 1969*

b | *Titus/Iphigenie 1969*

#67 a *Barraque D'Dull Odde 1961–1967*
(depository 1 and 2; [lower left])

In front of the case:
Split Block of Wood with grey oil-based paint ("Bathing Trunks") + Small Butter Board
Gespaltener Holzklotz mit grauer Ölfarbenbemalung ("Badehose") + Butterbrettchen

"Hare": Parts of a wooden construction set
"Hase": Systembaukastenteile aus Holz

(installation view)

b *Barraque D'Dull Odde 1961–1967*
(depository 2 [lower left], installation view)

c *Barraque D'Dull Odde 1961–1967*
(depository 2 and 3 [lower left], installation view)

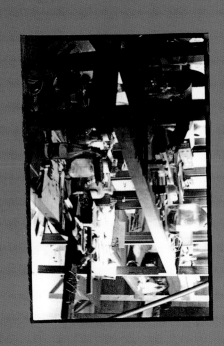
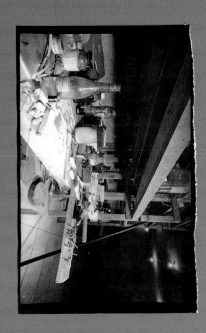

#68 a *Partitur (Score) to EURASIAN STAFF 1967*
Partitur zu EURASIENSTAB

b *Partitur to: The Greatest Contemporary Composer is the Thalidomide Child ca. 1966*
Partitur zu: Der größte Komponist der Gegenwart ist das Contergankind

c *Champagne-chalk with Needle*
Champagnerkreide mit Nadel
(detail from Barraque D'Dull Odde 1961–1967)

d *Champagne-chalk with Needle*
(detail from Barraque D'Dull Odde 1961–1967)

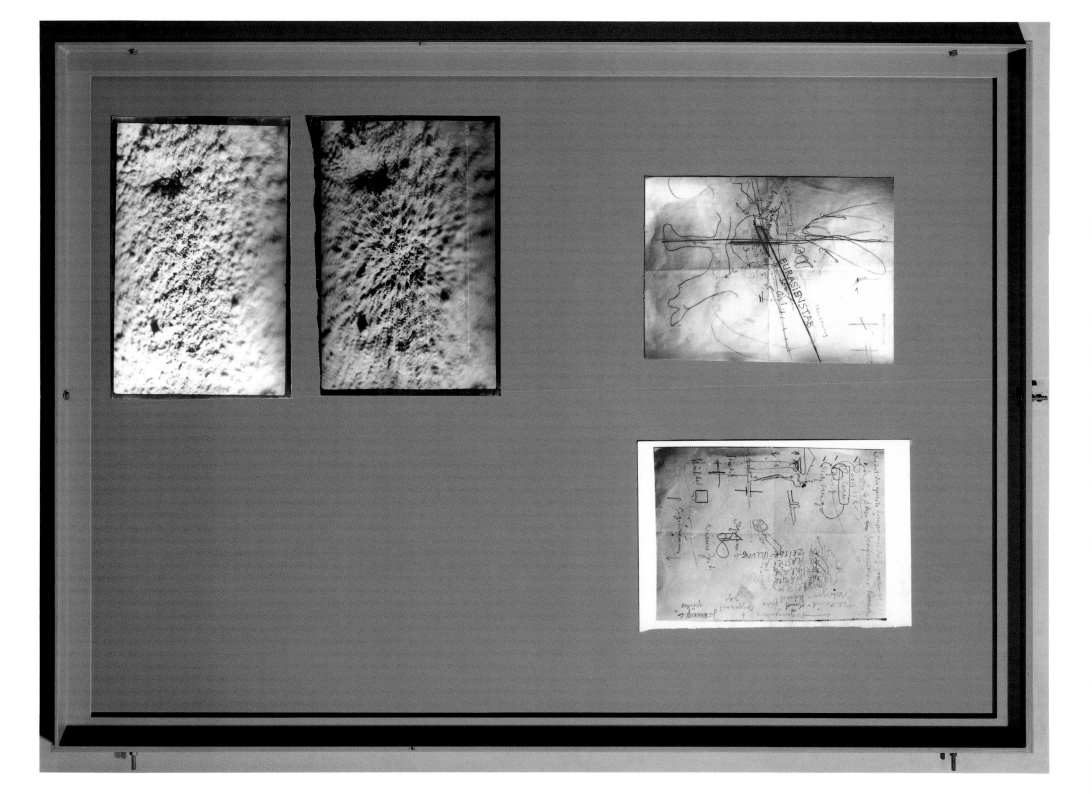

#69 a *Intuition Wood-Fat 1968*
Intuition Holz-Fett

b *Celtic (Kinloch Rannoch) Scottish Symphony 1970*
Celtic (Kinloch Rannoch) Schottische Symphonie

c *Revolutionary Piano 1969*
Revolutionsklavier

#70 a Wood Sausage 1962
 Holzwurst

 Emanator from: Vehicle art 1964
 Emanator aus: Vehicle art

 From: Actions/Agit Pop/de-Collage/Happening/Events/Antiart/L'Autrisme/Art Total/Refluxus July 20,
 1964 Aachen 1964
 Aus: Actions/Agit Pop/de-Collage/Happening/Events/Antiart/L'Autrisme/Art Total/Refluxus 20. Juli
 1964 Aachen 1964

 Monument of the Dwarves 1956
 Zwergendenkmal

 Girl 1956
 Mädchen

 (close-up, Vitrine 1949–1966, "Block Beuys")

 b Barraque D'Dull Odde 1961–1967
 (details from depository 2 [lower left])

 Tin can with brown color, closed + Brown Color
 Dose mit brauner Farbe, geschlossen + Braune Farbe

 Paper can, open, with brown color + Brown Color
 Papierdose, offen, mit brauner Farbe + Braune Farbe

 File case with stick + Brown Color
 Feilhelft mit Stock + Braune Farbe

 Bottle with de-ruster
 Flasche mit Entroster

 2 hubs + Brown Color
 2 Naben + Braune Farbe

 Clay relief with screaming head
 Tonrelief mit schreiendem Kopf

 Brake shoe + Brown Color
 Bremsbacke + Braune Farbe

 brown color - 3 dry pieces
 braune Farbe - 3 Trockenstücke

 scan: felt + wood + Brown Colo
 Abtaster: Filz + Holz + Braune Farbe

#71 a *Brown Head* 1968
 brauner Kopf

 Grave (shooting ground) 1951
 Grab (Schießplatz)

 (close-up, Vitrine 1949–1968, "Block Beuys")

 b *VAL (Vadrec [?])* 1961

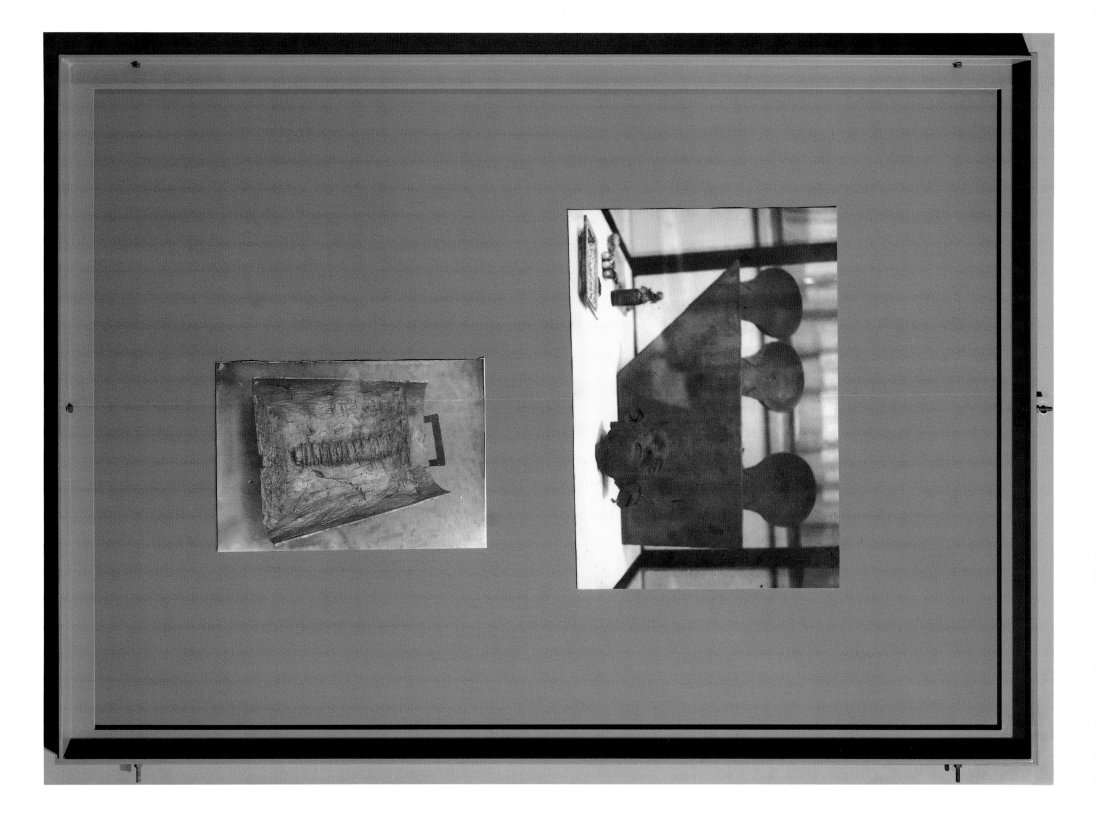

#72 a | *Electrode (Fat-Felt)* 1963
Elektrode (Fett-Filz)

b | *(Stag Leader)* 1968
(Hirschführer)

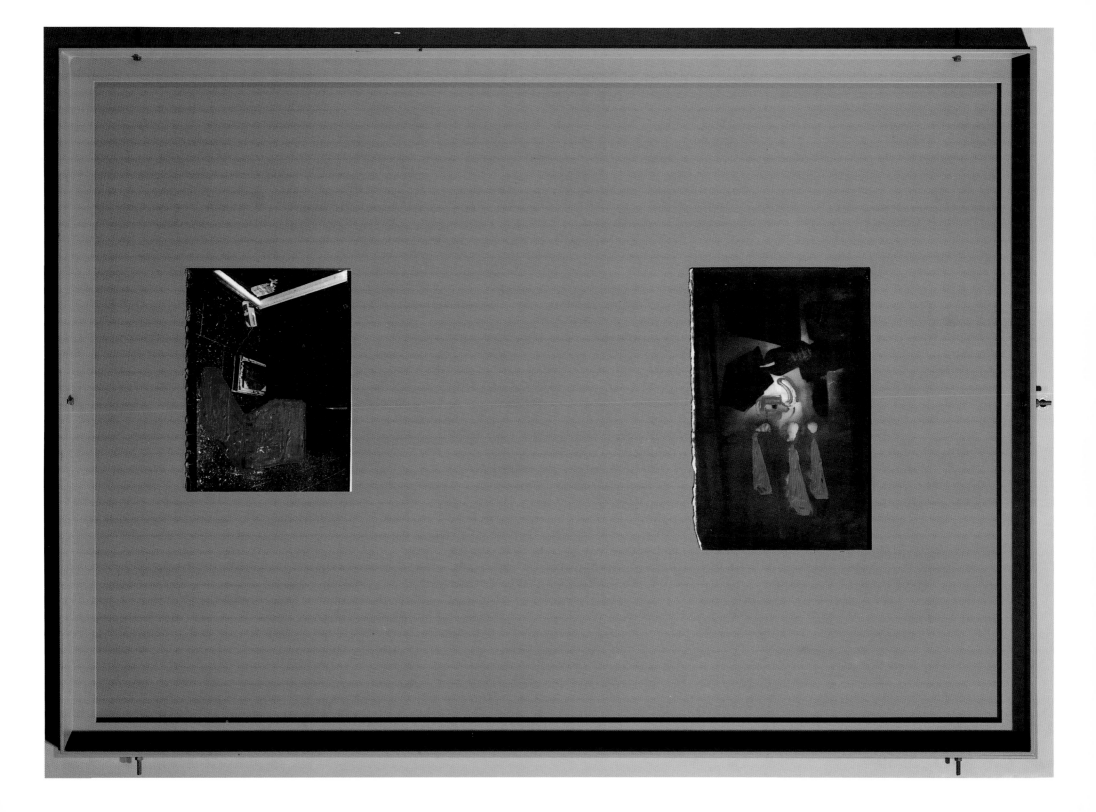

#73 a *Eurasian 1958*
Eurasier

b *Acoustic Filter 1962*
akustischer Filter

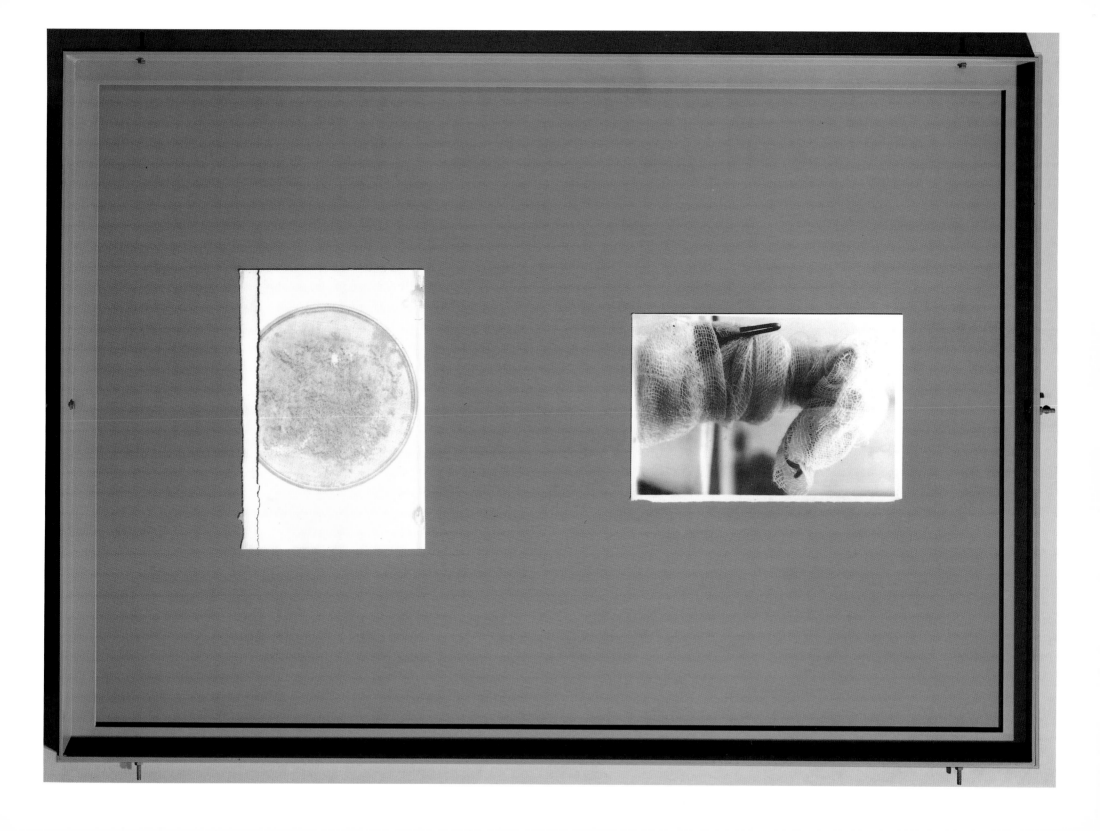

#74 **a** *Electric Object (static)* 1958
Electric Objekt (static)

Earth Cushion with Pedestal for Corner 1964
Erdkissen mit Gestell für Ecke

b *Hare Rods (EURASIA)* 1965
Hasenstangen (EURASIA)

Fat Filled with Powder (EURASIA) 1965
Fett gefüllt mit Puder (EURASIA)

Table I 1953
Tisch I

c (Beuys wrapping up the two halves of the *Eurasian Staff*: not part of an action)

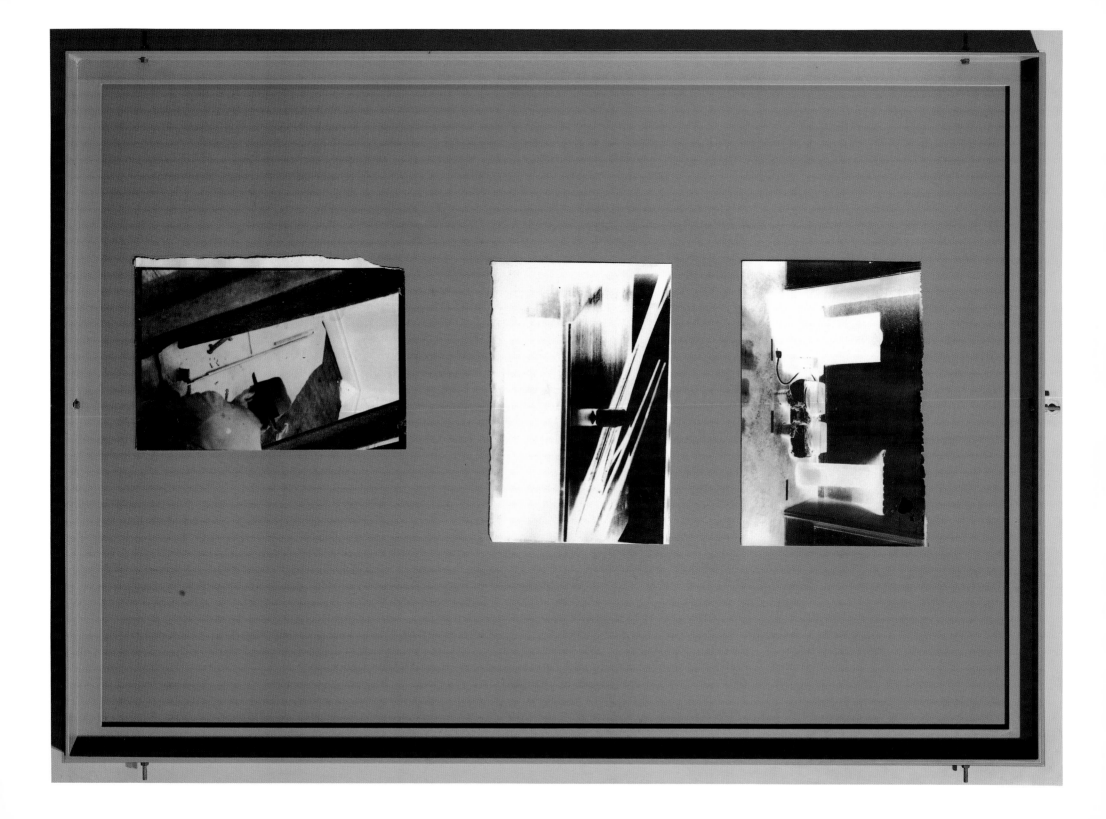

#75 a (not identified)

b *Hand Action/Corner Action 1968*
Handaktion/Eckenaktion

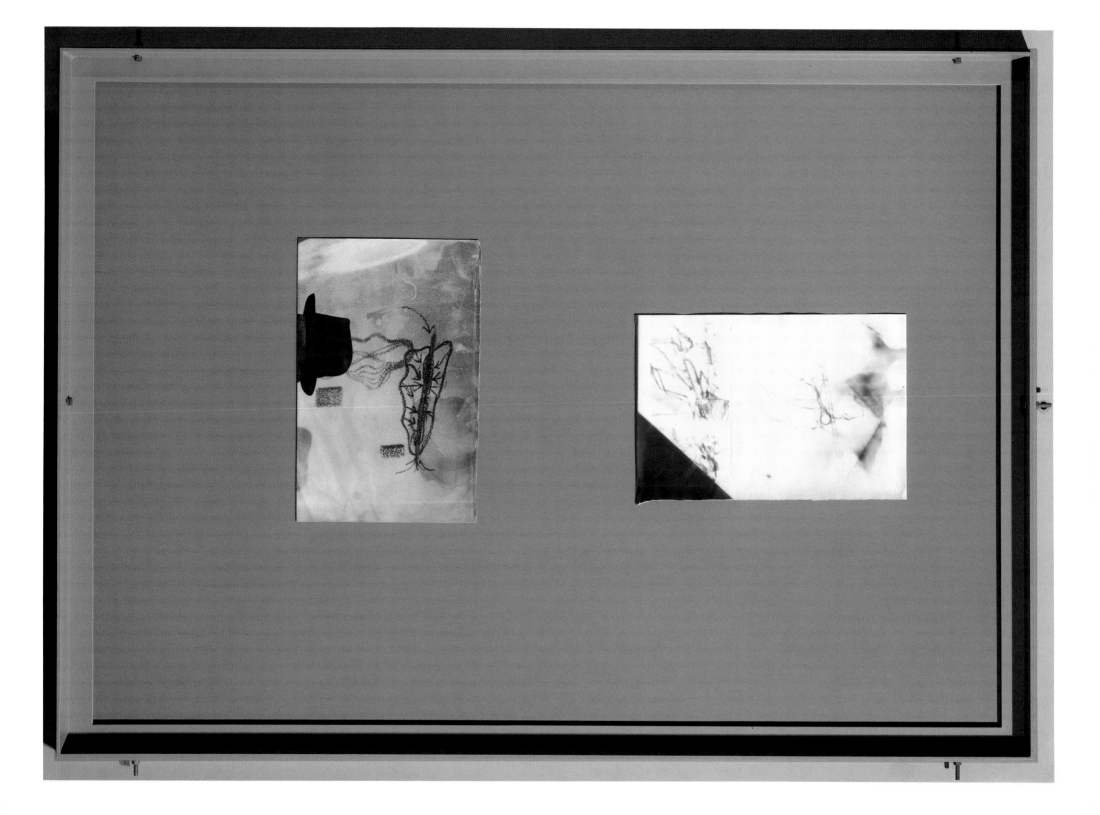

#76 a (not identified)

b *Drawing* 1959
Zeichnung

c *EVERVESS II* 1 1968
(positioned by Beuys for the camera, Drakeplatz 4, Düsseldorf)

d *Scene from the Stag Hunt* 1961
Szene aus der Hirschjagd

The Flag Alan Khoa 1956
Die Fahne Alan Khoa

(close-up "Block Beuys")

e *3 Cast Crosses with 2 Toy Stopwatches* 1951
3 Wurfkreuze mit 2 Spielstoppuhren

Queen Bee 3 1952
Bienenkönigin 3

Action Object from: ⊃→
Aktionsobjekt aus: *:»Hauptstrom»*
 1967

Queen Bee 2 1952
Bienenkönigin 2

Transformation Sign 1957
Transformationszeichen

Felt Sculpture 1963
Filzplastik

Tantalus from: ›and in us . . . under us . . . landunder‹ 1965
Tantalus aus: ›und in uns . . . unter uns . . . landunter‹

Stack 1964
Stapel

(installation view "Block Beuys")

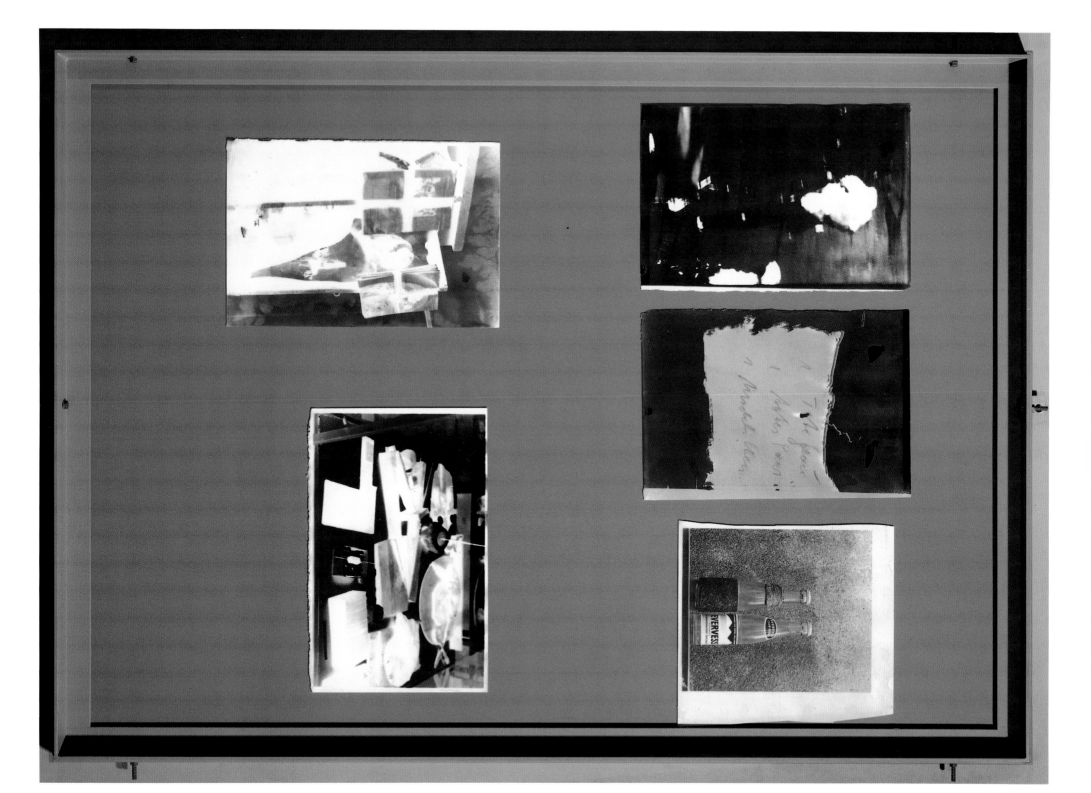

#77 a *High Voltage-High Frequency Generator for FOND II* 1968
Hochspannungs-Hochfrequenz-Generator von FOND II
(detail)

b Celtic + ⌃⌃⌃⌃⌃ 1971

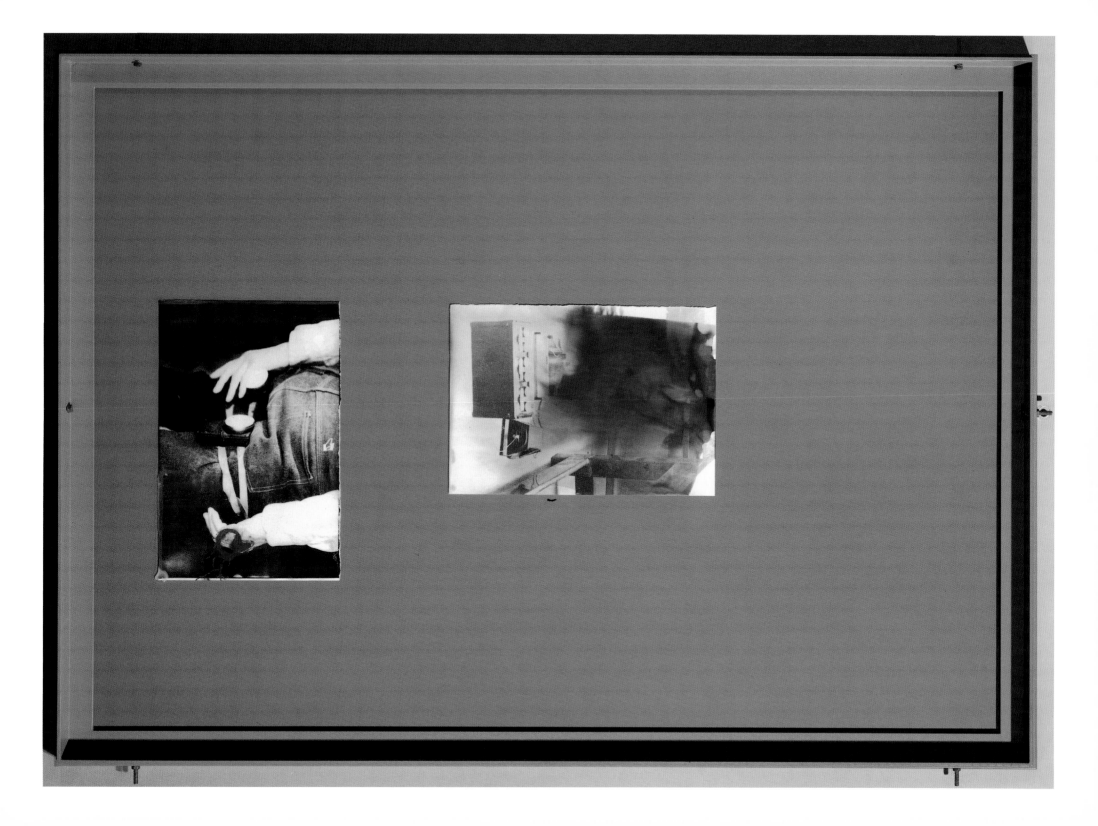

#78

a *Telephone* ca. 1969
 Telephon

b *EURASIAN STAFF 82 min fluxorum organum* 1967
 EURASIENSTAB 82 min fluxorum organum

c *Hand Action/Corner Action* 1968
 Handaktion/Eckenaktion

d *I want to see my mountains* 1971
 Voglio vedere i miei montagne

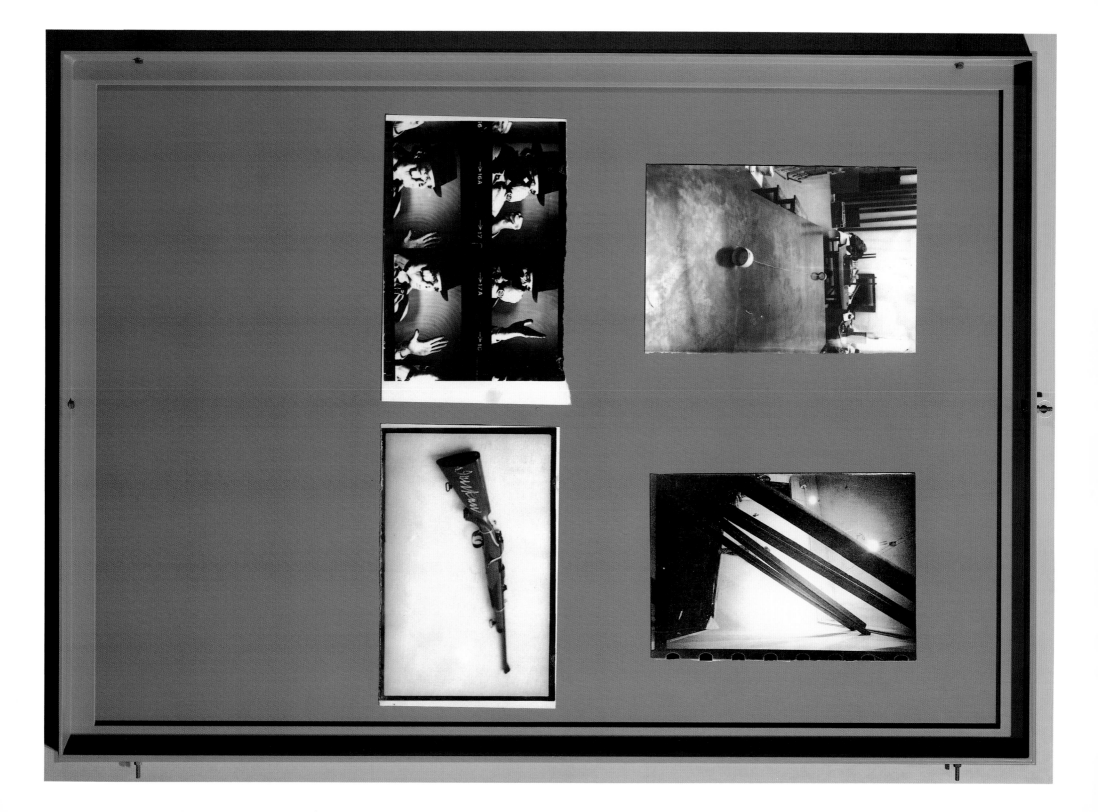

#79

a *Celtic +* ∿∿∿ **1971**

b *Celtic +* ∿∿∿ **1971**

c *Celtic +* ∿∿∿ **1971**

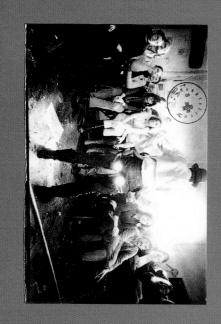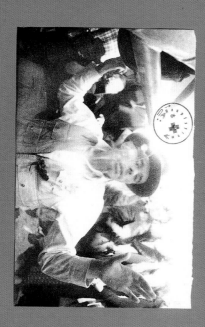

#80 a *Virgin* 1961
Jungfrau

b *Camera* 1963
Photoapparat

c *I want to see my mountains* 1971
Voglio vedere i miei montagne

d *I want to see my mountains* 1971

e *I want to see my mountains* 1971

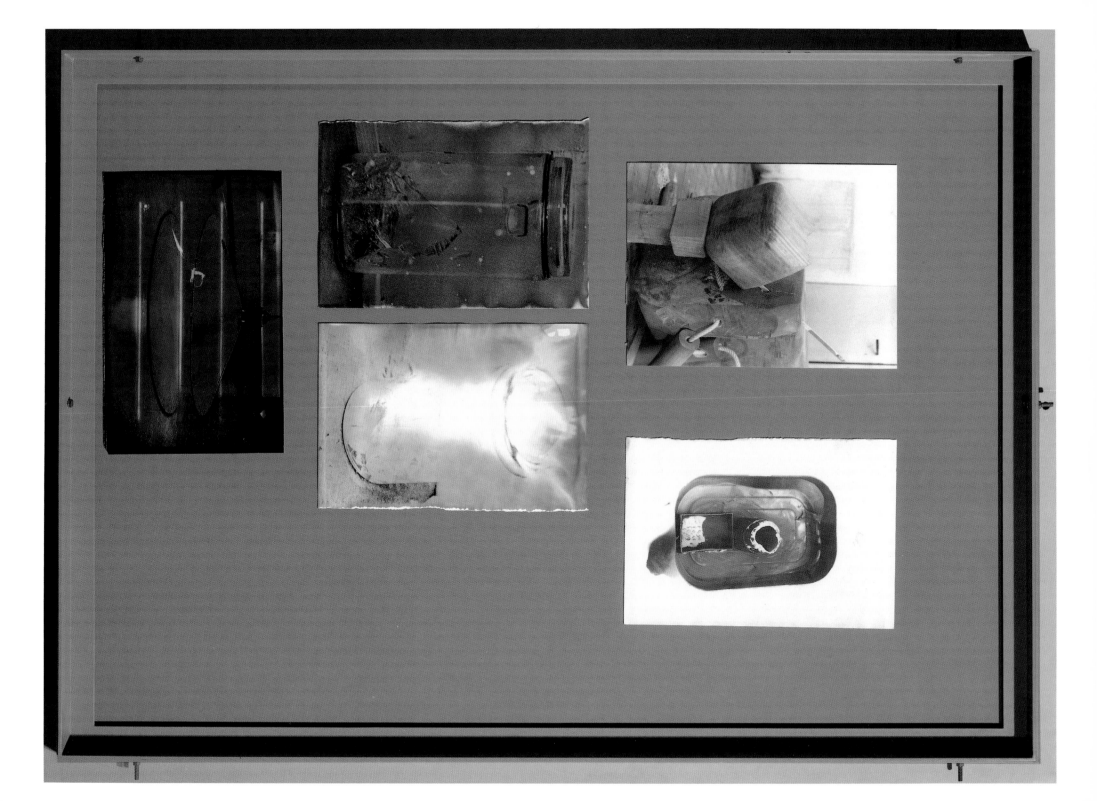

#81 a *Fat Figure with Filter 1961*
 Fettfigur mit Filter

 b (not identified)

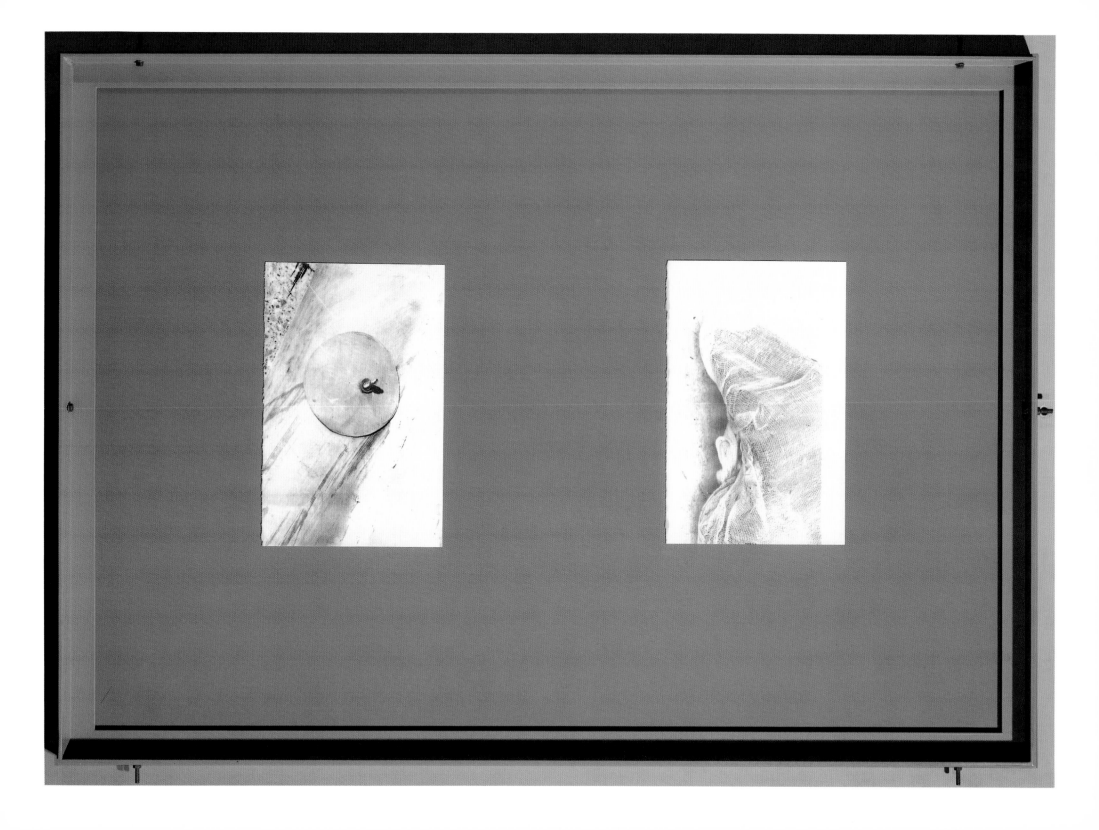

#82 a | (plate of yellow glass)

#83 a

Vacuum ↔ Mass
Simultaneous=Iron box
Halved Cross
Contents: 20 kg fat
 100 air pumps 1968

Vakuum ↔ Masse
Simultan=Eisenkiste
halbiertes Kreuz
Inhalt: 20 kg Fett
 100 Luftpumpen

b

Vacuum ↔ Mass
Simultaneous=Iron box
Halved Cross
Contents: 20 kg fat
 100 air pumps 1968

c

Vacuum ↔ Mass
Simultaneous=Iron box
Halved Cross
Contents: 20 kg fat
 100 air pumps 1968

d

Vacuum ↔ Mass
Simultaneous=Iron box
Halved Cross
Contents: 20 kg fat
 100 air pumps 1968

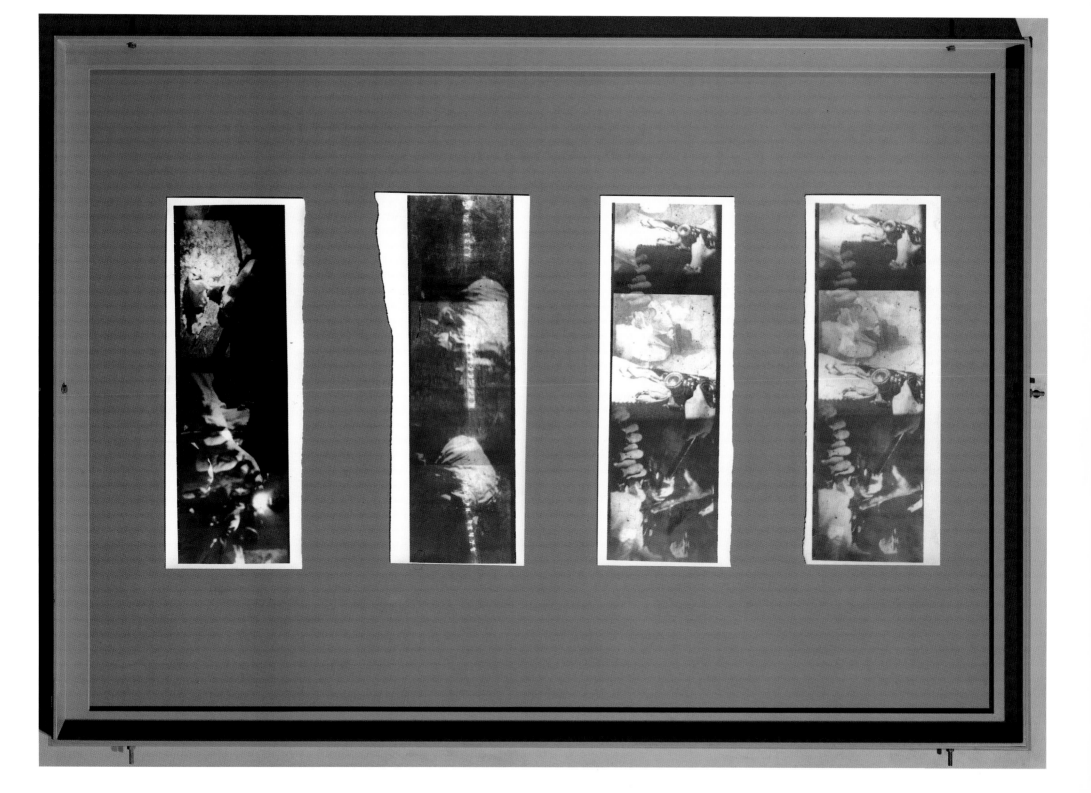

#84

a *FOND I 1957*

Chemicals and a Glass 1958
Chemikalien und ein Glas

(installation view "Block Beuys')

b ⊃→
:››Hauptstrom››
FLUXUS 1967

c *Eurasian Staff with 1 x 90 Degree Felt Corner 1967*
Eurasienstab mit 1 x 90 Grad Filzwinkel

ELEMENT 1 and parts of ELEMENT 2 (complete with high-voltage alternating current) [six parts] 1966
ELEMENT 1 und Teile von ELEMENT 2 (vollständig mit Hochspannungswechselstrom) [sechs Teile]

Warm Chair with Felt Sole, Iron Sole, and Magnet 1965
warmer Stuhl mit Filzsohle, Eisensohle und Magnet

Felt Roll from: The Chief 1964
Filzrolle aus: Der Chef

(installation view "Block Beuys")

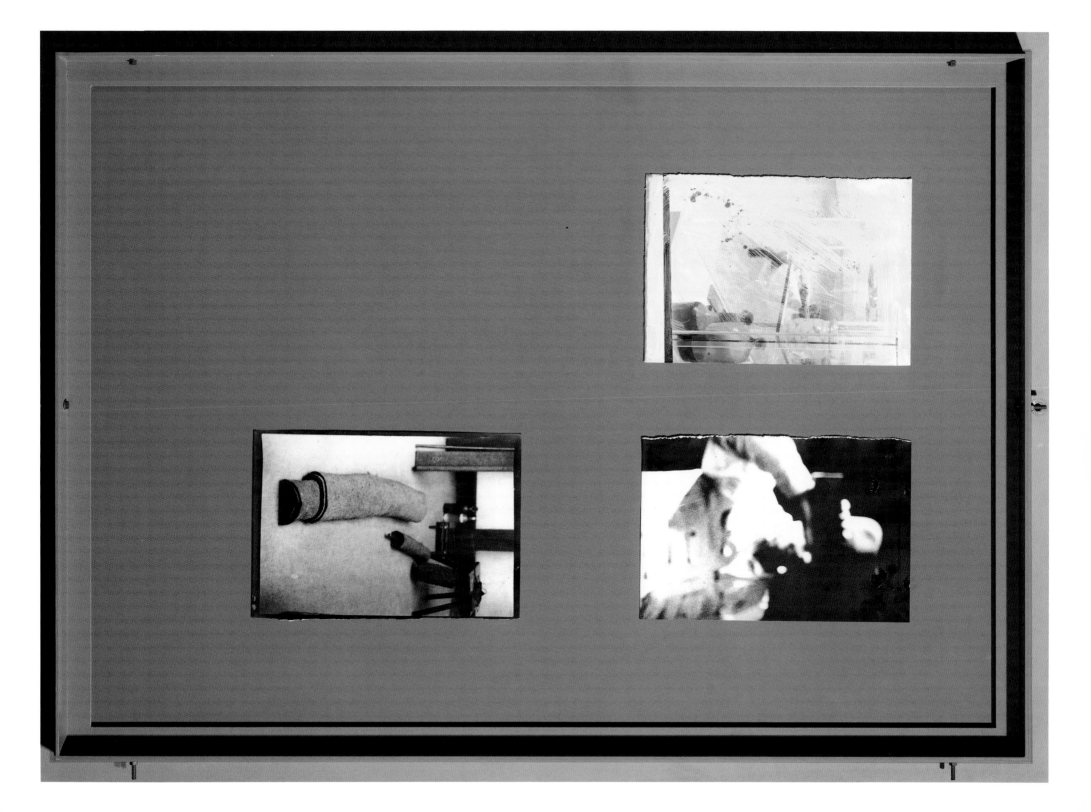

#85 a | (plate of blue glass)

#86 a *Gelatin-Object 1968*
Gelose-Objekt

b *Train: Fat-Felt-Sculpture 1963*
Zug: Fett-Filz-Plastik

 Untitled (Felt-Canvas) 1967
ohne Titel (Filz-Leinwand)

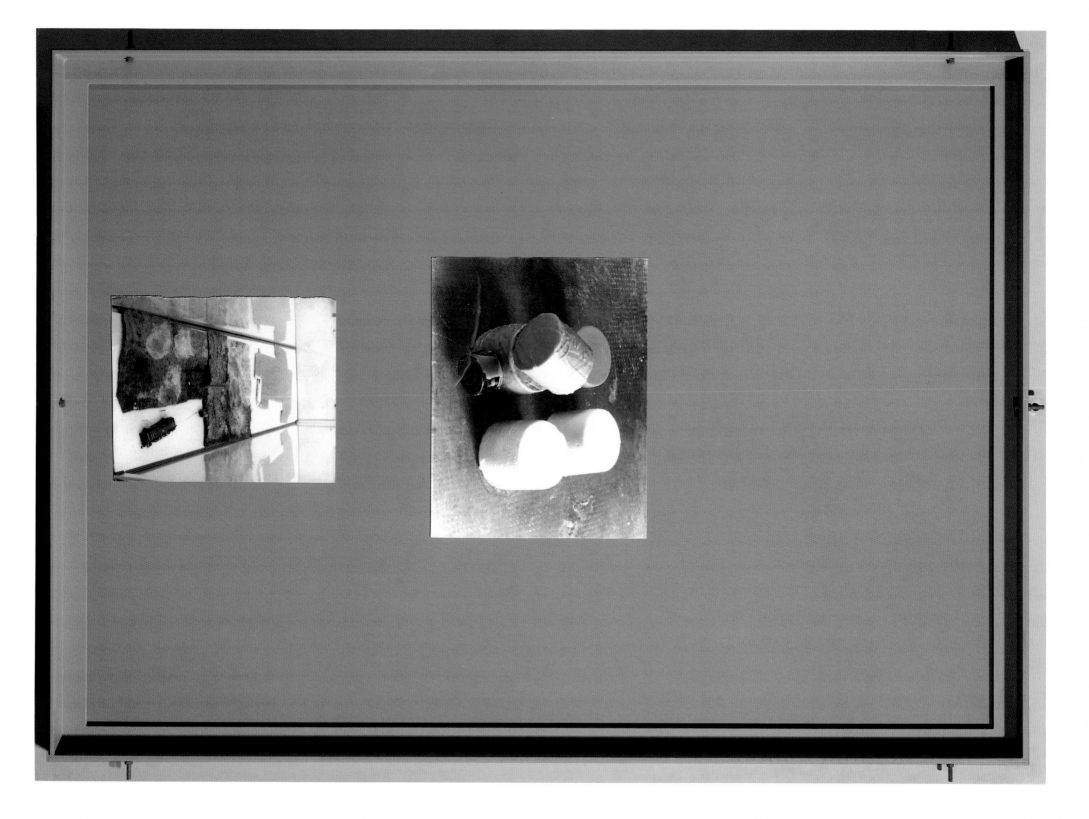

#87 a

Vacuum ↔ Mass
Simultaneous=Iron box
Halved Cross
Contents: 20 kg fat
 100 air pumps 1968

Vakuum ↔ Masse
Simultan=Eisenkiste
halbiertes Kreuz
Inhalt: 20 kg Fett
 100 Luftpumpen

b

⊃→
:»Hauptstrom»
FLUXUS 1967

238

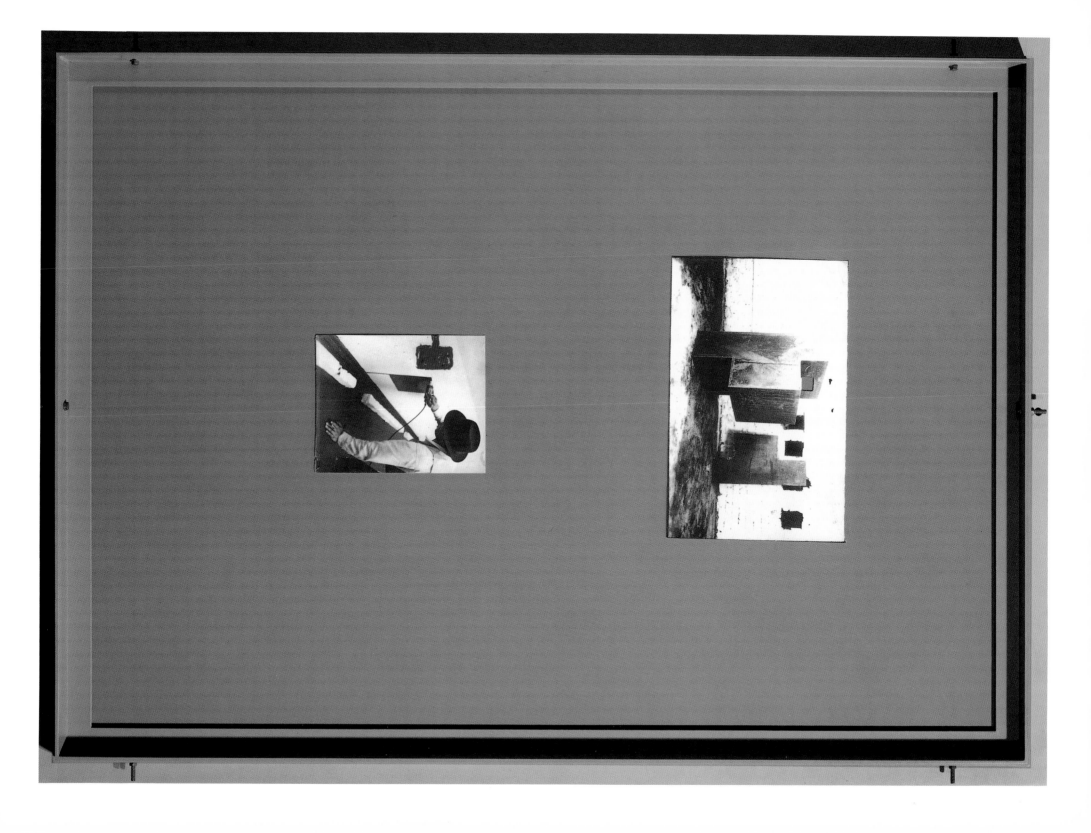

#88

a *24 Hours: and in us . . . under us . . . landunder 1965*
 24 Stunden: und in uns . . . unter uns . . . landunter

b *ELEMENT 1 and parts of ELEMENT 2 (complete with high-voltage alternating current) [six parts] 1966*
 ELEMENT 1 und Teile von ELEMENT 2 (vollständig mit Hochspannungswechselstrom) [sechs Teile]

 (positioned by Beuys for the camera, Drakeplatz 4, Düsseldorf)

c *Radio 1961*

d *24 Hours: and in us . . . under us . . . landunder 1965*

e *24 Hours: and in us . . . under us . . . landunder 1965*

f *ROOM 563 x 491 x 563 with Fat Corners and Dismantled Air Pumps 1968*
 RAUM 563 x 491 x 563 mit Fettecken und auseinandergerissenen Luftpumpen

g *ROOM 563 x 491 x 563 with Fat Corners and Dismantled Air Pumps 1968*

h *ROOM 563 x 491 x 563 with Fat Corners and Dismantled Air Pumps 1968*

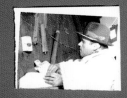
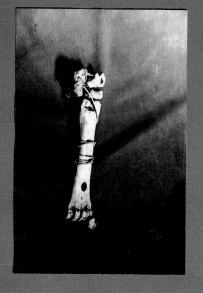
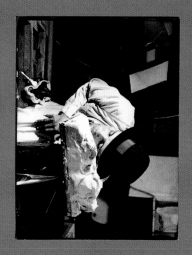

#89 a | (plate of blue glass)

#90 a *Celtic (Kinloch Rannoch) Scottish Symphony* 1970
Celtic (Kinloch Rannoch) Schottische Symphonie

b *Felt-TV II* 1968
Filz-TV II

c *EURASIAN STAFF 82 min fluxorum organum* 1968
EURASIENSTAB 82 min fluxorum organum

d *Infiltration Homogeneous for Grand Piano* 1966
Infiltration homogen für Konzertflügel

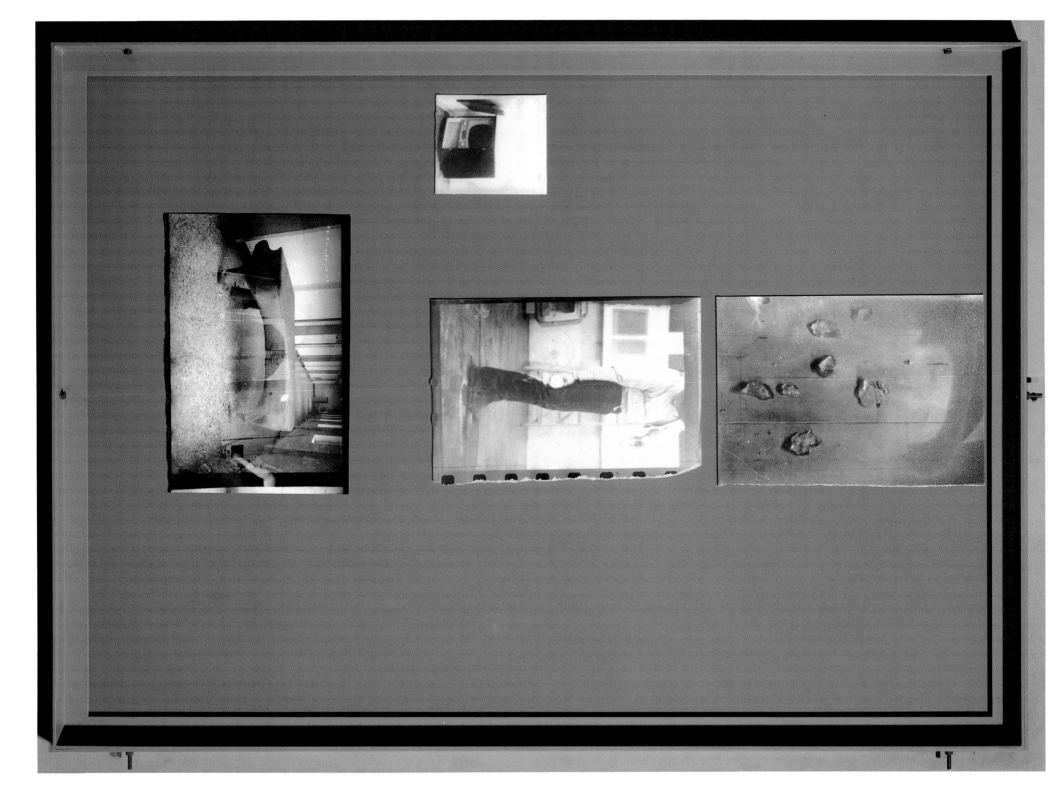

#91 a *24 Hours: and in us . . . under us . . . landunder* 1965
 24 Stunden: und in uns . . . unter uns . . . landunter

b *Titus/Iphigenie* 1969

c *(establishment of the German Students' Party, 1967)*

d *How to Explain Pictures to a Dead Hare* 1965
 wie man dem toten Hasen die Bilder erklärt

e *(photocopy with installation numbers to vitrine 1954–1967, "Block Beuys")*

f *(photocopy with installation numbers to vitrine 1954–1967, "Block Beuys")*

g *(photocopy with installation numbers to a vitrine in progress in "Block Beuys")*

h *ROOM 563 x 491 x 563 with Fat Corners and Dismantled Air Pumps 1968*
 RAUM 563 x 491 x 563 mit Fettecken und auseinandergerissenen Luftpumpen

i *Fat Elements Fat-Felt 1963*
 Fettelemente Fett-Filz

246

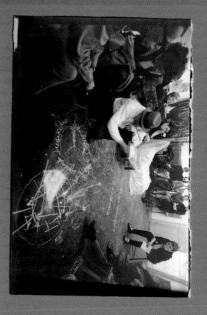

ELEMENT 1

ELEMENT 2

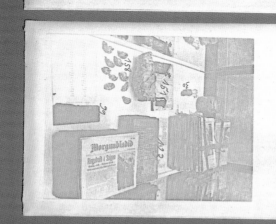

Morgunblaðið

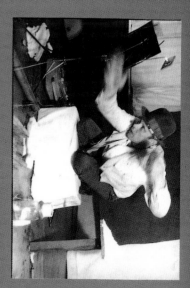

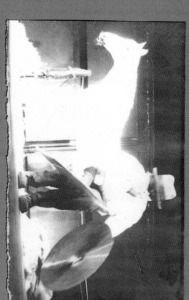

#92 a Silent Gramophone (II) 1962
stummes Grammophon (II)

b Fat-Felt-Sculpture 1963
Fett-Filz-Plastik

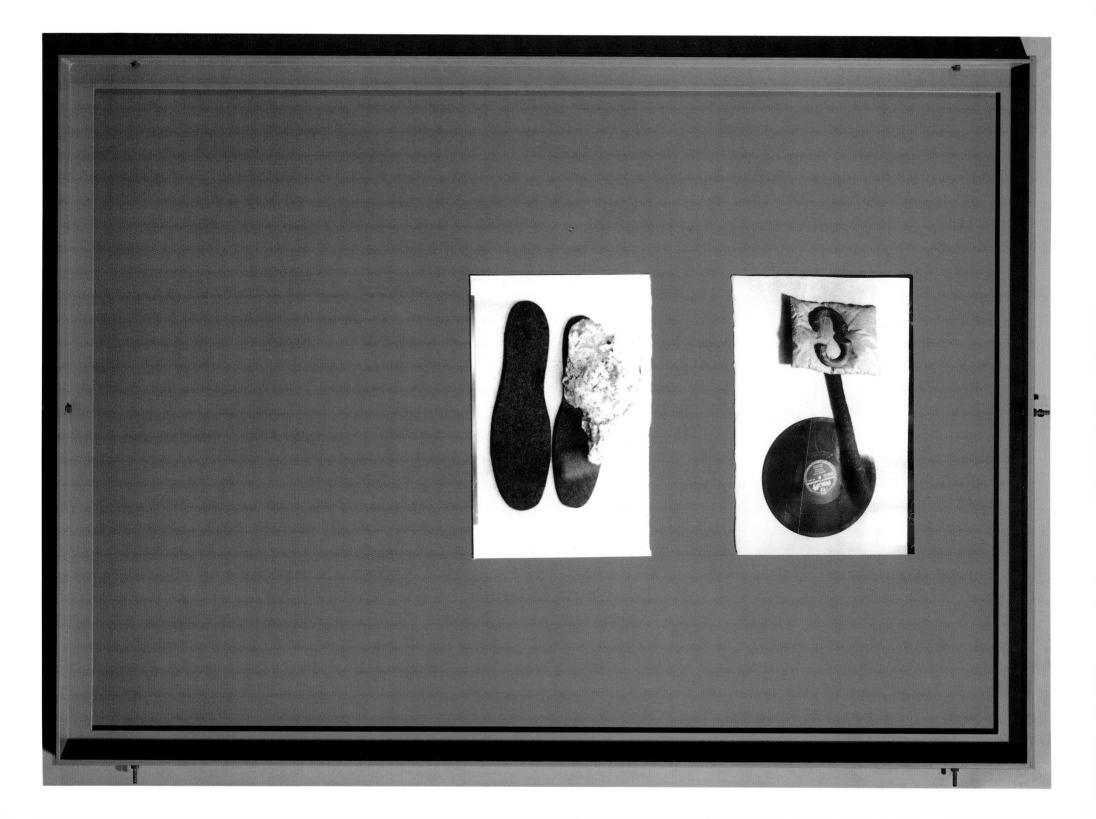

#93 a *Gliding Sculptural Charge→before←Isolation Pedestal 1960–1969*
Anschwebende plastische Ladung→vor←Isolationsgestell

b *Gliding Sculptural Charge→before←Isolation Pedestal 1960–1969*

c *ROOM 563 x 491 x 563 with Fat Corners and Dismantled Air Pumps 1968*
RAUM 563 x 491 x 563 mit Fettecken und auseinandergerissenen Luftpumpen

d *Action the dead mouse/Isolation Unit 1970*

#94 a *Hare Rods (EURASIA) 1965*
Hasenstangen (EURASIA)

Fat Filled with Powder (EURASIA) 1965
Fett gefüllt mit Puder (EURASIA)

Table I 1953
Tisch I

b *Hare Rods (EURASIA) 1965*

Fat Filled with Powder (EURASIA) 1965

Table I 1953

c *(not identified) ca. 1968*

#95 a | *Eurasian Staff* 1967
Eurasienstab

#96 a *Diver Demonstration 1962*
 Taucherin Demonstration

 b (Not identified)

 Emission Drill 1956
 Australbohrer

 (installation view "Block Beuys")

 c *ROOM 563 x 491 x 563 with Fat Corners and Dismantled Air Pumps 1968*
 RAUM 563 x 491 x 563 mit Fettecken und auseinandergerissenen Luftpumpen

#97 a *Fat Elements Fat-Felt 1963*
Fettelemente Fett-Filz

b *Fat Elements Fat-Felt 1963*

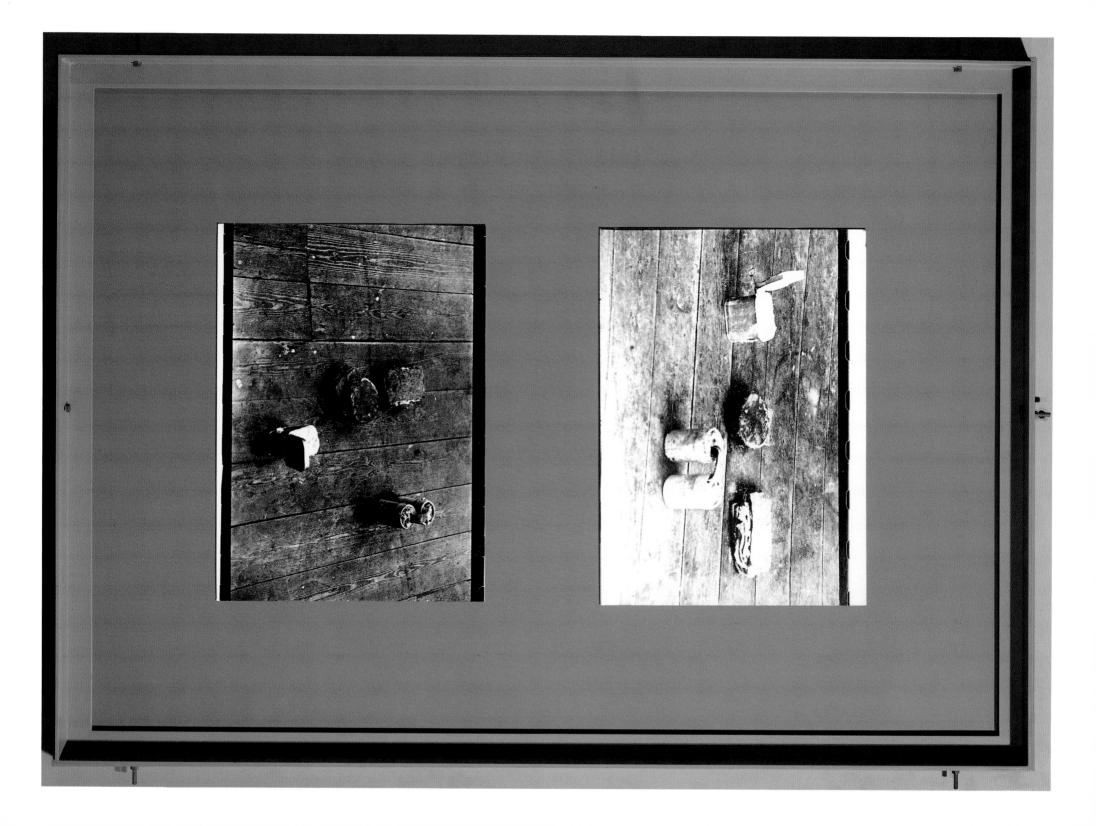

#98 a | *The Unconquerable* 1963
der Unbesiegbare

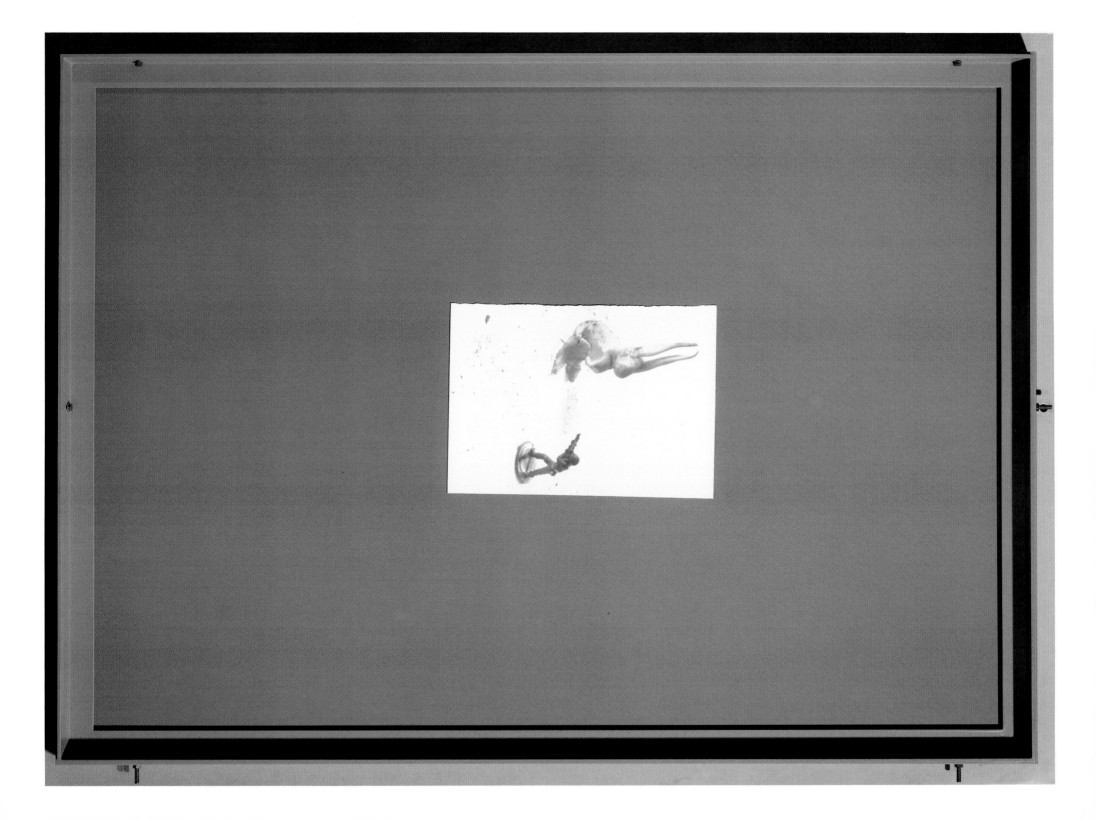

#100 a 24 Hours: and in us . . . under us . . . landunder 1965

24 Stunden: und in uns . . . unter uns . . . landunter

b ⊃ ↑

:»Hauptstrom»
FLUXUS 1967

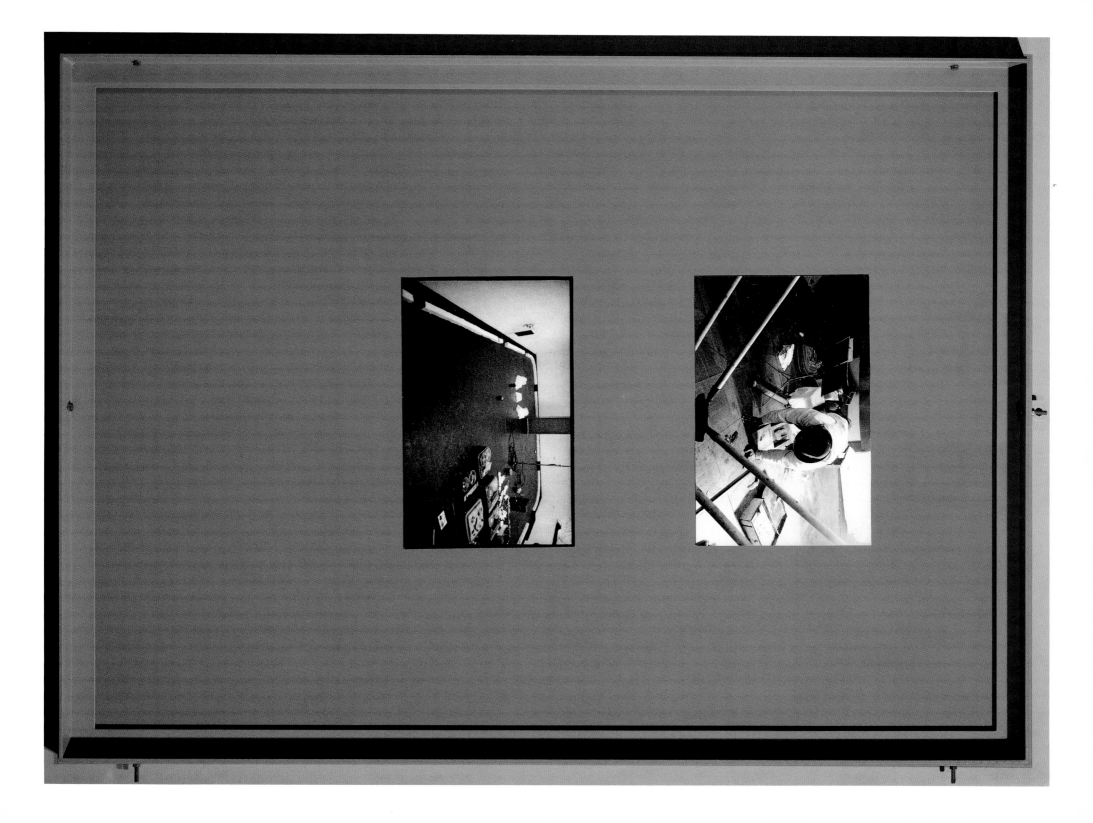

Glossary

The photographs that Beuys included in *Arena* were taken by various photographers whose names are catalogued in "*Arena's* Photographers" on pages 284–292. These often fragmentary traces of Beuys's sculpture, drawings, actions, and installations, resist didactic interpretation. It is for this reason that the glossary entries focus upon the display history (origins and present destinations) of the works caught by the camera, rather than their formal features. Individual works, now part of a larger complex, are listed separately in alphabetical order, when their exhibition history includes stations other than the site of their current location. Actions and works highlighted in italics within entries are detailed elsewhere in the glossary. Several entries lack numbers: these are informative references with only a general relationship to a specific photograph. Information on all works in "Block Beuys" is based upon Eva, Wenzel and Jessyka Beuys in *Joseph Beuys: Block Beuys* (Munich: Schirmer/Mosel, 1990). Details of actions are based upon Uwe M. Schneede, *Joseph Beuys: Die Aktionen* (Stuttgart: Verlag Gerd Hatje, 1994). Compiled by Pamela Kort.

Acoustic Filter 1962
akustischer Filter

From *4 akustische Filter* (*4 Acoustic Filters*), present location unknown. (58a) (73b)

Acoustic Instrument From:
Akustisches Instrument Aus: ⊃→
:›*Hauptstrom*››
1967

Following the action, first exhibited in "BEUYS," Städtisches Museum Abteiberg Mönchengladbach (September 13–October 29, 1967), and now in Vitrine 1954–1967, "Block Beuys" Hessisches Landesmuseum Darmstadt. (59a)

Action Corner (Sausage)—Physiology 1963
Aktionswinkel (Wurst)—Physiologie

From *EURASIA*, first exhibited in "BEUYS," Städtisches Museum Abteiberg Mönchengladbach (September 13–October 29, 1967), and now in Vitrine 1963–1966, "Block Beuys" Hessisches Landesmuseum Darmstadt. (8a)

Action Object from:
Aktionsobjekt aus: ⊃→
:›*Hauptstrom*››
1967

Now in the Estate of Joseph Beuys, Düsseldorf. (27c) (76e)

Action Sculpture 1963
Aktionsplastik

Now in the Stiftung Ludwig, Museum Ludwig, Cologne. (18b)

Action the dead mouse/Isolation Unit 1970

Terry Fox's action *Isolation Unit* occurred in collaboration with Beuys's *Action the dead mouse* in the basement of the Düsseldorf Art Academy on November 24, 1971. (1b) (46b) (58c) (93d)

Auschwitz Demonstration 1956–1964

Vitrine now in "Block Beuys," Hessisches Landesmuseum Darmstadt. (1a)

Barraque D'Dull Odde 1961–1967

Environment first installed in the Galerie Alfred Schmela, Düsseldorf (September 17–October 2, 1971). Consists of over six hundred fifty single objects and now in the Sammlung Helga and Walther Lauffs, Kaiser Wilhelm Museum, Krefeld. (7c) (24a) (62c) (67a) (67b) (67c) (68c) (68d) (70b)

Bathtub 1960
Badewanne

Now in the collection of Lothar Schirmer, Munich. (5c)

Bees (Giocondology) 1963
Bienen (Giocondologie)

First exhibited in "BEUYS," Städtisches Museum Abteiberg Mönchengladbach (September 13–October 29, 1967), and now in Vitrine 1950–1967, "Block Beuys" Hessisches Landesmuseum Darmstadt. (47e) (47f)

First exhibited in "Sammlung 1968 Karl Ströher," Galerie Verein Munich, Neue Pinakothek, West Wing of the Haus der Kunst, Munich (June 14–August 9, 1968), and now in Vitrine 1950–1967, "Block Beuys," Hessisches Landesmuseum Darmstadt. (47e)

BEUYS 1962

Group of objects, drawings, and sculpture by Joseph Beuys first acquired by Karl Ströher September 23, 1967, a majority of which were exhibited in "BEUYS," Städtisches Museum Abteiberg Mönchengladbach (September 13–October 29, 1967) and given on long-term loan to the Hessisches Landesmuseum Darmstadt, April 24, 1970. Beuys continued to install these objects until May 1984. (3a) (4b)

"Block Beuys" 1967–1984

First exhibited in "Sammlung 1968 Karl Ströher," Nationalgalerie der Staatlichen Museen Preußischer Kulturbesitz, Berlin (March 1–April 14, 1969), and now in Vitrine 1949–1968, "Block Beuys," Hessisches Landesmuseum Darmstadt. (71a)

Brown Head 1968
brauner Kopf

Now in Vitrine 3, in "Joseph Beuys: Raum in der Neuen Galerie," Staatliche Museen Kassel. (80b)

Camera 1963
Photoapparat

Action with Henning Christiansen in the civilian air-raid shelter at the Stadion St. Jakob, Basel, April 5, 1971, and part of the series, "Montagabend der Basler Theater." (5e) (24c) (77b) (79a) (79b) (79c)

Celtic + ∿∿∿ 1971

Action with Henning Christiansen at the Edinburgh College of Art (August 23–30, 1970) during the exhibition "Strategy: Get Arts" (August 23–September 12, 1970), and part of the official program of Edinburgh International Festival. (5d) (56a) (56b) (64b) (69b) (90a)

Celtic (Kinloch Rannoch) Scottish Symphony 1970
Celtic (Kinloch Rannoch) Schottische Symphonie

From MANRESA, first exhibited in "Sammlung 1968 Karl Ströher," Nationalgalerie der Staatlichen Museen Preußischer Kulturbesitz, Berlin (March 1–April 14, 1969), and now in Vitrine 1963–1966, "Block Beuys," Hessisches Landesmuseum Darmstadt. (8a)

comprimed exhausted 1966

Now in a vitrine in "Block Beuys," Hessisches Landesmuseum Darmstadt. (3c) (39a) (65a)

Chair with Fat 1963
Stuhl mit Fett

Now in Vitrine 3, 1960–1969, in "Joseph Beuys: Raum in der Neuen Galerie," Staatliche Museen Kassel. (8b)

Chemicals and a Glass 1958
Chemikalien und ein Glas

Now in Vitrine 3, 1960–1969, in "Joseph Beuys: Raum in der Neuen Galerie," Staatliche Museen Kassel. (27d)

Concentration Camp=Food 2 1960
KZ=Essen 2

First exhibited in "BEUYS," Städtisches Museum Abteiberg Mönchengladbach (September 13–October 29, 1967), and now in Vitrine 1949–1966, "Block Beuys," Hessisches Landesmuseum Darmstadt. (84a)

Concentration Camp=Food 1 1963
KZ=Essen 1

First exhibited in "Sammlung 1968 Karl Ströher," Nationalgalerie der Staatlichen Museen Preußischer Kulturbesitz, Berlin (March 1–April 14, 1969), and now in Vitrine 1949–1966, "Block Beuys," Hessisches Landesmuseum Darmstadt. (10a)

Cross with Kneecap and Hare's Skull 1961
Kreuz mit Kniescheibe und Hasenschädel

Action in the Billedhuggersalen Charlottenborg, Copenhagen, August 30, 1964, as part of "Maj-udstillingen (7 concerts—new concert phenomena, happenings, action music August 29–September 11)" and presented again at the Galerie René Block, Berlin, December 1, 1964.

DER CHEF/THE CHIEF Fluxus Song 1964
DER CHEF/THE CHIEF Fluxus Gesang

Drawing (#90) from *The secret block for a secret person in Ireland*; now in Sammlung Dr. Erich Marx, on loan to the Wilhelm-Lehmbruck-Museum, Duisburg. (21a)

Dead Man 1953
toter Mann

Present location unknown. (96a)

Diver Demonstration 1962
Taucherin Demonstration

First exhibited in "BEUYS," Städtisches Museum Abteiberg Mönchengladbach (September 13–October 29, 1967), and now in "Block Beuys," Hessisches Landesmuseum Darmstadt. (17d)

Double Aggregate 1958–1968
Doppelaggregat

Drawing 1959
Zeichnung

Present location unknown. (76b)

(Dried Cod) 1957
(Stockfisch)

Now in the Estate of Joseph Beuys, Düsseldorf. (29b) (47b)

Earth Cushion with Pedestal for Corner 1964
Erdkissen mit Gestell für Ecke

Pedestal from *24 Stunden: und in uns …unter uns …landunter* (*24 Hours: and in us …under us …landunder*), 1965, with the cushion first exhibited in "BEUYS," Städtisches Museum Abteiberg Mönchengladbach (September 13–October 29, 1967), and now in Vitrine 1949–1966, "Block Beuys," Hessisches Landesmuseum Darmstadt. (74a)

THE EARTH TELEPHONE 1967
DAS ERDTELEFON

First exhibited in "Sammlung 1968 Karl Ströher," Nationalgalerie der Staatlichen Museen Preußischer Kulturbesitz, Berlin (March 1–April 14, 1969), and now in "Block Beuys," Hessisches Landesmuseum Darmstadt. (44a)

Electric Object (static) 1958
Electric Objekt (static)

Present location unknown. (74a)

Electrode (Fat-Felt) 1963
Elektrode (Fett-Filz)

First exhibited in "Sammlung 1968 Karl Ströher," Galerie Verein Munich, Neue Pinakothek, West Wing of the Haus der Kunst, Munich (June 14–August 9, 1968), and now in Vitrine 1963, "Block Beuys," Hessisches Landesmuseum Darmstadt. (47f) (60b) (72a)

Element 1, Element 2, Paper 1966
Element 1, Element 2, Papier

From *MANRESA*, first exhibited in "Sammlung 1968 Karl Ströher," Nationalgalerie der Staatlichen Museen Preußischer Kulturbesitz, Berlin (March 1–April 14, 1969), and now in Vitrine 1963–1966, "Block Beuys," Hessisches Landesmuseum Darmstadt. (8a)

ELEMENT 1 and parts of ELEMENT 2
(complete with high-voltage alternating current)
[six parts] 1966
ELEMENT 1 und Teile von ELEMENT 2
(vollständig mit Hochspannungswechselstrom)
[sechs Teile]

From *MANRESA*, first exhibited in "BEUYS," Städtisches Museum Abteiberg Mönchengladbach (September 13–October 29, 1967), and now in "Block Beuys," Hessisches Landesmuseum Darmstadt. (11a) (11b) (11c) (84c) (88b)

Emanator From: Vehicle art 1964
Emanator Aus: Vehicle art

First exhibited in "BEUYS," Städtisches Museum Abteiberg Mönchengladbach (September 13–October 29, 1967), and now in Vitrine 1949–1966, "Block Beuys," Hessisches Landesmuseum Darmstadt. (70a)

Emission Drill 1956
Australbohrer

Now in "Block Beuys," Hessisches Landesmuseum Darmstadt. (96b)

EURASIA SIBERIAN SYMPHONY 1963
32nd COMPOSITION (EURASIA) FLUXUS 1966
EURASIA SIBIRISCHE SYMPHONIE 1963
32. SATZ (EURASIA) FLUXUS

Action in Galleri 101, Copenhagen, October 15, 1966, and part of "Eksperimentalforestillingen 'Tilstande'" organized by Trækvogn 13. *EURASIA* was presented a second time at the ninth and last "Soirée," October 31, 1966, Galerie René Block, Berlin. (19a) (20a)

Eurasian 1958
Eurasier

First exhibited in "Sammlung 1968 Karl Ströher," Nationalgalerie der Staatlichen Museen Preußischer Kulturbesitz, Berlin (March 1–April 14, 1969), and now in Vitrine 1949–1966, "Block Beuys," Hessisches Landesmuseum Darmstadt. (43b) (73a)

Eurasian Staff 1967
Eurasienstab

From *EURASIENSTAB* (*EURASIAN STAFF*); present location unknown. (95a)

EURASIAN STAFF 82 min fluxorum organum 1967
EURASIENSTAB 82 min fluxorum organum

Action with Henning Christiansen at the Galerie nächst St. Stephan, Vienna, July 2, 1967, in conjunction with the opening of the "XIII Internationalen Kunstgespräche," Galerie nächst St. Stephan (July 2–4, 1967). (31a) (46a) (78b)

EURASIAN STAFF 82 min fluxorum organum 1968
EURASIENSTAB 82 min fluxorum organum

Action with Henning Christiansen at the Wide White Space Gallery, Antwerp, February 9, 1968, in conjunction with the opening of "Zeichnungen, Fettplastiken" (February 10–March 5, 1968). (10d) (14a) (14b) (17b) (45d) (90c)

Eurasian Staff with 1 x 90 Degree Felt Corner
1967
Eurasienstab mit 1 x 90 Grad Filzwinkel

First exhibited in "BEUYS," Städtisches Museum Abteiberg Mönchengladbach (September 13–October 29, 1967), and now in "Block Beuys," Hessisches Landesmuseum Darmstadt. (11c) (84c)

Eurasian Staff with 4 x 90 Degree Felt Corners (I)
1967
Eurasienstab mit 4 x 90 Grad Filzwinkel (I)

From EURASIENSTAB (EURASIAN STAFF), July 2, 1967, first exhibited in "BEUYS," Städtisches Museum Abteiberg Mönchengladbach (September 13–October 29, 1967), and now in "Block Beuys," Hessisches Landesmuseum Darmstadt. (11c)

Eurasian Staff with 4 x 90 Degree Felt Corners (II)
1967
Eurasienstab mit 4 x 90 Grad Filzwinkel (II)

From EURASIENSTAB (EURASIAN STAFF), February 9, 1968, first exhibited in "BEUYS," Stedelijk Van Abbemuseum, Eindhoven, the Netherlands (March 22–May 5, 1968) and now in "Block Beuys," Hessisches Landesmuseum Darmstadt. (11a) (11b) (11c)

EVERVESS II 1 1968

First exhibited in "Sammlung 1968 Karl Ströher," Nationalgalerie der Staatlichen Museen Preußischer Kulturbesitz, Berlin (March 1–April 14, 1969), and now in Vitrine 1967–1970, "Block Beuys," Hessisches Landesmuseum Darmstadt. (76c)

Fat Battery 1964
Fettbatterie

Revised version of the work Fettelemente Fett-Filz (Fat Elements Fat-Felt), now in the collection of the Tate Gallery, London. (28b)

Fat Corner 1963 (1968)
Fettecke

From RAUM 563 x 491 x 563 mit Fettecken und auseinandergerissenen Luftpumpen (ROOM 563 x 491 x 563 with Fat Corners and Dismantled Air Pumps) at the Künstlerhaus, Nuremberg (July 20–September 15, 1968), based on a prototype of a Fat Corner from 1963. (3b) (7b) (49a) (50b)

Fat Corner 1963
Fettecke

Present location unknown. (15a)

Fat Corner from: The silence of Marcel Duchamp is overrated 1964
Fettecke aus: Das Schweigen von Marcel Duchamp wird überbewertet

Following the action, first exhibited in "BEUYS," Städtisches Museum Abteiberg Mönchengladbach (September 13–October 29, 1967), and now in "Block Beuys," Hessisches Landesmuseum Darmstadt. (3c) (65a)

Fat Elements Fat-Felt 1963
Fettelemente Fett-Filz

Now in the collection of the Tate Gallery, London. (28a) (91i) (97a) (97b)

Fat-Felt-Sculpture 1963
Fett-Filz-Plastik

First exhibited in April 1970 in "Endgültige Installation des Block Beuys," Hessisches Landesmuseum Darmstadt, where it remains in Vitrine 1949–1972 today. (92b)

Fat Figure with Filter 1961
Fettfigur mit Filter

First exhibited in "Sammlung 1968 Karl Ströher," Nationalgalerie der Staatlichen Museen Preußischer Kulturbesitz, Berlin (March 1–April 1969), and now in Vitrine 1950–1964, "Block Beuys," Hessisches Landesmuseum Darmstadt. (81a)

Fat Filled with Powder (EURASIA) 1965
Fett gefüllt mit Puder (EURASIA)

From EURASIA, first exhibited in "BEUYS," Städtisches Museum Abteiberg Mönchengladbach (September 13–October 29, 1967), and now in "Block Beuys," Hessisches Landesmuseum Darmstadt. (74b) (94a) (94b)

Fat Sculpture 1952
Fettplastik

First exhibited in "Sammlung 1968 Karl Ströher," Nationalgalerie der Staatlichen Museen Abteiberg Mönchengladbach (September 13–October 29, 1967), and now in Vitrine 1949–1966, in "Block Beuys," Hessisches Landesmuseum Darmstadt. (30b)

Fat Sculpture (transposed) Wax 1964
Fettplastik (transponiert) Wachs

First exhibited in "Sammlung 1968 Karl Ströher," Nationalgalerie der Staatlichen Museen Preußischer Kulturbesitz, Berlin (March 1–April 14, 1969), and now in Vitrine 1950–1967, "Block Beuys," Hessisches Landesmuseum Darmstadt. (47f) (48a)

Felt and Iron Elements from Actions 1963–1968
Filz und Eisenelemente aus Aktionen
Now in "Block Beuys," Hessisches Landesmuseum Darmstadt. (26c)

Felt Corner 1964
Filzecke
From EURASIA and MANRESA, first exhibited in "BEUYS," Städtisches Museum Abteiberg Mönchengladbach (September 13–October 29, 1967), and now in "Block Beuys," Hessisches Landesmuseum Darmstadt. (40c)

Felt Roll From: The Chief 1964
Filzrolle Aus: Der Chef
From DER CHEF/THE CHIEF Fluxus Gesang (DER CHEF/THE CHIEF CHIEF Fluxus Song) first exhibited in "BEUYS," Städtisches Museum Abteiberg Mönchengladbach (September 13–October 29, 1967), and now in "Block Beuys," Hessisches Landesmuseum Darmstadt. (2a) (11a) (11b) (84c)

Felt Sculpture 1963
Filzplastik
Now in Vitrine 1949–1966, "Block Beuys," Hessisches Landesmuseum Darmstadt. (76e)

Felt-TV 1966
Filz-TV
Action in Galleri 101, Copenhagen, October 14, 1966; and part of "Eksperimentalforestillingen 'Tilstande'" organized by Trækvogn 13.

Felt TV 1970
Filz TV
Videotape of the action Filz-TV (Felt-TV) 1966 made by Gerry Schum, now in Vitrine 1967–1970, "Block Beuys," Hessisches Landesmuseum Darmstadt. (63c)

Felt-TV II 1968
Filz-TV II
First exhibited in "Prospect 68," Düsseldorf (September 20–29, 1968) and now in "Joseph Beuys: Raum in der Neuen Galerie," Staatliche Museen Kassel. (44a) (90b)

Filter From:
Filter Aus: ⊃→
:>>Hauptstrom>>
1967
First exhibited in "Sammlung 1968 Karl Ströher," Nationalgalerie der Staatlichen Museen Preußischer Kulturbesitz, Berlin (March 1–April 14, 1969), and now in Vitrine 1967–1970, "Block Beuys," Hessisches Landesmuseum Darmstadt. (29a)

The Flag Alan Khoa 1956
Die Fahne Alan Khoa
First exhibited in "Joseph Beuys … irgend ein Strang …," Galerie Schmela, Düsseldorf (November 26–December 11, 1965), and now part of Szene aus der Hirschjagd (Scene from the Stag Hunt) in "Block Beuys," Hessisches Landesmuseum Darmstadt. (42d) (76d)

FOND 0 + Iron Plate 1957
FOND 0 + Eisenplatte
First exhibited in April 1970 in "Endgültige Installation des Block Beuys," Hessisches Landesmuseum Darmstadt, where it remains today.

FOND I 1957
First exhibited in "Sammlung 1968 Karl Ströher," Nationalgalerie der Staatlichen Museen Preußischer Kulturbesitz, Berlin (March 1–April 14, 1969), and now in Vitrine 1952–1967, "Block Beuys," Hessisches Landesmuseum Darmstadt. (84a)

FOND II 1961–1967 . . . 2 Copper Tables with
High Voltage–High Frequency Generator 1968
FOND II 1961–1967 . . . 2 Kupfertische mit
Hochspannungs-Hochfrequenz Generator
First exhibited in "BEUYS," Stedelijk Van Abbemuseum, Eindhoven (March 22–May 5, 1968), and now in "Block Beuys," Hessisches Landesmuseum Darmstadt. (17c)

FOND III 1969
First exhibited in "Fond III," at Galerie Schmela, Düsseldorf (January 29–February 21, 1969), and now in "Block Beuys," Hessisches Landesmuseum Darmstadt. (33b)

4 Acoustic Filters 1962
4 akustische Filter
Now in Vitrine 1950–1966, "Block Beuys," Hessisches Landesmuseum Darmstadt.

From: Actions/Agit Pop/De-Collage/Happening/
Events/Antiart/L'Autrisme/Art Total/Refluxus
July 20, 1964 Aachen 1964
Aus: Actions/AgitPop/De-Collage/Happening/
Events/Antiart/L'Autrisme/Art Total/Refluxus
20. Juli 1964 Aachen
From a Fluxus event by the same name at the Technischen Hochschule Aachen, July 20, 1964, organized by Valdis Abolins and Tomas Schmit as part of the Festival der neuen Kunst, first exhibited in "BEUYS," Städtisches Museum Abteiberg Mönchengladbach (September 13–October 29, 1967), and now in Vitrine 1949–1966, "Block Beuys," Hessisches Landesmuseum Darmstadt. (7oa)

Now in "Block Beuys," Hessisches Landesmuseum Darmstadt. (11a) (11b) (44a)

From: Eurasian Staff (Detail) 1967
Aus: Eurasienstab (Detail)

Following the action, the two wax objects were first exhibited in "BEUYS," Städtisches Museum Abteiberg Mönchengladbach (September 13–October 29, 1967), and now in Vitrine 1949–1966, "Block Beuys," Hessisches Landesmuseum Darmstadt. (23a) The felt piano cover was first exhibited in "BEUYS," Städtisches Museum Abteiberg Mönchengladbach (September 13–October 29, 1967), and now in "Block Beuys," Hessisches Landesmuseum Darmstadt. (41a) (63a)

From: Infiltration Homogeneous for Grand Piano 1966
Aus: Infiltration homogen für Konzertflügel

First exhibited in "Sammlung 1968 Karl Ströher," Galerie Verein Munich, Neue Pinakothek, West Wing of the Haus der Kunst, Munich (June 14–August 9, 1968), and now in Vitrine 1949–1962, "Block Beuys," Hessisches Landesmuseum Darmstadt. (37a)

From: Intelligence of Swans (scratched) 1952
Aus: Intelligenz der Schwäne (geritzt)

From *Titus/Iphigenie* and now part of *FOND O + Eisenplatte (FOND O + Iron Plate)*, "Block Beuys," Hessisches Landesmuseum Darmstadt. (54a)

From: IPHIGENIE 1969
Aus: IPHIGENIE

Following the action, first exhibited at Documenta 4 (June 27–October 6, 1968), and now in "Block Beuys," Hessisches Landesmuseum Darmstadt. (2a) (11a) (11b)

From: »THE CHIEF« (2 Parts) Felt-Copper 1964
Aus: »DER CHEF« (2 Teile) Filz-Kupfer

Present location unknown. (47c)

From: The silence of Marcel Duchamp is overrated 1964
Aus: Das Schweigen von Marcel Duchamp wird überbewertet

From *24 Stunden: und in uns ...unter uns ...landunter (24 Hours: and in us ...under us ...landunder)*, 1965, present location unknown. (24b)

Funnel 1965
Trichter

Now in the Collection of Lothar Schirmer, Munich. (86a)

Girl 1956
Mädchen

Now in the Sammlung Helga and Walther Lauffs, Kaiser Wilhelm Museum, Krefeld. (37b)

Gelatin-Object 1968
Gelose-Objekt

First exhibited in "Sammlung 1968 Karl Ströher," Galerie Verein Munich, Neue Pinakothek, West Wing of the Haus der Kunst, Munich (June 14–August 9, 1968), and now in Vitrine 1949–1966, "Block Beuys," Hessisches Landesmuseum Darmstadt. (70a)

Gliding Sculptural Charge→before←Isolation Pedestal 1960
Anschwebende plastische Ladung→vor←Isolationsgestell

First exhibited at the Kunstmarkt, Cologne (October 14–November 9, 1969), and now in the Sammlung Helga and Walther Lauffs, Kaiser Wilhelm Museum, Krefeld. (46c) (93a) (93b)

Gliding Sculptural Charge→before←Isolation Pedestal 1960–1969
Anschwebende plastische Ladung→vor←Isolationsgestell

First exhibited in "BEUYS," Städtisches Museum Abteiberg Mönchengladbach (September 13–October 29, 1967), and now in "Block Beuys," Hessisches Landesmuseum Darmstadt. (38c)

Grave (shooting ground) 1951
Grab (Schießplatz)

First exhibited in "BEUYS," Städtisches Museum Abteiberg Mönchengladbach (September 13–October 29, 1967), and now in Vitrine 1949–1968, "Block Beuys," Hessisches Landesmuseum Darmstadt. (7a)

Grauballe Man 1952
Grauballemann

Now in the Estate of Joseph Beuys, Düsseldorf. (29b)

Hammer for the Hard of Hearing 1963
Hammer für Schwerhörige

Action at Creamcheese, Düsseldorf, December 5, 1968, which was within the scope of Anatol Herzfeld's action *Der Tisch: Drama Stahltisch (The Table: Drama Steel Table)*. (31b) (32a) (75b) (78c)

Hand Action/Corner Action 1968
Handaktion/Eckenaktion

Hare Rods (EURASIA) 1965
Hasenstangen (EURASIA)

From *EURASIA*, first exhibited in "BEUYS," Städtisches Museum Abteiberg Mönchengladbach (September 13–October 29, 1967), and now in "Block Beuys," Hessisches Landesmuseum Darmstadt. (74b) (94a) (94b)

⊃→

:>>Hauptstrom>>
FLUXUS 1967

Action with Henning Christiansen at the Galerie Franz Dahlem, Darmstadt, March 20, 1967, in conjunction with the opening of "FETTRAUM," March 21–28, 1967. (1c) (17a) (20b) (58b) (61b) (62a) (62d) (84b) (87b) (100b)

High Voltage-High Frequency Generator for
FOND II 1968
Hochspannungs-Hochfrequenz-Generator von
FOND II

First exhibited in "BEUYS," Stedelijk Van Abbemuseum, Eindhoven (March 22–May 5, 1968), and now in "Block Beuys," Hessisches Landesmuseum Darmstadt. (77a)

How to Explain Pictures to a Dead Hare 1965
wie man dem toten Hasen die Bilder erklärt

Action at the Galerie Schmela, Düsseldorf, November 26, 1965, in conjunction with the opening of "Joseph Beuys … irgend ein Strang …" (November 26–December 11, 1965). (91d)

I attempt to set (make) you free 1969
Ich versuche dich freizulassen (machen)

Action with Henning Christiansen at the Akademie der Künste, Berlin, February 27, 1969. (34a) (45a)

I want to see my mountains 1971
Voglio vedere i miei montagne

Environment first installed in the Stedelijk Van Abbemuseum, Eindhoven (August 17–September 5, 1971), and now in this museum's collection. (9c) (78d) (80c) (80d) (80e)

Infiltration Homogeneous for Grand Piano 1966
Infiltration homogen für Konzertflügel

From the action *Infiltration homogen für Konzertflügel, der größte Komponist der Gegenwart ist das Contergankind* (*Infiltration Homogeneous for Grand Piano, The Greatest Contemporary Composer is the Thalidomide Child*) 1966; and now in the collection of the Musée National d'Art Moderne, Centre Georges Pompidou, Paris. (19c) (44a) (90d)

Infiltration Homogeneous for Grand Piano,
The Greatest Contemporary Composer is the
Thalidomide Child 1966
Infiltration Homogen für Konzertflügel, der
größte Komponist der Gegenwart ist das
Contergankind

Action at the Düsseldorf Art Academy, July 28, 1966, within the scope of a concert by Charlotte Moorman and Nam June Paik.

Instrument for Concert 1961
Instrument für Konzert

Present location unknown. (21b)

Intuition Wood-Fat 1968
Intuition Holz-Fett

First exhibited in "Sammlung 1968 Karl Ströher," Nationalgalerie der Staatlichen Museen Preußischer Kulturbesitz, Berlin (March 1–April 14, 1969), and now in Vitrine 1967–1970, "Block Beuys," Hessisches Landesmuseum Darmstadt. (69a)

Irish cross/Birth signs 1951

Present location unknown. (10c)

(Joyce) 1961

Part of a theater piece, *Jahrhundertwende*, written by Eva Beuys-Wurmbach, performed by her students in December 1962, and now in the collection of Anny De Decker, Antwerp. (55a)

Let's overcome the party dictatorship now 1971
Überwindet endlich die Parteiendiktatur

Action with fifty students from the Düsseldorf Art Academy in the Grafenberger forest near Düsseldorf, September 14, 1971. (16c)

LICHAMEN 1967

First exhibited in "BEUYS," Städtisches Museum Abteiberg Mönchengladbach (September 13–October 29, 1967), and now in "Block Beuys," Hessisches Landesmuseum Darmstadt. (52a)

Lightning 1964
Blitz

First exhibited in "BEUYS," Städtisches Museum Abteiberg Mönchengladbach (September 13–October 29, 1967), and now in *Auschwitz Demonstration* in "Block Beuys," Hessisches Landesmuseum Darmstadt. (4a) (43c)

Action with Henning Christiansen and Bjørn Nørgaard in conjunction with the closing of the group exhibition "Hommage an Schmela," Galerie Schmela, Düsseldorf, December 15, 1966. (8c) (35b) (62b)

MANRESA 1966

First exhibited in "Sammlung 1968 Karl Ströher," Galerie Verein Munich, Neue Pinakothek, West Wing of the Haus der Kunst, Munich (June 14–August 9, 1968), and now in "Block Beuys," Hessisches Landesmuseum Darmstadt. (70a)

Monument of the Dwarves 1956
Zwergendenkmal

First exhibited in April 1970 in "Endgültige Installation des Block Beuys," Hessisches Landesmuseum Darmstadt, where it remains today. (47d)

Mountain King (Tunnel) 2 Planets 1958–1961
Bergkönig (Tunnel) 2 Planeten

Installed by Beuys in Autumn of 1969; includes *Wärmeplastik* (*Warmth Sculpture*), a tape recording of Beuys's "Ja Ja Ja, Nee Nee Nee," and a grand piano. (42b)

(Music room: home of Hans Ulrich and Clara Bodenmann, Basel, ca. 1969)

Now in Vitrine 1950–1967, "Block Beuys," Hessisches Landesmuseum Darmstadt. (27b)

Neptune 1967
Neptun

First exhibited at "Joseph Beuys ... irgend ein Strang ...," Galerie Schmela, Düsseldorf (November 26–December 11, 1965), and now in "Block Beuys," Hessisches Landesmuseum Darmstadt. (11a) (11b)

90 Degree Felt Corner Notch 1965
90 Grad Filzwinkelkerbe

First exhibited in "Joseph Beuys ... irgend ein Strang ...," Galerie Schmela, Düsseldorf (November 26–December 11, 1965), and now in "Block Beuys," Hessisches Landesmuseum Darmstadt. (22a)

90 Degree Tented Felt Corner 1965
90 Grad überzelteter Filzwinkel

First exhibited at the Kunstmarkt, Cologne (October 14–November 9, 1969), and now in "Joseph Beuys: Raum in der Neuen Galerie," Staatliche Museen Kassel. (16a) (16b) (30c)

The Pack (das Rudel) 1969

Following the action, first exhibited in "Sammlung 1968 Karl Ströher," Galerie Verein Munich, Neue Pinakothek, West Wing in the Haus der Kunst, Munich (June 14–August 9, 1968), and now in Vitrine 1954–1967, "Block Beuys," Hessisches Landesmuseum Darmstadt. (42e)

PAN XXX ttt From: »24 Hours« 1965
PAN XXX ttt Aus: »24 Stunden«

Present location unknown. (68b)

Partitur (score) to The Greatest Contemporary Composer is the Thalidomide Child ca. 1966
Partitur zu: Der größte Komponist der Gegenwart ist das Contergankind

Present location unknown. (68a)

Partitur (score) to EURASIAN STAFF 1967
Partitur zu EURASIENSTAB

Now in the collection of the Staatsgalerie Stuttgart. (33a)

Plastic Base Elastic Base 1969
Plastischer Fuß Elastischer Fuß

Photographic detail of *Anschwebende plastische Ladung→vor→Isolationsgestell 1960* (*Gliding Sculptural Charge→before→Isolation Pedestal*). (14c)

(Plastic Charge Lighting [detail]) 1969
(plastische Ladung Blitz)

Present location unknown. (53c)

Project for Felt-Environment 1965
Entwurf für Filz-Environment

Now in a vitrine in "Block Beuys," Hessisches Landesmuseum Darmstadt. (39a)

Project Westmensch 1963
Projekt Westmensch

First exhibited at Documenta 3 (June 27–October 5, 1964), and now in Vitrine 1950–1963, "Block Beuys," Hessisches Landesmuseum Darmstadt. (76e)

Queen Bee 2 1952
Bienenkönigin 2

First exhibited at Documenta 3 (June 27–October 5, 1964), and now in Vitrine 1950–1963, "Block Beuys," Hessisches Landesmuseum Darmstadt. (76e)

Queen Bee 3 1952
Bienenkönigin 3

Radio 1961

First exhibited in "Sammlung 1968 Karl Ströher," Nationalgalerie der Staatlichen Museen Preußischer Kulturbesitz, Berlin (March 1–April 14, 1969), and now in Vitrine 1950–1967, "Block Beuys," Hessisches Landesmuseum Darmstadt. (88c)

Revolutionary Piano 1969
Revolutionsklavier

Now in Städtisches Museum Abteiberg Mönchengladbach. (69c)

ROOM 563 x 491 x 563 with Fat Corners and Dismantled Air Pumps 1968
RAUM 563 x 491 x 563 mit Fettecken und auseinandergerissenen Luftpumpen

Exhibition at the Künstlerhaus, Nuremberg, July 20–September 15, 1968. (23b) (26b) (50a) (57b) (65b) (88f) (88g) (88h) (91h) (93c) (96c)

Room: Warmth-Time Machine (Aggregate) 1958
Raum: Wärme-Zeitmaschine (Aggregat)

Element of *Doppelaggregat* (*Double Aggregate*) now in "Block Beuys," Hessisches Landesmuseum Darmstadt. (53a)

Room: Warmth-Time Machine (One-Armed Aggregate) 1959
Raum: Wärme-Zeitmaschine (einarmiges Aggregat)

Element of *Doppelaggregat* (*Double Aggregate*), also from MANRESA, and now in "Block Beuys," Hessisches Landesmuseum Darmstadt. (12a)

Rubberized Box 1957
gummierte Kiste

First exhibited in "Joseph Beuys ...irgend ein Strang . ..," Galerie Schmela, Düsseldorf (November 26–December 11, 1965), and now in "Block Beuys," Hessisches Landesmuseum Darmstadt. (1c)

Samurai Sword (Sausage) 1962
Samuraischwert (Wurst)

First exhibited in "BEUYS," Städtisches Museum Abteiberg Mönchengladbach (September 13–October 29, 1967), and now in Vitrine 1954–1967, "Block Beuys," Hessisches Landesmuseum Darmstadt. (36a)

Scene from the Stag Hunt 1961
Szene aus der Hirschjagd

First exhibited in "BEUYS," Stedelijk Van Abbemuseum, Eindhoven, (March 22–May 5, 1968) and now in "Block Beuys," Hessisches Landesmuseum Darmstadt. (17d) (42a) (53b) (76d)

The secret block for a secret person in Ireland 1936–1976

Group of drawings first exhibited at the Museum of Modern Art, Oxford (April 7–May 12, 1974), and now in the Sammlung Dr. Erich Marx, on loan to Wilhelm-Lehmbruck-Museum, Duisburg.

Sheep in Snow 1952
Schaf im Schnee

First exhibited in "BEUYS," Städtisches Museum Abteiberg Mönchengladbach (September 13–October 29, 1967), and now in Vitrine 1950–1967, "Block Beuys," Hessisches Landesmuseum Darmstadt. (7a)

Siberian Symphony 1st Composition 1963
Sibirische Symphonie 1. Satz

Action at the Düsseldorf Art Academy, February 2, 1963, and part of the FESTUM FLUXORUM. FLUXUS. MUSIK UND ANTIMUSIK. DAS INSTRUMENTALE THEATER.

Siberian Symphony (Finale) 1963
Sibirische Symphonie (Finale)

From *Sibirische Symphonie 1. Satz* (*Siberian Symphony 1st Composition*), first exhibited in "Sammlung 1968 Karl Ströher," Nationalgalerie der Staatlichen Museen Preußischer Kulturbesitz, Berlin (March 1–April 14, 1969), and now in Vitrine 1949–1966, "Block Beuys," Hessisches Landesmuseum Darmstadt. (10b)

The silence of Marcel Duchamp is overrated 1964
Das Schweigen von Marcel Duchamp wird überbewertet

Action with Bazon Brock, Tomas Schmit, and Wolf Vostell in the Landesstudio Nordrhein-Westfalen des Zweiten Deutschen Fernsehens, Düsseldorf, transmitted live as "Fluxus-Gruppe," December 11, 1964, and part of the series "Die Drehscheibe."

Silent Gramophone (I) 1961
stummes Grammophon (I)

Now in a private collection. (25b)

Silent Gramophone (II) 1962
stummes Grammophon (II)

First exhibited in April 1970 in "Endgültige Installation des Block Beuys," Hessisches Landesmuseum Darmstadt, where it remains in Vitrine 1949–1962 today. (92a)

First exhibited in "BEUYS," Stedelijk Van Abbemuseum, Eindhoven (March 22–May 5, 1968), and now in "Block Beuys," Hessisches Landesmuseum Darmstadt. (15b) (44b)

SITE (Fat Felt Sculpture) Complete with High-Voltage Alternating Current and Charged Copper Plate 1967
STELLE (Fettfilzplastik) vollständig mit Hochspannungswechselstrom aufgeladener Kupferplatte

Now in the Emanuel Hoffmann-Stiftung, Museum für Gegenwartskunst Basel. (54b)

Snowfall 1965
Schneefall

Now in the collection of the Museum am Ostwall Dortmund. (40a)

Space Compass 1962
Raumzirkel

From *24 Stunden: und in uns …unter uns …landunter* (24 Hours: and in us …under us …landunder) 1965, first exhibited in "BEUYS," Städtisches Museum Abteiberg Mönchengladbach (September 13–October 29, 1967), and now in a vitrine in "Block Beuys," Hessisches Landesmuseum Darmstadt. (39a)

Spade with 2 Handles (2x) 1964
Spaten mit 2 Stielen (2x)

First exhibited in "BEUYS," Städtisches Museum Abteiberg Mönchengladbach (September 13–October 29, 1967), and now in Vitrine 1949–1966, "Block Beuys," Hessisches Landesmuseum Darmstadt. (76e)

Slack 1964
Stapel

Title of a photograph, the sole documentation of a work no longer existent. (72b)

(Stag Leader) 1968
(Hirschführer)

Present location unknown. (27e)

… stayed too long on the ice 1953
… zu lange auf dem Eis geblieben

Now in the Stiftung Ludwig, Museum Ludwig, Cologne. (12b)

SYBILLA (Version II) 1954–1959
SYBILLA (Fassung II)

First exhibited in "BEUYS," Städtisches Museum Abteiberg Mönchengladbach (September 13–October 29, 1967), and now in "Block Beuys," Hessisches Landesmuseum Darmstadt. (74b) (94a) (94b)

Table I 1953
Tisch I

Following the action, first exhibited in "BEUYS," Städtisches Museum Abteiberg Mönchengladbach (September 13–October 29, 1967), and now in Vitrine 1949–1966, "Block Beuys," Hessisches Landesmuseum Darmstadt. (76e)

**Tantalus From: ›and in us … under us …
landunder‹ 1965**
*Tantalus Aus: ›und in uns … unter uns …
landunter‹*

Present location unknown. (78a)

Telephone ca. 1969
Telephon

First exhibited in "BEUYS," Städtisches Museum Abteiberg Mönchengladbach (September 13–October 29, 1967), and now in Vitrine 1949–1966, "Block Beuys," Hessisches Landesmuseum Darmstadt. (42c) (76e)

3 Cast Crosses with 2 Toy Stopwatches 1951
3 Wurfkreuze mit 2 Spielstoppuhren

First exhibited in "Sammlung 1968 Karl Ströher" Galerie Verein Munich, Neue Pinakothek, West Wing of the Haus der Kunst, Munich (June 14–August 9, 1968), and now in Vitrine 1950–1967, "Block Beuys," Hessisches Landesmuseum Darmstadt. (47e)

Thunderstorm 1957
Gewitter

First exhibited in "BEUYS," Städtisches Museum Abteiberg Mönchengladbach (September 13–October 29, 1967), and now in Vitrine 1954–1967, "Block Beuys," Hessisches Landesmuseum Darmstadt. (27a)

Tin of Fat for Piercing (Acoustic) FLUXUS 1963
Fettdose zum Stechen (Akustik) FLUXUS

Now in Vitrine 1949–1972, "Block Beuys," Hessisches Landesmuseum Darmstadt. (60b)

(title and year unknown)

Titus/Iphigenie 1969

Action at the Theater am Turm, Frankfurt, May 29, 1969, and May 30, 1969, with poetry from J. W. Goethe's *Iphigenie auf Tauris* reworked into a script by Beuys, and texts from both Goethe's text and Shakespeare's *Titus Andronicus* playing from a loudspeaker, in conjunction with the opening of "experimenta 3" (May 29–June 7, 1969), organized by the Deutschen Akademie der Darstellenden Künste. (5a) (18a) (20c) (26a) (66b) (91b)

TOTH 1949

First exhibited in "Sammlung 1968 Karl Ströher," Galerie Verein Munich, Neue Pinakothek, West Wing of the Haus der Kunst, Munich (June 14–August 9, 1968), and now in Vitrine 1949–1964, "Block Beuys," Hessisches Landesmuseum Darmstadt. (6a)

Train: Fat-Felt-Sculpture 1963
Zug: Fett-Filz-Plastik

Now in Vitrine 1963, "Block Beuys," Hessisches Landesmuseum Darmstadt. (86b)

Transformation Sign 1957
Transformationszeichen

First exhibited in "BEUYS," Städtisches Museum Abteiberg Mönchengladbach (September 13–October 29, 1967), and now in Vitrine 1950–1967, "Block Beuys," Hessisches Landesmuseum Darmstadt. (76e)

Transmitter 1963
Sender

Now in Vitrine 3, in "Joseph Beuys: Raum in der Neuen Galerie," Staatliche Museen Kassel. (30a)

Transsiberian Train 1961
Transsibirische Bahn

First exhibited in "BEUYS," Städtisches Museum Abteiberg Mönchengladbach (September 13–October 29, 1967), and now in "Block Beuys," Hessisches Landesmuseum Darmstadt. (47a)

Trap (copper) 1955
Falle (Kupfer)

First exhibited in "Sammlung 1968 Karl Ströher," Nationalgalerie der Staatliche Museen Preußischer Kulturbesitz, Berlin (March 1–April 14, 1969), and now in Vitrine 1949–1962, "Block Beuys," Hessisches Landesmuseum Darmstadt. (37a)

24 Hours: and in us . . . under us . . . land under us
1965

Action at the Galerie Parnass, Wuppertal, June 5, 1965, and part of "Happening 24 Stunden," with Bazon Brock, Charlotte Moorman, Nam June Paik, Eckart Rahn, Tomas Schmit, and Wolf Vostell, an event that

24 Stunden: und in uns . . . unter uns . . . land unter

marked the closing of this gallery. (25a) (35a) (38a) (45b) (45c) (88a) (88d) (88e) (91a) (100a)

2 x 90 Degree Felt Corners 1964
2 x 90 Grad Filzwinkel

First exhibited in "Joseph Beuys . . . irgend ein Strang . . . ," Galerie Schmela, Düsseldorf (November 26–December 11, 1965), and now in "Block Beuys," Hessisches Landesmuseum Darmstadt. (11a) (11b) (11c)

Two Hares are Bombarding the Mysterious Village 1969

Now in a vitrine in "Block Beuys," Hessisches Landesmuseum Darmstadt. (40b) (51a)

zwei Hasen bombardieren das geheimnisvolle Dorf

2 Loaves of Bread 1966
2 Brote

First exhibited in "BEUYS," Städtisches Museum Abteiberg Mönchengladbach (September 13–October 29, 1967), and now in Vitrine 1950–1967, "Block Beuys" Hessisches Landesmuseum Darmstadt. (47f)

2 Mining Lamps 1953
2 Berglampen

First exhibited in "BEUYS," Städtisches Museum Abteiberg Mönchengladbach (September 13–October 29, 1967), and now in Vitrine 1950–1963, "Block Beuys," Hessisches Landesmuseum Darmstadt. (6b)

U-Shaped Double Lamp with Hare's Fat (Rolled Picture) 1961
U-förmige Doppel-lampe mit Hasenfett (Rollenbild)

First exhibited in "BEUYS," Städtisches Museum Abteiberg Mönchengladbach (September 13–October 29, 1967), and now in Vitrine 1950–1967, "Block Beuys," Hessisches Landesmuseum Darmstadt. (2b)

The Unconquerable 1963
der Unbesiegbare

First exhibited in "Joseph Beuys," The Solomon R. Guggenheim Museum, New York (November 2, 1979–January 2, 1980), and now in Vitrine 1949–1968, "Block Beuys," Hessisches Landesmuseum Darmstadt. (98a)

Untitled 1956

Now in "Block Beuys," Hessisches Landesmuseum Darmstadt. (60a)

Untitled 1963

Present location unknown. (37d) (64d)

Untitled (Felt-Canvas) 1967
ohne Titel (Filz-Leinwand)

Present location unknown. (86b)

Vacuum ↔ Mass
Simultaneous=Iron box
Halved Cross
Contents: 20 kg fat
 100 air pumps 1968
Vakuum ↔ Masse
Simultan=Eisenkiste
halbiertes Kreuz
Inhalt: 20 kg Fett
 100 Luftpumpen

Action at Galerie Art Intermedia, Cologne, October 14, 1968, and part of the concurrent group exhibition "Zweite Realität" (October 15–November 28, 1968). (38b) (83a) (83b) (83c) (83d) (87a)

VAL (Vadrec [t]) 1961

First exhibited in April 1970 in "Endgültige Installation des Block Beuys," Hessisches Landesmuseum Darmstadt, where it remains today. (71b) (99a)

Variable Current Aggregate 1968
Wechselstromaggregat

Now in a private collection in Germany. (61a)

(Verona arena)

Photograph of the arena in Verona, Italy. (13a)

Virgin 1961
Jungfrau

First exhibited in "BEUYS," Städtisches Museum Abteiberg Mönchengladbach (September 13–October 29, 1967), and now in "Block Beuys," Hessisches Landesmuseum Darmstadt. (80a)

Warmth Sculpture 1968
Wärmeplastik

First exhibited in "When Attitudes Become Form" at the Kunsthalle Bern (March 22–April 27, 1969), and now in the collection of Hans Ulrich Bodenmann, Basel. (19b)

Warm Chair with Felt Sole, Iron Sole,
and Magnet 1965
warmer Stuhl mit Filzsohle, Eisensohle und
Magnet

From *wie man dem toten Hasen die Bilder erklärt* (*How to Explain Pictures to a Dead Hare*). *Felt Sole, Iron Sole, and Magnet* were also used in *EURASIENSTAB* (*EURASIAN STAFF*). All objects now in "Block Beuys," Hessisches Landesmuseum Darmstadt. (2a) (11a) (11b) (84c)

WEATHER TECHNICIAN 1960
WETTERWART

Now in Vitrine 3, in "Joseph Beuys: Raum in der Neuen Galerie," Staatliche Museen Kassel. (37c)

Wood Sausage 1962
Holzwurst

First exhibited in "Sammlung 1968 Karl Ströher," Galerie Verein Munich, Neue Pinakothek, West Wing of Haus der Kunst, Munich (June 14–August 9, 1968), and now in Vitrine 1949–1966, "Block Beuys," Hessisches Landesmuseum Darmstadt. (70a)

Biography

1921 born in Krefeld, Germany (May 12). Beuys, however, named Kleve as his birthplace in the *Lebenslauf/Werklauf (Life Course/Work Course)*

1940 graduation from Hindenberg Secondary School in Kleve

1941–45 combat pilot for the German military

1945–46 prisoner of war, Cuxhaven, England

1946–47 returns to Kleve to prepare for academic studies

1947–51 sculpture studies with Joseph Enseling at the Düsseldorf Art Academy

1949–51 continuation of studies with Ewald Mataré

1952–54 master student's studio at the Düsseldorf Art Academy

1953 first one-person exhibition, "Zeichnungen, Holzschnitte, Plastische Arbeiten," Haus van der Grinten, Kranenburg (February 13–March 15)

1954 studio in Düsseldorf

1955–57 lives through a phase of depressive exhaustion, from which he recovers by doing fieldwork at the van der Grinten family estate

1959 marriage to Eva Wurmbach

1961 birth of son Wenzel

appointment as Professor of Monumental Sculpture at the Düsseldorf Art Academy

1963 first participation in a Fluxus event, FESTUM FLUXORUM FLUXUS with Beuys's first action *Sibirische Symphonie 1. Satz (Siberian Symphony 1st Composition)*, February 2, and *Komposition für 2 Musikanten (Concert for 2 Musicians)*, February 3, Düsseldorf Art Academy

1964 birth of daughter Jessyka

participation in Documenta 3 where sculpture and drawings from the period 1951–1956 were exhibited (June 27–October 5)

1967 founding of the German Student Party in Düsseldorf (June 22)

1968 participation in Documenta 4 with the installation of *Raumplastik (Plastic Space)*, June 27–October 6

first "mistrust manifesto" filed by the professors of the Düsseldorf Art Academy against Joseph Beuys (November 24)

1970 exhibition of *The Pack (das Rudel)* and the early version of *Arena* at "Strategy: Get Arts," Edinburgh College of Art, Edinburgh (April 24–August 12)

1971 first exhibition with Lucio Amelio *We are the Revolution* at Modern Art Agency, Naples (November)

1972 second exhibition with Lucio Amelio at Modern Art Agency, Naples, *Arena—Dove sarei arrivato se fossi stato intelligente! (Arena—where would I have got if I had been intelligent!)* and the action *Vitex agnus castus* (June 10)

participation in Documenta 5 with the *Information Office of the Organization for Direct Democracy through Referendum* (June 30–October 8)

278

1972 dismissal from the Düsseldorf Art Academy by the Secretary of Sciences; beginning of the "Akademiestreit" (October 10)

exhibition of *Arena* and the action *Anacharsis Cloots* at Galleria L'Attico, Rome (October 31)

1973 exhibition of *Arena* at Studio Marconi, Milan (March)

exhibition of *Arena* at "Contemporanea," Rome (November–February 1974)

1974 first visit to the USA (January)

founding of the Free University in Düsseldorf (February)

1976 participation in the Venice Biennale with the installation *Tramstop, Strassenbahnhaltestelle I* (July 18–October 10)

receives Lichtwark Award of the city of Hamburg (December)

1977 participation in Documenta 6 with *Hönigpumpe am Arbeitsplatz* (*Honey Pump at the Workplace*) and *100 Days Free International University for Creativity and Interdisciplinary Research.* (June 24–October 2)

1978 receives Thorn-Prikker Honorary Award of the city of Krefeld (January 14)

dismissal of Beuys from the Düsseldorf Art Academy is declared unlawful by the Federal Court of Labor (April 7)

nomination to be member of the Academy of Arts in Berlin (May 6)

1979 candidacy for the European Parliament as a representative of the Green Party

receives Kaiserring Award of the city of Goslar (September 9)

participation in the Bienal Internacional de São Paulo with *Brazilian Fond* (October 3–December 9)

retrospective at the The Solomon R. Guggenheim Museum, New York (November 2–January 2, 1980)

1980 candidacy for the state of Nordrhein-Westfalen as a representative of the Green Party

participation in the Venice Biennale, "Das Kapital Raum 1970–77" (June 1–September 28)

1981 installation of *Terremoto in Palazzo*, Fondazione Lucio Amelio, Naples (April 17)

1982 participation in Documenta 7 with *7000 Eichen* (*7000 Oaks*), June 19–September 28

1985 installation of *Palazzo Regale*, Museo di Capodimonte, Naples (December 23)

1986 receives Wilhelm-Lehmbruck Award of the city of Duisburg (January 12)

Beuys dies in Düsseldorf (January 23)

279

Bibliography

Adriani, Götz, Winfried Konnertz, and Karin Thomas. *Joseph Beuys: Life and Works*. Trans. Patricia Lech. New York: Barron's, 1979. (Originally published as *Joseph Beuys: Leben und Werk*. Cologne: DuMont, 1973.)

Bastian, Heiner. *Dibujos Drawings*. Madrid: Fundacion Caja de Pensiones, 1985.

Bastian, Heiner, ed. *Joseph Beuys: The secret block for a secret person in Ireland*. Exhibition catalogue. Berlin: Martin-Gropius Bau, 1988.

Bastian, Heiner, ed. *Joseph Beuys: Skulpturen und Objekte*. Exhibition catalogue. Berlin: Martin-Gropius Bau, 1988.

Bastian, Heiner, and Jeannot Simmen, eds. *Joseph Beuys. Zeichnungen. Tekeningen. Drawings*. Exhibition catalogue. Berlin: Nationalgalerie, 1979; Rotterdam: Museum Boymans-van Beuningen, 1980.

Beuys. Exhibition catalogue. Mönchengladbach: Städtisches Museum Abteiberg, 1967.

Beuys MANRESA. Zeichnungen, Fotos, Materialien zu einer Fluxus Demonstration. Exhibition catalogue. Cologne: Kunst-Station Sankt Peter, 1991.

Beuys vor Beuys. Exhibition catalogue. Bonn: Ministerium für Bundesangelegenheiten des Landes Nordrhein-Westfalen, 1987.

Beuys, Eva, Wenzel and Jessyka. *Joseph Beuys: Block Beuys*. Munich: Schirmer/Mosel Verlag, 1990.

Bilderstreit: Widerspruch, Einheit und Fragment in der Kunst seit 1960. Cologne: Museum Ludwig in den Rheinhallen der Kölner Messe, 1989.

Blumenberg, Hans. *Work on Myth*. Translated by Robert M. Wallace. Cambridge, Mass.: MIT Press, 1985.

Bürger, Peter. "Der Alltag, die Allegorie und die Avantgarde: Bemerkungen mit Rücksicht auf Joseph Beuys." In *Postmoderne*, edited by Christa and Peter Bürger. Frankfurt: Suhrkamp, 1987.

Buzari, Pachutan, Matthias Roeser, and Jörg Zboralski. *Texte zur Kunst* 2, no. 7 (October 1992), 183–185.

Celant, Germano. *BEUYS: Tracce in Italia*. Naples: Amelio Editore, 1978.

Dennis Oppenheim: And the Mind Grew Fingers. Selected Works 1967–90. Exhibition catalogue. New York: Abrams in association with the Institute for Contemporary Art, P.S. 1 Museum, Long Island City, 1991.

Didi-Huberman, Georges. "Das Gesicht zwischen den Laken." *Jahresring* 39 (1992), 26–29.

Duchamp und die anderen. Cologne: DuMont, 1992.

Ellmann, Richard. *James Joyce*. Oxford: Oxford University Press, 1983.

Energy Plan for the Western Man: Joseph Beuys in America. New York: Four Walls Eight Windows, 1990.

Fleck, Robert. *Avant-Garde in Wien. Die Geschichte der Galerie nächst St. Stephan 1954–1982*. Vienna: Galerie nächst St. Stephan and Locker, 1982.

Fluxus: Aspekte eines Phänomens. Exhibition catalogue. Wuppertal: Von der Heydt Museum, 1981.

Friedrichs, Yvonne. "Wer repräsentiert in Edinburgh." *Düsseldorfer Feuilleton*, 142. June 24, 1970.

German Art in the 20th Century: Painting and Sculpture 1908–1985. Exhibition catalogue. London: Royal Academy of Arts, 1985.

Getlinger photographiert Beuys 1950–1963. Exhibition catalogue. Cologne: DuMont, 1990.

Glozer, Laszlo. *Kunstkritiken*. Frankfurt: Suhrkamp, 1974.

Goethe, Johann Wolfgang von. *Italian Journey*. Edited by Thomas P. Saine and Jeffrey L. Sammons. Translated by Robert R. Heitner. New York: Suhrkamp Publishers, 1989.

Gordon, Donald E. *Expressionism: Art and Idea*. New Haven: Yale University Press, 1987.

Grasskamp, Walter. *Die unbewältigte Moderne: Kunst und Öffenlichkeit*. Munich: C.H. Beck, 1989.

Habermas, Jürgen. *The Philosophical Discourse of Modernity: Twelve Lectures.* Translated by Frederick Lawrence. Cambridge, Mass.: MIT Press, 1987.

Harlan, Volker, Dieter Koepplin, and Rudolf Velhagen, eds. *Joseph Beuys—Tagung Basel 1–4. Mai 1991.* Basel: Wiese, 1991.

Harlan, Volker. *Was ist Kunst? Werkstattgespräch mit Beuys.* Stuttgart: Urachhaus, 1986.

Henri, Adrian. "Get Arts." *Scottish International.* November 12, 1970, 43–44.

Hofmann, Werner, ed. *Europa 1789: Aufklärung. Verklärung. Verfall.* Exhibition catalogue. Hamburg: Hamburger Kunsthalle, 1989.

Höhle, Augusta, and Anton Henze. *Römische Amphitheater und Stadien: Gladiatorenkämpfe und Circusspiele.* Zurich: Atlantis, 1981.

In Memoriam Joseph Beuys: Obituaries, Essays, Speeches. Bonn: Inter Nationes, 1986.

Joseph Beuys. Exhibition catalogue. Mönchengladbach: Städtisches Museum Mönchengladbach, 1967.

Joseph Beuys: Arbeiten aus Münchner Sammlungen. Exhibition catalogue. Munich: Städtische Galerie im Lenbachhaus, 1981.

Joseph Beuys: "Die Sozialen Plastik". Naples: Accademia di Belle Arti, 1987.

Joseph Beuys: Documenta Arbeit. Stuttgart: Edition Cantz, 1993.

Joseph Beuys: Fluxus aus der Sammlung van der Grinten. Exhibition catalogue. Kranenburg: Stallausstellung im Hause van der Grinten, 1963.

Joseph Beuys—Ölfarben 1949-1967. Exhibition catalogue. Tübingen: Kunsthalle Tübingen, 1984.

Joseph Beuys: Il ciclo del suo lavoro. Exhibition catalogue. Milan: Studio Marconi, 1973.

Joseph Beuys: Raum in der Neuen Galerie. Kassel: Staatliche Museen Kassel Neue Galerie, 1993.

Joseph Beuys: Nature Materie Form. Exhibition catalogue. Düsseldorf: Kunstsammlung Nordrhein-Westfalen, 1991.

Joseph Beuys Talks to Louwrien Wijers. Velp: Kantoor voor Cultuur Extracten, 1980.

Joseph Beuys: Nueve acciones fotografiadas por Ute Klophaus. Exhibition catalogue. Madrid: Fundacio Caja de Pensiones, 1985.

Joseph Beuys: zeige deine Wunde. Exhibition catalogue. Munich: Schellmann & Klüser, 1980.

Joseph Beuys: Werke aus der Sammlung Karl Ströher. Exhibition catalogue. Basel: Kunstmuseum, 1969.

Joseph Beuys, Zeichnungen, Aquarelle, Ölbilder, Plastische Bilder aus der Sammlung van der Grinten. Exhibition catalogue. Kleve: Städtisches Museum Haus Koekkoek, 1961.

Joyce, James. *Finnegans Wake.* London: Faber and Faber, 1939.

Joyce, James. *Ulysses.* New York: Vintage, 1990.

Kaes, Anton. "Germany as Memory." In *From Hitler to Heimat.* Cambridge, Mass.: Harvard University Press, 1989, 161–182.

Kaprow, Allan. *Assemblage, Environments & Happenings.* New York: Abrams, 1966.

Klocker, Hubert. "The Shattered Mirror." In *Viennese Actionism. Vienna 1960-1971. The Shattered Mirror.* Ed. Hubert Klocker. Klagenfurt, Austria: Ritter Verlag, 1989, 93.

Klophaus, Ute. *Sein und Bleiben. Photographie zu Joseph Beuys.* Exhibition catalogue. Bonn: Kunstverein, 1986.

Klüser, Bernd, and Katharina Hegewisch, eds. *Die Kunst der Ausstellung.* Frankfurt am Main: Insel Verlag, 1991.

Kort, Pamela. *A. R. Penck: Venice Paintings.* Santa Monica: Fred Hoffman Gallery, 1989.

Kramer, Mario. *Joseph Beuys: Das Kapital Raum 1970–1977.* Heidelberg: Edition Staeck, 1991.

Kunst der sechziger Jahre in der Neuen Galerie Kassel. Kassel: Staatliche Kunstsammlungen, 1982.

L'Atelier de Jackson Pollock. Hans Namuth. Paris: Macula, 1978.

L'Attico 1957–1987. Exhibition catalogue. Milan: Arnoldo Mondadori Editore; Rome: De Luca Editore, 1987.

Leppien, Helmut R. Joseph Beuys in der Hamburger Kunsthalle. Hamburg: Hamburger Kunsthalle, 1991.

Lucie-Smith, Edward. "A Great Subversive." The Sunday Times. August, 30, 1970.

Lurker, Manfred, ed. Wörterbuch der Symbolik. Stuttgart: Alfred Kröner, 1991.

Mackintosh, Alastair. "Beuys in Edinburgh." Art and Artists 5, no. 8 (November 1970), 10.

Mai, Ekkehard. "Kunst lehren, mit der Kunst leben: Kunsthochschulen in NRW–Umrisse." In Zeitzeichen: Stationen Bildender Kunst in Nordrhein-Westfalen. Exhibition catalogue, edited by Karl Ruhrberg. Bonn: Ministerium für Bundesangelegenheiten des Landes Nordrhein-Westfalen, 1989, 191–192.

"Multiple Authenticity." Art and Artists 9 (July 1974), 22–27.

"Multiples Supplement." Studio International 184, no. 947 (September 1972), 94–108.

Mythos und Ritual in der Kunst der siebziger Jahre. Exhibition catalogue. Hamburg: Hamburger Kunstverein, 1981.

Neumann, Eckhard. Künstlermythen. Frankfurt and New York: Campus, 1986.

Neumann, Erich. The Origins and History of Consciousness. Translated by R.F.C. Hull. Bollingen Series 42. Princeton: Princeton University Press, 1973.

Nielsen, Hans Jörgen. "Beuys's Joyce," Hvedekorn 5 (1966), 178–179.

Nietzsche, Friedrich. Ecce Homo: How One Becomes What One Is. Trans. R.J. Hollingdale. New York: Penguin, 1982.

Oliva, Achille Bonito, ed. Arte natura. Milan: Electa, 1978.

Phillips, Christopher. "Back to Beuys." Art in America 81, no. 9 (September 1993), 88–93.

Phillips, Christopher, ed. Photography in the Modern Era: European Documents and Critical Writings, 1913–1940. New York: Metropolitan Museum of Art, 1989.

Plouffe, Paul-Albert. "Joseph Beuys: Avers et revers." Parachute 21 (Winter 1980), 32–41.

Reden zur Verleihung des Wilhelm-Lehmbruck-Preises der Stadt Duisburg 1986 an Joseph Beuys. Duisburg: Wilhelm-Lehmbruck-Museum, 1986.

Reiner Ruthenbeck. Fotografie 1956-1976. Exhibition catalogue. Stuttgart: Edition Cantz, 1991.

Rimbaud, Arthur. Complete Works, Selected Letters. Translated by Wallace Fowlie. Chicago: University of Illinois Press, 1966.

Romain, Lothar, and Rolf Wedewer. Über Beuys. Düsseldorf: Droste, 1972.

Ronte, Dieter. "Hermann Nitsch. Fragen zur Ästhetik der Aktionsfotografie." In Nitsch. Das bilderische Werk. Salzburg and Vienna: Residenz Verlag, 1988.

Rosenberg, Harold. The Anxious Object. Chicago: University of Chicago Press, 1982.

Stüttgen, Johannes, ed. Similia Similibus: Joseph Beuys zum 60. Geburtstag. Cologne: DuMont, 1981.

Stationen der Moderne. Exhibition catalogue. Berlin: Berlinische Galerie, 1988.

Strategy: Get Arts. Exhibition catalogue. Edinburgh: Edinburgh International Festival, 1970.

"Subjektive Fotografie" Images of the '50s. Exhibition catalogue. Essen: Museum Folkwang, 1984.

Schama, Simon. Citizens: A Chronicle of the French Revolution. New York: Alfred A. Knopf, 1989.

Schellmann, Jörg, and Bernd Klüser. Joseph Beuys: Multiples 1965–1980. Translated by Caroline Tisdall. New York: New York University Press, 1980.

Schellmann, Jörg, ed. Joseph Beuys: Die Multiples. Munich: Edition Schellmann and Schirmer/Mosel Verlag, 1992.

Schmidt, Hans-Werner. "Andy Warhol 'Mao'—Joseph Beuys 'Ausfegen,'" *Idea* 9 (1990), 224.

Schmidt, Jochen. *Die Geschichte des Genie-Gedankens in der deutschen Literatur, Philosophie, und Politik 1750–1945,* I. Darmstadt: Wissenschaftliche Buchgesellschaft, 1988.

Schmied, Wieland, ed. *Zeichen des Glaubens: Geist der Avantgarde.* Stuttgart: Klett-Cotta, 1980.

Schneckenburger, Manfred, ed. *Documenta: Idee und Institution.* Munich: Bruckmann, 1983.

Schneede, Uwe. *Joseph Beuys: Die Aktionen.* Stuttgart: Verlag Gerd Hatje, 1994.

Staeck, Klaus, and Gerhard Steidel, eds. *Joseph Beuys in Amerika.* Heidelberg: Editions Staeck, 1987.

Starobinski, Jean. *1789: The Emblems of Reason.* Translated by Barbara Bray. Charlottesville: University Press of Virginia, 1982.

Szeemann, Harald, ed. *Joseph Beuys.* Zürich: Kunsthaus Zürich, 1993.

Szeemann, Harald, ed. *Visionäre Schweiz.* Exhibition catalogue. Aarau: Saurlander, 1991.

Temkin, Ann, and Bernice Rose. *Thinking is Form: The Drawings of Joseph Beuys.* Philadelphia: The Philadelphia Museum of Art; New York: The Museum of Modern Art, 1993.

Three Towards Infinity: New Multiple Art. Exhibition catalogue. London: Arts Council of Great Britian, 1970.

Tisdall, Caroline. *Bits and Pieces: A Collection of Work by Joseph Beuys from 1957–1985.* London: Richard Demarco Gallery in association with the Red Lion House and the Arnolfini Gallery, 1987.

Tisdall, Caroline, ed. *Joseph Beuys.* Exhibition catalogue. New York: The Solomon R. Guggenheim Museum, 1979.

Tisdall, Caroline. *Joseph Beuys: Coyote.* Munich: Schirmer-Mosel, 1980.

Transit: Joseph Beuys Plastische Arbeiten 1947–1985/Zeichnungen 1947–1977. Exhibition catalogue. Krefeld: Kaiser Wilhelm Museum, 1991.

Treffpunkt Parnass. Exhibition catalogue. Wuppertal: Von der Heydt Museum, 1980.

van Winkel, Camiel. "'jetzt brechen wir hier den Scheiss ab' Installations of Joseph Beuys in Dutch Museum Collections." *Kunst & Museumjournaal* 5, no. 2 (1993), 34–47.

Vergine, Lea, ed. *Il corpo come linguaggio.* Milan: Giampaolo Prearo Editore, 1971.

von Wiese, Stephan, ed. *Brennpunkt Düsseldorf 1962–1987.* Exhibition catalogue. Düsseldorf: Kunstmuseum Düsseldorf, 1987.

Vostell, Wolf. "DADA und Mentale Energie." *Sprache im technischen Zeitalter* 55 (1975), 214–215.

Wagner, Jan. *Terrae Motus alla Reggia di Caserta.* Naples: Electa Napoli and Guida Editori in association with the Fondazione Amelio, 1992.

Although the photographs in the panels of *Arena* have been attributed to or have been identified as having been taken by at least nine different photographers, Joseph Beuys not only assembled them but often altered them by painting, cropping, reversing, and turning. Beuys's overpainting ranges from the application of small colored dots, as in #27a, to near-obliteration of the original photograph, as in #23a. Though many of the photographs found in *Arena* have been reproduced as documentation in various catalogues and books, others have limited illustrative value, as they are out-of-focus and under- or over-exposed. Attributions have been made, when possible, below.

Arena's Photographers

frame #	photographer	notes
1 a	attributed to Ute Klophaus	drawing in iron oxide, red wax with thin layer of yellow wax; feather-torn top edge
1 b	Ute Klophaus	layer of wax with two finger marks; brown nick in the image; torn bottom edge
1 c	Ute Klophaus	drawing in iron oxide, red wax
2 a	attributed to Ute Klophaus	thin layer of wax; feather-torn top edge
2 b	Ute Klophaus	thin layer of wax, with some wax buildup in the upper right corner and along the bottom edge; torn bottom edge
3 a	attributed to Ute Klophaus	thin layer of wax; torn bottom edge
3 b		turned 90°; thin layer of wax, extending over edges; torn bottom edge
3 c	attributed to Ute Klophaus	thin layer of wax; torn right edge
3 d		thin layer of wax; torn left edge
4 a	Ute Klophaus	layer of wax interrupted along the top edge, with heavy drip extending over bottom edge; finger marks in upper right; torn left and bottom edges
4 b		layer of wax; largely overpainted in black wax; torn bottom edge
5 a	Abisag Tüllmann or Ute Klophaus	layer of wax; torn right edge
5 b		layer of wax; chemical stain; torn left and bottom edge
5 c	attributed to Ute Klophaus	torn bottom edge
5 d		purple stamp marks; feather-torn bottom edge
5 e	Ute Klophaus	purple stamp marks; feather-torn top edge

6 a	attributed to Günter Schott	layer of wax stamp mark; irregular cropping
6 b	Eva Beuys-Wurmbach	brown chemical stain
7 a	Ute Klophaus	layer of wax; torn top edge
7 b	attributed to Ute Klophaus	turned 90°; layer of wax; torn bottom edge
7 c		layer of wax; small areas of burnishing in the corners; torn bottom edge
8 a		thin layer of wax, with heavy drips along the bottom edge; torn bottom edge
8 b		layer of wax; stamp mark; feather-torn top edge
8 c	attributed to Ute Klophaus	uniformly trimmed sides; very small abrasions in the emulsion layer at the edges
9 a		layer of wax
9 b		layer of wax
9 c	Ute Klophaus	layer of wax; torn right edge
10 a	attributed to Ute Klophaus	layer of wax; two rectangular patches of heavy wax deposit, and heavily dripped wax layer extending over bottom edge; torn bottom edge
10 b	Manfred Tischer	layer of wax gradually becoming denser toward bottom
10 c		layer of wax; torn left edge
10 d		torn right edge
11 a		thin layer of wax; torn left and right edges
11 b		thin layer of wax; torn left and right edges
11 c	attributed to Ute Klophaus	thin layer of wax; torn bottom edge
12 a	Manfred Tischer	layer of wax with drips along the top and bottom edges
12 b	attributed to Fritz Getlinger	irregular layer of wax
13 a	Verona arena	sun or acid damage forming a line down the center
14 a	attributed to Ute Klophaus	thin layer of wax; finger marks along the top edge; torn bottom edge; overpainted in brown tone on right and left top corners
14 b	attributed to Ute Klophaus	thin layer of wax; finger marks along the top edge; cropped; torn bottom edge; brown tone on right edge
14 c	attributed to Ute Klophaus	turned 90°; thin layer of wax; finger marks along the top edge; torn top edge
15 a	Eva Beuys-Wurmbach	fat or wax splatters; some scratches in the emulsion layer
15 b	Eva Beuys-Wurmbach	top cropped; bottom unevenly trimmed
16 a	Caroline Tisdall or Eva Beuys-Wurmbach	
16 b		
16 c		torn left edge
17 a	Ute Klophaus or Camillo Fischer	mottled layer of wax; two stamp marks at the bottom; finger marks at the top edges
17 b	attributed to Ute Klophaus	layer of wax with finger marks and smudges; two overlapping exposures

No.	Attribution	Description
17 c	**Eva Beuys-Wurmbach**	
17 d	**Ute Klophaus**	crease along upper left corner
18 a	**Abisag Tüllmann or Ute Klophaus**	layer of wax; stamp mark
18 b		layer of wax with finger marks
19 a	**Ute Klophaus**	torn bottom edge
19 b	**attributed to Ute Klophaus**	torn bottom edge
19 c	**Ute Klophaus**	torn bottom edge
20 a	**Ute Klophaus**	torn bottom edge
20 b	**attributed to Ute Klophaus**	layer of wax; torn bottom edge
20 c	**Ute Klophaus**	reversed; detail of larger image; torn left edge
21 a		layer of wax; torn bottom edge
21 b		layer of wax; torn bottom edge
22 a		layer of wax
23 a	**Ute Klophaus**	largely overpainted in iron oxide, red wax; torn top edge
23 b	**attributed to Ute Klophaus**	yellow layer of wax with finger marks; torn top edge
24 a		thin layer of wax with finger marks; scratch marks in the emulsion; feather-torn bottom edge
24 b	**Ute Klophaus**	uneven layer of wax with drip, extending over bottom edge; areas of transparency from the grease of wax or fat; feather-torn left and bottom edges
24 c	**Ute Klophaus**	layer of wax with finger marks; torn bottom edge
24 d	**Ute Klophaus**	layer of wax with finger marks; torn bottom edge
25 a	**Ute Klophaus**	torn left edge
25 b	**attributed to Eva Beuys-Wurmbach**	
25 c	**attributed to Ute Klophaus**	
26 a	**Ute Klophaus**	thin layer of wax; top left edge overpainted in yellow color; torn bottom edge
26 b	**attributed to Ute Klophaus**	layer of wax with drip; torn bottom edge
26 c	**Ute Klophaus**	heavy layer of wax with finger marks; torn left edge
27 a	**attributed to Ute Klophaus**	uniform yellow layer of wax with finger marks; heavy hand-applied areas of wax along top left; four yellow paint spots
27 b		layer of wax with finger marks
27 c	**Ute Klophaus**	layer of wax with rubbed areas and heavy wax area along bottom edge; feather-torn right edge
27 d		layer of wax; some translucent areas
27 e		layer of wax with finger marks
28 a	**attributed to Ute Klophaus**	
28 b	**attributed to Ute Klophaus**	
29 a	**Ute Klophaus**	turned 90°; layer of wax; reversed; cropped; torn top edge

No.	Attribution	Description
29 b	Ute Klophaus	layer of wax; torn top edge
30 a		thin layer of wax with finger marks; feather-torn bottom edge
30 b	attributed to Eva Beuys-Wurmbach	layer of wax; torn bottom edge
30 c	attributed to Ute Klophaus	feather-torn bottom edge
31 a		thin layer of yellow wax
31 b	Ute Klophaus	thin layer of yellow wax; torn left edge
32 a		thin, uneven layer of wax; torn left edge
33 a	attributed to Ute Klophaus	torn bottom edge
33 b	Eva Beuys-Wurmbach	torn bottom edge
34 a	attributed to Müller Schneck	torn right edge
35 a	attributed to Ute Klophaus	torn bottom edge
35 b	attributed to Ute Klophaus	
36 a	Ute Klophaus	inverted; layer of wax; some translucence from fat-wax mixture; torn top edge
37 d		thin layer of wax with finger marks; torn bottom edge
37 c		thin layer of wax with finger marks; torn top edge
37 b		thin layer of wax; torn left edge
37 a		thin layer of wax with finger marks; torn bottom edge
38 a	attributed to Ute Klophaus	torn top edge
38 b	Ute Klophaus	torn top edge
38 c	Ute Klophaus	
39 a	attributed to Ute Klophaus	thin layer of wax; feather-torn top edge
40 a		layer of wax
40 b		uneven layer of wax with finger marks; torn bottom edge
40 c	Ute Klophaus	uneven layer of wax with finger marks
41 a	attributed to Ute Klophaus	layer of wax with finger marks at top edges; areas of translucence; feather-torn right edge
42 a		layer of wax with finger mark at upper edge and lower left
42 b		layer of wax with finger marks; torn bottom edge
42 c		layer of yellow wax; feather-torn bottom edge
42 d		torn bottom edge
42 e	Ute Klophaus	detail of larger image
43 a		layer of wax with finger marks; overpainting in yellow; brownish chemical stain around applied color; feather-torn bottom edge
43 b	Ute Klophaus	thin layer of wax; feather-torn right edge
43 c	Ute Klophaus	mottled layer of wax; feather-torn right edge
44 a		layer of wax; feather-torn top edge

44 b	attributed to Ute Klophaus	uniform layer of yellow wax; feather-torn left edge
45 a		thin layer of wax with finger marks; heavy deposit of wax along the bottom edge
45 b	Ute Klophaus	layer of wax with finger marks; feather-torn top edge
45 c	Ute Klophaus	layer of wax with drips on the left; slightly heavier layer of wax at the bottom
45 d	attributed to Müller Schneck	chemically manipulated emulsion with double exposure
46 a	Ute Klophaus	from film made by Paul de Fru; layer of wax with finger marks; torn left edge
46 b	attributed to Ute Klophaus	feather-torn left edge
46 c	attributed to Ute Klophaus	feather-torn bottom edge
47 a	attributed to Ute Klophaus	thin layer of wax with drips and finger marks; torn right edge
47 b	Ute Klophaus	thin layer of wax with drips and finger marks; cropped; torn right edge
47 c		thin layer of wax with drips and finger marks; torn bottom edge
47 d	Ute Klophaus	thin layer of wax with drips and finger marks; reversed; torn top edge
47 e		thin layer of wax with drips and finger marks; torn top edge
47 f		thin layer of wax with drips and finger marks; torn top edge
48 a	Eva Beuys-Wurmbach	layer of wax; double exposure; feather-torn bottom edge
49 a	Ute Klophaus	pulp residue on the top edge; torn bottom edge
50 a	Ute Klophaus	layer of wax; cropped; feather-torn left edge
50 b	Ute Klophaus	layer of wax; feather-torn bottom edge
51 a		uneven layer of wax; copy print
51 b		layer of wax with finger marks; streaking in the surface of the print
52 a	attributed to Ute Klophaus	mottled layer of wax; torn left edge
53 a	attributed to Manfred Tischer	layer of wax over bottom half with delicate dripping pattern
53 b	Eva Beuys-Wurmbach	layer of wax; scratches in the emulsion layers; torn bottom edge
53 c	Eva Beuys-Wurmbach	layer of wax; scratches in the emulsion layers; cropped
54 a		
54 b		
55 a		feather-torn bottom edge
56 a		
56 b		
57 a		thin layer of wax with finger marks

57 b	attributed to Ute Klophaus	thin layer of wax with finger marks; wax extends over the bottom edge; torn left edge
58 a		layer of yellow wax; torn bottom edge
58 b	Ute Klophaus	layer of yellow wax with finger marks; cropped
58 c		uniform layer of yellow wax; torn bottom edge
59 a	Ute Klophaus	layer of wax with finger marks; reversed; feather-torn left edge
60 a		layer of wax with finger marks; torn left edge
60 b	Ute Klophaus	layer of wax with finger marks
60 c		stamp on left side; feather-torn bottom edge
61 a		red drawing in iron oxide, red wax; torn bottom edge
61 b	Ute Klophaus	layer of wax; cropped; torn left and bottom edges
62 a	attributed to Ute Klophaus	
62 b	Ute Klophaus	photo-lithographic print with hand inscription in both ink and graphite pencil; tape and adhesive residue at edges
62 c		feather-torn left edge
62 d	attributed to Ute Klophaus	layer of wax; yellow coloration; torn left edge
63 a		layer of wax; yellow coloration; torn left edge
63 b		layer of wax; yellow coloration; photo from the video *Filz-TV (Felt-TV)* with camera by Gerry Schum; torn top edge
63 c	attributed to Ute Klophaus	thin, uniform layer of wax; stamp on upper left
64 b		brown irregular splotches
64 b		thin, uniform layer of wax
64 a	attributed to Ute Klophaus	drawing in red running horizontally at the bottom; small brown mark in upper left
64 d	attributed to Fritz Getlinger	torn top edge
65 a		torn top edge
65 b	Ute Klophaus	slight scratches in the surface
66 a	attributed to Abisag Tüllmann or Ute Klophaus	slight scratches in the surface
66 b	attributed to Abisag Tüllmann or Ute Klophaus	torn left edge
67 a	attributed to Ute Klophaus	torn top edge
67 b	attributed to Ute Klophaus	torn bottom edge
67 c	attributed to Ute Klophaus	layer of wax with finger marks on top edges and drips over the bottom edge
68 a	Ute Klophaus	torn right edge
68 b	Ute Klophaus	feather-torn bottom edge
68 c		feather-torn top edge
68 d		layer of wax; feather-torn bottom edge
69 a		

No.	Attribution	Description
69 b		chemically manipulated for brown tonality; torn right edge
69 c	attributed to Ute Klophaus	layer of yellow wax; torn left edge
70 a		feather-torn top edge
70 b	attributed to Eva Beuys-Wurmbach	layer of wax, heavier along the bottom edge
71 a	Ute Klophaus	uniform layer of wax; feather-torn left edge
71 b		overpainting in iron oxide, red wax; uniform layer of yellow wax; torn bottom edge
72 a		overpainting in iron oxide, red wax; uniform layer of yellow wax; torn bottom edge
72 b	Ute Klophaus	layer of wax with finger marks; feather-torn right edge
73 a	Ute Klophaus	layer of wax; thick blobs of wax in upper right and upper left; areas of translucence; torn bottom edge
73 b	Ute Klophaus	layer of yellow wax with finger marks at top edges; torn top edge
74 a		layer of yellow wax with finger marks at top edges; negative of #94 a and b; torn bottom edge
74 b	attributed to Ute Klophaus	layer of yellow wax with finger marks at top edges; torn left edge
74 c		brown tonality; torn right edge
75 a		layer of wax; torn top edge
75 b	attributed to Ute Klophaus	layer of wax with finger marks along the bottom edge at the corners; feather-torn right edge
76 a	attributed to Ute Klophaus	scratched and mottled layer of wax delicately extending over the bottom edge; torn left edge
76 b		layer of wax with a large drip in the lower left corner; irregularly trimmed left and right edges
76 c	Eva Beuys-Wurmbach	layer of wax; torn left edge
76 d	attributed to Ute Klophaus	layer of wax; feather-torn bottom edge
76 e	attributed to Ute Klophaus	layer of wax; feather-torn left edge
77 a		small smudged red circle overpainting; irregular layer of wax with finger marks; large wax deposit in lower right corner; feather-torn top edge
77 b	Ute Klophaus	layer of wax; torn right edge
78 a		layer of wax; torn right edge
78 b	Ute Klophaus	torn right edge
78 c	Ute Klophaus	layer of wax; torn top edge
78 d	Ute Klophaus	layer of wax; torn bottom edge
79 a	Ute Klophaus	torn right edge
79 b	Ute Klophaus	stamp in upper left; torn top edge
79 c	Ute Klophaus	stamp in upper left; torn bottom edge
80 a		layer of wax

80 b — layer of wax; torn left edge

80 c — layer of wax; torn left edge

80 d — layer of wax; torn right edge

80 e — Ute Klophaus — layer of wax; torn bottom edge

81 a — Ute Klophaus — layer of wax; torn bottom edge

81 b — layer of wax; torn bottom edge

82 — sheet of yellow glass

83 a — Ute Klophaus — layer of wax torn top and bottom edges

83 b — Ute Klophaus — torn top and bottom edges

83 c — Ute Klophaus — torn top and bottom edges

83 d — Ute Klophaus — torn top and bottom edges

84 a — layer of yellow wax, brushmarked throughout; strip of dark material at lower edge; torn left edge

84 b — thin layer of yellow wax; torn left edge

84 c — brown coloration; torn right edge

85 — sheet of blue glass

86 a — Eva Beuys-Wurmbach — thin layer of wax with finger marks along the top edge

86 b — Ute Klophaus — layer of wax; cropped; feather-torn left edge

87 a — layer of wax with finger marks; heavier deposit of wax along bottom edge; feather-torn top edge

87 b — red square overpainted in iron oxide, red wax; layer of wax with two finger marks; heavy, brittle wax layer along bottom edge

88 a — Ute Klophaus — brown processing stains in upper section

88 b — drawing in heavy yellow wax along right edge; two stamp marks; thinly applied layer of wax overall

88 c — attributed to Ute Klophaus — thin layer of yellow wax with finger marks; chemical processing marks

88 d — Ute Klophaus — torn bottom edge

88 e — attributed to Ute Klophaus — thin layer of wax; torn top edge

88 f — uniform layer of wax; torn top edge

88 g — attributed to Ute Klophaus — layer of wax with finger marks near edges; torn bottom edge

88 h — sheet of blue glass

89 — turned 90°; feather-torn right edge

90 a — attributed to Ute Klophaus — layer of wax with drips along the bottom

90 b — layer of wax with finger marks at top; from film made by Paul de Fru; stamp mark in center; torn right edge

90 c — attributed to Ute Klophaus — feather-torn bottom edge

90 d — attributed to Ute Klophaus — layer of wax

91 a — attributed to Ute Klophaus

291

	Attribution	Description
91 b	attributed to Abisag Tüllmann or Ute Klophaus	layer of wax; stamp marks; torn bottom edge
91 c		layer of wax; torn top edge
91 d	Ute Klophaus	torn bottom edge
91 e		layer of wax
91 f		layer of wax
91 g		layer of wax
91 h	attributed to Ute Klophaus	layer of wax; stamp marks; torn bottom edge
91 i	Ute Klophaus	layer of wax; torn top edge
92 a	attributed to Ute Klophaus	irregular layer of wax with finger marks and heavy drip along left edge; torn bottom edge
92 b	Ute Klophaus	layer of wax with finger marks; stamp mark; feather-torn top edge
93 a	attributed to Ute Klophaus	layer of wax with finger marks; chemical distortion of emulsion at the lower left edge; torn left edge
93 b	attributed to Ute Klophaus	layer of wax with finger marks
93 c	attributed to Ute Klophaus	thin layer of wax with finger marks; torn bottom edge
93 d	Ute Klophaus	torn top edge
94 a	attributed to Ute Klophaus	layer of wax; torn top edge
94 b	attributed to Ute Klophaus	mottled and manipulated layer of wax with finger marks
94 c		
95 a		layer of wax, extending from bottom left corner; heavy deposit of yellow wax along top edge; torn right and bottom edges
96 a		
96 b		torn top edge
96 c	attributed to Ute Klophaus	irregular layer of wax with finger marks; torn top edge
97 a	attributed to Ute Klophaus	
97 b	attributed to Ute Klophaus	
98 a	Ute Klophaus	very similar photos exist by Eva Beuys-Wurmbach; torn left edge
99 a	Ute Klophaus	mottled layer of wax; feather-torn left edge
100 a	attributed to Ute Klophaus	
100 b		

Contributors

Lucio Amelio opened his gallery Modern Art Agency in Naples in 1965, where he has since shown the work of numerous artists, including Andy Warhol, Robert Rauschenberg, Cy Twombly, and Joseph Beuys. Fondazione Lucio Amelio was founded in 1982 to form "Terrae Motus," a collection of contemporary art.

Lynne Cooke has been Curator at the Dia Center for the Arts since 1991. She has published widely on contemporary art, and has taught at various institutions including the University of London.

Karen Kelly is Director of Publications and Program Coordinator at the Dia Center for the Arts. She is the organizer of exhibition catalogues and "Discussions in Contemporary Culture," an ongoing program of symposia and publications dedicated to contemporary debate and discussion.

Pamela Kort will receive her doctorate in art history from the University of California at Los Angeles in Fall 1994. She writes exclusively about twentieth-century art in German-speaking Europe. Her publications include books and catalogue essays on Lyonel Feininger, Jörg Immendorff, Wassily Kandinsky, Paul Klee, A.R. Penck, and Oskar Schlemmer. She lives and works in Cologne and Los Angeles.

Christopher Phillips is Senior Editor at *Art in America*. He has written widely about contemporary art and photography, and is Editor of the book *Photography in the Modern Era*, which was published by the Metropolitan Museum of Art in 1989.

Photo credits

Title pages courtesy Lucio Amelio, Naples; page 13 (above) © The Scotsman Publications Ltd., Edinburgh, (below) courtesy Lucio Amelio, Naples, photograph by Claudio Abate; page 14 (above) Collection Dia Center for the Arts, New York, photograph by Oren Slor, (below) courtesy Lucio Amelio, Naples; page 15 (above, middle, and below) © Fabio Donati, Naples; page 16 (above and below) © The Solomon R. Guggenheim Foundation, New York, photograph by Mary Donlon; page 17 photograph by Bill Jacobson Studio, New York; page 19 courtesy Cordelia Oliver, Edinburgh, photograph by George Oliver; page 20 courtesy Armin Hundertmark, Cologne; page 21 courtesy Caroline Tisdall, London; page 23 courtesy Eva Beuys-Wurmbach; page 24 (above) photograph by Cathy Carver, (below) courtesy Staatliche Museen Kassel; page 25 courtesy Edition Staeck, Heidelberg; page 26 (above) photograph by Cathy Carver, (below) Collection Dia Center for the Arts, New York, photograph by Oren Slor; page 27 (above) photograph by Cathy Carver, (below) courtesy Alte Pinakothek, Munich; page 28 © TMR/ADAGP, Paris, Collection L. Treillard; page 29 Collection Dia Center for the Arts, New York; page 30 courtesy Edition Schellmann, Cologne-New York, (below) courtesy Heiner Bastian; pages 35–38 courtesy Lucio Amelio, Naples; page 39 courtesy © The Scotsman Publications Ltd., Edinburgh; page 42 courtesy Lucio Amelio, Naples; page 44 still from film by Nino Longobardi; page 47 courtesy Cathy Carver; page 49 courtesy Lucio Amelio, Naples; page 50 (above and below) courtesy Kunstsammlung Nordrhein-Westfalen, Düsseldorf; page 54 courtesy Edition Schellmann, Cologne-New York; page 55 (above and below) courtesy Reiner Ruthenbeck, Ratingen; page 56 courtesy Hermann Nitsch, Prinzendorf; page 57 courtesy Robert R. McElroy, New York; page 58 courtesy Heinrich Riebesehl, Hannover; page 59 courtesy Edition Staeck, Heidelberg; page 60 photograph by Oren Slor; page 61 Collection Dia Center for the Arts, New York, photograph by Oren Slor.